CONTENTS

目錄

ABBREVIATIONS （英文縮寫）

AdSC = Accademia Di Santa Cecilia, Rom

AdSMF = Academy of St. Martins in the Fields

CgOA = Concertgebouw Orchestra of Amsterdam

Clvld = Cleveland Orchstra

CSO = Chicago Symphony Orchestra

DSO = Detroit Symphony Orchestra

ECO = English Chamber Orchestra

GOS = Gran Orchestra Sinfonica

IPO = Israel Philharmonic Orchestra

LAPO = Los Angeles Philharmonic Orchestra

LAPE = Los Angeles Percussion Ensemble

LPO = London Philharmonic Orchestra

LSO = London Symphony Orchestra

MMF = Maggio Musicale Fiorentino Orchestra

NPhO = New Philharmonia Orchestra

NOS = National Orchestra of Spain

NPO = National Philharmonic Orchestra

NSODC = National Symphony Orchestra of Washington D.C.

NwSO = New Symphony Orchestra of London

OSR = L'Orchestre de la Suisse Romande

PCO = Paris Conservatoire Orchestra

PhH = Philharmonia Hungarica

PhO = Philharmonia Orchestra

ROHCG = Royal Opera House Orchestra, Covent Garden

RPO = Royal Philharmonic Orchestra

StCO = Stuttgart Chamber Orchestra

VPO = Vienna Philharmonic Orchestra

VSOO = Vienna State Opera Orchestra

VVO = Vienna Volksoper Orchestra

ABBREVIATIONS 英文縮寫

Asterisk after the series number, e.g. Decca SXL 2001 or London CS 6013*

 Means: it was reissued by Speakers Corner.

* [序號後加星號，表示有 Speakers Corner 的復刻片，如 Decca SXL 2001* 或 London CS 6013*]

() after the series number, e.g. Decca SXL 2153 (SXL 2107-8, ©=SDD 257)

 Means: SXL 2153 (is one of the SXL 2107-8, ©= the equivalent reissue)

() 在序號後的括號，如 Decca SXL 2153 （SXL 2107-8, ©=SDD 257）

 表示：SXL 2153 （是 SXL2107-8 中的一張，©= 相同錄音的再版編號）

Ⓟ1958 © 1959; @1958 = Produced in 1958, released in 1959; @ =1958 Edition （1958年版）

Ⓟ & © symbols are not copy right, Ⓟ= produced or producer; © = copy, released year

AS List = Arthur Salvatore Supreme LP Recordings List (from www.high-endaudio.com)

 AS-DIV = The Divinity List (finest sounding records)

 AS-DG = The Demi-Gods List

 AS List = The Basic List

 AS List-H = The Honorable Mentions

 AS List-F = His Favorite Recordings (not considers the sonics)

BB = Blue Border or Blue Back Cover （中文請參照本書前言中，唱片內標與版本）

ED1 = 1st Label (ED1 是首版)

 DECCA: Wide Band Grooved (WBG), rim text "Original Recording By.." at 10 o'clock

 LONDON: FFSS, Wide Band Grooved (WBG)

ED2 = 2nd Label (ED2 是首版)

 DECCA: Wide Band Grooved (WBG), rim text "Made in England" at 10 o'clock

 LONDON: *ffrr,* Grooved, rim text "Made in England" at 11 o'clock

ED3 = 3rd Label (ED3 是首版)

 DECCA: Wide Band Non-Grooved (WB), rim text "Made in England" at 10 o'clock

 LONDON: *ffrr*, Non-Grooved, rim text "Made in England" at 11 o'clock

ED4 = 4th Label (ED4 是首版)

 DECCA: Narrow Band (NB), "Made in England"

 LONDON: *ffrr*, "Made in England" at left above the STEREOPHONIC

ED5 = 5th Label (ED5 是首版)

 DECCA: Dutch Narrow Band (NB), "Made in Holland" at bottom rim

 LONDON: *ffrr*, "Made in Holland" at bottom rim

G. Top 100 = The British Gramophone Magazine TOP 100

 [留聲機雜誌百大古典唱片]

Japan 300 = Best 300 CD & LP [Japan - Ongaku No Tomo (Ontomo Mook) 1984-2011]

 [日本音樂之友社出版的定期刊物 - 唱片藝術（レコード芸術）（Record Geijutsu），
 針對古典樂最基本的 300 個曲目（後來有陸續擴充），選出最受好評的版本，稱之為
 唱片藝術 - 名曲名盤 300]

Penguin = [The Penguin Stereo Record Guide ℗1975 ©1977; ℗ ©1982; ℗ ©1984]

Penguin ★★★ ❀ = The Penguin Guide 3 star rating with Rosette（企鵝三星帶花）

 (❀ Rosettes indicate that they are of extra special quality)

Penguin ★★★ = The Penguin Guide 3 star rating (outstanding performance and recording)

Penguin ★★ (★) = Brackets round one or more of the star indicate some reservations

 about its inclusion & readers are advised to refer to the text.

RM = Robert Moon's "Full Frequency Stereophonic Sound", ratings for Early London/ Decca Classical Recordings – Performance Rating (1-10) +Sound Rating (1-10) = Maximum rating is RM 20

Robert Moon 在他的 "FFSS" 一書中，對早期 London/Decca 唱片的評價，演出 (1-10 分) + 音效 (1-10 分)，最高 RM 20 分。

TASEC = TAS Editor's Choice (Harry Pearson – HP's List 2014)

 [TAS 主編哈利 · 皮爾森（HP）2014 年的榜單]

TASEC ✲✲ = Best of the Bunch [TAS 主編哈利 · 皮爾森的 12 張發燒天碟榜單]

TAS-OLD = HP's Old List [TAS 主編哈利 · 皮爾森的舊榜單]

TAS2016 & TAS2017 = TAS Super LP List 2016 & 2017, by Jonathan Valin

TAS SM 67-138++, (SM = Ratings from Sid Marks)　[TAS 雜誌 Sid Marks 的正面評價]

TAS 65-176++ = TAS issue 65, page 176　　　　[即 TAS 第 65 期, 176 頁]

TAS xx /xxx+, ++, +++ = (+, ++ & +++) indicate the TAS degree of praise

[代表 TAS 雜誌正面評價的多寡]

$ & $+　　　　= Reference Price from 15-30 & 30-50 Usd

$$ & $$+　　　= Reference Price from 50-75 & 75-100 Usd

$$$ & $$$+　= Reference Price from 100-170 & 170-200 Usd

$$$$　　　　= Reference Price from 200-300 Usd

$$$$$　　　= Reference Price from 300 Usd & Very expensive

There are more and more vinyl collectors, so the prices is climbing every year. Prices also depend on the different conditions and pressings of the records. Some are higher because they are newer; some are lower because they are older or simply came from good luck of online bidding.

The prices are only for readers' reference. [價格只是作為讀者的參考]

笛卡與倫敦唱片版本簡介

　　DECCA 唱片以及 LONDON 早期 ED1 的內標都以 "FFSS" Logo 發行，LONDON 唱片在 1964 年，從序號 CS 6379 之後，第一版則改為有溝紋內標的 ED2 小 LONDON 版，Logo 不用 FFSS，改成 *LONDON ffrr* Logo，下面列印了 *FULL FREQUENCY RANGE RECORDING*，原來商標中間大寫的 FULL FREQUENCY STEREO SOUND 字樣改成 STEROPHONIC，但是此間在英國出版的同一 DECCA SXL 系列版本，並未改內標，還是採用 ED1, FFSS 版（一直到 1965-66 年才換成 ED2 版），所以之後發行的 ED2, ED3, ED4 & ED5 版本，原來的 [FFSS - FULL FREQUENCY STEREO SOUND] 成為英國DECCA的商標，[*LONDON ffrr* - STEROPHONIC] 則為美版LONDON的商標，純粹是市場推廣因素，並非兩種不一樣的錄音技術。

　　DECCA 古典音樂唱片的主要出版，分早期 SXL 2000（1958-1962）和 SXL 6000（1962 年之後）系列，套裝版則是 1960 年開始出版的 SET 系列，所有系列編號先後的順序，並不代表出版時間的先後，有些編號在前，卻在後來才出版。從 1958 到 1959 年，DECCA 早期發行的唱片 SXL 2001-2115 的封套，首版片有藍框封背（Blue Border Back ED1），但是到了 1959 年，系列號 SXL 2116 之後，唱片內標一樣是 ED1 的首版片，則沒有了藍框封背，因此之前有藍框封背的 ED1，更代表是首版的發行。內標版本一般分大、小 DECCA（Wide Band & Narrow Band）兩種，DECCA 唱片的製作年份，都打印在商標，但是早期在美國出版的 LONDON 唱片，都未打印製作及出版年份。所以發行版本的辨識，需要從其它方面來鑑定，除了封面商標與封背外，還需看內標有否溝紋（Groove），也需看內標外圍 Dead Wax 地區中，鋼模、鋼印的編號與代碼，來判斷出版的先後。

　　LONDON 古典音樂唱片的主要出版，分為器樂 CS 6000 系列，聲樂 OS 系列，套裝版則是器樂 CSA 系列及聲樂 OSA 系列，所有系列編號先後的順序，並不代表出版時間的先後，有些編號在前，卻在後來才出版。LONDON CS 系列的唱片，ED1 大倫敦版，從 1958 發行到 1964 年，系列編號 CS 6000 到 CS 6379，它們的封套除了十幾張，內標一樣是 ED1 的首版片，沒有藍色封背之外，所有 ED1 首版片都有藍色封背（Blue Back ED1），很容易確認是首版的發行。大 LONDON 唱片的內標版本一般分大、小倫敦（FFSS & FFrr）兩種，DECCA 唱片的製作年份，都打印在商標，但是早期在美國出版的 LONDON 唱片，都未打印製作及出版年份。所以發行版本的辨識，需要從其它方面來鑑定，除了封面商標與封背外，還需看內標有否溝紋（Groove），也需看內標外圍 Dead Wax 地區中，鋼模、鋼印的編號與代碼，來判斷出版的先後，鋼模、鋼印的編號與代碼辨識，如同之前的介紹，完全與 Decca 唱片一樣。

　　根據查證，只有極少數 LONDON 的古典音樂唱片是在美國製作，所有刻片、壓片及商標全都是在英國製作，出口到美國後，只在美國裝上 LONDON 的封面。

　　DECCA 以及 LONDON 唱片，因為版本的不同，價差甚大，一併附上古典音樂版的主要商標圖片，以便開始收藏唱片的朋友作為參考。（**詳情請參照黑膠唱片聖經收藏圖鑑 II 與 III 的內容介紹**）

笛卡唱片的版本

ED1 = 第一版本，從 1958 年到 1966 年

大 DECCA (WBG)，離內標外圍 15mm 有溝槽，Original Recording by the Decca co. ltd. London 在內標外圍 10 點鐘方向

ED2 = 第二版本, 從 1964 年到 1968 年

大 DECCA (WBG)，離內標外圍 15mm 有溝槽，"Made in England" 在內標外圍 10 點鐘方向

ED3 = 第三版本, 從 1968 年到 1970 年

大 DECCA (WB)，內標內無溝槽，"Made in England" 在內標外圍 10 點鐘方向

ED4 = 第四版本, 從 1970 年到 1980 年

小 DECCA (NB)，較小的 DECCA 字樣在銀色長方形框內，其左上角有 "Made in England" 字樣

ED5 = 第五版本，從 1980 年開始，在荷蘭壓片，內標 6 點鐘下緣有 "Made in Holland" 字樣

ED1 從 1958 年到 1966 都有首版，而 ED2 從 1964 年到 1968 也有首版，因此在 1964 到 1966 間，有那些 ED2 版是首版，那些是原 ED1 的再版，最難分辨，容易造成混淆，本書依序號編輯，對此間發行的 ED2 首版也都加以註明（詳情請參考本書）。

所有的 SXL 2000 系列唱片，只有一張 SXL 2306 的 ED2 是首版，它在 1966 年才發行，在 SXL 6000 系列中，最後一張依序號出現的 ED1 是 SXL 6248，它在 1966 年出版之後 [筆者發現有兩張 SXL 6336 及 SXL 6363，在 1968 年（ED2 版的最後一年），不知為何還用 ED1 商標出版]。

DECCA SXL 2000系列（首版發行的商標）

ED1 (BB) 首版：從 1958 發行到 1959，SXL 2001 到 SXL 2115

ED1 首版：從 1959 到 1962，SXL 2115 到 SXL 2316（只有一張 SXL 2306 的 ED2 是首版）

DECCA SXL 6000 系列（首版發行的商標）

ED1 首版：從 1962 到 1964, SXL 6000 到 SXL 6119

ED1 及 ED2 首版：從 1964 到 1966，SXL 6120 到 SXL 6248（詳情請參照本書）

ED2 首版：從 1966 到 1968，SXL 6249 到 SXL 6371，此間所發行的 ED2 都是首版，只有兩張 SXL 6336 及 SXL 6363（ED1 是首版）另外兩張 SXL 6339 及 SXL 6355 沒有 ED2（ED3 是首版）。

ED3 首版：從 1968 到 1970，SXL 6372 到 SXL 6441，只有一張 SXL 6376 ED2 才是首版，另外一張 SXL 6435（ED4 是首版）。

ED4 首版：從 1970 到 1980 年，SXL 6442 到 SXL 69xx

ED5 首版：在荷蘭壓片，序號從 SXL 69xx 開始。（詳情參照本書內容）

倫敦唱片的版本

ED1 = 第一版本，從 1958 年到 1964 年

LONDON: FFSS，大倫敦版，內標上有大的 LONDON 及 FFSS 字樣，離內標外圍 15mm 有溝槽

ED2 = 第二版本，從 1964 年到 1968 年

LONDON: ffrr, Grooved，小倫敦版，內標上改成較小的 *LONDON ffrr* Logo，離內標外圍 15mm 有溝槽 "Made in England" 在內標上方 12 點鐘方向

ED3 = 第三版本，從 1968 年到 1970 年

LONDON: ffrr, Non-Grooved 小倫敦版，內標上沒有溝槽，"Made in England By Decca Records Co. Ltd." 在內標上方 10 點鐘方向

ED4 = 第四版本，從 1970 年到 1980 年

LONDON: ffrr，小倫敦版，內標上沒有溝槽，小字體的 "Made in England" 在內標中間 STEROPHONIC 銀色長方形框外的左上角

ED5 = 第五版本，從 1980 年開始，在荷蘭壓片

LONDON: ffrr, "Made in Holland"，內標 6 點鐘下緣有 "Made in Holland" 字樣

倫敦唱片 ED1 的發行，從 1958 到 1964 年，系列編號從 CS 6000 到 CS 6368，其中只有 CS 6230, 6234, 6235, 6367 四張的首版片，加上之後 CS 6369 到 CS 6379 中，有九張的 ED1 首版，沒有藍色封背，很容易確認首版的發行。（另外，CS 6333-6335 找不到 ED1，只有 ED2 的首版，應該是在 1962 年製作，後來才出版）

這些 ED1, BB 發行的封面，都採 FFSS 或大字體 LONDON 的商標（參見商標附圖），然而最後出版的三十張 ED1（含 ED1, BB）的封面商標，在 1963-1964 間，從序號 CS 6338 開始（除了一張 CS 6339 之外），都改為 *LONDON ffrr* 的 Logo，常常會錯認是 ED1 的再版片，但是它們的內標若是 ED1 或是有藍色封背，也都是首版，若是單看封面的 *LONDON ffrr* 商標，一定會造成混淆。倫敦唱片的內標在 1964 年，從序號 CS 6379 之後才改為 ED2 [*LONDON ffrr* – STEROPHONIC] 的商標。

LONDON CS系列（首版發行的商標）

ED1 (BB) 首版：從 1958 到 1964 年，系列編號從 CS 6000 到 CS 6368，其中只有 CS 6230, 6234, 6235, 6367 四張的首版沒有藍色封背，*（CS 6333-6335 找不到 ED1，只有 ED2 的首版，應該是在 1962 年製作，後來才出版）

ED1 首版：從 CS 6369 到 CS 6379，所有九張的 ED1 的首版，都沒有藍色封背

ED1 首版：從 CS 6338 到 CS 6379，除了一張 CS 6339 之外，封面都改為 FFrr 的 Logo

ED2 首版，從 1964 年到 1968 年，CS 6379 到 CS 659x

ED3 首版發行的最少，從 1968 年到 1970 年，CS 659x 到 CS 6628

ED4 首版，從 1970 年到 1980 年，CS 6632 到 CS 71xx

ED5 首版，1980 年在荷蘭壓片，從 CS 71xx 開始。

註：所有系列編號先後的順序，與DECCA唱片一樣，並不代表出版時間的先後，有些編號在前，卻在後來才出版。從1968年開始，ED3和ED4之後的唱片製作，採用更好品質的 Vinyl 原料，加上使用了新進的刻片設備，更能承現母帶中所錄製的甜美高頻，明顯地改良了音效的品質。

INTRODUCTION - DECCA & LONDON RECORDS

According to my research in this subject matter, I am convinced that the Decca and London Records were pressed from the same Masters in the UK. Only few of them were made after 1970 from the USA. The same Decca pressings with London's label were produced in the UK and later exported to the USA. London Records only provided their own designed covers & inner sleeves. In the following section I will provide the reasons behind my conviction.

From 1958 "FFSS" was the same Logo on the label for all the early Decca & London's ED1 issues. During 1964 London Records changed the label design from the "FFSS" logo to *LONDON ffrr*. There was a new slogan below the logo in small fonts *" FULL FREQUENCY RANGE RECORDING "* and in the middle of the label "FULL FREQUENCY STEREO SOUND" was changed to "STEREOPHONIC". This was the beginning of the so-called "ED2" of the London Records. In the meantime, the same UK Decca issues still used the ED1 FFSS label until 1966.

After the release of London ED2, the logo [FFSS - FULL FREQUENCY STEREO SOUND] became the trade mark of UK-DECCA and the logo [*LONDON ffrr* -STEREOPHONIC] became the trademark for the London Records. The main reason for this had to be the consideration of the new promotion in the USA market. As a matter of fact, the records are from the same productions.

The main series of the classical music category from Decca Records were the early released SXL 2000 series (1958-1962), SXL 6000 series (after 1962) & SET series (from 1960).

The early first pressing of the Decca Records have the Blue Border back cover. Only those are considered the first issue of ED1 label (ED1, BB), published from 1958 to 1959, SXL 2001 to SXL 2115. No Blue Border back covers were issued after SXL 2116 for the ED1, 1st label.

The main series of the classical music from London Records are the Instrumental Series - CS 6000, CSA (SET) & Vocal Series - OS, OSA (SET).

The early first pressing of the London Records have the Blue color back cover. Those covers symbolize the first issue of ED1 label (ED1, BB), published from 1958 to 1964, CS 6000 to CS 6368, except CS 6230, 6234, 6235, 6367, the rest of ED1 first issue from CS 6369 to 6379 are without Blue Back Cover.

The order of the series numbers do not signify the order of the year of publication. Some LPs with earlier series numbers were published later.

In order to identify the record versions, we also need to recognize other details of each record, especially on the inner labels and the matrix numbers which are embossed in the dead wax area.

Prices for Decca & London Records vary because of the conditions, but they also greatly depend on the pressings and versions. (For details, please refer to the Collector's Illustrated Vinyl Bible II & III)

DECCA RECORDS - LABEL & VERSION

ED1 = First Label, from 1958 to 1966

Wide Band Grooved (WBG), rim text "Original Recording by the Decca co. ltd" at 10 o'clock

ED2 = 2nd Label, from 1964 to 1968

Wide Band Grooved (WBG), rim text "Made in England" at 10 o'clock

ED3 = 3rd Label, from 1968 to 1970

Wide Band Non-Grooved (WB), rim text "Made in England" at 10 o'clock

ED4 = 4th Label, from 1970 to 1980

Narrow Band (NB), "Made in England"

ED5 = 5th Label, from 1980, pressing in Holland.

Dutch Narrow Band (NB), "Made in Holland" at bottom rim

Useful information about the labels & versions for the Vinyl collectors & sellers:

DECCA SXL 2000 series (1st label)

ED1, 1st (BB): 1958-1959, SXL 2001 to SXL 2115

ED1, 1st: 1959-1962, SXL 2115 to SXL 2316, except SXL 2306, ED2 is the 1st label

DECCA SXL 6000 series (1st label)

ED1, 1st: 1962-1964, SXL 6000 to SXL 6119

ED1, 1st & ED2, 1st : 1964-1966, SXL 6120 to SXL 6248. ED1 labels were issued until 1966, but ED2 label appeared from 1964, there are about 48 ED2, 1st label issued from1964 to 1966. It caused confusion to verify which ED2 label is a first issue & which one is a reissue from the ED1 (details see the book)

ED2, 1st : 1966-1968, SXL 6249 to SXL 6371, except SXL 6336 & SXL 6363 (ED1, 1st); SXL 6339 & SXL 6355 (ED3, 1st)

ED3, 1st : 1968-1970, SXL 6372 to SXL 6441, except SXL 6376 (ED2, 1st) & SXL 6435 ED4, 1st)

ED4, 1st: 1970-1980, SXL 6442 to SXL 69xx

ED5, 1st: 1980-, From SXL 69xx

LONDON RECORDS - LABEL & VERSION

ED1 = First Label (1958-1964)

LONDON: FFSS, Wide Band Grooved (WBG)

ED2 = 2nd Label (1964-1968)

LONDON: ffrr, Grooved, rim text "Made in England" at 11 o'clock

ED3 = 3rd Label (1968-1970)

LONDON: ffrr, Non-Grooved, rim text "Made in England By..." at 11 o'clock

ED4 = 4th Label (1970-1980)

LONDON: ffrr, "Made in England" Left above the STEREOPHONIC

ED5 = 5th Label (after 1980)

LONDON: ffrr, "Made in Holland" at bottom rim

Useful information about the labels & versions for the Vinyl collectors & sellers:

LONDON CS 6000 Series (1st label)

ED1 (BB) 1st : 1958-1964, CS 6000 to CS 6368, except CS 6230, 6234, 6235, 6367, No Blue back cover，*[CS 6333-6335, can't find ED1 (only ED2, 1st), produced in 1962, might be issued later]

ED1, 1st: 1963-1964, CS 6369 to 6379 [No Blue Back Cover].

ED1, 1st: Cover Logo changed to LONDON ffrr, from CS 6338 to CS 6379, except CS6339

ED2, 1st: 1964-1968, CS 6379 to CS 659x

ED3, 1st: 1968-1970, CS 659x to CS 6628

ED4, 1st: 1970-1980, CS 6632 to CS 71xx

ED5, 1st: 1980-, Made in Hollan, from CS 71xx

*Note: *All the Decca & London ED3 & ED4 pressings* made after 1968 were made with the superior cutting heads and mastering amplifiers which could reveal the sweet high frequencies on the original tape & improved the acoustic quality.

DECCA RECORDS LABEL - 笛卡唱片內標

For details, please refer to the Collector's Illustrated Vinyl Bible (II)

詳情請參照黑膠唱片聖經收藏圖鑑 II 的內容介紹

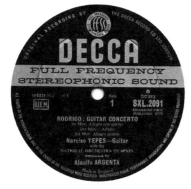

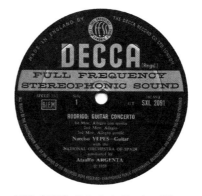

ED1, (WBG) "Original Recordings BY.."
 Deep groove 15mm near the outer edge of the label

ED 1, (Wide Band, Pancake)
 Deep groove 4-5mm near the outer edge of the label

(The label of SET Series is purple color)

ED2, (WBG, "Made in England")
 Deep groove 15mm near the outer edge of the label

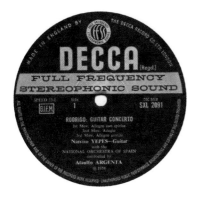

ED3, (WB, "Made in England"), No Groove

ED4, (NB, "Made in England")

ED5, Dutch Narrow Band

LONDON RECORDS LABEL - 倫敦唱片內標

For details, please refer to the Collector's Illustrated Vinyl Bible (III)

詳情請參照黑膠唱片聖經收藏圖鑑 III 的內容介紹

ED1, *LONDON: FFSS,*
 Wide Band Grooved (WBG)

ED 1, (Wide Band, Pancake)

 Deep groove 4-5mm near the outer edge of the label

(The label of London Vocal Series is black color)

ED2, *LONDON: ffrr,* Grooved

ED3, *LONDON: ffrr,* Non-Grooved, "Made in England By…"

ED4, *LONDON: ffrr,* "Made in England"

ED5, *LONDON: ffrr,* "Made in Holland"

List of Best Recordings of Decca & London Records (Performance & Sound Quality)

Listed according to the name of the performer

The most popular DECCA Record stereo series, the SXL, SET series released in the United Kingdom and the CS, OS, OSA series released in the United States are the same recordings. Starting 1968 recordings from DECCA (LONDON) have significantly improved due to new recording equipment and better raw material of vinyl. The recordings have been recorded with a quieter background and more detailed sound quality. Therefore many outstanding recordings are not limited to the early distribution. Among the 1,500 records from 1958 until 1980, there are many excellent performers who have produced many classic works. The music and audio ratings are very high. Almost half (more than 700) are in the TASEC, AS list, have RM 17 to 20 points, have Penguin 3 star rating or above, or are well reviewed in other magazines.

The special list is as follows:

[For details, please refer to the Collector's Illustrated Vinyl Bible (II) & (III)]

笛卡和倫敦唱片中最佳演奏與音效的榜單

依演奏者姓名分類排序

迪卡唱片立體聲系列，在英國發行的SXL、SET系列唱片與在美國發行的CS、OS、OSA系列唱片，都是同樣的錄音，在1968年後，因為錄音設備，刻片技術與黑膠原料的改良，許多優秀的錄音與演出，在DECCA (LONDON) 唱片的製作中，有了更安靜的背景與更細緻的音效，很多精典的錄製，並非只侷限在早期的發行，在1500多張的唱片中，網羅了許多優秀的演奏家，演出了許多經典的作品，不但曲目眾多，音樂與音響的評價也都非常的高，幾乎有一半 (700多張) 的錄音，都在TASEC、AS的榜單上，還有RM 18到20分、企鵝三星以上以及其它雜誌推薦的好評價。

特別列表介紹如下：[詳情請參照黑膠唱片聖經收藏圖鑑 II 及 III 中的內容介紹]

[Abbado, Claudio Abbado]

Bruckner: ‹Symphony No.1›, VPO. Decca SXL 6494, London CS 6706

Janacek: ‹Sinfonietta›, Hindemith: ‹Symphonic Metamorphoses›. Decca SXL6398 (CS 6620)

Mendelssohn: ‹Symphony No.3 & No.4›, LSO. Decca SXL 6363, London CS 6587

Prokofiev: ‹Symphony No.1 &No.3›, LSO. Decca SXL 6469, London CS 6679

[Aeolian String Quartet] - [The String Quartets of Joseph Haydn, Volume 1 to Volume 11]
(Decca HDN Series, HDNL 49-51 to HDNV 82-84)

[Allegri String Quartet] - Britten: ‹String Quartet No.1›. Decca SXL 6564 (No London CS)

[Alonso, Odon Alonso] - E.Halftter: ‹Rapsodia Portuguesa›; Turiana: ‹Rapsodia Sinfonica›; Granados: ‹Le Maja y El Ruisenor›, Gonzalo Soriano (piano), NOS-Odon Alonso. London CS 6034 (No Decca SXL)

[Amadeus Quartet] - Britten: ‹String Quartet No.3›. Decca SXL 6893 (No London CS)

[Alwyn, Kenneth Alwyn] - Tchaikovsky: ‹1812, Capriccio Italien & Marche Slave›, SXL 2001 (CS 6038)

[Ansermet, Ernest Ansermet & OSR]

Albeniz: ‹Iberia›, Turina: ‹Danzas Fantasticas›. Decca SXL 2243, London CS 6194

Beethoven: ‹Symphony No.9›. Decca SXL 2274, London CS 6143

Bizet: ‹Carmen Suite›, ‹L'Arlesienne Suite›, Decca SXL 2037, London CS 6062

Borodin: ‹Symphony No.2 & No.3›. London CS 6126 (No Decca SXL)

Chabrier: ‹Rhapsody Espana›. Decca SXL 6168, London CS 6438

Debussy: ‹Jeux› ‹Danse›, Dukas: ‹La Peri›. Decca SXL 2027 (CS 6043)

Debussy: ‹La Boite a Joujoux›, ‹Printemps›. Decca SXL 2136 (CS 6079)

Delibes: ‹Coppelia›. Decca SXL 2084-5 (London CSA 2201)

Delibes: ‹Coppelia & Sylvia, Highlights ›, London CS 6185 (No Decca SXL)

Falla: ‹El Amor Brujo (Love The Magician)›. Decca SXL 2260 (No London CS)

Falla: ‹The Three Cornered Hat (Complete Ballet)›. Decca SXL 2296 (CS 6224)

Faure: ‹Masques & Bergamasques› ‹Pelleas & Melisande›. Decca SXL 2303 (CS 6227)

Franck Martin: ‹Concerto for 7 Wind›‹Etudes for String Orchestra›. Decca SXL 2311 (CS 6241)

Franck Martin: ‹In Terra Pax›. Decca SXL 6098 (London OS 25847)

Lalo: ‹Namouna› ‹Divertissement› ‹Rapsodie›. Decca SXL 6302 (CS 6536)

Prokofiev: ‹Scythian Suite› ‹The Prodical Son›. Decca SXL 6308 (CS 6538)

Prokofiev: ‹Violin Concerto No.1 & No.2›, Ruggiero Ricci (violin), OSR. London CS 6059 (No Decca SXL)

Ravel: ‹Mother Goose Suite›; Debussy: ‹La Mer›, ‹Nocturnes›. Decca SXL 2062 (CS 6023)

Ravel: ‹L'Enfant Et Les Sortilèges›. Decca SXL 2212 (No London CS)

Ravel: ‹Bolero, La Valse›; Honegger: ‹Pacific 231›; Dukas: ‹Sorcerer's Apprentice›. SXL 6065 (CS 6367)

Ravel: ‹Sheherazade›; Berlioz: ‹Nuits D'ete›. Decca SXL 6081 (OS 25821)

Ravel: ‹Daphnis et Chloe›. Decca SXL 6204 (CS 6456)

Rimsky-Korsakov:‹Christmas Eve› ‹Sadko› ‹Flight-Bumble Bee›. Decca SXL 2113 (CS 6036)

Rimsky-Korsakov: ‹The Tale of Tsar Saltan› ‹May Night› ‹Russian Easter Festival›, SXL 2221 (CS 6012)

Stravinsky: ‹Apollon Musagete› Complete ballet, ‹Renard›, London CS 6034 (No Decca SXL)

Stravinsky: ‹Quatre études pour orchestre›, ‹Suite no.1 pour petit orchestre›, ‹Suite no.2 pour petit orchestre›, ‹Divertimento from Le baiser de la fée ›, London CS 6325 (No Decca SXL)

[Ballet music from Stravinsky] SXL 2011 (CS 6009), SXL 2017 (CS 6017), SXL 2042 (CS 6031), SXL 6066 (CS 6368), (London CSA 2308), SXL 2188 (CS 6138), SXL 6171 (OS 25929), SET 468 (FBD-S 1)

[Stravinsky Works] : ‹The Firebird›, ‹Petrushka›, ‹Le Sacre Du Printemps›, ‹Le Baiser De La Fee› &1 bonus LP CS 6541: ‹What Everyone should know about music›, London CSA 2308 (No Decca SET)

[Ballet music from Tchaikovsky] SXL 2092-3 (CSA 2203), SXL 2107-8 (CSA 2204), SXL 2153 (CS 6127), SXL 2160-2 (CSA 2304), SXL 6312 (CS 6542), London CS 6097 (No Decca SXL = SWL 8010, 10" LP)

[Argenta, Ataulfo Argenta]

Albeniz: ‹Navvarra›; Guridi: ‹Ten Basque Dances›; Turina: ‹La Procesion del Rocio› & ‹La Oracion Del Torero›, National
 Orchestra of Spain. London CS 6130 (No Decca SXL)

Falla: ‹Night in the Garden of Spain›, National Orchestra of Spain. Decca SXL 2091 (CS 6046)

Falla: ‹Concerto For Harpsichord›, Robert Veyron-Lacroix (harpsichord), ‹El Retablo de Maese Pedro (Master Peter's
 Puppet Show)›, NOS. London CS 6028 (No Decca SXL)

Ernesto Halffter: ‹Sinfonietta›, National Orchestra of Spain. London CS 6029 (No Decca SXL)

[España] Rimsky Korsakov: ‹Capriccio Espagnol›; Granados: ‹Andalusia›; Chabrier: ‹Espana›;
 Moszkowsky: ‹Spanish Dances›, LSO. Decca SXL 2020 (London CS 6006)

[Music From Spain - Preludios e Intermedios] Gran Orquesta Sinfonica. London CS 6152 (No SXL)

[Ashkenazy, Vladimir Ashkenazy]

Bartok: ‹Piano Concerto No.2 & No.3›, LPO-Solti. Decca SXL 6937 (CS 7167)

Beethoven: ‹Five Piano Concertos›. CSO-Solti. SXL 6651-55 (CS 6853-57) & SXLG 6594 (CSA 2404)

Beethoven: ‹The Complete Piano Sonatas›. Decca D258D 12 (London CSP 11)

Beethoven: [Piano Sonatas] SXL 6603 (CS 6821), SXL 6630 (CS 6843), SXL 6706 (CS 6921 & CS 7256),

SXL 6804 (CS7024), SXL 6808 (CS 7028), SXL 6809 (CS 7029), SXL 6871 (CS 7088), SXL 6889 (CS 7111),

SXL 6960-62 (CS 7190-92), SXL 6994 (CS 7247), SXL 7012 (CS 7111 & 7247)

Beethoven & Mozart: ‹Piano Quintet, Op. 16 & K. 452›. SXL 6252 (CS 6494)

Chopin: ‹Piano Concerto No. 2›; Bach: ‹Concerto in D minor›, LSO. Decca SXL 6174 (CS 6440)

Chopin: ‹Piano Concerto No. 2›, LSO. Decca SXL 6693 (part of SXL 6174 & CS 6440, reissue)

Chopin: ‹4 Ballades No.1-No.4, Op.23, 38, 47 & 52›, ‹3 Nouvelles Etudes›. Decca SXL 6143 (CS 6422)

Chopin: ‹Scherzo No .4, Op. 54›, ‹Nocturne, Op. 62, no 1›; Ravel: ‹Gaspard de la nuit›;

Debussy: ‹Lisle joyeuse›. Decca SXL 6215 (CS 6472)

Chopin: ‹4 Scherzi, Op.20, 31, 39 & 54› ‹Prelude, Op.45› ‹Barcarolle, Op.60›. SXL6334 (CS 6562)

Chopin: ‹Sonata No.2›, ‹Nocturnes Op.15 No.1 & 2›, ‹Mazurka Op.59 No.2›, ‹Grande Valse Op.18›. Decca SXL 6575
 (CS 6794)

Chopin: ‹Etudes Op.10 & Op.25›. Decca SXL 6710 (CS 6844)

Chopin: "The Piano Music of Chopin, Vol. 2". Decca SXL 6801 (CS 7022)

Chopin: "The Piano Music of Chopin, Vol. 3". Decca SXL 6810 (CS 7030)

Chopin: "The Piano Music of Chopin, Vol. 4". Decca 414 465-1 (Penguin ✲✲✲, not listed in the Illustrated Vinyl Bible)

Chopin: "The Piano Music of Chopin, Vol. 5". Decca SXL 6922 (CS 7150)

Chopin: "The Piano Music of Chopin, Vol. 6". Decca SXDL 7593 (Penguin ✲✲✲, not listed in the Illustrated Vinyl Bible)

Chopin: "The Piano Music of Chopin, Vol. 7". Decca SXL 6995 (CS 7235)

Chopin: "The Piano Music of Chopin, Vol. 8". Decca 410 122-1 (Penguin ✲✲✲, not listed in the Illustrated Vinyl Bible)

Chopin: "The Piano Music of Chopin, Vol. 9". Decca SXL 6877 (CS 7101)

Chopin: "The Piano Music of Chopin, Vol. 8". Decca 410 122-1 (Penguin ✲✲✲, not listed in the Illustrated Vinyl Bible)

Chopin: "The Piano Music of Chopin, Vol. 9". Decca SXL 6877 (CS 7101)

Chopin: "The Piano Music of Chopin, Vol. 10". Decca 410 123-1 (Penguin ✲✲✲, not listed in the Illustrated Vinyl Bible)

Chopin: "The Piano Music of Chopin, Vol. 11". Decca 410 258-1 (Penguin ✲✲✲, not listed in the Illustrated Vinyl Bible)

Chopin: "The Piano Music of Chopin, Vol. 12". Decca 411 896-1 (Penguin ✲✲✲, not listed in the Illustrated Vinyl Bible)

Chopin: "The Piano Music of Chopin, Vol. 13". Decca SXDL 7584 (Penguin ✲✲✲, not listed in the Illustrated Vinyl Bible)

Chopin: "The Piano Music of Chopin, Vol. 14". Decca SXL 6911 (CS 7135)

Chopin: "The Piano Music of Chopin, Vol. 15". Decca SXL 6981 (CS 7210)

Mozart: ‹Piano Concertos No.8 & No.9›, ‹Rondo in A, K.386›, LSO. Decca SXL 6259 (CS 6501)

Mozart: ‹Piano Concertos No.6 & No.20›, LSO. Decca SXL 6353 (CS 6579), Penguin ✲✲ (✲)

Mozart: ‹Piano Concertos No.17 & No.21›, PhO. Decca SXL 6881 (CS 7104)

Mozart: ‹Piano Concertos No.19 & No.24›. PhO. Decca SXL 6947 (CS 7174)

Mozart: ‹Piano Concerto No.22›, ‹Concert Rondo K.382›, PhO. Decca SXL 6982 (CS 7211)

Mozart: ‹Piano Concertos No.15 & No.16›, PhO. Decca SXL 7010 (CS 7254)

Mozart: ‹Piano Sonatas, K.576 & K.310›, ‹Rondo K.511›. Decca SXL 6439 (CS 6659)

Prokofiev: ‹Sonatas No.7 & No.8›, ‹2 Pieces, Op.75›. Decca SXL 6346 (CS 6573)

Rachmaninov: ‹Etudes-Tableaux›, ‹Variations, theme-Corelli›. Decca SXL 6604 (CS 6822)

Rachmaninov: ‹Piano Sonata No.2›, ‹Etudes-tableaux›. Decca SXL 6996 (CS 7236)

Rachmaninov: ‹24 Preludes›, Decca 5BB 221-2 (London CSA 2241)

Schubert: ‹Piano Sonatas No.13 & No.14›, ‹Hungarian Melody, D.817›, ‹Twelve Waltzes Op.18, D.145›. Decca SXL 6260 (CS 6500)

Schubert: ‹Piano Sonata No.18 in G, D.894›. Decca SXL 6602 (CS 6820)

Schubert: ‹Piano Sonata No.17›, ‹4 German Dances›. Decca SXL (SXLI) 6739 (CS 6961)

Schumann: ‹Piano Concerto In A Minor›, ‹Introduction, Allegro Appassionato, Op.92›, ‹Concert Allegro, Op.134›, LSO-Uri Segal. Decca SXL 6861 (CS 7082)

Scriabin: ‹Piano Sonatas No.3, No.4, No.5 & No.9›, ‹Moderato›. Decca SXL 6705 (CS 6920)

Scriabin: ‹Piano Sonatas No.2, No.7 & No.10›, ‹Quatre Morceaux Op.56›, ‹Deux Poemes Op.32›, ‹Two Dances Op.73›. Decca SXL 6868 (CS 7087)

Tchaikovsky: ‹Symphonies No.4, No.5, No.6›, ‹Manfred Symphony›, NPhO, Decca D249D 4 (=SXL 6919; SXL 6884; SXL6941, SXL 6853)

Tchaikovsky: ‹Manfred Symphony, Op.58›, NPhO. Decca SXL 6853 (CS 7075)

Tchaikovsky: ‹Symphony No.4, in F Minor, Op.36›, PhO. Decca SXL 6919 (CS 7144)

Tchaikovsky: ‹Symphony No.5 in E Minor, Op.64›, PhO. Decca SXL 6884 (CS 7107)

Tchaikovsky: ‹Symphony No.6 in B Minor, Op.74›, Ph.O. Decca SXL 6941 (CS 7170)

Tchaikovsky: ‹Piano Concerto No.1›, LSO-Maazel. Decca SXL 6058 (CS 6360)

Tchaikovsky: ‹Piano Concerto No.1›, Mussorgsky: ‹Pictures at an Exhibition›, LSO-Maazel. Decca SXL 6840 (No CS) [Tchaikovsky is the reissue of SXL 6058=CS 6360]

[Ashkenazy & Previn, Andre Previn]

Prokofiev: ‹The Five Piano Concertos›, LSO-Andre Previn. Decca 15BB 218-20 (CSA 2314)

Prokofiev: ‹Piano Concertos No.1, Op.10 & No.2, Op.16›. Decca SXL 6767 (CS 7062)

Prokoviev: ‹Piano Concerto No.3 in C Major, Op. 26›, ‹Classical Symphony›, ‹Autumnal›. Decca SXL 6768 (CS 6964, part)

Prokofiev: ‹Piano Concertos No.4 & No.5›. Decca SXL 6769 (CS 7063 + CS 6964 part)

Rachmaninov: ‹Piano Concertos No.1 & No.2›, LSO-Andre Previn. Decca SXL 6554 (CS 6774)

Rachmaninov: ‹Piano Concerto No.3 in D Minor, Op.30›. Decca SXL 6555 (CS 6775)

Rachmaninov: ‹Piano Concerto No.4 ›, ‹Rhapsody (Paganini)›. Decca SXL 6556 (CS 6776)

Rachmaninov: ‹The 4 Piano Concertos & Rhapsody (Paganini)›. Decca SXLF 6565 (CSA 2311)

Rachmaninov: ‹Suites No.1 & No.2 for 2 Pianos›, play with André Previn. Decca SXL 6697 (CS 6893)

Rachmaninov: ‹Symphonic Dances›, ‹Russian Rhapsody› Ashkenazy and Previn on 2 pianos. Decca SXL 6926, London CS 7159

[Atherton, David Atherton]

[Three Welsh Concertos], from Alun Hoddinott & William Mathias. Decca SXL 6513 (No CS)

Hoddinott: ‹Symphony No.3›, ‹Sinfonietta No.3, Op.71 & Op.76›. Decca SXL 6570 (No CS)

William Mathias: ‹Dance Overture› ‹Ave Rex› ‹Invocation and Dance› ‹Harp Concerto›, Osian Ellis (harp), LSO. Decca SXL 6607 (No CS)

Anthony Milner: ‹Cantata-Salutio Angelica› ‹ Roman Spring›. Decca SXL 6607 (No CS)

Schoenberg: ‹Complete Works for Chamber Ensemble›. Decca SXL(SXLK) 6660-4 (No CSA)

Roberto Gerhard: Astrological Series ‹Libra›, ‹Gemini›, ‹Leo›. Decca HEAD 11 (No CS)

Gyorgy Ligeti: "Melodien for Orchestra", "Double Concerto for Flute & Oboe", "Chamber Concerto for 13 Instrumentalists". Decca HEAD 12 (No CS)

Andrzej Panufnik: ‹Sinfonia Di Sfere› ‹Sinfonia Mistica›. Decca HEAD 22 (No CS)

Harrison Birtwistle: ‹Punch and Judy) Opera in one act. Decca HEAD 24-5 (No OSA)

[Bachhaus, Wilhelm Bachhaus]

Beethoven: ‹Piano Concerto No.5›, VPO-Schmidt-Isserstedt. SXL 2179 (CS 6156)

Beethoven: Piano Sonatas ‹No.8, "Pathétique''›, ‹No.14, "Moonlight"›, ‹*No.26 "Les Adieux"›. SXLA 7506 (Australian issue), Decca issue is SWL 8016 (10" LP, without *No.26)

Beethoven: Piano Sonatas ‹No.21 "Waldstein"›, ‹No.23 "Appassionata"›. SXL 2241 (CS 6161)

Beethoven: Piano Sonatas ‹Sonata No.30, Op.109›, ‹No32, Op.111›, London CS 6246 (No Decca SXL only in 10" LP series Decca SWL 8500)

Brahms: ‹Piano Concerto No.2›, VPO-Karl Bohm. Decca SXL 6322 (CS 6550)
Mozart: ‹Piano Concerto No.27›, ‹Sonata No.11›, VPO-Karl Bohm. Decca SXL 2214 (CS 6141)

[Barshai, Rudolf Barshai] - Bartok: ‹Divertimento for String Orchestra›; Vivaldi: ‹ Concerto Grosso Op.3 No.10 & No.11›, Moscow Chamber Orchestra. Decca SXL 6026 (CS 6332)

[Bartoletti, Bruno Bartoletti] - Ponchielli: ‹La Gioconda› Complete, with Caballe, Pavarotti, Baltsa, Milnes, Ghiaurov. National Philharmonic Orchestra. Decca D232D 3 (LDR 73005)

[Baumgartner, Rudolf Baumgartner] - Vivaldi: ‹Concerti for Strings›, ‹Sinfornia for String›
Lucerne Festival Strings. Decca SXL 6628 (No CS)

[Bedford, Steuart Bedford]
Britten: ‹Death in Venice›. The English Opera Group & ECO. Decca SET 581-3 (London OSA 13109)
Purcell: ‹Dido & Aeneas›. London Opera Chorus & Aldeburgh Festival String. Decca SET 615 (London OSA 1170)

[Belkin, Boris Belkin]
Paganini: ‹Violin Concerto No.1›, Israel P.O.-Mehta. Decca SXL 6798 (CS 7019)
Tchaikovsky: ‹Violin Concerto in D›, ‹Valse-Scherzo›, NPhO-Ashkenazy. SXL 6854 (CS 7076)

[Berganza, Teresa Berganza]
[Berganza Sings Rossini] LSO-Alexander Gibson. Decca SXL 2132 (OS 25106)
[Arias of the 18th Century] Gluck, Pergolesi, Handel, Covent Garden-Gibson. SXL 2251 (OS 25225)
[Teresa Berganza Sings Mozart] LSO-Pritchard. Decca SXL 6045 (OS 25782)
Mozart: ‹Concert Arias›, Vienna Chamber Orchestra-Gyorgy Fischer. SXL 7001 (OS 26663)

[Bernstein, Leonard Bernstein
Mahler: ‹Das Lied von der Erde›, James King, Fischer-Dieskau, VPO. SET 331 (OS 26005)
Mozart: ‹Symphony No.36›, ‹Piano Concerto No.15›, VPO. SET 332 (CS 6499, CSA 2233)

[Böhm, Karl Böhm]
Bruckner: ‹Symphony No.3 (Nowak, 1889)›. VPO. Decca SXL 6505 (CS 6717)
Bruckner: ‹Symphony No.4 in E Flat Major›. VPO. Decca 6BB 171-2 (CSA 2240)

[Bolet, Jorge Bolet] - Max Reger: ‹Variations & Fugue on a Theme by Telemann Op.134›,
Brahms: ‹Variation & Fugue on a Theme.by Handel Op.24›. Decca SXL 6969 (CS 7197)

[Bonynge, Richard Bonynge]
[Pas de Deux] Ballet Music by Drigo, Minkus, Auber & Helsted, LSO. SXL 6137 (CS 6418)
[Russian Rarities] Gliere: ‹Concertos for Coloratura & Harp, Op.82 & 74›, ‹Songs by Stravinsky, Cui, Gretchaninov›,
 Sutherland (soprano), Ellis, (harp), LSO. Decca SXL 6406 (OS 26110)
[Straussiana], ‹Fledermaus Overture› ‹Bal de Vienne›, etc., NPO. Decca SXL 6701 (CS 6896)
[The Art of the Prima Balleriina Vol.1 & Vol.2] LSO. Decca SET 254-5 (CSA 2213)
Adolphe Adam: ‹Le Diable A Quatre, Complete Ballet›, LSO. SXL 6188 (CS 6454)
Bellini: ‹Norma›, Sutherland, Horne, LSO. SET 424-6 (OSA 1394) (=RCA LSC 6166)
Bellini: ‹I Puritani›, Sutherland; Pavarotti; Ghiaurov, LSO. SET 587-9 (OSA 13111) (highlights=SET 619)
Bellini: ‹La Sonnambula›, Sutherland, Pavarotti, NPO. Decca D230D 3 (LDR 73004)
Delibes: ‹Lakme›, Sutherland, Vanzo, Bacquier, Monte Carlo National Opera Orchestra. SET 387-9 (OSA 1391), Highlights =
 SET 488 (OS 26201)
Delibes: ‹Sylvia-Complete Ballet›, New Philharmonia Orchestra. SXL 6635-6 (CSA 2236)
Donizetti: ‹Maria Stuarda›, Sutherland, Pavarotti, Teatro Comunale Bologna. Decca D 2D 3 (OSA 13117)
Donizetti: ‹La Fille du Regiment›, Sutherland, Pavarotti, ROHCG. SET 372-3 (OSA 1273), Highlights = SET 491 (OS 26204)
Donizetti: ‹L'Elisir d'Amore›, Sutherland, Pavarotti, ECO. Decca SET 503-5 (OSA 13101), Highlights = SET 564 (OS 26343)

Donizetti: ‹Lucia di Lammermoor›, Sutherland, Pavarotti, Milnes, Ghiaurov, ROHCG.SET 528-30 (OSA 13103), Highlights =
SET 559 (OS 26332)

Handel: ‹Arias from Julius Caesar›, Sutherland, Conrad, NSOL. SXL 6116 (OS 25876)

Leoni: ‹L'Oracolo› Sutherland, Gobbi, Tourangeau, NPO. Decca D34D 2 (OSA 12107)

[Richard Bonynge conducts Massenet] NPO. Decca SXL 6827 (CS 7048)

Massenet: ‹Cigale (Ballet in 2 Acts)›, ‹Valse Tres Lente› NPO. Decca SXL 6932 (CS 7163)

Massenet: ‹Therese›, Tourangeau, Davies, Quilico, NPhO. Decca SET 572 (OSA 165)

Massenet: ‹Esclarmonde›, Sutherland, Aragall, Grant, NPO. Decca SET 612-4 (OSA 13118)

Massenet: ‹Le roi de Lahore›, Sutherland, Lima, Ghiaurov, NPO. Decca D210D 3 (3LDR 10025)

Meyerbeer: ‹Les Huguenots›, Sutherland, Arroyo, Tourangeau, NPO. Decca SET 460-3 (OSA 1437), Highlights = SET 513
(OS 26239)

Offenbach: ‹Le Papillon, Ballet-Pantomime in 2 Acts & 4 Scenes›, LSO. SXL 6588 (CS 6812)

Offenbach: ‹Tells of Hoffmann›, Sutherland, Domingo, OSR. SET 545-7 (OSA 13106), Highlights = SET 569 (OS 26369)

Rossini: ‹Semiramide›, Sutherland, Horne, Rouleau, LSO. SET 317-9 (OSA 1383), Highlights = SET 391 (OS26086)

Verdi: ‹Il Trovatore›, Pavarotti, Sutherland, Horne, Wixell, Ghiaurov, NPO. Decca D 82D 3 (OSA 13124) Highlights = SET 631

Verdi: ‹Rigoletto›, Sutherland, Pavarotti, Milnes, Tourangeau, Talvela, LSO.

Decca SET 542-4 (OSA 13105) Highlights = SET 580 (OS 26401)

[Borodin Quartet]

Borodin: ‹String Quartet No.2›; Shostakovich: ‹String Quartet No.8, Op.110›. SXL 6036 (CS 6338)

[Boskovsky, Willi Boskovsky]

Brahms: ‹Hungarian Dances›; Dvorak: ‹Slavonic Dances›, LSO. Decca SXL 6696 (No CS)

Mozart: [Serenades Vol. 1 to Vol. 9], Vienna Mozart Ensemble. SXL 6330, SXL 6366, SXL 6420, SXL 6499, SXL 6500,
SXL 6515, SXL 6514, SXL 6670, SXL 6724, (No CS, only STS)

Mozart: [Complete Dances & Marches, Volume 1 to Vol. 10], Vienna Mozart Ensemble. (D121D 10) SXL 6131,6132, 6133
(=CS 6412, 6413, 6414), SXL 6197, 6198, 6199 (=CS 6459, 6460, 6461), SXL 6246, 6247, 6248 (=CS 6489,
6490, 6491), SXL 6275 (CS 6513)

Schubert: ‹Octet in F Major, Op.166›, The Vienna Octet. Decca SXL 2028 (CS 6051)

[Johann Strauss Concert], ‹Champagne›, ‹Pizzicato›, ‹Heiterer Mut›, ‹Explosions›, ‹Wiener Blut›, ‹Liebeslieder›,
‹Weiner Bonbons›, ‹Persian March›, etc., VPO. Decca SXL 2082 (CS 6008)

[Vienna Carnival], Johann & Josef Strauss: ‹Eljen a Magyar!›, ‹Banditen Polka› & ‹Sphärenklänge›, ‹Plappermäulchen›,
etc., VPO. Decca SXL 2163 (CS 6149)

[Philharmonic Ball], J. Strauss: ‹Auf der Jagd› ‹Blue Danube› etc., VPO. SXL 2198 (CS 6182)

[Tales from the Vienna Woods], Anton Karas (Zither), VPO. Decca SXL 6040 (CS 6340)

[Invitation to a Strauss Festival], Johann Strauss family, VPO. SXL 6242-4 (CSA 2307)

[Overtures Of Old Vienna] Overtures from Johann Strauss; Otto Nicolai; Nikolaus von Reznicek & Richard Heuberger, VPO.
Decca SXL 6383 (CS 6605)

[Vienna Imperial - New Year Concert 1970], VPO. Decca SXL 6419 (CS 6641)

[Happy New Year], VPO. SXL 6495 (CS 6707, Viennese New Year Concert)

[Welcome the New Year], VPO. SXL 6526 (CS 6731, Welcome the New Year)

[New Year's Concert], State Opera Chorus & VPO. Decca SXL 6692 (No CS)

[Prosit! 150 Years of Josef Strauss] ‹Delirien Walzer, Jokey-Polka schnell, etc.›. VPO. SXL 6817 (No CS)

[Boult, Adrian Boult]

Holst: ‹The Hymn of Jesus›, BBC SO, ‹The Perfect Fool›, LPO. Decca SXL 6006 (CS 6324)

Searle: ‹Symphony No.1›; Seiber: ‹Elegy› ‹3 Fragments›, LPO. Decca SXL 2232 (CS 6196)

[Britten, Benjamin Britten]

J.S. Bach: ‹St. John Passion›, ECO. Decca SET 531-3 (OSA 13104)

Britten: ‹Peter Grimes, Opera in 3 acts and a prologue›, ROHCG. SXL 2150-2 (OSA 1305), Highlights = SXL 2309 (OS 26004)

Britten: ‹Nocturne, Op.60›, Pears & Strings of LSO.‹4 Sea Interludes & Passacaglia from Peter Grimes›, ROHCG, SXL
2189 (CS 6179)

Britten: ‹Spring Symphony›, ROHCG. Decca SXL 2264 (London OS 25424)

Britten: ‹Serenade Op.31, For tenor solo, horn & strings›, Peter Pears (tenor) & Barry Tuckwell (horn); ‹Young Person's Guide to the Orchestra›, LSO. SXL 6110 (CS 6398)

Britten: ‹Symphony for Cello & Orchestra, Op.68›*; Haydn: ‹Cello Concerto in C›, Rostropovich (cello), ECO-Britten. Decca SXL 6138, London CS 6419. (* Reissued in Decca SXL 6641)

Britten: ‹Misericordium›; ‹Sinfonia da Requiem›, LSO & NPhO. Decca SXL 6175 (OS 25937)

Britten: [School Concert], Downside School Purley Choir. Decca SXL 6264 (No CS)

Britten: ‹Songs & Proverbs of William Blake, Op.74›, ‹Holy Sonnets of John Donne, Op.35›, Peter Pears (tenor), Fischer-Dieskau (baritone), Britten (piano). Decca SXL 6391 (OS 26099)

[Britten Conducts English Music For Strings] Britten: ‹Simple Symphony›; Elgar: ‹Introduction and Allegro for strings, Op.47›; other works from Purcell, Delius & Bridge, ECO. SXL 6405 (CS 6618)

Britten: ‹Serenade, Op.31, (For tenor, horn & string)›, ‹Illuminations, Op.18, (For tenor & string)›, Peter Pears (tenor), Barry Tuckwell (horn), LSO & ECO-Benjamin Britten. Decca SXL 6449 (OS 26161)

Britten: ‹Young Person's Guide›, ‹Variation, theme of Frank Bridge›. LSO, SXL 6450 (CS 6671)

Britten: ‹Concerto for Violin and Orchestra› & ‹Concerto for Piano and Orchestra›, Lubotsky (violin), Sviatoslav Richter (piano), ECO. Decca SXL 6512, London CS 6723

Britten: [Three Cantatas], ‹Misericordium›, ‹Academica›, ‹Rejoice In The Lamb›, LSO-Britten & Malcolm; Choir of St.John's College-George Guest. Decca SXL 6640 (No CS & OS)

Britten: ‹Sinfonia Da Requiem, Op.20›, NPhO, ‹Symphony for Cello and Orchestra, Op.68›, Rostropovich (cello), ECO. SXL 6641 (No CS), (Op.68 also in SXL 6138 & CS 6419)

Britten: ‹Prelude & Fugue›, ‹Phaedra›, ‹A Wealden Trio›, etc., ECO. SXL 6847 (OS 26527)

Britten: ‹War Requiem, Op 66›, Vishnevskaya, Pears & Fischer-Diskau and Simon Preston (organ), LSO & the Melos Ensemble. Decca SET 252-3 (OSA 1255)

Britten: ‹Albert Herring›, Pears, Fischer, Noble, Evans, Rex, ECO. Decca SET 274-6 (OSA 1378)

Britten: ‹Curlew River›, Pears; Shirley-Quirk; Drake; Blackburn, English Opera Group-Britten & Viola Tunnard. Decca SET 301 (=1BB 101-3) & (OSA 1156)

Britten: ‹A Midsummer Night's Dream›, Alfred Deller; Elizabeth Harwood; Peter Pears; John Shirley-Quirk, London Symphony Orchestra. Decca SET 338-40 (OSA 1385)

Britten: ‹The Burning Fiery Furnace›, Pears; Shirley-Quirk; Drake; Tear; Dean; Leeming, English Opera Group-Britten & Viola Tunnard. Decca SET 356 (=1BB 101-3) & (OSA 1163)

Britten: ‹Billy Budd›, Glossop, Pears, Langdon, Ambrosian Opera Chorus & London Symphony Orchestra. Decca SET 379-81 (OSA 1390)

Britten: ‹The Prodigal Son, Op.81›, Pears; Shirley-Quirk; Drake; Tear, English Opera Group-Benjamin Britten & Viola Tunnard. Decca SET 438 (=1BB 101-3) & (OSA 1164)

Britten: ‹The Golden Vanity, Op.78›, ‹Childrens Crusade›, Wandsworth School Boys' Choir-Russell Burgess (conductor) & Benjamin Britten (piano). Decca SET 445

Britten: ‹The Rape of Lucretia, Chamber Opera, Op.37›, Heather Harper; Janet Baker; Peter Pears; Bryan Drake, English Chamber Orchestra. Decca SET 492-3 (OSA 1288)

Britten: ‹Owen Wingrave, Op.85›, Luxon; Baker; Douglas; Harper; Pears and others, The Wandsworth Boys' Choir with ECO. Decca SET 501-2 (OSA 1291), Highlights = SET 536

Britten: ‹Noye's Fludde›, ECO. London OS 25331; No Decca SXL (ARGO ZNF 1; ZK 1)

Britten: ‹Prince of Pagoda, Op.57›, ROHCG. London STS 15081-2; No Decca SXL (©=GOS 558-9)

Britten: [Three Church Parables] = ‹Curlew River›, Decca SET 301 (OSA 1156); ‹The Burning Fiery Furnace›, SET 356 (OSA 1163); ‹The Prodial Son›, SET 438 (OSA 1164). Decca 1BB 101-3

Elgar: ‹The Dream of Gerontius, Op.38›, LSO. Decca SET 525-6 (OSA 1293)

Grainger: [Salute to Percy Grainger], Ambrosian Singers & ECO. Decca SXL 6410 (CS 6632)

Mozart: ‹Symphony No.25 & No.29›, ECO. Decca SXL 6879 (CS 7103)

Mozart: ‹Symphony No.38›; Schubert: ‹Symphony No.8›, ECO. Decca SXL 6539 (CS 6741)

Purcell: ‹The Fairy Queen›, Ambrosian Opera Chorus & ECO. Decca SET 499-500 (OSA 1290), Highlights = Decca SET 560

Schumann: ‹Scenes from Goethe's Faust›, ECO. Decca SET 567-8 (London OSA 12100)

[Brymer, Jack Brymer]

Beethoven: [Complete Music for Wind Band], London Wind Soloists. Decca SXL 6170 (CS 6442)

Mozart: [Wind Music Vol. 1 to Vol. 5], London Wind Soloists. Decca SXL 6050, London CS 6347, SXL 6050 (6348), SXL 6049 (CS 6346), SXL 6052 (CS 6349), SXL 6053 (CS 5350)

[Caballe, Montserrat Caballe with Miguel Zanetti]
[Montserrat Caballe - Falla Seven Popular Spanish Songs] Decca SXL(SXLR) 6888 (OS 26575)
[Monserrat Caballe Recital] from Granados; Falla; Albeniz, etc., SXL(SXLR) 6935 (OS 26617)

[Campoli, Alfredo Campoli]
Tchaikovsky: ‹Violin Concerto in D›, LSO-Ataulfo Argenta. Decca SXL 2029 (CS6011)

[Capuana, Franco Capuana]
Puccini: ‹La Fanciulla Del West, Complete recording›, AdSC. Decca SXL 2039-41 (OSA 1306), Highlights = SXL 2267 (OS 25196)

[Chailly, Riccardo Chailly]
Rossini: ‹Guglielmo Tell (William Tell)›, NPO. Decca D219D 4 (OSA 1446)

[Chiara, Maria Chiara]
[Presenting Maria Chiara], Vienna Volksoper Orcheatra-Nello Santi. SXL 6548 (OS 26262)
[Maria Chiara sings Verdi Arias], ROHCG-Nello Santi. Decca SXL 6605 (No CS)

[Choruses - Grand Opera]
[Grand Opera Choruses] Choruses from ‹Boris Godunov›; ‹Nabucco›; ‹Otello›; ‹Madama Butterfly›; ‹Die Meistersinger von Nürnberg›; ‹Tannhäuser›; ‹Parsifal›; ‹Fidelio›. Vienna State Opera Chorus & VPO with various conductors. Decca SXL 6826 (No CS)

[Chung, Kyung-Wha Chung]
Bruch: ‹Violin Concerto No.1›, ‹Scottish Fantasia›, RPO-Kempe. Decca SXL 6573 (CS 6795)
Chausson: ‹Poème›; Saint-Saëns: ‹Introduction and Rondo Capriccioso›, ‹Havanaise ›; Ravel: ‹Tzigane›. RPO-Charles Dutoit. Decca SXL 6851 (CS 7073)
Debussy: ‹Violin Sonata›, Franck: ‹Violin Sonata in A›, Lupu (piano). Decca SXL 6944 (CS 7171)
Prokofiev: ‹Violin Concertos No.1 & No.2›, LSO-Previn. Decca SXL 6773 (CS 6997)
Saint-Saens: ‹Violin Concerto No.3 in B Minor, Op.61›, LSO-Lawrence Foster. SXL 6759 (CS 6992)
Sibelius: ‹Violin Concerto in D Minor, Op.47›, LSO-Previn. Decca SXL 6493 (CS 6710)
Stravinsky: ‹Concerto in D for Violin and Orchestra›, LSO-Previn. Decca SXL 6601 (CS 6819)
Tchaikovsky: ‹Violin Concerto in D Major›, LSO-Previn. Decca SXL 6493 (CS 6710)
Vieutemps: ‹Violin Concerto No.5 in A Minor, Op.37›, LSO-Lawrence Foster. SXL 6759 (CS 6992)
Walton: ‹Concerto for Violin and Orchestra›, LSO-Previn. Decca SXL 6601 (CS 6819)

[Chung, Myung-Whun Chung & Myung-Wha Chung]
Tchaikovsky: ‹Piano Concerto No.1› & ‹Variations on a Rococo Theme for Cello›, LAPO-Dutoit, Myung-Whun Chung (piano) & Myung-Wha Chung (cello). Decca SXL 6955 (No CS)

[Curzon, Clifford Curzon]
Beethoven: ‹Eroica Variations›; Schubert: ‹Moments Musicaux›. Decca SXL 6523 (CS 6727)
Brahms: ‹Sonata No.3, Op.5›, ‹Intermezzo Op.117 n.1, Op.119 n.3›. SXL 6041 (CS 6341)
Brahms: ‹Piano Concerto No.1 In D Minor Op.15›, LSO-George Szell. SXL 6023 (CS 6329)
Dvorak: ‹Piano Quintet in A Major›; Schubert: ‹Quartettsatz in C Minor›, The VPO Quartet. Decca SXL 6043 (CS 6357)
Grieg: ‹Piano Concerto in A Minor, Op.16›, LSO-Fjeldstad; Franck: ‹Variations›;
Litolff: ‹Scherzo from Symphonique No.4›, LPO-Adrian Boult. Decca SXL 2173 (CS 6157)
Liszt: ‹Sonata in B Minor›, ‹Liebestraum No.3›, ‹Valse Oublée No.1›, etc. SXL 6076 (CS 6371)
Mozart: Piano Concertos ‹No.20, K.466 & No.27, K.595›, ECO-Britten. SXL 7007 (CS 7251)
Schubert: ‹Sonata No.17 in D Major, Op.53, D.850›, ‹Impromptu in G Flat, Op.90, no.3, D899/3›, ‹Impromptu in A Flat, Op.90, no.4, D.899/4›. Decca SXL 6135 (CS 6416)
Schubert: ‹Piano Sonata No.21, D.960›, ‹Impromptu in A Flat, D935/2›. SXL 6580 (CS 6801)
Schubert: ‹"The Trout", Piano Quintet in A Major, D.667›, The Vienna Octet. SXL 2110 (CS 6090)

[Davis, Andrew Davis] - Alun Hoddinott: ‹Symphony No.5, Op.81› ‹Concerto for Piano No.2, Op.21, Piano: Martin Jones› ‹Concerto For Horn Op.65, Horn: Tuckwell›, RPO. SXL 6043 (CS 6357)

[Davis, Ivan Davis]
Gottschalk: ‹Great Galloping Gottschalk›, ‹Piano Music of Louis M. Gottschalk›. SXL 6725 (CS 6943)

[Dohnanyi, Christoph von Dohnanyi] - Alban Berg: ‹Lulu›, VPO. Decca D 48D 3 (OSA 13120)

[Dorati, Antal Dorati]
[Rhapsody !] Dvorak: ‹Slavonic Rhapsody Op.45 No.3›; Enesco: ‹Roumanian Rhapsody No.1›;
 Ravel: ‹Spanish Rhapsody› & Liszt: ‹Hungarian Rhapsody No.2›, DSO. SXL 6896 (CS 7119)
Bartok: ‹Suite No.1, Op.3›, ‹Two Pictures, Op.10›, DSO. SXL 6897 (CS 7120)
Dallapiccola: ‹Il Prigioniero› (First recording), NSODC. Decca HEAD 10 (OSA 1166)
Debussy: ‹Nocturnes›, ‹Iberia (Images Pour Orchestre No.2)›, NSODC. SXL 6742 (CS 6968)
Roberto Gerhard: ‹The Plague›, Chorus Washington D.C. & NSODC. Decca HEAD 6 (No CS)
Haydn: ‹The Seasons (Die Jahreszeiten)›, Brighton Festival Chorus & RPO. D 88D 3 (OSA 13128)
Haydn: ‹Il Ritorno di Tobia›, Brighton Festival Chorus & RPO. Decca D216D 4 (OSA 1445)
Haydn: "The Complete Symphonies (No. 1 - 19)", The Philharmonia Hungarica. Decca HDNA 1-6
Haydn: "The Complete Symphonies (No.20 - 35)", The Philharmonia Hungarica. Decca HDNB 7-12
Haydn: "The Complete Symphonies (No.36 - 48)", The Philharmonia Hungarica. Decca HDNC 13-18
Haydn: "The Complete Symphonies (No.49 - 56)", The Philharmonia Hungarica. Decca HDND 19-22
Haydn: "The Complete Symphonies (No.57 - 64)", The Philharmonia Hungarica. Decca HDNE 23-26
Haydn: "The Complete Symphonies (No.65 - 72)", The Philharmonia Hungarica. Decca HDNF 27-30
Haydn: "The Complete Symphonies (No.73 - 81)", The Philharmonia Hungarica. Decca HDNG 31-34
Haydn: "The Complete Symphonies (No.82 - 92)", The Philharmonia Hungarica. Decca HDNH 35-40
Haydn: "The Complete Symphonies (No.93 - 104)", The Philharmonia Hungarica. Decca HDNJ 41-46
Haydn: "The Complete Symphonies (Appendices)", ‹Symphony "A" & "B" in B Flat Major›, ‹No.22 in E Flat Major (2nd
 Version)›, ‹No.63 in C Major (1st Version)›, ‹No.53 & No.103 (Alternative Ending)›, The Philharmonia Hungarica.
 Decca HDNK 47-48
Haydn: ‹24 Minuets›, The Philharmonia Hungarica. Decca HDNW 90-1
 [The Orchestral Works of Zoltan Kodaly] Philharmonia Hungarica. SXL(SXLM) 6665-7 (CSA 2313)
Kodaly: [Orchestral Works Vol.1], ‹Dances of Galanta›, ‹Dances of Marosszek›, ‹Concerto for Orchestra› & ‹Theatre
 Overture›, PhH. Decca SXL 6712 (CS 6862)
Kodaly: [Orchestral Works Vol.2], ‹Harry Janos Suite›, ‹Minuetto Serio›, ‹Symphony in C Mjor›, Philharmonia Hungarica.
 Decca SXL 6713 (CS 6863 in the CSA 2313 box set)
Kodaly: [Orchestral Works Vol.3], ‹Peacock Varitations›, ‹Ballet Music›, ‹Summer Evening›, ‹Hungarian Rondo›,
 Philharmonia Hungarica. SXL 6714 (=CS 6864, London issue Vol.2)
Messiaen: ‹La Transfiguration de Notre Seigneur Jesus Christ›, NSODC. Decca HEAD 1-2
Pettersson: ‹Symphony No.7›, Stockholm Philharmonic Orchestra. Decca SXL 6538 (CS 6740)
Richard Strauss: ‹Die Agyptische Helena›, (World Premiere Recording), DSO. D176D 3 (OSA 13135)
Tchaikovsky: ‹Francesca da Rimini, Op.32›, ‹Hamlet - Fantasy after Shakespeare, Op.67›, ‹Voyevode - Symphonic Ballads,
 Op.78›, NSODC. SXL 6627 (CS 6841)

[Dutroit, Charles Dutroit] - Saint-Saëns: [Danse Macabre - Symphonic poems] PhO. SXL 6975 (CS 7204)

[Bracha Eden & Alexander Tamir]
[Music For Two Pianos], Rachmaninov: ‹Suite No.2, Op.17›; Milhaud: ‹Scaramouche - Suite›; Poulenc: ‹Sonata 1918 (Revised
1939)›; Lutoslawski: ‹Variations On A Theme Of Paganini›. SXL 6158 (CS 6434)

[Ehrling, Sixten Ehrling]
Berwald: ‹Symphony No.3 (Singuliere)›, ‹Symphony No.1 in E Flat›, LSO. SXL 6374 (CS 6602)

[Evans, Geraint Evans & Bryan Balkwill]
[Geraint Evans Operatic Recital] SRO. SXL 6262 (OS 25994)

[Ferrier, Kathleen Ferrier & Adrian Boult]
[A Ricital of Bach and Handel Arias] LPO. SXL 2234 (No CS)

[Fischer-Dieskau, Dietrich Fischer-Dieskau]
Britten: ‹Songs & Proverbs of William Blake, Op.74›, ‹Holy Sonnets of John Donne, Op.35›,
 Peter Pears (tenor), Fischer-Dieskau (baritone), Britten (piano). Decca SXL 6391 (OS 26099)
[Haydn & Mozart Discoveries], Arias, Dietrich Fischer-Dieskau, Vienna Haydn Orchestra-Reinhard Peters.
 Decca SXL 6490 (OS 26182)

[Fistoulari, Anatole Fistoulari] - Tchaikovsky: ‹Swan Lake, Highlights›, CgOA. SXL 2285 (CS 6218)

[Fitzwilliam String Quarte]
Borodin: ‹String Quartets No.1 & No.2›. Decca SXL 6983, London CS 7239
Shostakovich: ‹The String Quartets, Nos.1 to 15›, Decca D188D 7.
*(Original issue is Decca L'Oiseau Lyre DSLO 9, 11, 23, 28, 29, 30, 31)

[Fjeldstad, Øivin Fjeldstad] - Grieg: ‹Peer Gynt, Incidental music›, LSO. SXL 2012 (CS 6049)

[Flagstad, Kirsten Flagstad & Øivin Fjeldstad]
Sibelius: [Kirsten Flagstad-Song Recital] ‹Om Kvällen›; ‹Var Det En Dröm›, LSO. SXL 2030 (OS 25005)

[Frühbeck de Burgos, Rafael Frühbeck de Burgos]
Albeniz: ‹Suite Espanol›, NPO. Decca SXL 6355 (CS 6581)
Falla: ‹El Amor Brujo›; Granados: ‹Intermezzo from Goyescas›; Ravel: ‹Pavane pour une infante défunte›, ‹Alborada del
 gracioso›, NPO. Decca SXL 6287 (CS 6521)

[Gamba, Pierino Gamba] - [Rossini - Overtures] LSO. Decca SXL 2266 (CS 6204)

[Gamley, Dauglas Gamley] - [Waltzes by Emile Waldteufel] NPO. Decca SXL 6704 (CS 6899)

[Gardelli, Lamberto Gardelli]
Ponchielli: ‹La Gioconda›, AdSC. SET 364-6 (OS 26162), Highlights = SET 450 (OS 26162)
Puccini: [Il Triticco], ‹Il Tabarro (The Clock)›; ‹Suor Angelica›; ‹Gianni Schicchi›, MMG.
 SET 236-8 (OSA 1364), (=SXL 6122, 6123, 6124 & OSA 1151, 1152, 1153)
Verdi: ‹Macbeth, Highlights›, LPO. Decca SET 539
Verdi: ‹Nabucco›, Vienna State Opera. SET 298-300 (OSA 1382), Highlights = SET 367 (OS 26059)

[Gardiner, John Elliott Gardiner]
Monteverdi: ‹Vespro della Beata Virgine, 1610›, The Monteverdi Choir & Orchestra. Decca SET 593-4

[Gavazzeni, Gianandrea Gavazzeni] - Giordano: ‹Andrea Chenier›, AdSC. SXL 2208-10 (OSA 1303)

[Nicolai Ghiaurov & Abbado] - [Great Scenes from Verdi] Ambrosian & LSO. SXL 6443 (OS 26146)

[Isidore Godfrey & The D'Oyly Carte Opera Company]
Gilbert & Sullivan: Decca 9BB 156-61, (=SKL 4081-2; 4119-20 & 4925-6)
 ‹HMS Pinafore›, NwSO. (Decca SKL 4081-2 = London OSA 1209, ℗1960)
 ‹Iolanthe›, NwSO. (SKL 4119-20 = OSA 1215, ℗1960), ‹The Pirates of Penzance›, RPO.
 (=SKL 4925-6 = OSA 1277, ℗1968)
Gilbert & Sullivan: Decca 9BB 162-7, (=SKL *4138-40; 4006-7 & 4624-5)
 ‹Gondoliers›, NwSO, (SKL *4138-40 = London OSA 1323, ℗1961, Penguin ✲✲✲)

<The Mikado>, NwSO, (SKL 4006-7 = OSA 1201, ℗1958), Penguin ✷✷ (✷)

 <The Yeomen of the Guard>, RPO-Malcolm Sargent. (SKL 4624-5, OSA 1258, ℗1964)

Gilbert & Sullivan: <Trial by Jury>, <Excerpts from Utopia limited>, ROHCG. (Decca SKL 4579 = London OSA 1155)

[Goldberg, Szymon Goldberg]

Mozart: <Sonatas for Piano & Violin, Volume 1, 2, 3>, (6LPs), Radu Lupu (piano). Decca 13BB 207-212 (ⓒ=SDD 513-8)
 =London CSA 2243-5

[Gruberova, Edita Gruberova & Gyorgy Fischer]

Mozart: <Concert Arias- K.578, K.374, K.83, K.217>, Vienna Chamber Orchestra - Gyorgy Fischer. Decca SXL 7000,
 London OS 26662

[Guest, Geroge Guest]

John Steiner: <The Crucifixion>, Richard Lewis (tenor), Owen Brannigan (bass), Brian Runnett (organ), Choir of St. John's
College, Cambridge. London OS 25333; No Decca SXL (ⓒ=ARGO SPA 267)

[Guilini, Carlo Maria Guilini]

Mozart: <Symphony No.40, K. 550 & No.41, K. 551, "Jupiter">, NPhO. SXL 6225 (CS 6479)

[Haitink, Bernard Haitink]

Berlioz: <Symphonie Fantastique Op.14>, VPO. Decca SXL 6938 (London CS 7168)

Shostakovich: <Symphony No.10 in E minor>, LPO. Decca SXL 6838 (London CS 7061)

Shostakovich: <Symphony No.15 in A Major>, LPO. Decca SXL 6906 (London CS 7130)

Shostakovich: <Symphony No.4 in C Minor, Op.43>, Decca SXL 6927 (London CS 7160)

[Harrell, Lynn Harrell]

Elgar: <Cello Concerto, Op.85>; Tchaikovsky: <Variations on a Rococo Theme, Op.33>, <Pezzo Capriccioso, op.62>,
 Clvlnd-Maazel. Decca SXL 6965, London CS 7195

[Heltay, Laszlo Heltay]

Kodaly: <Missa Brevis>, <Pange Lingua>, Brighton Festival Chorus. Decca SXL 6803 (No CS)

[Henderson, Skitch Henderson]

Prokofiev: <Peter and the Wolf>; Saint-Saëns: <Carnival of the Animals>, Julius Katchen (piano), LSO. Decca SXL 2218,
 London CS 6187

[Henze, Hans Werner Henze]

Henze: <Compases Para Preguntas Ensimismades>, Hirofumi Fukai (viola),
 <Violin Concerto No.2>, Brenton Langbein (violin), London Sinfonietta. Decca HEAD 5

Henze: <Voices>, S. Walker (m soprano), P. Sperry (tenor), London Sinfonietta. Decca HEAD 19-20

[Horne, Marilyn Horne & Henry Lewis]

[Marilyn Horne sings Rossini], Ambrosian Opera Chorus & RPO. Decca SXL 6584 (OS 26305)

[Howarth, Elgar Howarth]

[Classics for Brass Band]

Holst: <A Moorside Suite>; Ireland: <Comedy Overture>; Elgar: <The Severn Suite>; Bliss: <Kenilworth>, Grimethorpe
 Colliery Band. Decca SXL 6820 (No CS)

[Grimethorpe Special]

Howarth: <Fireworks (Variations On A Theme Of W. Hogarth Lee)>; Takemitsu: <Garden Rain>; Birtwistle: <Grimethorp
 Aria>; Henze: <Ragtimes And Habaneras>, The Grimethorpe Colliery Band. Decca HEAD 14

Ferneyhough: <Transit>, The London Sinfonietta. Decca HEAD 18

Xenakis: <Synaphai Connexties> <Auroura> <Antikhthon>, NPhO. Decca HEAD 13

[Huybrechts, Francois Huybrechts]
Janacek: ‹Taras Bulba› ‹Lachian Dances›, LPO. Decca SXL 6507 (London CS 6718)

[Janacek Quartet]
Dvorak: ‹Quartet Op.96 "American"›, ‹Quartet in D Minor, Op.34›, Decca SXL 6103 (CS 6394)
Haydn: ‹Quartet in E Flat Op.33 no.2 "Joke"›, ‹Quartet in F Op.3 no.5 "Serenade"›, ‹Quartet in D Minor Op.76 no.2
 "Fifths"›. Decca SXL 6093, London CS 6385

[Kiri Te Kanawa & Gyorgy Fischer]
Mozart: ‹Concert Arias- K.272, K.79 (K.73d), K.583, K.582, K.490, K.528, K.383›,
 Vienna Chamber Orchestra-Gyorgy Fischer. Decca SXL 6999, London OS 26661

[Karajan, Herbert von Karajan]
Holst: ‹The Planets, Op.32›, VPO. Decca SXL 2305, London CS 6244
Mussorgsky: ‹Boris Godunov›, VPO. Decca SET 514-7 (OSA 1439), Highlights = SET 557 (OS 26300)
Puccini: ‹La Boheme›, BPO. SET 565-6 (OSA 1299), Highlights = SET 579 (OS 26399)
Puccini: ‹Madama Butterfly›, VPO. SET 584-6 (OSA 13110), Highlights = SET 605 (OS 26455)
Puccini: ‹Tosca›, VPO. Decca 5BB 123-4 (=RCA LDS 7022), London OSA 1284
Johan Strauss: ‹Die Fledermaus, Highlights›, VPO. Decca SXL 6155, London OS 25923 [Highlights from SET 201-3; SXL
 6015-6 & OSA 1249; OSA 1319, Penguin ✶✶ (✶)]
Tchaikovsky: ‹Nutcracker suite›, Grieg: ‹Peer Gynt Suite›, VPO. Decca SXL 2308 (CS 6420)
Tchaikovsky: ‹Romeo and Juliet›; R. Strauss: ‹Don Juan, Op.20›, VPO. Decca SXL 2269 (CS 6209)
Verdi: ‹Aiida›, VPO. Decca SXL 2167-9, London OSA 1313, Highlights = SXL 2242 (OS 25206)
Verdi: ‹Otello›, VPO, Decca SET 209-11 (=Decca D55D 3), London OSA 1324, Penguin ✶✶(✶), Highlights = SXL 2314 (OS
 25701)

[Kars, Jean-Rodolphe Kars & Alexander Gibson]
Delius: ‹Piano Concerto in Cm›; Debussy: ‹Fantaisie, Piano & Orch.›, LSO. SXL 6435 (CS 6657)

[Katchen, Julius Katchen]
Bartok: ‹Piano Concerto No.3›; Ravel: ‹Piano Concerto in G›, LSO-Kertesz. SXL 6209 (CS 6487)
Beethoven: ‹Piano Concerto No.1›, ‹Choral Fantasia, Op.80›, LSO-Gamba. SXL 6189 –(CS 6451)
Beethoven: ‹Piano Concerto No.3›; ‹Piano Concerto No.2 & No.4›; ‹Piano Concerto No.5›, LSO-Gamba. [=Decca SXL
 2106 (CS 6096); SXL 6082 (CS 6374); SXL 6109 (CS 6397), Penguin ✶✶ (✶)]
Brahms: [Complete Piano Works Volume 4], ‹Waltzes, Op. 39›, ‹Two Rhapsodies, Op. 79›, ‹Four Ballades, Op. 10›, Decca
 SXL 6160 (CS 6444), Penguin ✶✶ (✶)
Brahms: [Complete Piano Works Volume 5], ‹Hungarian Dances 1 - 21 (4 Hands)›, Julius Katchen (piano), Jean-Pierre Marty
 (2nd piano). Decca SXL 6217, London CS 6473
Brahms: [Complete Piano Works Volume 6], ‹Variations on a theme by Schumann›, ‹Variations on an original theme›,
 ‹Variations on a Hungarian song›. SXL 6219 (CS 6477)
Brahms: ‹Piano Trio No.1 in B Major, Op.8›, ‹Piano No.3 in C Minor, Op.101›, Katchen (piano); Suk (violin); Starker
 (cello). Decca SXL 6387, London CS 6611
Brahms: ‹Piano Trio No. 2, in C Major, Op.87›, ‹Sonata No. 2 in F Major for piano and cello, Op.99›, Katchen (piano); Suk
 (violin); Starker (cello). Decca SXL 6589, London CS 6814
Liszt: ‹Piano Concertos No.1 & No.2›, LPO-Argenta. Decca SXL 2097, London CS 6033
Prokoviev: ‹Piano Concerto No.3›; Ravel: ‹Concerto For Left Hand›; Gershwin: ‹Rhapsody In Blue›, LSO-Kertesz. Decca
 SXL 6411, London CS 6633
Rachmaninov: ‹Rhapsody On A Theme of Paganini, Op.43›, Dohnanyi: ‹Variations On A Nursery Tune›, LPO-Adrian Boult.
 Decca SXL 2176, London CS 6153
Rachmaninov: ‹Piano Concerto No.2, Op.18›; Balakirev: ‹Islamey-Oriental Fatasia›, LSO-Solti. Decca SXL 2076 (London CS
 6064), Penguin ✶✶ (✶)

[Kempe, Rudolf Kempe] - Janacek: ‹Glagolitic Mass›, RPO, Decca SXL 6600, London OS 26338

[Kertesz, Istvan Kertesz]

[Bohemian Rhapsody] Smetana: ‹The Bartered Bride›, ‹Moldau (Vltava)›; Dvorak: ‹ Slavonic Dances - Op.46, no.1, no.3 & no.8; Op.72, no.1 & no.2›, IPO. Decca SXL 6024, London CS 6330

Bartok: ‹Duke Bluebeard's Castle›, LSO. Decca SET 311, London OSA 1158 (=OS 25968)

Brahms: ‹Serenade No.1 in D Major, Op.11›, LSO. Decca SXL 6340, London CS 6567

Brahms: ‹Serenade No. 2, Op.16›, Dvorak: ‹Serenade for Wind, Op.44›, LSO. SXL 6368 (CS 6594)

Brahms: ‹The Four Symphonies›, Decca SXL 6610-3 (SXLH 6610), Penguin ✹✹ (✹) [No.1 =SXL 6675 (CS 6836); No.2 =SXL 6172 & 6676 (CS 6435); No.3 =SXL 6677 (CS 6837)]

Brahms: ‹Symphony No.4 in E Minor, Op.98›, VPO. Decca SXL 6678 (London CS 6838) Penguin ✹✹✹

Bruckner: ‹Symphony No.4 in E Flat Major "Romantic"›, LSO. Decca SXL 6227 (London CS 6480)

Donizetti: ‹Don Pasquale, Highlights›, Vienna State Opera Orchestra & Chorus.

Decca SET 337, London OS 26013, (Highlights from SET 280-1 & OSA 1260)

Dvorak: [Concert Overtures], ‹In Nature's Realm Op.91›, ‹Carnival Op.92›, ‹Othello Op.93›, ‹Scherzo Capricioso Op.66›, LSO. Decca SXL 6348, London CS 6574

Dvorak: ‹Requiem Mass, Op.89›, Ambrosian Singers & LPO. Decca SET 416-7, London OSA 1281

Dvorak: [The Complete Nine Symphonies] LSO. Decca SXL(SXLD) 6515-21, D6D 7 (London DVO S-1)

Dvorak: ‹Symphony No.1 in C Minor, Op.3, "Bells of Zlonice"›, LSO. Decca SXL 6288 (CS 6523)

Dvorak: ‹Symphony No.2 in B Flat Major, Op.4›, LSO. Decca SXL 6289 (CS 6524)

Dvorak: ‹Symphony No.3 in E Flat Major, Op.10›, ‹Hussite Overture›, LSO. SXL 6290 (CS 6525)

Dvorak: ‹Symphony No.4 in D Minor, Op.13›, ‹Overture "In Nature's Realm"›, LSO. SXL 6257 (CS 6526)

Dvorak: ‹Symphony No.5 (No.3) in F Major, Op.76›, ‹Overture "My Home"›, LSO. SXL 6273 (CS 6511)

Dvorak: ‹Symphony No.6 (No.1) in D Major, Op.60›, ‹Overture "Carnival"›, LSO. SXL 6253 (CS 6495)

Dvorak: ‹Symphony No.7 (No.2) in D Minor, Op.70›, LSO. Decca SXL 6115 (CS 6402)

Dvorak: ‹Symphony No.8 (No.4) Op.88›, ‹Scherzo Capriccioso›, LSO. Decca SXL 6044 (CS 6358)

Dvorak: ‹Symphony No.9 " New World", Op.95›, ‹Overture "Othello" Op.93›, LSO. SXL 6291 (CS 6527)

Dvorak: ‹Symphony No.9 " New World", Op.95›, VPO. 1961. Decca SXL 2289 (CS 6228)

Dvorak: ‹Symphonic Variations›, ‹The Golden Spinning-Wheel›, Decca SXL 6510 (CS 6721)

Dvorak: Symphonic Poems & Overtures, ‹Water Goblin, Op.107›, ‹The Noonday Witch, Op.108›, ‹My Home, Op.62›, ‹The Hussite, Op.67›, LSO. Decca SXL 6543 (CS 6746)

Kodaly: [Music of Kodaly], ‹Háry János Suite›, ‹Dances Of Galanta - Arias From "Háry János"›, with Olga Szönyi (soprano), LSO. Decca SXL 6136, London CS 6417

Kodaly: ‹Hary Janos, Highlights›, Peter Ustinov (narrator), Edinburgh, Wandsworth Boys Choir & LSO. Decca SXL 6631, OS 26390 [Highlights from SET 399-400 (OSA 1278), Penguin ✹✹ (✹)]

Kodaly: ‹Psalmus Hungaricus, Op.13›, ‹Peacock Variations›, LSO. SXL 6497 (OS 26186)

Mozart: ‹Complete Masonic Funeral Music›, LSO. Decca SXL 6409, London OS 26111

Mozart: ‹Symphony No.29, K.201›, ‹No.35, "Haffner", K.385›, VPO. Decca SXL 6616 (CS 6830)

Mozart: ‹Symphony No.25, K.183/173dB›, ‹No.40, K.550›, Decca SXL 6617 (CS 6831), Penguin ✹✹ (✹)

Mozart: ‹Symphony No.36 "Linz", K.425›, Decca SXL 6091 (CS 6383), Penguin ✹✹ (✹)

Respighi: ‹Pines of Rome›, ‹The Birds›, ‹Fountains of Rome›, LSO. Decca SXL 6401 (CS 6624)

Schubert: ‹Symphony No.4 "Tragic", D.417›, ‹Symphony No.5, D.485›, VPO. SXL 6483 (CS 6682)

Schubert: ‹Symphony No.8 "The Unfinished", D.759›, Overtures ‹Des Teufels Lustschloss, D.84›, ‹In the Italian style, D.591›, ‹Fierabras, D.796›, VPO. Decca SXL 6090, London CS 6382

Schubert: ‹Symphony No.9 in C Major "The Great", D.944›, VPO. Decca SXL 6089, London CS 6381

Schubert: ‹The Symphonies›, VPO. Decca SXLJ 6644 (=D105D 5), (London CSP 6) Penguin ✹ ✹ (✹) [=SXL 6089 (CS 6381); 6090 (CS 6382); 6483 (CS 6682); 6552 (CS 6772); 6553(CS 6773)]

[Khachaturian, Aram Khachaturian]

Khachaturian: Ballet Suite ‹Spartacuss› & ‹Gayaneh›, VPO. Decca SXL 6000, London CS 6322

Khachaturian: ‹Symphony No.2 (The Bell)›, VPO. Decca SXL 6001, London CS 6323

[Kleiber, Erich Kleiber]

Mozart: ‹Le Nozze di Figaro (Marriage of Figaro)›, VPO. Decca SXL 2087-90, London OSA 1402, Highlights = SXL 2314 (OS 25045)

[Kletzki, Paul Kletzki]

Hindemith: ‹Mathis Der Mahler›; Lutoslawski: ‹Concerto for Orchestra), OSR. SXL 6445 (CS 6665)

Carl Nielsen: ‹Symphony No.5›, OSR. Decca SXL 6491 (CS 6699), Penguin ✶✶ (✶)

Rachmaninov: ‹Symphony No.3, Op.30›; Mussorgsky: ‹Night on the Bare Mountain›, OSR.
　　　　Decca SXL 2035, London CS 6622

[Knappertsbusch, Hans Knappertsbusch]

Wagner:‹"Die Walküre", Act 1›, ‹Götterdämmerung›, VPO. Decca SXL 2074-5, London OSA 1204

[Kord, Kazimierz Kord] - Massenet: ‹Don Quichotte›, OSR. Decca D156D 3 (OSA 13134)

[Krips, Josef Krips]

Mozart: ‹Don Giovanni›, VPO. Decca SXL 2117-20, London OSA 1401 (Highlights =OS 25115)

Schubert: ‹Symphony No.9 in C Major "The Great"›, LSO. Decca SXL 2045, London CS 6061

[Lanchberry, John Lanchberry]

Ferdinand Herold: ‹La fille mal Gardee›, ROHCG. Decca SXL 2313, London CS 6252

[Larrocha, Alica De Larrocha]

[Favourite Spanish Encores] Decca SXL 6734, London CS 6953

[Concertos from Spain] Montsalvatge: ‹Concerto Breve for Piano & Orchestra›; Surinach: ‹Concerto for Piano &
　　　　Orchestra›, RPO-Frühbeck De Burgos. Decca SXL 6757 (CS 6990)

Albeniz: ‹Iberia›, ‹Navarra›, ‹Cantos de Espana, Op.232›, Decca SXL 6586-7, London CSA 2235

Beethoven: ‹Bagatelles, Op.33›. Decca SXL 6951, London CS 7179

Bach: ‹Clavier Concerto in F Minor, BWV 1056›; Haydn: ‹Concerto in D Major, Hob.XVIII:2 ›;

Mozart: ‹Piano Concerto No.12, K.414›, London Sinfonietta-Zinman. SXL 6952 (CS 7180)

De Falla: ‹Nights in the Gardens of Spain›; Albeniz: ‹Turina›, LPO-Frühbeck. Decca 410 289-1

De Falla: ‹Nights in the Gardens of Spain›; Chopin: ‹Piano Concerto No.2, Op.21›, OSR-Sergiu Comissiona. Decca SXL
　　　　6528, London CS 6733

[The Piano Music of Manuel De Falla] ‹Three Dances from "El Sombrero de Tres Picos"›, ‹Cuatro Piezas Españolas›, ‹Suite
　　　　from "El Amor Brujo"›. Decca SXL 6683 (CS 6881)

Franck: ‹Symphonic Variations For Piano & Orchestra›; Katchaturian: ‹Piano Concerto in D Flat›; LPO-Rafael Frühbeck De
　　　　Burgos. Decca SXL 6599, London CS 6818

Granados:‹12 Danzas Espanolas›, Decca SXL 6980, London CS 7209

Federico Mompou: Piano Works ‹Impresiones intimas›, ‹Preludio VII a Alicia de Larrocha›, ‹Musica callada IV›, ‹Cancons I
　　　　dansas›, Decca-London 410 287-1

[Mostly Mozart, Vol. I], Mozart: ‹Rondo in D Major, K.485›, ‹Sonata in A Major, K.331›,
　　　　　　　　‹Fantasia in C Minor, K.475›; Bach/Busoni: ‹Chaconne in D Minor›. SXL 6669 (CS 6866)

[Mostly Mozart, Vol. II], Mozart: ‹Piano Sonata in D Major, K.311 & in C Major, K.330›, ‹Fantasy in D Minor, K.397›;
　　　　　　　　Haydn: ‹Andante & Varazioni in Fm›. SXL 6784 (CS 7008)

[Mostly Mozart, Vol. IV], Mozart: ‹Piano Sonata in E flat Major, K. 282›, ‹Sonata in A Minor, K.310›;

Rave: ‹Concerto for the Left Hand›, ‹Concerto in G›; Faure: ‹Fantasie for Piano and Orchestra›, LPO-Rafael Frühbeck de
　　　　Burgos. Decca SXL 6680, London CS 6878

[Lubotsky, Mark Lubotsky]

Britten: ‹Concerto for Violin and Orchestra› & ‹Concerto for Piano and Orchestra›, Lubotsky (violin), Sviatoslav Richter
　　　　(piano), ECO. Decca SXL 6512, London CS 6723

[Lopez-Cobos, Jesus Lopez-Cobos]

Respighi: ‹Ancient Airs & Dances Suites Nos.1, 2 & 3›, LPO, Decca SXL 6846 (No CS)

[Lupu, Radu Lupu]

Brahms: ‹Piano Concerto No.1 in D Minor, Op.15›, LPO-Edo De Waart. Decca SXL 6728, London CS 6947

Brahms: Piano Pieces Op.118 - ‹No.1 to No.6›; Piano Pieces Op.119 - ‹No.1 to No.4›; ‹Rhapsody in G Minor, Op.79, No.2›. Decca SXL 6831, London CS 7051

Grieg: ‹Piano Concertos in A Minor, Op.16›; Schumann: ‹Piano Concertos in A Minor, Op.54›, LSO-Andre Previn. Decca SXL 6624, London CS 6840

Schubert: ‹Piano Sonata No.18 in G Minor, D.894›, ‹Two Scherzi D.593›. Decca SXL 6741 (CS 6966)

[Lutoslawski, Witold Lutoslawski]

Lutoslawski: ‹Paroles Tissees›; Lennox Berkeley: ‹Four Ronsard Sonnets›; David Medford: ‹Tentacles of The Dark Nebula›, London Sinfonietta conducted by the composers. Decca HEAD 3

[Maag, Peter Maag]

Chopin : ‹Les Sylphides›; Delibes: ‹La Source›, Paris Consevatoire Orchestra. SXL 2044 (CS 6026)

Mendelssohn: ‹A Midsummer Nights Dream›, Chorus ROHCG & LSO. Decca SXL 2060, London CS 6001

[MendelssohnIn in Scotland] ‹Symphony No.3, "Scotch", Op.56›, ‹Fingal's Cave, Op.26›, LSO.
 Decca SXL 2246, London CS 6191

Mozart: ‹Notturno in D Major for 4 Orchestras, K.286›, ‹Serenada Notturna in D Major, K.239›, ‹Overture "Lucio Silla", K.135›, ‹Interludes "King Thamos", K.345›. LSO. SXL 2196 (CS 6133)

Mozart: ‹Clarinet Concerto, K.622›, ‹Horn Concertos K.412 & K.447›, De Peyer (Clarinet),
 Tuckwell (Horn), LSO. Decca SXL 2238, London CS 6178

Rossini: Overtures ‹William Tell›, ‹La Cenerentola›, ‹Semiramide›, ‹La Gazza Ladra›, PCO.
 Decca SXL 2182, London CS 6089

[Maazel, Lorin Maazel]

Berlioz: ‹Romero et Juliette›, VPO. Decca SET 570-1, London OSA 12102

Debussy: ‹Nocturnes›, ‹Iberia (Images no.2)›, ‹Jeux›, Clvld. Decca SXL 6904, London CS 7128

Gershwin: ‹Porgy & Bess›, Clevld & Chorus. Decca SET 609-11, London OSA 13116

Prokofiev: ‹ Symphony No.5 in B Flat, Op.100›, Clvld. Decca SXL 6875, London CS 7099

Prokofiev: ‹Romeo And Juliet, Op.64, Complete Ballet›, Clvlnd. Decca SXL 6620-2, London CSA 2312, Highlights = Decca SXL 6668, London CS 6865

Ravel: ‹Daphnis and Chloe (Complete Ballet)›, Clvlnd & Chorus. Decca SXL 6703, London CS 6898

Respighi: ‹Roman Festival›, ‹Pines Of Rome›, Clvlnd. Decca SXL 6822, London CS 7043

Rimsky-Korsakov: ‹Scheherazade›, D. Majeske (solo violin), Clvlnd. Decca SXL 6874, London CS 7098

Rimsky-Korsakov: ‹Suite from the opera Le Coq d'or›, ‹Capriccio Espagnol, Op. 34›, ‹Russian Easter Overture, Op. 36 ›, Clvlnd. Decca SXL 6966, London CS 7196

Scriabin: ‹Prometheus-The Poem of Fire›, ‹Piano Concerto in F sharp minor›, Ashkenazy (piano), LPO. Decca SXL 6527, London CS 6732

Sibelius: ‹Symphony No.1 in E Minor, Op.39›, ‹Karelia Suite, Op.11›, VPO. Decca SXL 6084 (CS 6375)

Sibelius: ‹Symphony No.2 In D Major, Op.43›, VPO. Decca SXL 6125, London CS 6408

Sibelius: ‹Symphony No.4 in A Minor, Op.63›, ‹Tapiola›, VPO. Decca SXL 6365 (CS 6592)

Richard Strauss: ‹Don Juan, Op.20›, ‹Death & Transfiguration, Op.24›, VPO. Decca SXL 6134 (CS 6415)

Tchaikovsky: ‹Symphony No.4 in F Minor, Op.36›, VPO. Decca SXL 6157, London CS 6429

Verdi: [Ballet Music from Verdi Operas], Clvlnd. Decca SXL 6726, London CS 6945

[Mackerras, Charles Mackerras]

Janacek: ‹Kata Kabanova›, VPO. Decca D 51D 2, London OSA 12109

Janacek: ‹The Makropulos Case (Vec Makropulos)›, VPO. Decca D144D 2, London OSA 12116

Janacek: ‹From the House of the Dead, (complete)›, VPO. Decca D224D 2 (=London LDR 10036)

Janacek: ‹Jenufa, (complete)›, VPO. Decca D276D 3 (=London LDR 73009)

[Malcolm, George Malcolm]

J.S.Bach: [Harpsichord Recital], ‹Chromatic Fantasia and Fugue, BWV 903 & Italian Concerto, BWV 971›, ‹Toccata BWV 912 & French Suite, BWV 816›. Decca SXL 2259, London CS 6197

J.S.Bach: Harpsichord Concerti ‹No.1, BWV 1052›, ‹No.2, BWV 1053›, Malcolm (harpsichord), StCO-Karl Munchinger. Decca SXL 6101, London CS 6392

J.C.Bach: ‹Harpsichord Concerto in A Major› & Haydn: ‹Harpsichord Concerto & Overture in D Major›, AdSMF-Marriner.
 Decca SXL 6385 (No CS)

[Marriner, Neville Marriner]
Gluck: ‹"Don Juan", Complete Ballet›, AdSMF. Decca SXL 6339 (No CS, =STS 15169)
Handel: ‹12 Grand Concertos (Concerti Grossi) No. 1-No. 4, Op.6›, AdSMF. Decca SXL 6369
Handel: ‹12 Grand Concertos (Concerti Grossi) No. 5-No. 8, Op.6›, AdSMF. Decca SXL 6370
Handel: ‹12 Grand Concertos (Concerti Grossi) No. 9-No.12, Op.6›, AdSMF. Decca SXL 6371
 [SXL 6369, 6370 & 6371, No CS single issue, only in CSA 2390 SET]

[Martinon, Jean Martinon]
Adolphe Adam: ‹Giselle -Ballet›, The Paris Conservatoire Orchestra. Decca SXL 2128, London CS 6098
Ibert: ‹Divertissemen›; Saint-Saens: ‹Danse Macabre, Op.40 & Le Rourt D' Omphale, Op.31›; Bizet: ‹Jeux D' Enfants›,
 The Paris Conservatoire Orchestra. Decca SXL 2252, London CS 6200
Meyerbeer: ‹Les Patineurs -Ballet›; Massenet: ‹Le Cid-Ballet Music›, IPO. Decca SXL 2021 (CS 6058)

[McCabe, John McCabe]
Haydn: [The Piano Sonatas Of Joseph Haydn, Volume 1 to 4] Decca HDN 100-2, 103-5, 106-8 & 109-11

[Mehta, Zubin Mehta]
Bartok: ‹Concerto for orchestra›, ‹Hungarian pictures›, LPO. Decca SXL 6730, London CS 6949
Beethoven: ‹Creatures Of Prometheus›, IPO. Decca SXL 6438, London CS 6660
Beethoven: ‹Symphony No.7, Op.92›, ‹Egmont Overture›, LAPO. Decca SXL(SXLN) 6673, (CS 6870)
Bernstein: ‹Candide Overture›; Gershwin: ‹An American in Paris›; Copland: ‹Appalachian Spring›, LAPO. Decca SXL
 6811, London CS 7031
Bloch: ‹Schelomo›, ‹Voice in the Wilderness›, Janos Starker (cello), IPO. SXL 6440 (CS 6661)
Copland: ‹Lincoln Portrait›; Kraft: ‹Concerto for Four Percussion Soloists and Orchestra›, ‹Contextures: Riots-Decade
 '60›, LAPO. Decca SXL 6388, London CS 6613
Dvorak: ‹Symphony No.9 " New World", Op.95›, ‹Carnival Overture›, LAPO. SXL 6751 (CS 6980)
Elgar: ‹Enigma Variations Op.36›; Ives: ‹Symphony No.1›, LAPO. Decca SXL 6592, London CS 6816
Holst: ‹The Planets, Op.32›, LAPO. Decca SXL 6529, London CS 6734
Ives: ‹Symphony No. 2›, ‹Decoration Day, from 'Holiday Symphony'›, ‹Variations on America›, LAPO. Decca SXL 6753
 [Part of CSA 2246]
Liszt: ‹Battle of Huns, Symphonic Poem No. 11›, ‹Orpheus, Symphonic Poem No. 4›,
 ‹Mazeppa, Symphonic Poem No. 6›, LAPO. Decca SXL 6535, London CS 6738
Mahler: ‹Symphony No.2 in C Minor (Resurrection)›, VPO. Decca SXL 6744-5, London CSA 2242
Mahler: ‹Symphony No.3 in D Minor›, LAPO. Decca D117D 2, London CSA 2249
Mahler:‹Symphony No.5 in C Sharp Minor›, ‹Adagio-Symphony No.10›, LAPO. SXL 6806-7 (CSA 2248)
Puccini: ‹Turandot›, Sutherland, Pavarotti, John Alldis Choir & LPO. Decca SET 561-3 (OSA 13108,)Highlights = Decca
 SET 573, London OS 26377
Rimsky-Korsakov: ‹Scheherazade›, LAPO. Decca SXL 6731, London CS 6950
Rossini: ‹William Tell Overture›; Beethoven: ‹Leonore Overture No.3›; Tchaikovsky: ‹Capriccio Italein›; Rimsky-Korsakov:
 ‹Capriccio Espagnol›, IPO. Decca SXL 6977, London CS 7205
Saint-Saëns: ‹Symphonie No.3 in C Minor Op.78›, LAPO. Decca SXL 6482, London CS 6680
Franz Schmidt: ‹Symphony No.4 in C Major›, VPO. Decca SXL 6544, London CS 6747
Schoenberg: ‹Chamber Symphony No.1, Op.9›, ‹Variations Op.31›, LAPO. Decca SXL 6390, (CS 6612)
Schumann: ‹Symphony No.1 "Spring"›, ‹ Symphony No.4›, VPO. Decca SXL 6819, London CS 7039
Schoenberg: ‹Verklärte Nacht (Transfigured Night), Op.4›; Scriabin: ‹Poem of Ecstasy›, LAPO.
 Decca SXL 6325, London CS 6552
Richard Strauss: ‹Also Sprach Zarathustra, Op.30›, LAPO. Decca SXL 6379, London CS 6609
Richard Strauss: ‹Ein Heldenleben›, David Frisina (Solo Violin), LAPO. Decca SXL 6382, London CS 6608
 Richard Strauss: ‹An Alpine Symphony, Op.64›, LAPO. Decca SXL 6752, London CS 6981

Stravinsky: ‹Rite of Spring›, ‹8 Instrumental Miniatures for 15 Players›, LAPO. SXL 6444 (CS 6664)

Tchaikovsky: ‹Overture Solennelle 1812, Op.49›, ‹Fantasy Overture 'Romeo and Juliet'›, LAPO. Decca SXL 6448, London
 CS 6670

Tchaikovsky: ‹Symphony No.1,'Winter Daydreams'›, ‹Marche Slave›, LAPO. Decca SXL 6913 (CS 7148)

Tchaikovsky: ‹Symphony No.2›, ‹Romeo and Juliet›, LAPO. London CS 7149 (No Decca SXL)

Tchaikovsky: ‹Symphony No.3, in D Major, Op.29 "Polish"›, LAPO. London CS 7154 (No Decca SXL)

Tchaikovsky: ‹Symphony No.4 in F Minor, Op.36›, LAPO. London CS 7155 (No Decca SXL)

Tchaikovsky: ‹Symphony No.5 in E Minor, Op.64›, LAPO. London CS 7165 (No Decca SXL)

Tchaikovsky: ‹Symphony No.6 in B Minor, Op.74 "Pathetique"›, LAPO. London CS 7166 (No Decca SXL)

Tchaikovsky: ‹The Complete Symphonies Nos.1-6›, LAPO. Decca D 95D 6 (London CSP 10)

Varese: ‹Arcana›, ‹Integrales›, ‹Ionisation›, LAPE & LAPO. Decca SXL 6550, London CS 6752

[Michelangeli, Arturo Benedetti Michelangeli]

[The Art Of Arturo Benedetti Michelangeli] Beethoven: ‹Sonata No.32 in C Minor, Op.111›;
Galuppi: ‹Sonata No.5 in C›; Scarlatti: ‹3 Sonatas›. Decca SXL 6181, London CS 6446

[Minton, Yvonne Minton & Georg Solti]

Mahler: ‹Lieder Eines Fahrenden Gesellen›, ‹4 Songs from Des Knaben Wunderhorn›, CSO-Solti. Decca SXL 6679, London
 OS 26195

[Monteux, Pierre Monteux]

Ravel: ‹Daphnis et Chloe (Complete Ballet)›, ROHCG Chorus & LSO. Decca SXL 2164, London CS 6147

[Münchinger, Karl Münchinger]

J.S. Bach: [Complete Brandenburg Concertos, No.1-No.6], StCO. 5BB 130-1 (=SXL 2125-7), CSA 2301

J.S.Bach: ‹Magnificat in D Major›, ‹Cantata No.10›, StCO. Decca SXL 6400 (London OS 26103)

J.S. Bach: ‹Matthaus Passion›, StCO. SET 288-91 (OSA 1431), Excerpts = SXL 6272 (OS 26008)

J.S. Bach: ‹Easter Oratorio›, StCO. Decca SET 398, London OS 26100

Johann Christian Bach: ‹Sinfonias Op.18, No.2, 4 & 6›; Telemann: ‹Don Quichotte Suite›, StCO. Decca SXL 6755, London
 CS 6988

Corelli: ‹Conceto Groosso No.8); Pachelbel: ‹Kanon›; Ricciotti: ‹ Concerto No.2 in G Major›; Gluck: ‹Chaconne›, StCO.
 Decca SXL 2265, London CS 6206

Haydn: ‹Die Schöpfung (The Creation)›, VPO. Decca SET 362-3, London OSA 1271

Mozart: ‹Eine kleine Nachtmusik, K.525›, ‹Divertimento No.1 in D Major, K.136›, ‹A Musical Joke, KV. 522)›, StCO. Decca
 SXL 2270, London CS 6207

Mozart: ‹Clarinet Concerto in A Major, K.622›, ‹Flute and Harp Concerto in C Major, K.299›,
 Alfred Prinz (clarinet); Werner Tripp (flute); Hubert Jellinek (harp), VPO. SXL 6054 (CS 6351)

Pergolesi: ‹Flute Concerti Nos. 1 & 2›, ‹Concerti Armonici Nos. 5-6›, Jean-Pierre Rmpal (flute), StCO-Münchingerr. Decca
 SXL 6104, London CS 6395

Schubert: ‹Rosamunde Von Cypern, D.797 (Op.26)›, ‹Overture Die Zauberharfe, D.644›,
 Rohangiz Yachmi (contralto), VPO. Decca SXL 6748, London OS 26444

Schubert: ‹Five Minuets, Five German Dnaces›*; Mozart: ‹Divertimento No.11, K.251›, StCO. London CS 6169 (No Decca
 SXL), *Schubert =Penguin ✫✫✫

Vivaldi: ‹The Four Seasons›, StCO. Decca SXL 6557, London CS 6809

[Nash, Royston Nash & D'Oyly Carte Opera Company]

Gilbert & Sullivan: ‹The Mikado›, RPO. London OSA 12103 (=Decca SKL 5158-9)

Gilbert & Sullivan: ‹Iolanthe›, RPO. London OSA 12104 (=Decca SKL 5188-9), Penguin ✫✫ (✫)

[Oistrakh, David & Igor Oistrakh]

Bruch: ‹Scottish Fantasia, Op.46›; Hindemith: ‹Violin Concerto (1939)›, LSO-Horenstein & Hindemith, Decca SXL 6035,
 London CS 6337

Mozart: ‹Sinfonia Concertante K.364›, ‹Duo in G Major K.473›, David & Igor Oistrakh (violin), Moscow Philharmonic
 Orchestra-Kyril Kondrashin. Decca SXL 6088, London CS 6377, Penguin ✫✫ (✫)

[Pavarotti, Luciano Pavarotti]

[Aries by Verdi and Donizetti], Vienna Opera Orchestra-Edward Downes. Decca SXL 6377 (OS 26087)

[King of the High C's], Arias from La Favorita; Il Trovatore; La Boheme, etc. Decca SXL 6658 (OS 26373)

[The Art of Pavarotti], Arias from L'Elisir d'Amore, Maria Stuarda, Lucia, etc. Decca SXL 6839 (OS 26510)

[O Solo Mio - Pavarotti], Favourite Neapolitan Songs. Decca SXL 6870, London OS 26560

[Pears, Peter Pears]

[Folk Songs] 〈The brisk young widow〉, 〈O waly, waly〉, 〈Sweet Polly Oliver〉, 〈Early one morning〉, 〈The bonny Earl O'Moray〉, etc., Benjamin Britten (piano). Decca SXL 6007 (OS 25327)

Britten: 〈Serenade Op.31, For tenor solo, horn & strings〉, Peter Pears (tenor) & Barry Tuckwell (horn); 〈Young Person's Guide to the Orchestra〉, LSO. SXL 6110 (CS 6398)

Britten: 〈Songs & Proverbs of William Blake, Op.74〉, 〈Holy Sonnets of John Donne, Op.35〉, Peter Pears (tenor), Fischer-Dieskau (baritone), Britten (piano). Decca SXL 6391 (OS 26099)

Britten: 〈Serenade, Op.31, (For tenor, horn & string)〉, 〈Illuminations, Op.18, (For tenor & string)〉, Barry Tuckwell (horn), LSO & ECO-Benjamin Britten. Decca SXL 6449, London OS 26161

Britten: 〈Journey of the Magi〉, 〈Who are these children〉, 〈Tit for Tat〉 & Songs by Henry Purcell, Pears, Shirley-Quirke, Bowman, Benjamin Britten (piano). Decca SXL 6608 (No CS)

Britten: 〈A Birthday Hansel, Op.92〉, 〈2 Scottish Folk Songs〉, 〈Suite For Harp, Op.83〉, 〈Canticle V〉, 〈Second Lute Song from "Gloriana", Op.53〉, Osian Ellis (harp). Decca SXL 6788 (No CS)

Britten: 〈Folk Song Arrangements〉, Peter Pears (tenor), Osian Ellis (harp). Decca SXL 6793 (No CS, OS)

[Franz Schubert Songs], 〈Im Frühling (Schulze)〉, 〈Auf dem Wasser zu singen (Stolberg)〉, 〈Nachstücke (Mayrhofer)〉, etc., Benjamin Britten (piano). Decca SXL 6722 (No CS, OS)

Schubert: 〈Die Schöne Müllerin, Op.25, D.795〉, Benjamin Britten (piano). Decca SXL 2200 (OS 25155)

Schubert: 〈Die Winterreise, D.911〉, Schumann: 〈Dichterliebe, Op.48〉, Benjamin Britten (piano). Decca SET 270-1, London OSA 1261

[Madrigals by Thomas Weelkes], The Wilbye Consort directed by Peter Pears. Decca SXL 6384 (No CS)

[Perlman, Itzhak Perlman]

Beethoven: [Complete Violin Sonatas], Itzhak Perlman (violin), Vladimir Ashkenazy (piano).Decca D 92D 5 (=SXL 6632, 6736, 6789, 6790, 6791 & 6990), London CSA 2501

Beethoven: Violin Sonatas Volume 1, 〈No.2, Op.12 no.2〉, 〈No.9, Op.47〉, Ashkenazy (piano).Decca SXL 6632, London CS 6845

Beethoven: Violin Sonatas Volume 2, 〈No.4, Op.23〉, 〈No.5, Op.24,"Spring"〉, Ashkenazy (piano). Decca SXL 6736, London CS 6958

Beethoven: Violin Sonatas Volume 3, 〈No.3, Op.12 no.3 〉, 〈No.8, Op. 30 no.3〉, Ashkenazy (piano). Decca SXL 6789, London CS 7012

Beethoven: Violin Sonatas Volume 4, 〈No.1, Op.12 no.1〉, 〈No.10, Op.96〉, Ashkenazy (piano). Decca SXL 6790, London CS 7013

Beethoven: Violin Sonatas Volume 5, 〈No.6, Op.30 no.1〉 & 〈No.7, Op.30 no.2〉, Ashkenazy (piano). Decca SXL 6791, London CS 7014

Beethoven: 〈Violin Sonata No.9 in A Major, Op.47 "Kreutzer"〉, 〈 No.5 in F Major, Op.24,"Spring"〉, Ashkenazy (piano). Decca SXL 6990 (Part of SXL 6632 & 6736) [=London CS 6845 & 6958]

Franck: 〈Violin Sonata in A Major〉; Brahms: 〈Trio for Violin, Horn & Piano in E Flat Major, op.40〉, Perlman (violin); Tuckwell (horn) & Ashkenazy (piano). Decca SXL 6408, London CS 6628

[Pradelli, Francesco Molinari-Pradelli]

Leoncavallo: 〈I Pagliacci〉, Monaco, Tucci, MacNeil, AdSC. Decca SXL 2185-6, London OSA 1212

[Previn, André Previn & Musikvereinquartett]

Mozart: Piano Quartets, 〈Quartet No.1 in G, K.478〉, 〈Quartet No.2 in Es K.493〉, Members of the Musikvereinquartett with Andre Previn (piano). Decca SXL 6989 (CS 7220)

[Price, Leontyne Price & Karajan]

[Christmas with Leontyne Price] Leontyne Price, VPO-Karajan. Decca SXL 2294, London OS 25280

[Pritchard, John Pritchard]

Donizetti: ⟨Lucia di Lammermoor⟩, Sutherland, Cioni, Merrill, Siepi, etc., AdSC. Decca SET 212-4, London OSA 1327, Highlights = Decca SXL 2315 (London OS 25702)

Verdi: ⟨La Traviata, Highlights⟩, Sutherland, Bergonzi & Merrill, MMG. Decca SXL 6127 (OS 25886) (Highlights from SET 249-51 & OSA 1366)

[Rampal, Jean-Pierre Rmpal & Münchinger]

Pergolesi: ⟨Flute Concerti Nos. 1 & 2⟩, ⟨Concerti Armonici Nos. 5-6⟩, Jean-Pierre Rmpal (flute), StCO-Münchingerr. Decca SXL 6104, London CS 6395

[Rattle, Simon Rattle]

Peter Maxwell Davies: ⟨Symphony⟩, Philharmonia Orchestra-Simon Rattle. Decca HEAD 21

[Reiner, Fritz Reiner]

Brahms: Hungarian Dances, ⟨ No.1, No.5, No.6, No.7, No.12, No.13, No.19, No.21 ⟩;

Dvorak: Slavonic Dances, ⟨Op.46, no.1; 3; 8 ⟩, ⟨Op. 72, no.1; 2⟩, VPO. Decca SXL 2249 (CS 6198)

[Richter, Sviatoslav Richter]

Britten: ⟨Concerto for Violin and Orchestra⟩ & ⟨Concerto for Piano and Orchestra⟩, Lubotsky (violin), Sviatoslav Richter (piano), ECO. Decca SXL 6512, London CS 6723

[Ricci, Ruggiero Ricci]

Bizet-Sarasate: ⟨Carmen Fantasy⟩; Sarasate: ⟨Zigeunerweisen, Op.20⟩; Saint-Saëns: ⟨Havanaise, Op.83⟩, ⟨Introduction & Rondo Capriccioso⟩, LSO-Pierino Gamba. Decca SXL 2197, London CS 6165

Paganini: ⟨24 Caprices Op.1, Nos. 1-24, for unaccompanied violin⟩, Decca SXL 2194, London CS 6163

Mendelssohn: ⟨Violin Concerto in E Minor Op.64⟩; Bruch: ⟨Violin Concerto No.1 in G Minor, Op.26⟩, LSO-Piero Gamba. Decca SXL 2006, London CS 6010

Prokofiev: ⟨Violin Concerto No.1 in D Major, Op.19⟩, ⟨Violin Concerto No.2nin G Minor, Op.63⟩, Ruggiero Ricci (violin), OSR-Ansermet. London CS 6059 (No Decca SXL)

Tchaikovsky: *⟨Serenade Melancolique, Op.26⟩, *⟨Scherzo from "Souvenir d'un lieu cher, Op.42, no.2⟩,

Sibelius: ⟨Violin Concerto in D Minor⟩, LSO-Øivin Fjelstad. Decca SXL 2077 (CS 6067), * Penguin ✻✻✻

[Rogé, Pascal Rogé]

Bartok: ⟨Piano Concerto No.1⟩, ⟨Rhapsody, Op.1⟩, LSO-Weller. Decca SXL 6815 (No CS), Penguin ✻✻ (✻)

Debussy: "Piano Works Vol. 1", ⟨Pour le piano⟩, ⟨Mazurka⟩, ⟨Deux arabesques⟩, ⟨Reveries⟩, ⟨Suite bergamasque⟩, ⟨Estampes⟩, ⟨Danse bohémienne⟩. Decca SXL 6855 (No CS)

Debussy: "Piano Works Vol. 2", ⟨Images Books 1 and 2⟩, ⟨L"Isle joyeuse⟩ ⟨D"un cahier desquisses⟩, ⟨Masques⟩. Decca SXL 6957 (No CS)

Debussy: "Piano Works Vol. 3", ⟨ Oeuvres de Piano⟩, ⟨Préludes Book 1⟩, ⟨Children's Corner⟩. Decca SXL 6928 (No CS)

[A Liszt Recital] ⟨Sonata in B minor⟩ ⟨Etudes d'execution transcendance No.4⟩ ⟨Liebestraum No.3⟩, ⟨Mazeppa⟩ ⟨Annees de pelerinage⟩ ⟨Premiere Annee "Suisse" No.6⟩. SXL 6485 (CS 6693)

Saint-Saëns: [5 Piano Concertos], Pascal Rogé with PhO, LPO & RPO-Charles Dutoit. Decca D244D 3

Saint-Saëns: ⟨Piano Concerto No.2, Op.22 & No.4, Op.44⟩. RPO-Dutoit. Decca SXL 7008 (CS 7253)

[Rostropovich, Mstislav Rostropovich]

Britten: ⟨Symphony for Cello & Orchestra, Op.68⟩*; Haydn: ⟨Cello Concerto in C⟩, ECO-Britten. Decca SXL 6138, London CS 6419. *(Reissued in Decca SXL 6641)

Britten: ⟨The Suites for Cello Op.72 & Op.80⟩, Decca SXL 6393, London CS 6617

Britten: ⟨Sonata in C for Cello and Piano, Op.65⟩; Debussy: ⟨Sonata for Cello & Piano⟩;

Schumann: ⟨Fünf Stücke im Volkston⟩, Benjamin Britten (piano). Decca SXL 2298, London CS 6237

Schubert: ⟨Sonata in A Minor "Arpeggione", D.821⟩; Frank Bridge: ⟨Sonata for Cello and Piano⟩, Benjamin Britten (piano). Decca SXL 6426, London CS 6649, Penguin ✻✻ (✻)

[Rubinstein, Artur Rubinstein]

Brahms: ‹Piano Concerto No.1 in D Minor, Op.15›, IPO-Mehta. Decca SXL 6797, London CS 7018 [Sass, Sylvia Sass & Andras Schiff]

Liszt: ‹8 Songs›; Bartok: ‹5 Songs›, Andras Schiff (piano). Decca SXL 6964 (No OS)

[Schiff, Andras Schiff]

Mozart: Piano Sonatas (Volume 1), ‹Sonata in B Flat Major, K.333›, ‹Sonata in C Major, K.545›, ‹Sonata in C Minor, K.457› & ‹Fantasia in C Minor, K.475›, Decca SXL 6997 (D222D 6), CS 7240

[Schmidt-Isserstedt, Hans Schmidt-Isserstedt & VPO]

Beethoven: ‹Symphony No.1 & No.2 ›, VPO. Decca SXL 6437 (CS 6658), Penguin ✺✺ (✼)

Beethoven: ‹Symphony No.3 in E Flat Major "Eroica", Op.55›, VPO. Decca SXL 6232, London CS 6483

Beethoven: ‹Symphony No.4 in B Flat Major, Op.60›, ‹Consecration of the House Overture, Op.124›, VPO. Decca SXL 6274, London CS 6512

Beethoven: ‹Symphony No.5 in C Minor "Fate", Op.67› & ‹Symphony No.8 in F Major, Op.93›, VPO. Decca SXL 6396, London CS 6619

Beethoven: ‹Symphony No.7›, ‹Overture Leonora No.3›, Decca SXL 6447 (CS 6668), Penguin ✺✺ (✼)

Beethoven: ‹Symphony No.9 in D Minor, "Choral", Op.125›, Sutherland, Horne, King, VPO.
 Decca SXL 6233, London OSA 1159 (=OS 25974)

[Schwarzkopf, Elisabeth Schwarzkopf]

[Elisabeth Schwarzkopf - To My Friends], Geoffrey Parsons (piano). Decca SXL 6943, London OS 26592

[Soderstrom, Elisabeth Soderstrom]

[Elisabeth Soderstrom Sings Songs for Children] Decca SXL 6900, London OS 26579

Rachmaninov: ‹Songs Volume 1›, Ashkenazy (piano). Decca SXL 6718, London OS 26428

Rachmaninov: ‹Songs Volume 2›, Ashkenazy (piano). Decca SXL 6772, London OS 26453

Rachmaninov: ‹Songs Volume 3›, Ashkenazy (piano). Decca SXL 6832, London OS 26433

Rachmaninov: ‹Songs Volume 4›, Ashkenazy (piano). Decca SXL 6869, London OS 26559

Rachmaninov: ‹Songs Volume 5›, Ashkenazy (piano). Decca SXL 6940, London OS 26615

Tchaikovsky: ‹Songs, Melodies, Chansons, Lieder, Vol.1›, Ashkenazy (piano). Decca SXL 6972 (No CS)

[Solti, Georg Solti]

[Romantic Russia] Borodin: ‹Prince Igor, Overture & Polovtsian Dances›; Glinka: ‹Russlan & Ludmilla›;
 Mussorgsky: ‹Khovanshchina Prelude›, ‹Night On Bald Mountain›; LSO. SXL 6263 (CS 6503=CS 6785)

Borodin: ‹Overture Prince Igor›; Glinka: ‹Russian and Ludmilla›; Mussorgsky: ‹Night On Bald Mountain›, ‹Khovanschina-Prelude & Persian Dance›, BPO. London CS 6944 (No Decca SXL)

Bartok: ‹Duke Bluebeard's Castle›, LPO. Decca SET 630, London OSA 1174

Bartok: ‹The Miraculous Madarin Suite, Op.19›, ‹Music For Strings, Percussion & Celesta›, LSO.
 Decca SXL 6111, London CS 6399 (Reissue=CS 6783)

Bartok: ‹Concerto for Orchestra›, ‹Dance Suite›, LSO. Decca SXL 6212, London CS 6469 (=CS 6784)

Beethoven: ‹Missa Solemnis›, CSO. Decca D 87D 2, London OSA 12111

Beethoven: ‹Symphony No.1 & No.8 ›, CSO. Decca SXL 6760 (CS 6926), Penguin ✺✺ (✼)

Beethoven: ‹Symphony No.2 in D Major, Op.36›, ‹Egmont Overture›, CSO. Decca SXL 6761 (CS 6927)

Beethoven: ‹Symphony No.3 in E Flat Major "Eroica", Op.55›, CSO. Decca SXL 6829 (CS 7049)

Beethoven: ‹Symphony No.4 in B Flat Major, Op.60›, CSO. Decca SXL 6830 (CS 7050), Penguin ✺✺ (✼)

Beethoven: ‹Symphony No.5 in C Minor, Op.67›, ‹Leonore Overture›, CSO. Decca SXL 6762 (CS 6930)

Beethoven: ‹Symphony No.6 "Pastoral", Op.68›, CSO. Decca SXL 6763 (CS 6931), Penguin ✺✺ (✼)

Beethoven: ‹Symphony No.7 in A Major, Op.92›, ‹Coriolan Overture›, CSO. Decca SXL 6764 (CS 6932)

Beethoven: ‹Symphony No.9 in D Minor, "Choral", Op.125›, Lorengar, Minton, Burrows, Talvela, CSO. Decca 6BB 121-2,
 London CSP 8

Berlioz: ‹Symphonie Fantastique, Op.14›, CSO. Decca SXL 6571, London CS 6790

Bizet: ‹Carmen›, Tatiana Troyanos, Kiri Te Kanawa, Placido Domingo, Jose van Dam, LPO. Decca D 11D 3, London OSA 13115, (Highlights = Decca SET 621, London OSA 13115)

Bizet: Bizet: *‹Carmen›, Tatiana Troyanos (mezzo-soprano); Borodin: ‹Prince Igor, The Dance
of the Polovtsian›; Tchaikovsky: ‹Eugene Onegin›, LSO, ROHCG & LPO. Decca SET 622 (* AS List)

Brahms: ‹Symphony No.1 in C Minor, Op.68›, CSO. Decca SXL 6924, London CS 7198, Penguin ✸✸ (✸)

Brahms: ‹Symphony No.2›, ‹Tragic Overture›, CSO. Decca SXL 6925 (CS 7199), Penguin ✸✸ (✸)

Brahms: ‹Symphony No.3 in F Major, Op.90›, ‹Academic Festival Overture, Op.80›, CSO.
Decca SXL 6902, London CS 7200

Brahms: ‹Symphony No.4 in E Minor, Op.98›, CSO. Decca SXL 6890, London CS 7201

Bruckner: ‹Symphony No.6›, CSO. Decca SXL 6946, London CS 7173

Elgar: ‹Symphony No.1, in A-Flat, Op.55›, LPO. Decca SXL 6569, London CS 6789

Elgar: ‹Symphony No.2, in E-Flat, Op.63›, LPO. Decca SXL 6723, London CS 6941

Elgar: ‹Pomp & Circumstance Military Marches, Op.30, No.1-No.5›, ‹Overture Cockaigne, Op.40›, ‹The National Anthem
'God Save The Queen'›, LPO. Decca SXL 6848, London CS 7072

Elgar: ‹Enigma Variations, Op.36›, CSO. ‹Overture Cockaigne (In London Town), LPO. Decca SXL 6795 (London CS 6984,
part)

Holst: ‹The Planets›, LPO. Decca SET 628, London CS 7110

Liszt: ‹Tasso-Symphonic Poem No.2›, ‹From the Cradle to the Grave-Symphonic Poem No.13›, ‹Mephisto Waltz No.1›,
L'Orchestre de Paris. Decca SXL 6709, London CS 6925

Liszt: Symphonic Poems, ‹Prometheus, No.5, G.99›, ‹Les Preludes, No.3, G.97›, ‹Festklänge, No.7, G.101›, LPO. Decca
SXL 6863, London CS 7084

Mahler: ‹Das Lied von der Erde›, Yvonne Minton, Rene Kollo, CSO. Decca SET 555, London OS 26292

Mahler: ‹Symphony No.1 in D Major "The Titan"›, LSO. Decca SXL 6113, London CS 6401

Mahler: ‹Symphony No.2 in C Minor (Resurrection)›, CSO. Decca SET 325-6, London CSA 2217

Mahler: ‹Symphony No.6, A Minor›, ‹Lieder Eines Fahrenden Gesellen›, Yvonne Minton, CSO. Decca SET 469-70, London
CSA 2227

Mahler: ‹Symphony No.7 in E Minor›, CSO. Decca SET 518-9, London CSA 2231

Mahler: ‹Symphony No.8 in E Flat (Symphony of Thousand)›, CSO. Decca SET 534-5, London OSA 1295

Mozart: ‹Le Nozze Di Figaro›, Samuel Ramey, Lucia Popp, LPO. Decca D267D 4 (=London LDR 74001)

Mozart: ‹Die Zauberfloete (The Magic Flute)›, VPO. Decca SET 479-81, London OSA 1397

Schumann: ‹Complete Symphony Four Symphonies›, VPO. Decca D190D 3, London CSA 2310

Schumann: ‹Symphony No.1 in B Flat Major, Op.38›, ‹Overture, Scherzo & Finale Op.52›, VPO.
Decca SXL 6486, London CS 6696

Schumann: ‹Symphony No.2 in C Major, Op.61›, ‹Overture 'Julius Caesar' Op.128›, VPO.
Decca SXL 6487, London CS 6697

Schumann: ‹Symphony No.3 in E flat Major, Op.97›, ‹Symphony No.4 in D Minor, Op.120›, VPO. Decca SXL 6356,
London CS 6582

[The Richard Strauss Album] ‹Also Sprach Zarathrustra›, ‹Till Eulenspiegel›, ‹Don Juan›, CSO.
Decca SXL 6749, London CS 6978

Richard Strauss: ‹Salome›, Nilsson, Stolze, Wächter, VPO. Decca SET 228-9, London OSA 1218
(Highlights = Decca SET 457, London OS 26169)

Richard Strauss: ‹Elektra›, Nilsson, Resnik, Stolze, Krause, VPO. Decca SET 354-5, London OSA 1269 (Highlights = Decca
SET 459, London OS 26171)

Richard Strauss: ‹Der Rosenkavalier›, Crespin, Pavarotti, Jungwirth, Minton, VPO. Decca SET 418-21, London OSA 1435,
Highlights = Decca SET 487 (OS 26200)

Richard Strauss: ‹Arabella›, with Hilde Gueden, George London, Otto Edelmann, Lisa Della Casa,
Chorus of Vienna State Opera & VPO. Decca SXL 2050-3, London OSA 1404

Richard Strauss: ‹An Alpine Symphony, Op.64›, Bavarian Radio SO. Decca SXL 6959, London CS 7189

Stravinsky: ‹Le Sacre du Printemos›, CSO. Decca SXL 6691, London CS 6885

Stravinsky: ‹Oedipus Rex›, Opera-Oratorio, LPO. Decca SET 616, London OSA 1168

Suppe: Overtures ‹Light Cavalry›, ‹Poet and Peasant›, ‹Morning, Noon and Night in Vienna›,
‹Pique Dame›, VPO. Decca SXL 2174, London CS 6146 (reissue=CS 6779)

Tchaikovsky: ‹Eugene Onegin›, Kubiak, Weikl, Burrows, Ghiaurov; ROHGC. SET 596-8 (OSA 13112) (Highlights = Decca
SET 599)

Verdi: ‹Falstaff›, Evans, Freni, Simionato, Ligabue, Merrill, Kraus, Elias, RCA Italiana Opera Orchestra. Decca 2BB 104-6, London OSA 1395 (=RCA LSC 6163)

Verdi: ‹Don Carlos›, Bergonzi, Tebaldi, Fischer-Dieskau, Ghiaurov, ROHCG, SET 305-8 (OSA 1432)

Verdi: ‹Requiem›, Sutherland, Horne, Pavarotti, Talvela, VPO. Decca SET 374-5, London OSA 1275

Verdi: ‹Aida›, Leontyne Price, ROHCG. Decca SET 427-9, London OSA 1393 (=RCA LSC 6158)

Verdi: ‹Four Sacred Pieces (Quattro Pezzi Sacri)›, CSO. Decca SET 602, London OS 26610

Verdi: ‹Otello, Highlights›, VPO. Decca SET 632, London OSA 13130 (part)

Wagner: ‹Tristan und Isolde›, Birgit Nilsson, Fritz Uhl, Regina Resnik, Tom Krause, Arnold van Mill, VPO. (1x Demo record "Project Tristan") Decca SET 204-8 (=D41D 5), OSA 1502

Wagner: ‹Die Walküre, Act III-complete›; ‹Act II-Todesverkündigung, Siegmund! Sieh' auf mich!›, Flagstad, Edelmann, Svanholm, etc.VPO. Decca SXL 2031-2 (London OSA 1203)

Wagner: ‹Der Ring des Nibelungen›, Vienna Philharmonic Orchestra. Decca Ring 1-22, London Ring S-1 [=D100D 19, SET 382-4 (SXL 2101-3); SET 312-6; 242-6; SET 292-7] [=OSA 1309; 1509; 1508; 1604]

Wagner: ‹Der Ring des Nibelungen›, Guide & Introduction to "Der Ring des Nibelungen", Decca SET 406-8, London RDN S-1, Wagner: ‹The Golden Ring, Highlights›, VPO. Decca SXL 6421, London OSA 1440

Wagner: ‹Das Rheingold›, VPO. Decca SXL 2101-3 (SET 382-4), London OSA 1309, Highlights = Decca SET 482, London OS 26194

Wagner: [Rheingold And Walküre Highlights], VPO. Decca SXL 2230, London OS 25126
[Highlights from Decca SET 382-4, SXL 2031-2, London OSA 1309 & 1203]

Wagner: ‹Die Walküre›, VPO. Decca SET 312-6, London OSA 1509
Highlights = SET 390, London OS 26085

Wagner: ‹Siegfried›, VPO. Decca SET 242-6, London OSA 1508

Wagner: ‹Siegfried, Forging Scene & Final Duet›, VPO. Decca SXL 6142, London OS 25898 (OSA 1508)

Wagner: ‹Götterdämmerung›, VPO. Decca SET 292-7, London OSA 1604, (Highlights =SXL 6220)

Wagner: ‹Tannhäuser›, VPO. Decca SET 506-9, London OSA 1438 (Highlights=SET 556, OS 26299)

Wagner: ‹Parsifal›, VPO. Decca SET 550-4, London OSA 1510 (Highlights = Decca SET 574)

Wagner: ‹The Flying Dutchman, Overture›, ‹Tannhäuser, Overture›, ‹Die Meistersinger, Prelude›, ‹Tristan und Isolde, Prelude and Liebestod›, CSO. Decca SXL 6856, London CS 7078

Wagner: ‹The Flying Dutchman (Der Fliegende Holländer)›, Kollo, Bailey, Martin, CSO. Decca D 24D 3. London OSA 13119, (Highlights=Decca SET 626)

Walton: ‹Balshazzar's Feast›, ‹Coronation Te Deum›, LPO. Decca SET 618 (London OS 26525)

[Stefano, Giuseppe Di Stefano]

[Italy, (La Voce D'Italia], Italian Songs, conducted by Dino Oliveri. Decca SXL 2083, London OS 25065

[Stein, Horst Stein]

Sibelius: ‹Finlandia Op.26, No.7›, ‹Night-Ride And Sunrise, Op.55›, ‹Pohjola's Daughter, Op.49›, ‹En Saga, Op.9›, OSR. Decca SXL 6542, London CS 6745

Sibelius: ‹Pelleas et Melisande, Op.49›, ‹The Tempest, Nos 1 & 2›, OSR. Decca SXL 6912, (No CS)

[Sutherland, Joan Sutherland]

[Art Of The Prima Donna, Volume 1 & 2] ROHCG-Pradelli. London OSA 1214 (Decca SXL 2256-57)

[Art Of The Prima Donna, Volume 1] ROHCG-Pradelli. Decca SXL 2256, London OS 25232

[Art Of The Prima Donna, Volume 2] ROHCG-Pradelli. Decca SXL 2257, London OS 25233

[Command Performance] Sutherland (soprano) with supporting soloists and choruses. LSO-Bonynge.

[Joan Sutherland, Command Performance Vol. 1 & 2] Decca SET 247-8 (SXL 6073-4), London OSA 1254

[Joan Sutherland, Command Performance Vol. 1] Decca SXL 6073, London OS 25776

[Joan Sutherland, Command Performance Vol. 2] Decca SXL 6074, London OS 25777

[Joan Sutherland sings Verdi], Arias from Verdi's Operas, with various orchestras, conducted by Santi, Bonynge, Pradelli, Pritchard. Decca SXL 6190, London OS 25939

[Joan Sutherland & Luciano Pavarotti Duets], ‹La Traviata›, ‹Sonnambula›, ‹ Aida›, ‹Otello›, ‹Linda di Chamounix›, NPO-Bonynge. Decca SXL 6828, London OS 26449

[Joan Sutherland & Luciano Pavarotti Duets], ‹Lucia›, ‹Rigoletto›, ‹L'Elisier d'Amore›, ‹I Puritani›,
　　　　　‹La Fille du Re'giment›, LSO, ECO & ROHCG-Bonynge. Decca SXL 6991, London OS 26437
[Duets From Bellini's Norma & Rossini's Semirande] Joan Sutherland & Marilyn Horne, LSO-Bonynge. Decca SET 456,
London OS 26168

[Swingle II]
Berio: ‹A-Ronne›, ‹Cries of London (for eight voices)›, directed by Luciano Berio. Decca HEAD 15

[Szell, Georg Szell]
Handel: ‹The Water Music›, ‹The Royal Fireworks›, LSO. Decca SXL 2302, London CS 6236
Tchaikovsky: ‹Symphony No.4 in F Minor›, LSO. London CS 6987 (No Decca SXL)

[Talvela, Martti Talvela]
Mussorgsky: ‹Songs and Dances of Death›; Rachmaninov : ‹Songs›, Talvela (bass), Ralf Gothoni (piano).
　　　　Decca SXL 6974 (No CS)

[Tebaldi, Renata Tebaldi & Oliviero di Fabritiis]
[Renata Tebaldi Recital] Works from Verdi, Puccini, Ponchielli, Mascagni. NwPhO-di Fabritiis.
　　　　　Decca SXL 6152, London OS 25912

[Tilbury, John Tilbury]
John Cage: ‹Sonatas & Interludes for Prepared Piano›, John Tilbury (prepared piano). Decca HEAD 9

[Tuckwell, Barry Tuckwell]
Britten: ‹Serenade Op.31, For tenor solo, horn & strings›, Peter Pears (tenor) & Barry Tuckwell (horn); ‹Young Person's
　　　　Guide to the Orchestra›, LSO. SXL 6110 (CS 6398)
Britten: ‹Serenade, Op.31, (For tenor, horn & string)›, ‹Illuminations, Op.18, (For tenor & string)›, Peter Pears (tenor),
　　　　Barry Tuckwell (horn), LSO & ECO-Benjamin Britten. Decca SXL 6449 (OS 26161)
Mozart: ‹Horn Concertos No. 1 to No. 4, (K.412, K.417, K.447, K.495)›, ‹Fragment from Horn Concerto›, Barry Tuckwell
　　　　(horn), LSO-Peter Maag. Decca SXL 6108, London CS 6403

[Various]
‹Grand Opera Choruses›, Choruses from ‹Boris Godunov›; ‹Nabucco›; ‹Otello›; ‹Madama Butterfly›;
　　　　　‹Die Meistersinger von Nürnberg›; ‹Tannhäuser›; ‹Parsifal›; ‹Fidelio›. Vienna State Opera Chorus &
　　　　　Vienna Philharmonic Orchestra with various conductors.

[Varviso, Silvio Varviso]
Prokofiev: ‹Selections from the Stone Flower›, OSR-Silvio Varviso. Decca SXL 6203, London CS 6458
Rossini: ‹L'Italiana in Algeri›, Berganza, Alva, Corena, MMG. Decca SET 262-4, London OSA 1375
　　　　Highlights = Decca SXL 6210, London OS 25947
Richard Strauss: ‹Der Rosenkavalier (excerpts)›, VPO. Decca SXL 6146, London OS 25905

[Vienna Octet]
Beethoven: ‹Quintet in E Flat Major, Op.16›; Spohr: ‹Octet in E Major›, Walter Panhoffer (Piano). Decca SXL 2158,
　　　　London CS 6063
Beethoven: ‹Septet in E Flat Major, Op. 20›. Decca SXL 2157, London CS 6132
Brahms: ‹Clarinet Quintet in B Minor, Op.115›; Wagner: ‹Adagio for Clarinet and String›. Decca SXL 2297,
　　　　London CS 6234
Dvorak: ‹Quintet in G Major, Op.77›; Spohr: ‹Quintet in C Minor for Piano & Winds, Op.52›. Decca SXL 6463,
　　　　London CS 6673
Mendelssohn: ‹Piano Sextet in D Major›, Borodin: ‹Piano Quintet in C Minor›. Decca SXL 6414 (CS 6636)
Mozart: ‹Divertimento in D, No.17, K.334›, ‹Divertimento in D, K.136›. Decca SXL 2290 (No CS)
Mozart: ‹Divertimento in D, K. 205›, ‹March in D, K. 290›, ‹Cassation in B Flat, K. 99›.
　　　　Decca SXL 6150, London CS 6433

[Vienna Philharmonic Quartet]

Mozart: ‹Quartet No.20 in D, K.499 (Hoffmeister)›, ‹Quartet No.22 in B Flat Major, K.589 (2nd Prussian)›. Decca SXL 2286, London CS 6231

Schubert: Quartets ‹In D Minor "Death and The Maiden, D.810›, ‹In E Flat, Op.125, No.1, D.87›. Decca SXL 6092, London CS 6384

[Vyvyan, Jennifer Vyvyan & Harry Newstone]

[Jennifer Vyvyan-Mozart and Handel Recital] Vyvyan (soprano), Vienna Haydn Orchestra- Newstone.

Mozart: ‹Two Concert Arias, K.272 & K.505›; Haydn: ‹Scena Di Berenice›, Decca SXL 2233 (OS 25231)

[Weathers, Felicia Weathers]

[Spirituals & Zoltan Kodály: Folk Songs]

Felicia Weathers (soprano), Georg Fischer (piano), Karl Scheid (guitar). Decca SXL 6245 (No CS, OS)

[Weller, Walter Weller]

Dukas: ‹Symphony in C›, ‹Sorcerer's Apprentice›, LPO. Decca SXL 6770, London CS 6995

Grieg: ‹Incidental Music From Peer Gynt›, RPO. Decca SXL 6901 (NO London CS), Penguin ✻✻ (✻)

Prokofiev: ‹Symphony No.1 in D Major, Op.25 "Classical"›, ‹Symphony No.7›, LSO. Decca SXL 6702, London CS 6897

Prokofiev: ‹Symphony No.2, Op.40›, ‹The Love of Three Oranges Suite, Op.33a›, LPO. Decca SXL 6945 (No London CS)

Prokofiev: ‹Symphony No.4, Op.47/112›, ‹Russian Overture, Op.72›, LPO. Decca SXL 6908 (No CS) Prokofiev: ‹Symphony No.5 in B Flat Major, Op.100›, Decca SXL 6787 (NO London CS), Penguin ✻✻ (✻)

Prokofiev: ‹Symphony No.6, in E-flat minor, Op.111›, LPO. Decca SXL 6777, London CS 7003

Rachmaninov: ‹Symphony No.1 in D minor, Op.13›, OSR. Decca SXL 6583 (CS 6803), Penguin ✻✻ (✻)

Rachmaninov: ‹Symphony No.2 in E minor, Op.27›, LPO. Decca SXL 6623, London CS 6839

Rachmaninov: ‹Symphony No.3 in A minor Op.44›, ‹"The Rock" Fantasy›, LPO.
Decca SXL 6720 (No CS) , Penguin ✻✻ (✻)

[The Weller Quartet]

Brahms: ‹Quartet No.1 in C Minor, Op.51, no.1› & ‹Quartet No.2 in A Minor, Op.51, no.2›. Decca SXL 6151, London CS 6432

Mozart: ‹String Quartet in D, K.575 "Prussian No.1"›, ‹String Quartet in F, K.590 "Prussian No.3"›. Decca SXL 6258, London CS 6502

[Willcocks, David Willcocks]

Haydn: ‹The Nelson Mass›, Choir of King's College & LSO. London OS 25731 (No Decca SXL)

[Woodword, Roger Woodword]

Takemitsu: ‹Corona (London Version)›, ‹For Away›, ‹Piano Distance›, ‹Undisturbed Rest›,
Roger Woodword (Keyboards). Decca HEAD 4

[Decca – London Records] Index of Equivalent Recordings
[笛卡 - 倫敦唱片] 同樣錄音版本的對照索引

Decca Label & Serial Number DECCA 唱片公司, 編號	London Label & Serial Number LONDON 唱片公司, 編號	Remarks & Ratings 附註和評價	1st Labels & Reference Prices 首版和參考價格
Decca SXL 2000 (©=GOS 551-3; London SRS 63509; LXT 5159-61)	London SRS 63509, =Decca GOS 551-3	Pink-Blue "Pancake" Test Pressing label,	Ultral rare!! $$$$$
Decca SXL 2001* (©=SDD 112, SPA 108)	London CS 6038 (©=STS 15221)	RM17, Penguin ***, AS list , (K. Wilkinson)	ED1, BB, 2E-1E, Rare! $$
Decca SXL 2002* (©=SPA 334)	London CS 6019	RM14, Penguin **(*)	ED1, BB, 3E-3K, $$
Decca SXL 2003 (©=SDD 105)	London CS 6037 (©=STS 15038)	RM14	ED1, BB, 1E-1E, $$
Decca SXL 2004 (©=SDD 138)	London CS 6052 (©=STS 15018)	(K. Wilkinson)	ED1, BB, 6E-3E, Rare!! $$$+
Decca SXL 2005 (©=SDD 128)	London CS 6020 (©=STS 15007)	RM15	ED1, BB, 3E-2E, $$
Decca SXL 2006 (©=SPA 88)	London CS 6010 (©=STS 15015)	RM16, Penguin ***	ED1, BB, 2E-1K, Very rare!! $$$+
Decca SXL 2007 (©=SDD 109, SPA 376)	London CS 6005 (©=STS 15002)	RM14	ED1, BB, 7E-6E, rare! $$
Decca SXL 2008*	London CS 6015	RM15	ED1, BB, 3E-2E, $$
Decca SXL 2009* (©=SDD 115)	London CS 6025 (©=STS 15006)	RM15	ED1, BB, 3E-3E, Very rare!! $$$$
Decca SXL 2010 (©=SPA 403)	London CS 6054	RM12	ED1, BB, 1E-1E, rare! $$$
Decca SXL 2011* (©=SDD 240, ECS 819)	London CS 6009	RM15, TASEC44	ED1, BB, 2E-3E, Very rare!! $$$$$
Decca SXL 2012* (©=SDD 111; SPA 421)	London CS 6049	RM19, TASEC, Penguin **(*)	ED1, BB, 2E-2E, Very rare!! $$$$
Decca SXL 2013 (©=SDD 117)	London CS 6016 (©=STS 15001)	RM14	ED1, BB, 1K-1K, Very rare!! $$$
Decca SXL 2014 (SXL 2208-10)	London OS 25076 (OSA 1303)		ED1, BB, 1E-1E
Decca SXL 2015 (©=ECS 742, part)	London CS 6048	RM12	ED1, BB, 2E-2E, Very rare!! $$$
Decca SXL 2016 (©=SPA 73)	London CS 6014	RM10	ED1, BB, 3E-3E, Very rare! $$$+
Decca SXL 2017* (©=SDD 246, ECS 817)	London CS 6017 (CSA 2308) (©=STS 15139)	RM13, TASEC, Penguin **(*)	ED1, BB, 2E-3E, Rare!! $$$+
Decca SXL 2019 (©=SPA 201)	London CS 6044 (©=STS 15043)	RM13	ED1, BB, 2E-2K, Very rare!! $$$+
Decca SXL 2020* (©=SDD 216, ECS 797)	London CS 6006	RM19, TASEC, Penguin ***, AS list (Speakers Corner)	ED1, BB, 5E-4E, Very rare!! $$$$

Decca Label & Serial Number DECCA 唱片公司, 編號	London Label & Serial Number LONDON 唱片公司, 編號	Remarks & Ratings 附註和評價	1st Labels & Reference Prices 首版和參考價格
Decca SXL 2021* (©=SDD 139, SPA 203)	London CS 6058 (©=STS 15051)	RM14, Penguin ***	ED1, BB, 3E-3E, Rare! $$
Decca SXL 2022-3 (©=SDD 113-4)	London OSA 1205	Penguin **(*), (K. Wilkinson)	ED1, BB, 1E-1E-2E-1E, Very rare! $$$
Decca SXL 2024 (©=SDD 177, ECS 769)	London CS 6041 (CSA 2305, ©=STS 15039)	RM14, Penguin **(*)	ED1, BB, 1E-1K, Rare! $$
Decca SXL 2025 (©=SDD 195, ECS 770)	London CS 6042 (CSA 2305, ©=STS 15050)	RM14, Penguin **(*)	ED1, BB,1E-1E, Rare! $$
Decca SXL 2026 (©=SDD 110, ECS 775)	London CS 6047 (©=STS 15015)	RM14, Penguin **, (K. Wilkinson)	ED1, BB, 1E-1E, Very rare!! $$$
Decca SXL 2027 (©=SDD 375)	London CS 6043 (©=STS 15022)	RM19	ED1, BB, 1E-1E, Very rare! $$$+
Decca SXL 2028* (©=SDD 230)	London CS 6051	RM16, Penguin ***	ED1, BB, 2E-3E, rare! $$
Decca SXL 2029 (©=SPA 183)	London CS 6011 (©=STS 15263)	RM16, Penguin ***	ED1, BB, 1E-1E, Very rare!! $$$$
Decca SXL 2030* (©=SDD 248, ECS 794)	London OS 25005	Penguin ***✕	ED1, 1K-1K, Very rare!! $$$
Decca SXL 2031-2 (©=GOS 577-8)	London OSA 1203	Penguin ***	ED1, 1E-3K-1E-1E, rare! $$
Decca SXL 2034 (©=SDD 188)	London CS 6055	RM12	ED1, BB, 1K-2K, $$
Decca SXL 2035 (©=SDD 237) (SXL 2087-90)	London OS 25045 (OSA 1402)	Penguin **(*), G.Top 100	ED1, 1K-2K, $
Decca SXL 2037* (©=SDD 141, ECS 755)	London CS 6062 (©=STS 15052)	RM17	ED1, BB, 3E-2E, Very rare!! $$$
Decca SXL 2039-41 (©=GOS 594-6)	London OSA 1306	Penguin *** & **(*)	ED1, 3G-3G-3G-3G-3G-3G (early Grey Box with Blue Spine) $$$
Decca SXL 2042 (©=ECS 818)	London CS 6031 (CSA 2308)	RM13, TASEC	ED1, BB, 1K-3K, $$$
Decca SXL 2043 (©=SDD 287)	London OS 25020		ED1, BB, 5K-4E, $$
Decca SXL 2044 (©=SDD 221, ECS 809)	London CS 6026 (©=STS 15594)	RM15, TAS 13-91+	ED1, BB, 1E-1E, $$$
Decca SXL 2045* (©=SDD 153; SPA 467)	London CS 6061 (©=STS 15140)	RM18, Penguin ***✕, AS list-F, (K. Wilkinson)	ED1, BB, 1E-1E, Rare!! $$+
Decca SXL 2046 (©=SDD 205)	London CS 6066 (©=STS 15141)	RM15	ED1, BB, 4E-2E, $$
Decca SXL 2047 (©=SDD 133)	London CS 6007 (©=STS 15012)	RM15	ED1, BB, 2E-1K, rare! $$
Decca SXL 2048* (©=SDD 308, 391; SPA 535)	London OS 25075	Penguin **(*)	ED1, BB, 2E-2E, $$
Decca SXL 2049 (©=SDD 207)	London OS 25038		ED1, BB, 3K-1E, $$

Decca Label & Serial Number DECCA 唱片公司, 編號	London Label & Serial Number LONDON 唱片公司, 編號	Remarks & Ratings 附註和評價	1st Labels & Reference Prices 首版和參考價格
Decca SXL 2050-3 (©=GOS 571-3)	London OSA 1404	Penguin ***	ED1, 2-3E-2E-1K-2-1E-1-1K (Plastic, Red & Blue Wallet), rare!! $$$ - $$$$
Decca SXL 2054-6 (=Decca D4D 3)	London OSA 1314 (=OSA 1406, 4LP-SET)	Penguin **(*)	ED1, BB, $$$
Decca SXL 2057	No London CS		ED1, 2F-2F, $+
Decca SXL 2058 (©=SDD 208)	London OS 25047 (OSA 1312)		ED1, 1K-1K, Rare!! $$
Decca SXL 2059 (©=SDD 118)	London CS 6004	RM14	ED1, BB, 4E-3E, $$$
Decca SXL 2060* (©=SDD 159, SPA 451)	London CS 6001 (©=STS 15084)	RM19, Penguin **(*), TAS 38-137+, AS list , (K. Wilkinson)	ED1, BB, 6D-5E, Very rare!! $$$$
Decca SXL 2061 (German & Spain pressing only, UK Decca ©=SDD 214)	London CS 6024 (©=STS 15109)	RM16	GD1, (Black-Gold label, $$$, Blak-Silver, $$)
Decca SXL 2062* (©=SDD 374, ECS 815, 816; DPA 619)	London CS 6023	RM18	ED1, BB, 2E-2E, $$$
Decca SXL 2064-5* (©=SDD 161-2)	London CSA 2202 (=CS 6056-7, ©=STS 15096-7)	RM10	ED1, BB, 2K-2K-3K-2K, Very rare!!! $$$$$+
Decca SXL 2067 (©=SDD 121)	London CS 6065 (©=STS 15008)	RM14	ED1, BB, 3E-4E, $$
Decca SXL 2068 (©=SDD 143, 426)	London OS 25044		ED1, BB, 2E-3E, rare!!
Decca SXL 2069-72 (©=GOS 597-9)	London OSA 1405	Penguin **(*)	ED1,BB, Raer! $$$
Decca SXL 2074-5 (©=GOS 581-2)	London OSA 1204	Penguin ***	ED1, BB, 5E-1K-1E-4K, Very rare!! $$$$$
Decca SXL 2076* (©=SDD 181; SPA 505)	London CS 6064 (©=STS 15086)	RM14, Penguin **(*), TAS-SM86+, (K. Wilkinson)	ED1, BB, 4E-2E, $$
Decca SXL 2077* (©=SDD 276, SPA 398)	London CS 6067 (©=STS 15054)	RM15, Penguin **(*)	ED1, 2E-1K (Blue Text Sleeve), Very rare!!! $$$$
Decca SXL 2078-80	London OSA 1308		ED1, 1E-2E-1E-2E-2E-3D (Box), Very rare!! $$$
Decca SXL 2081 (©=SDD 140; ECS 768)	London CS 6040 (CSA 2305, ©=STS 15029)	RM14, Penguin **	ED1, BB, 4K-4E, Rare! $$
Decca SXL 2082	London CS 6008 (©=STS 15596)	RM17	ED1, BB, 1E-1E, $+
Decca SXL 2083 (©=SPA 313)	London OS 25065	Penguin ***	ED1, BB, 2E-1E, Very rare! $$$
Decca SXL 2084-5 (©=SDD 371-2, DPA 581-2)	London CSA 2201 (=CS 6002-3)	RM15, Penguin **(*), Japan 300	ED1, (Gatefold,1-1K-3E-5K, $$$$)Very rare!! (Box,1K-3E-5K-1K, $$+)
Decca SXL 2086 (©=SDD 151)	London CS 6018 (©=STS 15126)	RM15	ED1, BB, 1D-1D, $$$+

Decca Label & Serial Number DECCA 唱片公司, 編號	London Label & Serial Number LONDON 唱片公司, 編號	Remarks & Ratings 附註和評價	1st Labels & Reference Prices 首版和參考價格
Decca SXL 2087-90 (©=GOS 585-7)	London OSA 1402	Penguin ***☆, G.Top 100	ED1, 5E-4F-4F-3E-3F- 2K-4F-4K, Very rare!!! $$$$$+
Decca SXL 2091* (©=SDD 446, part; SPA 233)	London CS 6046 (©=STS 15199)	RM18, TASEC65, Penguin **(*), Japan 300	ED1, BB, 2E-3E, Very rare!! $$$+ (ED2, 3E-5E, $$)
Decca SXL 2092-3* (©=SDD 378-9, DPA 569-70)	London CSA 2203 (=CS 6068 & CS 6069, ©=STS 15433)	RM19, Penguin ***	ED1, Gatefold, 1E-1E-1E-1K, rare! $$$
Decca SXL 2094-96 (©=GOS 591-3)	London OSA 1307	Penguin **(*)	ED1, Red box, 1E-1E-1K-1E-1E-1E, Very rare!! $$$
Decca SXL 2097 (©=SDD 124, SPA 318)	London CS 6033	RM14, Penguin ***	ED1, BB, 3K-2E, Rare! $$
Decca SXL 2098 (©=SDD 174; ECS 828)	London CS 6027 (©=STS 15085)	RM11	ED1, 2E-1K, Rare! $$
Decca SXL 2100	No London CS		ED1, BB, 1K-1K, Ultra rare!!! $$$$$
Decca SXL 2101-3 (SET 382-4)	London OSA 1309	TASEC, AS list-H	ED1, (Early Grey Box) $$$
Decca SXL 2104 (©=SDD 119)	London CS 6022 (©=STS 15003)	RM12	ED1, BB, 4E-1E, Rare! $$
Decca SXL 2105	London CS 6077 (©=STS 15057)	RM13, (K. Wilkinson)	ED1, BB, 1D-1D, $$$
Decca SXL 2106 (©=SDD 226)	London CS 6096 (©=STS 15111)	Penguin **(*)	ED1, BB, 1E-2E, Rare!! $$
Decca SXL 2107-8* (©=SDD 354-5, DPA 603-4)	London CSA 2204 (=CS 6075-6)	RM18, Penguin **(*)	ED1, 1E-2D-1E-2E, Very rare!! $$$$
Decca SXL 2109 (©=SDD 142)	London CS 6095 (©=STS 15017)	RM13	ED1, BB, 2D-1E, rare!! $$$
Decca SXL 2110* (©=SDD 185)	London CS 6090	RM18, Penguin ***, AS list-F	ED1, BB, 2D-2E, Rare!! $$$
Decca SXL 2111 (©=SDD 390)	London OS 25081		ED1, BB, 1E-1E, Rare! $$$
Decca SXL 2112 (©=ECS 645)	London CS 6074 (©=STS 15056)	RM14	ED1, BB, 2E-3D, Very rare! $$$
Decca SXL 2113* (©=SDD 281)	London CS 6036	RM16, Penguin ***	ED1, BB, 1K-2K, Very rare!! $$$$
Decca SXL 2114* (©=SDD 191)	London CS 6100 (©=STS 15471)	Penguin **(*)	ED1, BB, 2E-1D, Rare! $$
Decca SXL 2115 (©=SDD 470)	London CSA 2302, [CSA 2302-1=CS 6103]	RM14, Penguin **(*)	ED1, BB, 1E-1E, Rare!! $$ (Last BB in this series)
Decca SXL 2116 (©=SDD 104; ECS 671)	London CS 6070 (©=STS 15055)	RM15	ED1, 1E-3E, $$+
Decca SXL 2117-20 (©=GOS 604-6)	London OSA 1401	Penguin ***	ED1, 3E-2E-3D-1K, Very rare!!! $$$$
Decca SXL 2121	London CS 6093 (=CS 6777)	RM13	ED1, 3K-2K, $+
Decca SXL 2122	London OS 25021		ED1, 3E-5E, rare! $

Decca Label & Serial Number DECCA 唱片公司, 編號	London Label & Serial Number LONDON 唱片公司, 編號	Remarks & Ratings 附註和評價	1st Labels & Reference Prices 首版和參考價格
Decca SXL 2123	London OS 25139		ED1, 2D-2D, (Pancake), Very rare! $$+
Decca SXL 2124	London CS 6092	RM14	ED1, 1K-1K, rare!! $$
Decca SXL 2125 (5BB 130-1, ©=SDD 186)	London CSA 2301, (3-1 =CS 6071 ©=STS 15366-7)	RM16	ED1, 1E-2E, $$
Decca SXL 2126 (5BB 130-1, ©=SDD 187)	London CSA 2301, (3-2 =CS 6072 ©=STS 15366-7)	RM16	ED1, 1E-1E, $$
Decca SXL 2127 (5BB 130-1, ©=SDD 188)	London CSA 2301, (3-3 =CS 6073 (©=STS 15366-7)	RM16	ED1, 1E-1E, $$
Decca SXL 2128* (©=SDD 125, SPA 384)	London CS 6098 (©=STS 15010)	RM16, TAS 61-127++, Penguin *** (SPA 384), AS List-H, (K. Wilkinson)	ED1, 1E-1E, rare! $$+
Decca SXL 2129-31 (©=GOS 614-6)	London OSA 1304		ED1, 1E-1E-1E-1K-2E-3E, Very rare!! $$+
Decca SXL 2132 (©=SDD 224)	London OS 25106	Penguin ***, (K. Wilkinson)	ED1, 1E-1E, $$
Decca SXL 2133 (SXL 2022-3)	London OS 25077 (OSA 1205)	Penguin **(*), (K. Wilkinson)	ED1, 1K-1K, Pancake, $
Decca SXL 2134 (©=SDD 217)	London CS 6101 (©=STS 15031)	RM15, (K. Wilkinson)	ED1, 1K-1K, Very rare!! $$$
Decca SXL 2135 (©=SDD 122, 331, part)	London CS 6107 (©=STS 15087)	RM14, (K. Wilkinson)	ED1, 1E-1E, (2M-3M), Very rare!!! $$$+ - $$$$
Decca SXL 2136* (©=SDD 293, 373)	London CS 6079 (©=STS 15042)	RM20, Penguin ***	ED1, 1E-3E, Very rare!! $$$$
Decca SXL 2141* (©=ECS 642)	London CS 6116 (©=STS 15108)	RM13, Penguin **(*)	ED1, 1M-1M, Very rare!!! $$$
Decca SXL 2145 (©=SDD 209)	London OS 25103		ED1, 1E-1E, Very rare!! $$$
Decca SXL 2150-2	London OSA 1305	TAS2016, Penguin ***✲, G.Top 100, (K. Wilkinson)	ED1, pancake, rare!! (ED1, Box SET, 9L-6E-8L-11L-5E-8L, $$)
Decca SXL 2153 (SXL 2107-8, ©=SDD 257)	London CS 6127 (CSA 2204, ©=STS 15598)	RM18, Penguin **(*)	ED1, 2E-1E, $$+
Decca SXL 2154 (©=SDD 175)	London CS 6129 (©=STS 15083)	RM12, Penguin **(*)	ED1, 3E-2E, (3D-1K), Very rare!!! $$$
Decca SXL 2155* (©=ECS 670)	London CS 6134	RM12	ED1, 2E-2D, Very rare!! $$$$$
Decca SXL 2156 (©=SDD 130)	London CS 6131 (©=STS 15061)	RM12	ED1, 3E-1E, $$
Decca SXL 2157 (©=SDD 200)	London CS 6132 (©=STS 15361)	RM18, Penguin ***	ED1, 1E-3M, Rare! $$
Decca SXL 2158 (©=SDD 256)	London CS 6063 (©=STS 15053)	RM16, Penguin ***	ED1,1D-1E, Rare! $$
Decca SXL 2159 (©=SDD 146, JB 97)	London OS 25111	Penguin ***✲, (K. Wilkinson)	ED1, 2E-2E
Decca SXL 2160-2* (©=SDD 301-3)	London CSA 2304 (=CS 6135-7)	RM14, Penguin **(*), Japan 300	ED1, 1E-2E-1E-1E-1E-1E, Very rare!! $$$

Decca Label & Serial Number DECCA 唱片公司, 編號	London Label & Serial Number LONDON 唱片公司, 編號	Remarks & Ratings 附註和評價	1st Labels & Reference Prices 首版和參考價格
Decca SXL 2163 (©=SDD 474)	London CS 6149 (©=STS 15268)	RM14, Penguin ***	ED1, 1E-2E, $
Decca SXL 2164* (©=SDD 170)	London CS 6147 (©=STS 15090)	RM19, Penguin ***✲, G.Top 100, AS list-F	ED1, 2K-2K, $$
Decca SXL 2165 (©=SDD 103)	London CS 6145 (=CS 6778)	RM12	ED1, 3E-3D, $+
Decca SXL 2166 (©=SDD 131)	London CS 6150 (©=STS 15016)	(K. Wilkinson)	ED1, 1E-1E, rare!! $$$+
Decca SXL 2167-9	London OSA 1313	TASEC44, Penguin ***, AS list-H, Japan 300-CD	ED1, $$
Decca SXL 2170-1 (=Decca D5D 2)	London OSA 1208	Penguin **(*)	ED1, $$$
Decca SXL 2172 (©=SDD 137, SPA 385)	London CS 6151	RM14, (K. Wilkinson)	ED1, 1D-2D, $$
Decca SXL 2173*	London CS 6157 (©=STS 15407)	RM16, Penguin ***, AS-DG list (Speakers Corner)	ED1, 4D-2D, $
Decca SXL 2174* (©=SDD 194; SPA 374)	London CS 6146 (reissue=CS 6779)	RM16, Penguin **(*), AS list (Speakers Corner)	ED1, 1E-2E, $+
Decca SXL 2175 (SXL 2078-80)	London OS 25193 (OSA 1308)		ED1, 2S-2S
Decca SXL 2176 (©=SDD 428; SPA 505)	London CS 6153 (©=STS 15046)	RM15, Penguin ***, R2D4, (K. Wilkinson)	ED1, 2G-2G, $$
Decca SXL 2177 (©=SDD 452)	London CS 6154 (©=STS 15362)	RM16, Penguin **(*)	ED1, 2E-2E, $+
Decca SXL 2178	(=London CS 6099 & 6188, ©=SPA 401)	RM15 & 16, Penguin **(*)	ED1, 1E-1E, $$
Decca SXL 2179 (©=SPA 452)	London CS 6156	Penguin ***	ED1, 2E-2E, $$
Decca SXL 2180-1	London OSA 1210		ED1, 2E-2E-2E-2E, rare!! $$+-$$$
Decca SXL 2182	London CS 6089 (=STS 15030)	RM16, AS list-H (STS 15030)	ED1, 1D-2E, Very rare! $$$+
Decca SXL 2183	London CS 6106 (©=STS 15123)	RM16	ED1, 5E-2E, Very rare! $$
Decca SXL 2184	London OS 25138	Penguin **(*)	ED1, 1E-1E, rare! $$
Decca SXL 2185-6 (Part of SXL 2253-5)	London OSA 1212 (Part of OSA 1330)	Japan 300	ED1, 1E-1E-1E-1E, $$$ (Wallet or Box Set)
Decca SXL 2187 (©=SDD 471)	London CSA 2302, [CSA 2302-1=CS 6104]	RM14, Penguin **(*)	ED1, 1D-1D
Decca SXL 2188 (©=SDD 136, ECS 776)	London CS 6138 (©=STS 15011)	RM16, Penguin ***, (K. Wilkinson)	ED1, 2E-2E, Very rare!! $$$
Decca SXL 2189	London CS 6179	RM19, Penguin ***, TAS2016, AS List-H	ED1, 1E-1E, $$
Decca SXL 2190 (©=SPA 402)	London CS 6094	RM14, Penguin **(*)	ED1, 1E-1E, $$+

Decca Label & Serial Number DECCA 唱片公司, 編號	London Label & Serial Number LONDON 唱片公司, 編號	Remarks & Ratings 附註和評價	1st Labels & Reference Prices 首版和參考價格
Decca SXL 2191 (©=SDD 360)	London OS 25896		ED1, 1E-1E, Rare! $
Decca SXL 2192 (SXL 2094-6)	London OS 25083 (OSA 1307)		ED1, 1K-1K, $+
Decca SXL 2193 (©=SDD 106)	London CS 6160 (©=STS 15064)	RM13	ED1, 1E-1E, $+
Decca SXL 2194 (©=ECS 803)	London CS 6163	RM16, Penguin ***	ED1, 2E-2E, Very rare!!! $$$ - $$$$
Decca SXL 2195 (©=SPA 229)	London CS 6177	RM13	ED1, 1E-1E, $$$
Decca SXL 2196* (©=SDD 171; ECS 740; SPA 550)	London CS 6133 (©=STS 15088)	RM19, Penguin ***, (K. Wilkinson)	ED1, 1E-2E, $$$
Decca SXL 2197* (©=SDD 420; ECS 808; DPA 629)	London CS 6165	RM16, AS list-H	ED1, 2E-1E, Very rare & expensive !!! $$$$$
Decca SXL 2198* (©=DPA 549-50, part)	London CS 6182	RM18, Penguin ***	ED1, 1E-1E, $
Decca SXL 2199	No London CS		ED1, 2E-2E, Rare!! $$
Decca SXL 2200	London OS 25155	Penguin ***	ED1, 2E-2E, Rare! $
Decca SXL 2201 (©=SDD 472)	London CSA 2302, [CSA 2302-1=CS 6105]	RM14, Penguin **(*)	ED1, 1D-1D
Decca SXL 2202 (SXL 2054-6)	London OS 25084 (OSA 1314)		ED1,1E-1D
Decca SXL 2204* (©=SDD 310)	London CS 6142 (©=STS 15063)	RM15, Penguin **(*)	ED1, 1E-1E, rare! $$+
Decca SXL 2205 (©=Decca 16.41387, Germany)	No London CS (=London STS 15065)		ED1, 1M-2M, Very rare!! $$$$+
Decca SXL 2206 (©=SDD 120)	London CS 6170 (©=STS 15004)	RM13	ED1, 1E-1E, $$
Decca SXL 2207 (©=SDD 199; ECS 644)	London CS 6078 (©=STS 15216)	RM16, Penguin **(*), (K. Wilkinson)	ED1, 1D-1D, Rare! $$
Decca SXL 2208-10 (©=GOS 600-1)	London OSA 1303	Penguin ***	ED1, 1E-2K-2K-3E-1E- 2E, (Box Set & Wallet), rare! $$ - $$$
Decca SXL 2211 (©=SDD 154)	No London CS		ED1, 1M-1M, $$
Decca SXL 2212* (©=SDD 168)	No London CS	Penguin **(*), AS List (Speakers Corner)	ED1, 1D-1D, Very rare!! $$$+
Decca SXL 2213	London OS 25122		ED1, 3M-4M, rare!! $$+
Decca SXL 2214 (©=SDD 116)	London CS 6141 (©=STS 15062)	RM10, Penguin **(*), Japan 300	ED1, 1D-2D, Very rare!! $$$$+
Decca SXL 2215-7 (©=GOS 501-3; SDD 218)	No London CS, (©=London SRS 63507)	Penguin **	ED1, 1E-1E & 1E-2E, Very rare!!! (Red,White, plastic wallet & Box set) $$$$$
Decca SXL 2218*	London CS 6187	RM18, *AS List (Speakers Corner), (K. Wilkinson)	ED1, 3M-3E, Very rare! $$

Decca Label & Serial Number DECCA 唱片公司, 編號	London Label & Serial Number LONDON 唱片公司, 編號	Remarks & Ratings 附註和評價	1st Labels & Reference Prices 首版和參考價格
Decca SXL 2219 (©=SDD 258)	London CS 6172 (part) & CS 6173 (part)	RM14	ED1, 1E-2E, $$$
Decca SXL 2220 (©=SDD 178)	London CS 6081 (©=STS 15058)		ED1, 2E-2D, Rare!!! $$+
Decca SXL 2221* (©=SDD 282)	London CS 6012	RM16, Penguin ***	ED1, 1E-1E, Very rare!! $$$+
Decca SXL 2222 (©=ECS 691)	London CS 6021 (©=STS 15047)	RM13, Penguin **(*)	ED1, 10E-2E, Very rare!! $$$$
Decca SXL 2223 (©=SDD 157, ECS 758)	No London CS (=STS 15019)		ED1, 1M-1M, $$+
Decca SXL 2224 (©=SDD 215; ECS 780)	London OS 25039		ED1, 1K-1E, $$
Decca SXL 2225-7	London OSA 1302		ED1, 1E-1K-2E-3 K-1E-3 F, Very rare!!! $$$$$
Decca SXL 2228 (©=SDD 102; ECS 739)	London CS 6184 (©=STS 15068)	RM14	ED1, 1E-1E, rare!! $$$+
Decca SXL 2229	London CS 6186	RM13	ED1, 1E-1E, $$$
Decca SXL 2230 (SET 382-4 & SXL 2031-2)	London OS 25126 (OSA 1309 & 1203)	Penguin ***	ED1, 2E-2E
Decca SXL 2231	London CS 6174 (©=STS 15152)	RM15	ED1, 1M-1M, $$$
Decca SXL 2232*	London CS 6196	RM18, (K. Wilkinson)	ED1, 3E-1E, $$
Decca SXL 2233 (©=ECS 635)	London OS 25231	Penguin ***	ED1, 2E-3E, Very rare!! $$
Decca SXL 2234 (©=SDD 286)	No London CS	Penguin ***, (K. Wilkinson)	ED1, 1E-1E, $$
Decca SXL 2235 (©=SDD 107, SPA 237)	London CS 6183 (©=STS 15067)	RM12	ED1, 1E-1E, $$
Decca SXL 2236 (©=SDD 223; SPA 458)	London CS 6195	RM14, (K. Wilkinson)	ED1, 2E-1E, $$+
Decca SXL 2237* (©=SDD 239; ECS 820, 821)	London CS 6190	RM14	ED1, 1E-2E, &&
Decca SXL 2238* (©=SDD 331, part)	London CS 6178 (©=STS 15597)	RM19, Penguin ***, (Wilkinson)	ED1, 2E-1E, &&
Decca SXL 2239	London CS 6192 (©=STS 15045)		ED1, 2E-1E, Very rare!! $$$$
Decca SXL 2240	London CS 6193 (©=STS 15153)	RM15	ED1, 1E-1E, Very rare!! $$$$
Decca SXL 2241	London CS 6161	Penguin **(*), Japan 300	ED1, 1E-1E, $$$
Decca SXL 2242 (SXL 2167-9)	London OS 25206 (OSA 1313)	TASEC44, Penguin ***, AS list, Japan 300-CD	ED1, 3L-1E, $
Decca SXL 2243* (©=SDD 180)	London CS 6194	RM16, Penguin **(*), AS-DG list (Speakers Corner Reissue)	ED1, 3E-2E, Very rare!! $$$$

Decca Label & Serial Number DECCA 唱片公司, 編號	London Label & Serial Number LONDON 唱片公司, 編號	Remarks & Ratings 附註和評價	1st Labels & Reference Prices 首版和參考價格
Decca SXL 2244	London CS 6189 (©=STS 15069)		ED1, 2E-1E, Very rare!! $$$
Decca SXL 2245	London CS 6213 (©=STS 15094)		ED1, 1E-1E, $$+
Decca SXL 2246* (©=SDD 145, SPA 503)	London CS 6191 (©=STS 15091)	RM20, Penguin ***, G.Top 100, TAS 44-178, (K. Wilkinson)	ED1, 3D-3E, (1E-1E), Very rare!!! $$$-$$$$
Decca SXL 2247	London OS 25219	(K. Wilkinson)	ED1, 1E-1E, $
Decca SXL 2248 (SXL 2170-1)	London OS 25201 (OSA 1208)	Penguin **(*)	ED1, 1E-1E
Decca SXL 2249* (©=SDD 123, SPA 377)	London CS 6198 (©=STS 15009)	RM17, Penguin **(*)	ED1, 1E-3E, Very rare!! $$$ - $$$$
Decca SXL 2250 (©=SDD 127, SPA 406, part)	London CS 6199 (©=STS 15070)	RM14, Penguin **(*)	ED1, 1E-1E, $$
Decca SXL 2251 (©=SDD 193)	London OS 25225	Penguin ***	ED1, 2L-2L, $$
Decca SXL 2252* (©=SDD 144, ECS 782, 801)	London CS 6200	RM16, TAS SM 67- 138++, Penguin ***, AS list (Speakers Corner), (K. Wilkinson)	ED1, 1E-1E, Very rare!! $$$+
Decca SXL 2253-5 (©=GOS 588-10; SDD 418, part)	London OSA 1330 (=OSA 1212+1213)	Japan 300-CD	ED1, 2E-1E-1E-2E-1E- 1E, $$$
Decca SXL 2256*	London OS 25232 (OSA 1214)	Penguin ***, G.Top 100, (K. Wilkinson)	ED1, 1E-1E
Decca SXL 2256-57*	London OSA 1214	Penguin ***, G.Top 100, (K. Wilkinson)	ED1, BB, 1E-1E-1E-1E, $$
Decca SXL 2257*	London OS 25233 (OSA 1214)	Penguin ***, G.Top 100, (K. Wilkinson)	ED1, 1E-1E
Decca SXL 2258 (SXL 2180-1, ©=SDD 334)	London OS 25218 (OSA 1210)		ED1, 1E-2E
Decca SXL 2259 (©=SDD 272; ECS 788)	London CS 6197 (©=STS 15491)	RM17, Penguin ***	ED1, 2W-1E, $
Decca SXL 2260	London STS 15014 [CS 6028 (part), (No London CS)]	RM20, Penguin ** & Penguin ***	ED1, 1E-1E, Very rare!!!
Decca SXL 2261 (©=SDD 211)	London CS 6211	RM16	ED1, 2E-2E, $$
Decca SXL 2262	London CS 6203	(K. Wilkinson)	ED1, 1E-1E, $$
Decca SXL 2263 (©=SDD 192, ECS 827)	London CS 6205	RM16	ED1, 1E-1E, Very rare!! $$$
Decca SXL 2264 (©=Jubilee 410 171)	London OS 25242	Penguin ***, AS List-H (Jubilee 410 171), (K. Wilkinson)	ED1, 2E-2E, $
Decca SXL 2265* (©=SDD 411)	London CS 6206 (©=STS 15441)	RM16, Penguin ***, Japan 300	ED1, 1E-1E, rare! $$$
Decca SXL 2266*	London CS 6204	RM14, Penguin ***, AS List (Speakers Corner)	ED1, 2E-1E, rare! $$+
Decca SXL 2267 (SXL 2039-41, ©=SDD 333)	London OS 25196 (OSA 1306)	Penguin ***	ED1

Decca Label & Serial Number DECCA 唱片公司, 編號	London Label & Serial Number LONDON 唱片公司, 編號	Remarks & Ratings 附註和評價	1st Labels & Reference Prices 首版和參考價格
Decca SXL 2268 (©=SDD 496, SDD 151; ECS 735)	London CS 6212	RM15, Penguin **(*)	ED1, 1D-1D, $$
Decca SXL 2269 (©=SPA 119)	London CS 6209	RM15, Penguin ***	ED1, 1E-1E, $$+
Decca SXL 2270* (©=ECS 686)	London CS 6207	RM17	ED1, 1L-1L, Very rare! $$$
Decca SXL 2271	London OS 25244		ED1, 1E-2E, Very rare!! $$$
Decca SXL 2272 (©=SDD 198)	London CS 6214	RM13	ED1, 4E-1E, rare! $$
Decca SXL 2273	London CS 6210 (©=STS 15092)	RM12	ED1, 1L-2L, Very rare!! $$$
Decca SXL 2274 (©=SDD 108, SPA 328)	London CS 6143 (©=STS 15089)	RM14, Penguin ***	ED1, 1E-1E, $$
Decca SXL 2275 (©=SDD 231, ECS 801)	London CS 6208	RM16, Penguin **(*)	ED1, 2E-1L, $$$
Decca SXL 2276	London CS 6217 (=CS 6781)	RM14, Penguin **, (K. Wilkinson)	ED1, 1E-1E, $$
Decca SXL 2277 (©=SDD 238; ECS 820)	London CS 6219	RM12	ED1, 2L-1L, $$
Decca SXL 2278 (©=SDD 277)	London CS 6226	RM14, Penguin **(*)	ED1, 5E-4E, rare!! $$
Decca SXL 2279 (©=SDD 126, SPA 398)	London CS 6215		ED1, 1E-2E, Very rare!!! $$$$$
Decca SXL 2280	London CS 6216 (=CS 6780)	RM16, (K. Wilkinson)	ED1, 2E-2E, $$
Decca SXL 2281-2 (Part of SXL 2253-5)	London OSA 1213 (Part of OSA 1330)		ED1, 2E-3E-1E-1E, $$$
Decca SXL 2283	London CS 6430, (ED2 1st)		Swedish ED only, Rare! $
Decca SXL 2284	London CS 6230		ED1, 1D-1D, Very rare !! $$$
Decca SXL 2285	London CS 6218	RM17, Penguin ***, (Wilkinson)	ED1, 2E-2E, $$+
Decca SXL 2286 (©=SDD 291)	London CS 6231	RM16, Penguin ***	ED1, 1D-1D, $$+
Decca SXL 2287 (©=SDD 239, 425 & 425)	London CS 6225	RM13, Penguin **(*)	ED1, 2E-2D, $$+
Decca SXL 2288 (©=SDD 473)	London CS 6232		ED1, 6T-5T, $$
Decca SXL 2289* (©=SPA 87)	London CS 6228 (©=STS 15101)	RM17, Penguin ***, AS List-F (Speakers Corner)	ED1, 2E-1E, Very rare!!! $$$$$
Decca SXL 2290 (©=SDD 251)	No London CS (©=STS 15304)	Penguin ***, Japan 300	ED1, 2E-1E, Rare! $$$
Decca SXL 2291 (©=SDD 320)	London CS 6222		ED1, 2L-2L, $$+

Decca Label & Serial Number DECCA 唱片公司, 編號	London Label & Serial Number LONDON 唱片公司, 編號	Remarks & Ratings 附註和評價	1st Labels & Reference Prices 首版和參考價格
Decca SXL 2292* (©=SDD 399, part)	London CS 6223	RM13, Penguin**(*)	ED1, 1E-1E, Very rare!! $$$
Decca SXL 2293 (©=SPA 110)	London CS 6235 (©=STS 15115)	(K. Wilkinson)	ED1, 6W-1E, $$
Decca SXL 2294 (©=JB 38)	London OS 25280	Penguin **(*), R2D4	ED1, 1E-1E, $$
Decca SXL 2295	London OS 25281		ED1, 1D-1D, Rare!, $$$
Decca SXL 2296* (©=SDD 321)	London CS 6224	RM19, Penguin **(*), TAS2017 (45rpm), AS list-F (Speakers Corner), Japan 300	ED1, 3E-1E, Very rare!!! $$$$$
Decca SXL 2297 (©=SDD 249)	London CS 6234	RM16, Penguin **(*) & ***	ED1, 1D-1D, $$
Decca SXL 2298*	London CS 6237	RM16, Penguin ***	ED1, 1E-1E, $$$$
Decca SXL 2299	London OS 25312	(K. Wilkinson)	ED1, 2E-2E, Very rare!! $$$
Decca SXL 2300-1 (©=SDD 386-7, DPA 589-90)	London CSA 2206		ED1, 1E-1E-1E-1E, $$$
Decca SXL 2302* (©=SDD 169, SPA 120)	London CS 6236	RM19, Penguin ***, (K. Wilkinson)	ED1, 1E-1E, Very rare!! $$$
Decca SXL 2303 (©=SDD 388)	London CS 6227	RM16, Penguin ***	ED1, 6E-4E, $$
Decca SXL 2304 (©=SDD 222)	London OS 25316		ED1, 1E-1E, $$
Decca SXL 2305 (©=SDD 400)	London CS 6244	RM15, Penguin ***	ED1, 3E-1E, $$
Decca SXL 2306	London CS 6240		ED2 1st, 5W-3W, Very rare!! $$$
Decca SXL 2306-7 (=London CS 6240 + CS 6242, ©=SPA 226)	London CS 6240 & 6242		ED1, 1E-1E-1D-1D, Very rare!!! $$$$$
Decca SXL 2307	London CS 6242	RM15	ED1, !D-1D, Very rare!! $$$
Decca SXL 2308	London CS 6420, (ED2 1st)	Penguin ***	ED1, 1E-3E, $$
Decca SXL 2309 (SXL 2150-2)	London OS 26004 (OSA 1305)	Penguin ***, (K. Wilkinson)	ED1, 1E-1E
Decca SXL 2310	London OS 25330		ED1, 2D-2D, $$
Decca SXL 2311	London CS 6241	RM18, TAS2016, AS List-H	ED1, 1D-2D, $$$
Decca SXL 2312* (©=SDD 425)	London CS 6248 (©=STS 15356)	RM15, Penguin **(*), (Wilkinson)	ED1, 3D-1D, $$$
Decca SXL 2313*	London CS 6252	RM20, TASEC✲✲, Penguin ***, AS list	ED1, 1E-3E, Very rare!! $$$+ (ED2, 2E-3E, $$)
Decca SXL 2314 (SET 209-11)	London OS 25701 (OSA 1324)	Penguin **(*)	ED1, 5W-4W
Decca SXL 2315 (SET 212-4)	London OS 25702 (OSA 1327)	Gramophone, Grand Prix du Disc, Japan 300, (K. Wilkinson)	ED1, 1G-1G

Decca Label & Serial Number DECCA 唱片公司, 編號	London Label & Serial Number LONDON 唱片公司, 編號	Remarks & Ratings 附註和評價	1st Labels & Reference Prices 首版和參考價格
Decca SXL 2316 (SET 218-20)	London OS 25703 (OSA 1329)	(K. Wilkinson)	ED1, 2G-1G
Decca SXL 6000*	London CS 6322	RM17, TASEC65, Penguin ***, AS list	ED1, 2E-2E, Very rare!! $$$
Decca SXL 6001	London CS 6323	RM18, TASEC65, Penguin **(*), AS list	ED1, 1G-1G, Rare! $$
Decca SXL 6002	London CS 6251		ED1, 3E-4E, $
Decca SXL 6003 (©=SDD 189)	London OS 25320		ED1, 1E-1E, $$
Decca SXL 6004 (©=SDD 129; ECS 754)	London CS 6243 (©=STS 15541)	RM14	ED1, 1E-1E, rare!, $$
Decca SXL 6005 (©=SDD 206)	London OS 25726		ED1, 2W-1E, $
Decca SXL 6006	London CS 6324	RM18, TAS-OLD, Penguin ***, (K. Wilkinson)	ED1, 2E-2E, $
Decca SXL 6007	London OS 25327	Penguin ***	ED1, (ED2, 3W-1E, 15 Usd)
Decca SXL 6008 (SET 224-6)	London OS 25710 (OSA 1332)		ED1, 1W-1W
Decca SXL 6009 (SET 218-20)	London OS 25711 (OSA 1329)	(K. Wilkinson)	ED1, 1G-1G, $
Decca SXL 6010 (SET 218-20)	London OS 25712 (OSA 1329)	(K. Wilkinson)	ED1, 3W-2W, $
Decca SXL 6011 (GOS 607-8)	London OS 25713 (OSA 1317)		ED1, 2E-1G
Decca SXL 6012 (SXL 2185-6; 2253-5; 2281-2)	London OS 25334 (OSA 1330)		ED1, 3E-3E, $
Decca SXL 6013 (SET 215-7)	London OS 25714 (OSA 1328)		ED1, 2G-1G
Decca SXL 6014 (=LXT 6014 & 5016) (No SXL & London CS issue)	No London CS (=Decca LXT 5016 & London LL 1182)		Orange-Silver 1L-1L, rare! $
Decca SXL 6015-6 (=SET 201-3, part)	London OSA 1249 (OSA 1319)	Penguin **(*)	ED1, $
Decca SXL 6017 (SET 221-3)	London OS 25715 (OSA 1331)	(K. Wilkinson)	ED1, 4G-1G
Decca SXL 6018 (©=SDD 179; ECS 767)	London CS 6327	RM15	ED1, 2G-2W, Rare! $$$
Decca SXL 6020 (©=SDD 182)	London CS 6333 (CSA 2306)	RM13	ED1, 2G-1G, $$
Decca SXL 6021 (©=SDD 183)	London CS 6334 (CSA 2306)	RM14	ED1, 1G-3W, $$
Decca SXL 6022 (©=SDD 184)	London CS 6335 (CSA 2306)	RM14	ED1, 1G-1G, $$

Decca Label & Serial Number DECCA 唱片公司, 編號	London Label & Serial Number LONDON 唱片公司, 編號	Remarks & Ratings 附註和評價	1st Labels & Reference Prices 首版和參考價格
Decca SXL 6023*	London CS 6329	RM19, Penguin ***, TAS2016, G.Top 100, (K. Wilkinson)	ED1, 2G-3G, $$
Decca SXL 6024 (©=SPA 202)	London CS 6330	RM16, Penguin ***	ED1, 1G-1G, Rare!, $$
Decca SXL 6025 (©=SDD 421)	London CS 6328	RM14	ED1, 3W-2W, $
Decca SXL 6026* (©=SDD 417)	London CS 6332 (©=STS 15364)	RM17, TAS2016, Penguin ***, (K. Wilkinson)	ED1, 1D-1D, $
Decca SXL 6027 (©=SPA 228, part)	London CS 6331 (©=STS 15154)	RM14, Penguin **(*)	ED1, 1E-1E, Very rare!! $$$
Decca SXL 6028 (©=SDD 422)	London CS 6336	RM14, Penguin **(*)	ED1, $+
Decca SXL 6029	No London CS	Penguin **(*)	ED1, 1E-1E, $
Decca SXL 6030	London OS 25729		ED1,1E-1E, $
Decca SXL 6031 (No UK Decca)	No London CS (DECCA SXL 6031 Black-Gold label)		Black-Gold Label, Ultra rare!!! $$
Decca SXL 6032 (=LXT 6032)	No London CS		ED1, Rare!!
Decca SXL 6033	London OS 25742	(K. Wilkinson)	ED1, 2E-1E, $
Decca SXL 6035* (©=SDD 465)	London CS 6337	RM20, Penguin ***, AS List-H (Speakers Corner)	ED1, 1E-1E, Very rare!! $$$$$, (ED2 1E-1E,$$$$)
Decca SXL 6036* (©=SDD 156; ECS 795)	London CS 6338 (©=STS 15046)	RM18, Penguin ***, TAS2017 (Speakers Corner ADEC 6036)	ED1, Very rare!! $$$
Decca SXL 6037	London OS 25757		ED1, 1E-1E, $
Decca SXL 6038	London OS 25769		ED1, 1G-1G, $
Decca SXL 6039 (©=SDD 462)	London OS 25768	Penguin **(*)	ED1, 1E-1E
Decca SXL 6040	London CS 6340	RM17, Penguin **(*)	ED1, 2E-1E
Decca SXL 6041 (©=SDD 498)	London CS 6341 (©=STS 15272)	Penguin ***	ED1, 1E-1E, $
Decca SXL 6042	London OS 25778		ED1, 2D-1E, $
Decca SXL 6043 (©=SDD 270)	London CS 6357	Penguin ***	ED1, 1E-1E, rare! $$+
Decca SXL 6044*	London CS 6358	TAS2016, Penguin ***, AS List-H (D6D 7), (K. Wilkinson)	ED1, 3G-3G, $
Decca SXL 6045 (©=SDD 176)	London OS 25782	Penguin ***	ED1, 1D-1D, $$
Decca SXL 6046	London OS 25783		ED1, 2W-1D, $$
Decca SXL 6049	London CS 6346	RM16, Penguin ***	ED1, 1E-1E
Decca SXL 6050	London CS 6347	RM16, Penguin ***	ED1, 1E-1E

Decca Label & Serial Number DECCA 唱片公司, 編號	London Label & Serial Number LONDON 唱片公司, 編號	Remarks & Ratings 附註和評價	1st Labels & Reference Prices 首版和參考價格
Decca SXL 6051	London CS 6348	RM16, Penguin ***	ED1, 1E-3W
Decca SXL 6052	London CS 6349	RM16, Penguin ***	ED1, 1E-1E
Decca SXL 6053	London CS 6350	RM16, Penguin ***	ED1, 2E-1E
Decca SXL 6054 (©=SDD 155; SPA 495)	London CS 6351 (©=STS 15071)	Penguin ***, AS list-H (SDD 155)	ED1, 2E-2E, rare! $$
Decca SXL 6055 (©=SDD 290 & 340)	London CS 6352	Penguin **(*)	ED1, 1E-1E, rare! $$
Decca SXL 6056	London CS 6354	Penguin **	ED1, 1E-1E, Very rare!! $$+
Decca SXL 6057	London CS 6359	Penguin **(*)	ED1, 1E-2E, (ED2, 3L-3L, £ 30)
Decca SXL 6058	London CS 6360	Penguin ***	ED1, 3E-3E, $$
Decca SXL 6059 (=London CS 6361, one of CSA 2402)	London CSA 2402 (=Decca SXL 6059, 6060, 6061, 6062)		ED1, 1W-1W, rare! $$+
Decca SXL 6060 (=London CS 6362, one of CSA 2402)	(London CSA 2402)		ED1, 2W-5W, rare! $$$
Decca SXL 6061 (=London CS 6363, one of CSA 2402)	(London CSA 2402)		ED1, 2W-2W, rare! $$
Decca SXL 6062 (=London CS 6364, one of CSA 2402)	(London CSA 2402)		ED1, 3W-3W, rare! $$+
Decca SXL 6063	London CS 6365		ED1, 1E-1E, rare!! $$+
Decca SXL 6064	London CS 6366		ED1, 1E-2E, rare!! $$+
Decca SXL 6065*	London CS 6367	Penguin ***	ED1, 2E-2D, rare!! $$$
Decca SXL 6066 (©=SDD 244)	London CS 6368	TASEC (CSA 2308)	ED1, 3E-2E, rare!! $$
Decca SXL 6067	London CS 6369	Penguin **(*)	ED1, 2E-1E, rare!! $$
Decca SXL 6068	London OS 25798		ED1, 2E-2E, $
Decca SXL 6069	London OS 25797		ED1, rare! $$
Decca SXL 6073 (SET 247-8)	London OS 25776 (OSA 1254)	Penguin ***, (K. Wilkinson)	ED1, 4G-3G
Decca SXL 6073-4 (=SET 247-8)	London OSA 1254, (ED1) (OS 25776, 25777)	Penguin ***, (K. Wilkinson)	ED1, 4G-3G & 1D-1D, $
Decca SXL 6074 (SET 247-8)	London OS 25777 (OSA 1254)	Penguin ***, (K. Wilkinson)	ED1, 1D-1D
Decca SXL 6075 (©=SDD 313)	London OS 25799		ED1, 1G-1G, $$
Decca SXL 6076*	London CS 6371	Penguin ***	ED1, 4E-2E, rare! $$
Decca SXL 6077	London OS 25807, (ED1)	(K. Wilkinson)	ED1, 2E-1E, $
Decca SXL 6078	No London CS		ED1, 2E-1E, Ultral rare!!! $$
Decca SXL 6079 (©=SDD 429)	London OSA 1154, (ED1)		ED1, 1G-1G, $
Decca SXL 6080 (SET 232-4)	London OS 25874 (OSA 1361)		ED1, 1R-1R, $
Decca SXL 6081*	London OS 25821, (ED1)	Penguin ***	ED1, 1E-1E, rare! $$

Decca Label & Serial Number DECCA 唱片公司, 編號	London Label & Serial Number LONDON 唱片公司, 編號	Remarks & Ratings 附註和評價	1st Labels & Reference Prices 首版和參考價格
Decca SXL 6082 (©=SDD 228)	London CS 6374 (©=STS 15212)	Penguin **(*)	ED1, 1E-1E, rare! $$
Decca SXL 6083	London OS 25833		ED1, 1E-1E, $$
Decca SXL 6084	London CS 6375	Penguin ***	ED1, 3G-3G, $
Decca SXL 6085	London CS 6376		ED1, 5F-5F
Decca SXL 6086 (©=SDD 172; ECS 762)	London CS 6378		ED1, 1G-1G, rare! $
Decca SXL 6087 (©=SDD 289, 290)	London CS 6379	Penguin **(*)	ED1, 1G-2G, rare! $$
Decca SXL 6088* (©=SDD 445)	London CS 6377	Penguin **(*), TAS2016	ED1, 1B-1B, rare! $$$
Decca SXL 6089 (SXLJ 6644; D105D 5)	London CS 6381, (ED2 1st)	Penguin ***	ED1, 2G-2G, rare! $$
Decca SXL 6090 (SXLJ 6644; D105D 5)	London CS 6382, (ED2 1st)	Penguin ***	ED1, 1G-1G, rare! $$
Decca SXL 6091 (©=SDD 480)	London CS 6383, (ED2 1st)	Penguin **(*)	ED1, 1E-1E, rare! $$+
Decca SXL 6092 (©=SDD 254)	London CS 6384, (ED2 1st)	Penguin ***	ED1, rare! &&
Decca SXL 6093 (©=SDD 285)	London CS 6385, (ED2 1st)	Penguin ***	ED1, 1W-1W, rare! $$$
Decca SXL 6094	London CS 6386, (ED2 1st)		ED1, rare! $$
Decca SXL 6095	London CS 6387, (ED2 1st)		ED1, 1G-1G, $$
Decca SXL 6096 (©=SDD 101)	London CS 6388, (ED2 1st)		ED1, 1G-1G, rare! $$
Decca SXL 6097	London CS 6389, (ED2 1st)		ED1, 1E-2E, Very rare!! $$$
Decca SXL 6098 (©=DPA 594, part)	London OS 25847, (ED1)	Penguin ***	ED1, 1G-1G, $$
Decca SXL 6099	London CS 6390, (ED2 1st)		ED1, 5W-7W, $$
Decca SXL 6100 (©=SPA 282)	London CS 6391, (ED2 1st)		ED1, 2G-1G, rare! $$
Decca SXL 6101 (©=Jubilee JB 9)	London CS 6392, (ED2 1st)	Penguin ***	ED1, 1E-1E, $
Decca SXL 6102 (©=SDD 318)	London CS 6393, (ED2 1st)	Penguin **(*)	ED1, 1E-1E, $
Decca SXL 6103 (©=SDD 250)	London CS 6394, (ED2 1st) (©=STS 15207)	Penguin ***	ED1, 2E-1E, rare! $$+
Decca SXL 6104 (©=SDD 319)	London CS 6395, (ED2 1st)	Penguin ***	ED1, 1E-1E, $
Decca SXL 6105 (©=SDD 532, SDDA 261-9)	London CS 6396, (ED2 1st)	(K. Wilkinson)	ED1, 3G-2G, $
Decca SXL 6106	London OS 25866	(K. Wilkinson)	ED1, 5G-1G, $
Decca SXL 6107	London OS 25869, (ED1)		ED1, 3E-2E, $
Decca SXL 6108 (©=SDD 364)	London CS 6403, (ED2 1st)	Penguin ***	ED1, 1E-1E, $

Decca Label & Serial Number DECCA 唱片公司, 編號	London Label & Serial Number LONDON 唱片公司, 編號	Remarks & Ratings 附註和評價	1st Labels & Reference Prices 首版和參考價格
Decca SXL 6109 (©=SDD 225)	London CS 6397, (ED2 1st) (©=STS 15210)	Penguin **(*)	ED1, 2E-3E, $
Decca SXL 6110	London CS 6398, (ED2 1st)	Penguin ***, (K. Wilkinson)	ED1, 1E-2E, $
Decca SXL 6111*	London CS 6399, (ED2 1st) (Reissue=CS 6783)	Penguin ***, AS-DG list (Speakers Corner Reissue), TAS 72++	ED1, 4W-1W, $$
Decca SXL 6112 (©=SDD 427)	London CS 6400, (ED2 1st)	(K. Wilkinson)	ED1, 1E-1E, $$
Decca SXL 6113*	London CS 6401, (ED2 1st)	Penguin ***	ED1, 1E-3E, $
Decca SXL 6114	No London CS		ED1, 2E-1E, $
Decca SXL 6115	London CS 6402, (ED2 1st)	Penguin ***, AS List-H (D6D 7), (K. Wilkinson)	ED1, 1E-1E, $
Decca SXL 6116 (©=SDD 213, 574)	London OS 25876, (ED1)	Penguin ***	ED1, 2L-2L
Decca SXL 6118 (©=SDD 533, SDDA 261-9)	London CS 6404, (ED2 1st)	(K. Wilkinson)	ED1, 2L-2L, $
Decca SXL 6119	London CS 6405, (ED2 1st)		ED1, 2E-2L, $$+
Decca SXL 6120 (©=SDD 399, part)	London CS 6406, (ED2 1st)	Penguin**(*)	ED1 ?, ED2, 1L-1L, $$
Decca SXL 6121	London CS 6407, (ED2 1st)		ED1, 1L-1L, $$
Decca SXL 6122 (SET 236-8)	London OSA 1151 (OSA 1364)	AS list (SET 236-8)	ED1, 2E-1E, $
Decca SXL 6123 (SET 236-8)	London OSA 1152 (OSA 1364)	AS list (SET 236-8)	ED1, 4G-4G, $
Decca SXL 6124 (SET 236-8)	London OSA 1153 (OSA 1364)	AS list (SET 236-8)	ED1, 1E-1E, $$
Decca SXL 6125	London CS 6408, (ED2 1st)	Penguin ***	ED1, 1L-1L, $
Decca SXL 6127 (SET 249-51)	London OS 25886, (ED1) (OSA 1366)	Penguin ***	ED1 ?, ED2, 1E-1E
Decca SXL 6128 (SET 239-41)	London OS 25887, (ED1) (OSA 1365)		ED1, 2G-2G
Decca SXL 6129 (©=SDD 534, SDDA 261-9)	London CS 6410, (ED2 1st)	(K. Wilkinson)	ED1, 1E-3W, $
Decca SXL 6130	London CS 6411, (ED2 1st)		ED1, 1E-1E, $
Decca SXL 6131 (D121D 10)	London CS 6412, (ED2 1st)	Penguin ***	ED1, 1W-1W,
Decca SXL 6132 (D121D 10)	London CS 6413, (ED2 1st)	Penguin ***	ED1, 1W-1W
Decca SXL 6133 (D121D 10)	London CS 6414, (ED2 1st)	Penguin **(*)	ED1, 1W-1W
Decca SXL 6134	London CS 6415, (ED2 1st)	Penguin ***	ED1, 3W-2W, $
Decca SXL 6135	London CS 6416, (ED2 1st)	Penguin ***	ED1 ?, ED2, 3W-2W, $
Decca SXL 6136* (©=JB 55)	London CS 6417, (ED2 1st)	Penguin ***, AS-DG list (Speakers Corner Reissue),Japan 300, (K. Wilkinson)	ED1, 1E-2W, $
Decca SXL 6137	London CS 6418, (ED2 1st)	Penguin ***	ED2, 1W-1W, (1st), $
Decca SXL 6138 (©=JB 121, part)	London CS 6419, (ED2 1st)	Penguin ***, AS List (JB 121)	ED1, 2W-1W, $$
Decca SXL 6139	London OS 25893, (ED2)	Penguin **(*)	ED2, 1G-1G

Decca Label & Serial Number DECCA 唱片公司, 編號	London Label & Serial Number LONDON 唱片公司, 編號	Remarks & Ratings 附註和評價	1st Labels & Reference Prices 首版和參考價格
Decca SXL 6140	London OS 25894, (ED2)		ED1 ?, ED2, 1G-1G, $
Decca SXL 6141 (©=SPA 227)	London CS 6345 (©=STS 15524)	RM15	ED1, 1E-1E, rare! $ $
Decca SXL 6142 (SET 242-6)	London OS 25898 (OSA 1508)	Penguin ***	ED2, 1G-1G, (1st)
Decca SXL 6143	London CS 6422, (ED2 1st)	Penguin ***, Japan 300-CD	ED1, 4L-2W, $
Decca SXL 6144	London OS 25899		ED1, 2G-1G
Decca SXL 6146	London OS 25905	Penguin ***	ED1, 1W-1W, $
Decca SXL 6147	London OS 25911		ED1, 4L-4L, $
Decca SXL 6148 (©=SDD 309)	London CS 6431, (ED2 1st) (©=STS 15220)	Penguin **(*)	ED1, 1L-1L, rare!! $$$
Decca SXL 6149	London OS 25910		ED1, 3G-2G
Decca SXL 6150 (©=SDD 325)	London CS 6433, (ED2 1st) (©=STS 15247)	Penguin ***	ED1, 1L-1L, rare!! $$
Decca SXL 6151 (©=SDD 322)	London CS 6432, (ED2 1st) (©=STS 15245)	Penguin ***	ED1, 1L-1L, rare!! $$$
Decca SXL 6152	London OS 25912	Penguin ***✲	ED1, 1G-1G, $
Decca SXL 6153 (©=SDD 385)	London OS 25921		ED1, 1G-1G, $
Decca SXL 6154 (SET 239-41)	London OS 25922 (OSA 1373)		ED2, 2G-2G
Decca SXL 6155 (SXL 6015-6 & SET 201-3)	London OS 25923 (OSA 1249 & OSA 1319)	Penguin ***	ED1, 1G-1G
Decca SXL 6156 (SET 256-8)	London OS 25924 (OSA 1368)		ED1, rare, (ED2, 3L-2G)
Decca SXL 6157	London CS 6429, (ED2 1st)	Penguin ***	ED1, 1W-2W, $
Decca SXL 6158	London CS 6434, (ED2 1st)	Penguin ***, (K. Wilkinson)	ED1, 1W-1W, $$
Decca SXL 6159	London CS 6426, (ED2 1st)	Penguin **(*)	ED1, 1W-1W, $+
Decca SXL 6160 (©=SDD 535, SDDA 261-9)	London CS 6444, (ED2 1st)	Penguin **(*), (K. Wilkinson)	ED1, 2W-3W, $+
Decca SXL 6161	London OS 25927		ED1, rare!, $ (ED2, 3W-2W)
Decca SXL 6162	London CS 6427, (ED2 1st)		ED2, 1W-1W, (1st)
Decca SXL 6163	London CS 6428, (ED2 1st)	Penguin **(*)	ED2, 1W-1W, (1st)
Decca SXL 6164	London CS 6409, (ED2 1st)		ED2, 2W-1W, (1st)
Decca SXL 6165	London CS 6439, (ED2 1st)		ED1, 2L-4L, $$
Decca SXL 6166	London CS 6436, (ED2 1st)		ED2, 1G-1G (1st)
Decca SXL 6167	London CS 6437, (ED2 1st)		ED1, 2G-2G, rare! $$
Decca SXL 6168 (©=SPA 204; Jubilee JB 10)	London CS 6438, (ED2 1st)	Penguin **(*), AS List	ED1, 3G-1W, $$
Decca SXL 6169 (©=SDD 440)	London CS 6443, (ED2 1st)		ED2, 1L-1L (1st), $$
Decca SXL 6170 (©=SDD 383)	London CS 6442, (ED2 1st) (©=STS 15387)	Penguin ***	ED1, 1L-1L

Decca Label & Serial Number DECCA 唱片公司, 編號	London Label & Serial Number LONDON 唱片公司, 編號	Remarks & Ratings 附註和評價	1st Labels & Reference Prices 首版和參考價格
Decca SXL 6171 (=SDD 241)	London OS 25929, (ED2)	Penguin ***	ED2, 1W-2G, (1st) rare!, $$
Decca SXL 6172	London CS 6435, (ED2 1st)		ED2, 2W-1W (1st), rare! $$
Decca SXL 6173 (©=SDD 376)	London CS 6441, (ED2 1st)		ED2, 1W-1W (1st), rare! $
Decca SXL 6174	London CS 6440, (ED2 1st)	Penguin ***, (K. Wilkinson)	ED2, 1G-1G, (1st)
Decca SXL 6175	London OS 25937	Penguin ***, (K. Wilkinson)	ED1, 2W-2W, $
Decca SXL 6176	London OS 25936		ED1, 1W-2W, $
Decca SXL 6177	No London CS		ED2, 2W-1W, (1st)
Decca SXL 6178	London OS 25938 (OSA 1502)		ED1, 2G-3G, $+
Decca SXL 6179	London CS 6445, (ED2 1st)		ED2, 1W-2W, (1st), rare! $
Decca SXL 6180	No London CS		ED1, 1W-1W, rare! $+
Decca SXL 6181	London CS 6446, (ED2 1st)	Penguin ***	ED2, 2E-2E, (1st), Very rare!! $$$
Decca SXL 6182 (©=SDD 278)	London CS 6448, (ED2 1st) (One of CSA 2214)		ED2, 4L-5L, (1st), rare! $$
Decca SXL 6183 (©=SDD 279)	London CS 6449 (One of CSA 2214)		ED2, 1W-1W, (1st), rare! $$
Decca SXL 6184 (©=SDD 443)	London CS 6450, (ED2 1st)		ED2, 2W-1W, (1st), rare! $$
Decca SXL 6185	London OS 25942		ED1, 1W-1W, test pressing, grooved, rare!! $+
Decca SXL 6186	London CS 6453, (ED2 1st)		ED1, 1W-1W, rare! $
Decca SXL 6187	London CS 6452, (ED2 1st)	Penguin **(*)	ED1, 1W-1W, $
Decca SXL 6188	London CS 6454, (ED2 1st)	Penguin ***, AS List-H	ED1, rare! $$
Decca SXL 6189 (©=SDD 227)	London CS 6451, (ED2 1st) (©=STS 15211)	Penguin ***	ED1, 1W-1W, $+
Decca SXL 6190	London OS 25939, (ED1)	Penguin ***	ED1, 1W-3W
Decca SXL 6191	London OS 25941		ED2, 1W-1W, (1st), $
Decca SXL 6192	London OS 25940	Penguin **(*)	ED2, 1W-2L, (1st)
Decca SXL 6193	London OS 25943		ED2, 3D-2L, (1st)
Decca SXL 6194	No London CS		ED2, 2L-2L, (1st), $
Decca SXL 6195	London OS 25949		ED2, 2W-2W, (1st), rare!! $
Decca SXL 6196	London CS 6464, (ED2 1st)		ED2, 1W-1W, (1st), Very rare! $$
Decca SXL 6197 (D121D 10)	London CS 6459, (ED2 1st)	Penguin ***	ED2, 1W-1W, (1st)
Decca SXL 6198 (D121D 10)	London CS 6460, (ED2 1st)	Penguin ***	ED2, 2W-3W, (1st)
Decca SXL 6199 (D121D 10)	London CS 6461, (ED2 1st)	Penguin ***	ED2, 2W-4W, (1st)
Decca SXL 6200 (LXT 6200)	London RB 100		ED2, 1K-3K, (1st)
Decca SXL 6201	London OS 25948		ED2, 1G-2G, (1st), rare!
Decca SXL 6202	London CS 6462, (ED2 1st)	Penguin **(*)	ED1, 2G-2G, $+

Decca Label & Serial Number DECCA 唱片公司, 編號	London Label & Serial Number LONDON 唱片公司, 編號	Remarks & Ratings 附註和評價	1st Labels & Reference Prices 首版和參考價格
Decca SXL 6203	London CS 6458, (ED2 1st)	Penguin**(*), AS list-H	ED2, 2W-2W, (1st), $+
Decca SXL 6204 (©=ECS 824; SPA 230)	London CS 6456, (ED2 1st)	TASEC	ED1, 2W-2W, (1st), rare! $$
Decca SXL 6205 (©=ECS 759)	London CS 6457, (ED2 1st)		ED2, 1W-2W, (1st), $
Decca SXL 6206	London CS 6463, (ED2 1st)		ED1, 1G-1G, $
Decca SXL 6207	London OS 25946		ED1, 2W-2W, rare! $
Decca SXL 6208 (©=SDD 531)	London CS 6465, (ED2 1st)		ED1, 1W-2W, $+
Decca SXL 6209 (©=SDD 486)	London CS 6487, (ED2 1st)	TASEC =* Linn Recut 01, Penguin ***, (K. Wilkinson)	ED2, 4L-5L, (1st), rare! $$
Decca SXL 6210 (SET 262-4)	London OS 25947 (OSA 1375)	Penguin ***	ED1, 1G-1G, $
Decca SXL 6212	London CS 6469, (ED2 1st) (=CS 6784)	Penguin ***, AS list-F, TAS 65-176++ , (K. Wilkinson)	ED1, 1W-1W, $
Decca SXL 6213 (©=SDD 323; ECS 760)	London CS 6470, (ED2 1st)		ED1, 2W-1W, rare! $
Decca SXL 6214	London CS 6471, (ED2 1st)	Penguin **(*)	ED1, 3W-2W, $
Decca SXL 6215	London CS 6472, (ED2 1st)	Penguin ***	ED1, 1W-1W
Decca SXL 6217 (©=SDD 536, SDDA 261-9)	London CS 6473, (ED2 1st)	Penguin ***, (K. Wilkinson)	ED2, 1W-1W, (1st), $
Decca SXL 6218 (©=SDD 538, SDDA 261-9)	London CS 6474, **[Not CS 6158 & © ist not STS 15150]	(K. Wilkinson)	ED1, 1W-1W, $
Decca SXL 6219 (©=SDD 537, SDDA 261-9)	London CS 6477, (ED2 1st)	Penguin ***	ED2, 1W-4W, (1st), $
Decca SXL 6220 (SET 292-7)	London OSA 1604 (part)	TASEC, Penguin ***, AS list-H	ED2, 4G-6G, (1st)
Decca SXL 6221	London OS 25955		ED1, 1G-2G, $
Decca SXL 6225*	London CS 6479, (ED2 1st)	TAS2016	ED1, 1G-1G, $$
Decca SXL 6226	London CS 6481, (ED2 1st)		ED2, 1W-2W, (1st), $
Decca SXL 6227 (©=SDD 464)	London CS 6480, (ED2 1st) (©=STS 15289)	Penguin ***, (K. Wilkinson)	ED2, 2W-5W, (1st), rare! $
Decca SXL 6228 (©=SDD 539, SDDA 261-9)	London CS 6482, (ED2 1st)	(K. Wilkinson)	ED1, 1W-1W, $
Decca SXL 6230 (©=SDD 245)	London OS 25978		ED1, 1G-1G, Very rare! $$$
Decca SXL 6231 (©=SDD 461)	No London CS	Penguin **(*)	ED1, 1G-1G, $
Decca SXL 6232	London CS 6483, (ED2 1st)	Penguin ***	ED1, 2G-1G, Very rare! $$+ (ED2, $)
Decca SXL 6233	London OSA 1159 (=OS 25974)	Penguin ***	ED1, 2G-6G, rare! $+

Decca Label & Serial Number DECCA 唱片公司, 編號	London Label & Serial Number LONDON 唱片公司, 編號	Remarks & Ratings 附註和評價	1st Labels & Reference Prices 首版和參考價格
Decca SXL 6234	No London CS		ED2, 3G-2G, (1st), rare! $$
Decca SXL 6235	London CS 6486, (ED2 1st)		ED2, 2G-2G, (1st), $
Decca SXL 6236	London CS 6488, (ED2 1st)	Penguin **(*)	ED2, 3G-4W, (1st), $
Decca SXL 6237	No London CS		ED2, 1L-1L, (1st)
Decca SXL 6238-41	London CSA 2403		ED2, 2G-2W-1E-3M-1W-1W-2E-3E, (1st), rare!! $$$
Decca SXL 6242-4 (©=SDDC 298-300)	London CSA 2307 (CS 6496-8)	Penguin ***	ED2, 3W-2W-1E-2E-6T-1W, (1st), $
Decca SXL 6245	No London CS	Penguin ***	ED2, 2G-3G, (1st), rare! $
Decca SXL 6246 (D121D 10)	London CS 6489, (ED2 1st)	Penguin ***	ED1, 1W-3L, $
Decca SXL 6247 (D121D 10)	London CS 6490, (ED2 1st)	Penguin ***	ED1, 1W-1W, $
Decca SXL 6248, (D121D 10) [*Before SXL 6248 some ED2 is the 1st issue]	London CS 6491, (ED2 1st)	Penguin ***	ED1, 1W-1W, $
Decca SXL 6249 [*From SXL 6249 all the ED2 is the 1st issue]	London OS 25981		ED2, 3W-2G, (1st), rare!
Decca SXL 6251	No London CS		ED2, 1st, 1W-1W, $
Decca SXL 6252	London CS 6494, (ED2 1st)	Penguin ***	ED2, 1st, 1W-1W, $
Decca SXL 6253	London CS 6495, (ED2 1st)	Penguin ***, AS List-H (D6D 7), (K. Wilkinson)	ED2, 1st, 1W-2L, $
Decca SXL 6254	London OSA 1160		ED2, 1st, 1G-1G, rare! $
Decca SXL 6255	London OS 25992		ED2, 1st, 1G-3G
Decca SXL 6256	London CS 6485, (ED2 1st)	Penguin **(*)	ED2, 1st, 1W-1W
Decca SXL 6257	London CS 6526	Penguin ***, AS List-H (D6D 7), (K. Wilkinson)	ED2, 1st, 1W-1W
Decca SXL 6258 (©=SDD 330)	London CS 6502, (ED2 1st)	Penguin ***	ED2, 1st, 2G-1G, rare! $$
Decca SXL 6259	London CS 6501, (ED2 1st)	Penguin ***✲, (K. Wilkinson)	ED2, 1st, 2G-2G
Decca SXL 6260	London CS 6500, (ED2 1st)	Penguin ***✲	ED2, 1st, 1G-5G, $
Decca SXL 6261 (SET 228-9 & 292-7)	London OS 25991 (OSA 1218 & 1604)		ED2, 1G-8W
Decca SXL 6262	London OS 25994	Penguin ***	ED2, 1G-2G
Decca SXL 6263 (©=SPA 127)	London CS 6503 (=CS 6785)	Penguin ***, AS List	ED2, 2G-1G, rare! $$
Decca SXL 6264	No London CS (©=STS 15173)	Penguin ***	ED2, 1G-1G
Decca SXL 6265	No London CS		ED2, 1W-1W, rare!! $$
Decca SXL 6266 (©=SDD 384)	London OS 25996	Penguin **(*) (SDD 384)	ED2, 3G-1G
Decca SXL 6267	London OS 25995		ED2, 4G-2G, rare!
Decca SXL 6268	London CS 6508		ED2, 1W-2W, rare! $

Decca Label & Serial Number DECCA 唱片公司, 編號	London Label & Serial Number LONDON 唱片公司, 編號	Remarks & Ratings 附註和評價	1st Labels & Reference Prices 首版和參考價格
Decca SXL 6269	London CS 6509	Penguin **(*)	ED2, 1K-1K, $
Decca SXL 6270	London CS 6510		ED2, 2W-2W, $+
Decca SXL 6271 (SET 285-7)	London OS 26007 (OSA 1381)	Penguin **(*)	ED2, 2G-4W
Decca SXL 6272 (SET 288-91)	London OS 26008	Penguin **(*), AS List-H (excerpts)	ED2, 4W-2W
Decca SXL 6273	London CS 6511	Penguin ***, AS List-H (D6D 7), (K. Wilkinson)	ED2, 3G-2G, $
Decca SXL 6274	London CS 6512	Penguin ***	ED2, 1W-1W, $
Decca SXL 6275 (D121D 10)	London CS 6513	Penguin ***	ED2, 1W-2W
Decca SXL 6276 (SET 272-3)	London OS 26009 (OSA 1259)		ED2, 1G-1G
Decca SXL 6281	No London CS		ED2, 1W-1W, rare! $
Decca SXL 6282-4, (=SET 231 + SXL 2261 & SXL 6067)	London CS 6249 + CS 6211 & CS 6369		ED2, 2G/2G, 3E/3E, 6W/3W, rare!! $$
Decca SXL 6285*	London CS 6519	Penguin **(*), (K. Wilkinson)	ED2, 1W-1W
Decca SXL 6286	London CS 6522	Penguin**(*)	ED2, 3L-1G, $
Decca SXL 6287*	London CS 6521 (©=STS 15358))	Penguin ***, (K. Wilkinson), AS List (Speakers Corner)	ED2, 1G-1G, rare! $$
Decca SXL 6288	London CS 6523	Penguin ***, AS List-H (D6D 7), (K. Wilkinson)	ED2, 4W-1W, $
Decca SXL 6289	London CS 6524	Penguin ***, AS List-H (D6D 7), (K. Wilkinson)	ED2. 3W-1W, $
Decca SXL 6290	London CS 6525	Penguin ***, AS List-H (D6D 7), (K. Wilkinson)	ED2, 2W-1W, $
Decca SXL 6291 (©=SPA 87)	London CS 6527	TAS-OLD, AS list-F (D6D 7), Penguin ***, Japan 300, (K. Wilkinson)	ED2, 1W-1W, $
Decca SXL 6292-5, (=SET 227 + SXL 2179 + SXL 6089 + SXL 6125)	London CS 6245 + CS 6156 + CS 6381 & CS 6408		2E-2E,4W-4L,1L- 1L,3W-5W, rare! $$
Decca SXL 6296	No London CS		ED2, 3W-2W
Decca SXL 6297	London CS 6532		ED2, 1W-1W, rare! $$
Decca SXL 6298	London CS 6529	Penguin **(*)	ED2, 2W-2W, $+
Decca SXL 6299	London OS 26014		ED2,1G-1G
Decca SXL 6300	London CS 6535		ED2, 3W-2W, Very rare!! $$+
Decca SXL 6301	London CS 6534	Penguin **(*)	ED2, 2W-2W, Very rare!! $$+
Decca SXL 6302	London CS 6536	Penguin ***	ED2, 2W-2W, rare! $$
Decca SXL 6303	London CS 6533	Penguin **(*)	ED2, 2W-2W, $+
Decca SXL 6304	London CS 6537		ED2, 1W-1W, $
Decca SXL 6305	London OS 26021		ED2, 1G-1G, $
Decca SXL 6306	London OS 26018		ED2, 1G-1G
Decca SXL 6307 (=TELDEC 16.41759)	No London CS		ED2, WBG, rare! $
Decca SXL 6308	London CS 6538	AS List	ED2, 1W-1W, rare! $

Decca Label & Serial Number DECCA 唱片公司, 編號	London Label & Serial Number LONDON 唱片公司, 編號	Remarks & Ratings 附註和評價	1st Labels & Reference Prices 首版和參考價格
Decca SXL 6309	London CS 6539		ED2, 3W-2W
Decca SXL 6310 (=SDD 451)	London CS 6540 (©=STS 15294)		ED2, 1W-2W, rare! $
Decca SXL 6311	London CS 6543		ED2, 1W-2W, rare! $$
Decca SXL 6312	London CS 6542	AS list-H	ED2, 1W-1W, $$
Decca SXL 6313	London CS 6541 (CSA 2308)		ED2, 3W-2W, Very rare! $+
Decca SXL 6314	London OS 26030		ED2, 1G-1G, $+
Decca SXL 6315	No London CS (©=STS 15162)	Penguin **(*)	ED2, 2G-6W
Decca SXL 6316	London OS 26032		ED2, 1G-2G
Decca SXL 6318	No London CS		ED2, 2G-3L
Decca SXL 6319 (©=SDD 416)	No London CS		ED2, 1G-1G
Decca SXL 6320	No London CS		ED2, 1G-1G, $
Decca SXL 6321 (©=SDD 542)	London CS 6549	Penguin **(*), (K. Wilkinson)	ED2, 3W-4W
Decca SXL 6322	London CS 6550	Penguin **(*), AS List, TAS 78/146+, Japan 300	ED2, 1W-1W, $$
Decca SXL 6323	London CS 6553	Penguin **(*)	ED2, 1W-1W, $
Decca SXL 6324	London CS 6554		ED2, 1W-1W, $
Decca SXL 6325	London CS 6552	Penguin ***, AS list-F	ED2, 2W-2W
Decca SXL 6326	London OS 26039		ED2, 2G-2G, $
Decca SXL 6327	London OS 26042		ED2,1G-1G
Decca SXL 6328	London CS 6559	Penguin **(*)	ED2, 3W-1W, $
Decca SXL 6329	London CS 6556	Penguin **	ED2, 1G-2G, $
Decca SXL 6330	No London CS (=STS 15077)	Penguin ***	ED2, 1G-4G, $
Decca SXL 6331	No London CS (=London STS 15168)		ED2, 2W-1W, rare! $$
Decca SXL 6332	London CS 6555	Penguin **(*)	ED2, 1L-1L
Decca SXL 6333	London OS 26043		ED2, 1G-5G, $
Decca SXL 6334	London CS 6562	Penguin ***, Japan 300-CD	ED2, 1W-2W
Decca SXL 6335	London CS 6563	Penguin **	ED2, 1W-6W, $
Decca SXL 6336	London OS 26053		ED1, 1G-1G, rare! $
Decca SXL 6337 (©=SDD 424)	No London CS		ED2, 1W-1W, $
Decca SXL 6338 (©=SDD 450)	No London CS (©=STS 15078)	Penguin **(*)	ED2, 1W-1W, $
Decca SXL 6339	No London CS (=STS 15169)	Penguin ***	ED2 ?, (ED3, 2W-6W), $
Decca SXL 6340	London CS 6567	Penguin ***, AS List-H (JB 86)	ED2, 1W-3W
Decca SXL 6341	No London CS (=London STS 15164)		ED2, 1G-1G
Decca SXL 6342	London CS 6569		ED2, 1W-2W, $

Decca Label & Serial Number DECCA 唱片公司, 編號	London Label & Serial Number LONDON 唱片公司, 編號	Remarks & Ratings 附註和評價	1st Labels & Reference Prices 首版和參考價格
Decca SXL 6343	London CSA 2101 (CS 6568, 6575)		ED2, 1W-2W, $
Decca SXL 6344	London CS 6570		ED2-1W-2W, $
Decca SXL 6345	London OS 26064		ED2, 6G-4G, $
Decca SXL 6346	London CS 6573	Penguin***	ED2, 2W-1W, rare! $$
Decca SXL 6347	London OS 26063		ED2, 1G-1G
Decca SXL 6348*	London CS 6574	Penguin ***	ED2, 4W-2W, rare! $
Decca SXL 6349	London OS 26067		ED2, 2G-2G, $
Decca SXL 6350	No London CS		ED2, 2W-2W, $+
Decca SXL 6351	No London CS		ED2, 1W-1W, rare! $$
Decca SXL 6352	London CS 6578		ED2, 2W-1W, $
Decca SXL 6353	London CS 6579	Penguin **(*)	ED2, 1W-1W
Decca SXL 6354	London CS 6580	Penguin **(*)	ED2, 1W-1W, $
Decca SXL 6355*	London CS 6581, (ED2)	TAS2016, Penguin ***, AS-DG list, (K. Wilkinson)	ED3, 1G-1G (1st), rare! $$+
Decca SXL 6356 (D190D 3)	London CS 6582, (ED2) (CSA 2310)	Penguin ***, AS list-H (D190D 3)	ED2, 1W-1W, $
Decca SXL 6357	London CS 6583, (ED2)		ED2, 1W-1W, $
Decca SXL 6358	London CS 6584, (ED2)		ED2, 1G-2G, $$
Decca SXL 6359	London CS 6585, (ED2)		ED2, 1G-1G, $$
Decca SXL 6360	London CS 6586, (ED2) (London CSA 2247)		ED2, 1G-1G, $
Decca SXL 6361	London OS 26075		ED2, 1G-1G
Decca SXL 6362	No London CS		ED2, 1W-1W, $
Decca SXL 6363 [*Last ED1"Original WBG" Label in this series]	London CS 6587, (ED2)	Penguin *** (K. Wilkinson)	ED1, 1G-1G, rare! $$ (ED2, 1G-1G, $)
Decca SXL 6364	London CS 6591, (ED2)	Penguin *(**)	ED2, 1G-1G, $
Decca SXL 6365	London CS 6592, (ED2 ?, ED3, 1G-1G)	Penguin ***	ED2, 1G-1G, $
Decca SXL 6366	No London CS (=STS 15170)	Penguin ***	ED2, 1W-1W, rare! $
Decca SXL 6367	London CS 6593, (ED2)	Penguin **(*)	ED2, 1W-1W, $
Decca SXL 6368	London CS 6594, (ED2 ?, ED3, 1W-1W)	Penguin **(*) & ***, (K. Wilkinson)	ED2, 1W-1W, rare! $
Decca SXL 6369	London CS 6595 & 6596 (in CSA 2309)	Penguin ***	ED2, 2G-2G
Decca SXL 6370	London CS 6597 (in CSA 2309)	Penguin ***	ED2, 2G-2G
Decca SXL 6371	London CS 6596 & 6595 (in CSA 2309)	Penguin ***	ED2, 2G-2G
Decca SXL 6372	London CS 6598, (ED3, 1st)	Penguin **(*)	ED3, (1st), 1W-1W, $
Decca SXL 6373	London CS 6599, (ED3, 1st)		ED3, (1st), 1W-1W, $

Decca Label & Serial Number DECCA 唱片公司, 編號	London Label & Serial Number LONDON 唱片公司, 編號	Remarks & Ratings 附註和評價	1st Labels & Reference Prices 首版和參考價格
Decca SXL 6374	London CS 6602, (ED3, 1st)	Penguin ***	ED3, (1st), 1W-1W, $
Decca SXL 6375	London CS 6603, (ED3, 1st)	(K. Wilkinson)	ED3, (1st), 1W-3W, $
Decca SXL 6376 [*Last ED2 "WBG" Label in this series]	London OS 26081		ED2, 1R-2R, $
Decca SXL 6377	London OS 26087	Penguin ***	ED3, (1st), 1G-1G, $
Decca SXL 6378	London CS 6604, (ED3, 1st)		ED3, (1st), 1W-3W, $
Decca SXL 6379	London CS 6609, (ED3, 1st)	TAS-OLD	ED3, (1st), 2G-1G, $
Decca SXL 6380	London CS 6606, (ED3, 1st) (CSA 2224)		ED3, (1st), 2W-3W, $
Decca SXL 6381	London CS 6607, (ED3, 1st) (CSA 2224)		ED3, (1st), 2W-2W, $
Decca SXL 6382 (©=JB 101)	London CS 6608, (ED3, 1st)	Penguin ***, TAS 30-141+	ED3, (1st), 2G-2G
Decca SXL 6383 (©=JB 47)	London CS 6605, (ED3, 1st)	Penguin ***	ED3, (1st), 2G-1G
Decca SXL 6384	No London CS	Penguin ***	ED3, 1K-1K
Decca SXL 6385	No London CS	Penguin ***	ED3, 1G-1G
Decca SXL 6386	London OS 26106		ED3, 2G-2G
Decca SXL 6387 (©=SDD 540)	London CS 6611, (ED3, 1st)	Penguin ***, (K. Wilkinson)	ED3, 1W-1W, rare! $$
Decca SXL 6388	London CS 6613 (ED3 ?, ED4, 1W-1W)	Penguin ***	ED3, 1W-1W, rare! $$
Decca SXL 6389	London CS 6614, (ED3, 1st)		ED3, 1W-2W, $
Decca SXL 6390	London CS 6612, (ED3, 1st) (©=London 414 440-1)	Penguin ***, TAS2017, AS-DG List (London 414 440-1)	ED3, 1W-1W, $
Decca SXL 6391	London OS 26099	Penguin ***, (K. Wilkinson)	ED3, 3G-4G, $
Decca SXL 6392 (©=ECS 790, part)	London OS 26098		ED3, 1G-1G
Decca SXL 6393	London CS 6617, (ED3, 1st)	Penguin ***	ED3, 3W-1W, rare! $$
Decca SXL 6394	London CS 6616, (ED3, 1st)		ED3, 1W-1W, rare! $$
Decca SXL 6395	London CS 6615, (ED3, 1st)		ED3, 1W-2W, $
Decca SXL 6396	London CS 6619, (ED3, 1st)	Penguin ***, Japan 300-CD	ED3, 3W-3W
Decca SXL 6397	London CS 6621, (ED3, 1st)		ED3, 4W-2W
Decca SXL 6398*	London CS 6620, (ED3, 1st)	Penguin ***, AS List (Speakers Corner)	ED3, 1W-1W
Decca SXL 6399	London CS 6622, (ED3, 1st)	Penguin ***	ED3, 1W-1W, $
Decca SXL 6400	London OS 26103	Penguin ***	ED3, 1G-1G
Decca SXL 6401	London CS 6624, (ED3, 1st)	Penguin ***	ED3, 1W-1W, $
Decca SXL 6402	London CS 6625, (ED3, 1st)		ED3,1W-1W, rare! $

Decca Label & Serial Number DECCA 唱片公司, 編號	London Label & Serial Number LONDON 唱片公司, 編號	Remarks & Ratings 附註和評價	1st Labels & Reference Prices 首版和參考價格
Decca SXL 6403	London CS 6626, (ED3, 1st)		ED3, 3W-1W, rare! $$
Decca SXL 6404	London OS 26107	Penguin **(*)	ED3, 4G-3G, $
Decca SXL 6405	London CS 6618, (ED3, 1st)	Penguin ***, AS list (JUBILEE 410 171)	ED3, 1W-1W, $
Decca SXL 6406	London OS 26110	Penguin **(*), AS List	ED3, 1G-1G
Decca SXL 6407	London CS 6627, (ED3, 1st)		ED3, 1W-1W
Decca SXL 6408	London CS 6628, [ED3, 1st,last ED3 from CS series]	Penguin ***	ED3, 1W-1W, $
Decca SXL 6409	London OS 26111	Penguin ***	ED3, 1G-1G, $
Decca SXL 6410	London CS 6632, (ED4, 1st)	Penguin ***	ED3, 1G-1G
Decca SXL 6411 (©=SDD 486)	London CS 6633, (ED4)	Penguin*** &**(*) (K. Wilkinson)	ED3, 2W-2W, $
Decca SXL 6413	No London CS (=London STS 15166)		ED3, 2G-2G
Decca SXL 6414 (©=SDD 410)	London CS 6636, ED4, 1st)	Penguin ***	ED3, 1W-2W
Decca SXL 6415	London CS 6637, (ED4, 1st)		ED3, 1L-1L, $
Decca SXL 6416	London CS 6638, (ED4, 1st)		ED3, 1W-1W, rare!! $$+
Decca SXL 6417	London CS 6639, (ED4, 1st)		ED3, 1W-1W, rare!! $$+
Decca SXL 6418	No London CS		ED3, 1W-2L
Decca SXL 6419	London CS 6641, (ED4, 1st)	Penguin ***	ED3, 1W-1W
Decca SXL 6420	No London CS (=STS 15171)	Penguin ***	ED3, 2G-1G, $
Decca SXL 6421	London OSA 1440 (highlights)	Penguin ***, AS list-H & AS list-F	ED3, 4W-3W
Decca SXL 6422	London CS 6643, (ED4, 1st)		ED3, 3W-3W, $
Decca SXL 6423 (©=SDD 442)	London CS 6644, (ED4, 1st)		ED3, 3W-2W, rare! $$
Decca SXL 6424	No London CS (=STS 15167)		ED3, 2G-1G, Very rare!! $$
Decca SXL 6426	London CS 6649, (ED4, 1st)	Penguin **(*), Japan 300	ED3, 1W-3W, Very rare !!! $$$$$
Decca SXL 6427	No London CS	Penguin **(*)	ED3, 3W-3W, $
Decca SXL 6428	London OS 26141		ED3, 3W-3W, Rare! $
Decca SXL 6429	No London CS		ED3, 6G-1G, $
Decca SXL 6430	No London CS		ED3, 1W-1W
Decca SXL 6431	No London CS	Penguin **(*)	ED3, 2S-1G, $+
Decca SXL 6432	No London CS	Penguin **(*)	ED3, 1G-1G, $+
Decca SXL 6433	No London CS		ED2, 1G-1G, $+
Decca SXL 6434	No London CS		ED3, 1G-5G, $
Decca SXL 6435	London CS 6657, (ED4, 1st)	Penguin ***	ED4, (1st), 3W-2W

Decca Label & Serial Number DECCA 唱片公司, 編號	London Label & Serial Number LONDON 唱片公司, 編號	Remarks & Ratings 附註和評價	1st Labels & Reference Prices 首版和參考價格
Decca SXL 6436	London CS 6656, (ED4, 1st)		ED3, rare! $+, (ED4 2W-2W)
Decca SXL 6437	London CS 6658, (ED4, 1st)	Penguin **(*)	ED3, 1G-2G, $
Decca SXL 6438	London CS 6660, (ED4, 1st)	Penguin **(*), AS List-H	ED3, 1W-1W
Decca SXL 6439	London CS 6659, (ED4, 1st)	Penguin ***	ED3, 1W-1W, $
Decca SXL 6440	London CS 6661, (ED4, 1st)	AS List	ED3, 2W-1C, (2W-2W), Very rare!! $$
Decca SXL 6441	No London CS		ED3, 1W-1W, $+
Decca SXL 6442	London CS 6663, (ED4, 1st)		ED4, 1st, 1W-1W
Decca SXL 6443	London OS 26146	Penguin ***	ED4, 1st, 1G-1G
Decca SXL 6444	London CS 6664, (ED4, 1st)	Penguin **(*), AS list-H	ED4, 1st, 1W-1W, $
Decca SXL 6445	London CS 6665, (ED4, 1st)	TAS2017, TAS Top 100 20th Century Classic, Penguin **(*)	ED4, 1G-2G
Decca SXL 6446	London OS 26147		ED4, 1G-2G
Decca SXL 6447	London CS 6668, (ED4, 1st)	Penguin **(*)	ED4, 1st, 4W-2W
Decca SXL 6448	London CS 6670, (ED4, 1st)	Penguin ***, AS list-H	ED3, 1W-1W, $
Decca SXL 6449	London OS 26161	Penguin ***, AS List-H, (K. Wilkinson)	ED4, 1st, 4W-2R
Decca SXL 6450	London CS 6671, (ED4, 1st)	Penguin ***, Japan 300, (K. Wilkinson)	ED4, 1st, $
Decca SXL 6451	London OS 26080		ED4, 2G-2G
Decca SXL 6452-61 (=SXLA 6452)	London CSP 2		ED4, (10 LP SET, all 1W-1W), $$$$
Decca SXL 6462	London CS 6672, (ED4, 1st)		ED4, 1st, 2W-2W
Decca SXL 6463 (©=SDD 423)	London CS 6673, (ED4, 1st)	Penguin ***	ED4, 2W-1W, rare! $
Decca SXL 6464 (©=SDD 419)	London CS 6674, (ED4, 1st)		ED4, 1W-2W, rare!
Decca SXL 6465*	London CS 6675, (ED4, 1st)	Penguin **(*)	ED4, 2W-2W
Decca SXL 6466	London CS 6676, (ED4, 1st)		ED4, 1W-1W
Decca SXL 6467	London CS 6677, (ED4, 1st)		ED4, 2W-2W
Decca SXL 6468	No London CS		ED4,1W-1W, rare!
Decca SXL 6469	London CS 6679, (ED4, 1st)	TAS2017, Penguin**(*), AS list-H	ED4, 2W-2W
Decca SXL 6470-5 (SXLB 6470)	London CSP 1		ED4, (6 LP SET), $+
Decca SXL 6476-80 (SXLC 6476 ©=Decca D8D 6)	London TCH S-1	Penguin **(*)	ED4, (5 LP SET), $$

Decca Label & Serial Number DECCA 唱片公司, 編號	London Label & Serial Number LONDON 唱片公司, 編號	Remarks & Ratings 附註和評價	1st Labels & Reference Prices 首版和參考價格
Decca SXL 6481 (©=SDD 441)	No London CS		ED4, 1W-1W, $
Decca SXL 6482	London CS 6680	Penguin ***, AS list-H & AS list-F	ED4, 2K-4K
Decca SXL 6483 (SXLJ 6644; D105D 5)	London CS 6682	Penguin **(*), Gramophone	ED4, 4W-2W
Decca SXL 6484	London CS 6694		ED4, 2W-2W
Decca SXL 6485	London CS 6693	Penguin ***	ED4, 1W-2W
Decca SXL 6486 (D190D 3)	London CS 6696 (CSA 2310)	Penguin **(*), AS list-H (D190D 3)	ED4, 1W-1W
Decca SXL 6487 (D190D 3)	London CS 6697 (CSA 2310)	Penguin ***, AS list-H (D190D 3)	ED4, 2W-2W
Decca SXL 6488	London CS 6698		ED4, 2W-3W
Decca SXL 6489	London CS 6695		ED4, 6W-3W
Decca SXL 6490	London OS 26182	Penguin ***	ED4, 1G-1G
Decca SXL 6491	London CS 6699	Penguin **(*)	ED4,1W-1W
Decca SXL 6493	London CS 6710	Penguin ***, AS list-F	ED4, 2W-2W, $
Decca SXL 6494	London CS 6706	Penguin ***	ED4,1W-1W
Decca SXL 6495	London CS 6707	Penguin ***	ED4, 1W-1W
Decca SXL 6496	London CS 6711 (London CSA 2247)	(K. Wilkinson)	ED4, 1W-2W
Decca SXL 6497	London OS 26186	Penguin ***, AS list (JB 122), (K. Wilkinson)	ED4, 4W-3W
Decca SXL 6498	London OS 26192		ED4, 2G-1G
Decca SXL 6499	No London CS (=STS 15301)	Penguin ***	ED4, 1W-1W
Decca SXL 6500	No London CS (=STS 15302)	Penguin ***	ED4, 1W-2W
Decca SXL 6501	London OS 26199		ED4, 1G-1G
Decca SXL 6502	London CS 6714		ED4, 3W-2W, rare!
Decca SXL 6503	London CS 6715		ED4, 2W-2W
Decca SXL 6504	London CS 6716	Penguin **(*)	ED4, 1W-2W
Decca SXL 6505	London CS 6717	Penguin **(*), Japan 300-CD	ED4, 4W-6W
Decca SXL 6506	London OS 26216		ED4, 1G-1G
Decca SXL 6507	London CS 6718	Penguin **(*), AS List-H	ED4, 1D-1D
Decca SXL 6508	London CS 6719	Penguin **(*)	ED4, 2W-1D
Decca SXL 6510	London CS 6721	Penguin ***	ED4, 1G-1G
Decca SXL 6512	London CS 6723	Penguin ***, AS List-H, (K. Wilkinson)	ED4, 1W-1W
Decca SXL 6513	No London CS	Penguin ***, AS List	ED4, 1W-1W, rare!!, $
Decca SXL 6514	No London CS		ED4, 1G-2G, rare! $
Decca SXL 6515-21 (SXLD 6515 ©=Decca D6D 7)	London DVO S-1	Penguin ***⁎, AS List-H (D6D 7), (K. Wilkinson)	ED4, (7 LP SET), $$
Decca SXL 6522	London OS 26240		ED4, 1G-2G, $

Decca Label & Serial Number DECCA 唱片公司, 編號	London Label & Serial Number LONDON 唱片公司, 編號	Remarks & Ratings 附註和評價	1st Labels & Reference Prices 首版和參考價格
Decca SXL 6523	London CS 6727	Penguin ***	ED4, 1W-1W
Decca SXL 6524	London OS 26241		ED4, 2G-2L
Decca SXL 6525	London OS 26246		ED4, 1W-1W
Decca SXL 6526	London CS 6731	Penguin ***	ED4, 2W-3W
Decca SXL 6527	London CS 6732	Penguin ***, (K. Wilkinson)	ED4, 3G-1A
Decca SXL 6528	London CS 6733	Penguin ***	ED4, 2W-3W
Decca 410 287-1	London 410 287-1	Penguin ***☆	Another Penguin ***☆ from Larrocha
Decca 410 289-1	London 410 289-1	Penguin ***☆	Another Penguin ***☆ from Larrocha
Decca SXL 6529*	London CS 6734	TASEC☆☆, TAS Top 100 20th Century Classic, Penguin **(*), AS List-H	ED4, 2W-4W, $
Decca SXL 6530	London OS 26249		ED4, 1G-1G
Decca SXL 6531	London CS 6735		ED4, 1G-1G
DECCA SXL 6532	London CS 6736		ED4, 1W-1W, $
Decca SXL 6533	London CS 6737		ED4, 2W-1W
Decca SXL 6534	London OS 26250	Penguin **(*)	ED4, 3G-4L
Decca SXL 6535	London CS 6738	Penguin ***	ED4, 4W-2W
Decca SXL 6536	London CS 6739		ED4, 1W-2W
Decca SXL 6537	No London CS		ED4, 1G-2G, Very rare!! $
Decca SXL 6538	London CS 6740	Penguin ***	ED4, 1W-1W
Decca SXL 6539	London CS 6741	Penguin ***	ED4, 2W-2W
Decca SXL 6540 (SET 465-7)	London OS 26254 (OSA 1396)	Penguin **(*)	
Decca SXL 6541	London CS 6744		ED4, 1G-1G
Decca SXL 6542	London CS 6745	Penguin ***	ED4, 1W-2W
Decca SXL 6543	London CS 6746	Penguin ***	ED4, 7G-2G
Decca SXL 6544	London CS 6747	Penguin ***	ED4, 2Y-6Y
Decca SXL 6545	London CS 6748		ED4, 1W-1W
Decca SXL 6546	London CS 6749	Penguin **(*)	ED4, 2W-1W
Decca SXL 6547	London CS 6750		ED4, 4W-3W, rare! $
Decca SXL 6548	London OS 26262	Penguin ***(☆)	ED4, 1G-3G
Decca SXL 6549	No London CS	Penguin **(*)	ED4, 1W-4W
Decca SXL 6550*	London CS 6752	TAS2017, Penguin ***, AS-DIV list	ED4, 1W-1W
Decca SXL 6551	London CS 6754		ED4, 2W-2W
Decca SXL 6552 (SXLJ 6644; D105D 5)	London CS 6772	Penguin **(*)	ED4, 1W-1W
Decca SXL 6553 (SXLJ 6644; D105D 5)	London CS 6773	Penguin **(*)	ED4, 2W-2W

Decca Label & Serial Number DECCA 唱片公司, 編號	London Label & Serial Number LONDON 唱片公司, 編號	Remarks & Ratings 附註和評價	1st Labels & Reference Prices 首版和參考價格
Decca SXL 6554	London CS 6774	Penguin ***, Japan 300, (K. Wilkinson)	ED4, 9W-9W
Decca SXL 6555	London CS 6775	Penguin **(*), Gramophone, (K. Wilkinson)	ED4, 5W-5W
Decca SXL 6556	London CS 6776	Penguin ***, Japan 300, (K. Wilkinson)	ED4, 9W-5W
Decca SXL 6557	London CS 6809	Penguin ***	ED4, 1W-1W
Decca SXL 6558-61 (SXLE 6558 ©=Decca D7D 4)	London CSP 4		ED4, (4 LP SET)
Decca SXL 6562	London CS 6786		ED4, 1W-1W
Decca SXL 6563	London CS 6787		ED4
Decca SXL 6564	No London CS	Penguin ***	ED4, 1W-1W
Decca SXL 6565-7 (SXLF 6565)	London CSA 2311	Penguin ***, AS list-H	ED4, (3 LP Set), $
Decca SXL 6568	London CS 7132		ED4, 1W-1W
Decca SXL 6569	London CS 6789	Penguin ***✲, AS List-H, (K. Wilkinson)	ED4, 3W-3W
Decca SXL 6570	No London CS	TAS-OLD, Penguin ***, AS list	ED4, 1W-1W, $
Decca SXL 6571	London CS 6790	Grammy, (K. Wilkinson)	ED4, 5W-5W, $
Decca SXL 6572	London CS 6791		ED4, 4G-3G
Decca SXL 6573	London CS 6795	Penguin ***, AS List-H, Japan 300-CD	ED4, 5W-5W
Decca SXL 6574	London CS 6793	(K. Wilkinson)	ED4, 1W-1W, rare! $
Decca SXL 6575	London CS 6794	Penguin ***	ED4, 3W-3W
Decca SXL 6576	London CS 6806		ED4, 4W-3W
Decca SXL 6577	London OS 26301	(K. Wilkinson)	ED4, 1G-1G
Decca SXL 6578	London OS 26302	(K. Wilkinson)	ED4, 9G-7G, rare! $
Decca SXL 6579	London OS 26303		ED4, 3G-3G
Decca SXL 6580 (©=JB 140)	London CS 6801	Penguin ***✲	ED4, 7W-5W
Decca SXL 6581	London CS 6800		ED4, 1W-1W
Decca SXL 6582	No London CS		ED4, 2W-2W
Decca SXL 6583	London CS 6803	Penguin **(*), AS List	ED4, 1W-2W
Decca SXL 6584	London OS 26305	Penguin ***✲, (K. Wilkinson)	ED4, 1G-2G
Decca SXL 6585	London OS 26315		ED4, 1G-2G, rare!!
Decca SXL 6586-7	London CSA 2235	Penguin ***	ED4, 4W-3W-6W-3W, $
Decca SXL 6588	London CS 6812	TAS-OLD, Penguin ***, (K. Wilkinson)	ED4, 1G-1G
Decca SXL 6589 (©=SDD 541)	London CS 6814	Penguin ***, (K. Wilkinson)	ED4, 1W-1W
Decca SXL 6590	London OS 26328	Penguin **(*)	ED4, 2G-1G
Decca SXL 6592	London CS 6816	TASEC, Penguin ***	ED4, 6K-6W, $$
Decca SXL 6594-7 (SXLG 6594)	London CSA 2404	Penguin ***, AS list-F	ED4, (4 LP SET)

Decca Label & Serial Number DECCA 唱片公司, 編號	London Label & Serial Number LONDON 唱片公司, 編號	Remarks & Ratings 附註和評價	1st Labels & Reference Prices 首版和參考價格
Decca SXL 6598	No London CS		ED4, 1G-1G, rare!!
Decca SXL 6599	London CS 6818	Penguin **(*), AS List-H	ED4, 1W-1W
Decca SXL 6600	London OS 26338	Penguin ***, (K. Wilkinson)	EW1, 2G-3G
Decca SXL 6601	London CS 6819	Penguin ***✧, AS list-H	ED4, 2W-1W
Decca SXL 6602	London CS 6820	Penguin ***	ED4, 2W-3W
Decca SXL 6603	London CS 6821	Penguin ***, (K. Wilkinson)	ED4, 1W-2W
Decca SXL 6604	London CS 6822	Penguin ***	ED4, 7W-3W
Decca SXL 6605	No London CS	Penguin ***, (K. Wilkinson)	ED4, 3G-2G
Decca SXL 6606	No London CS	TAS-OLD, Penguin ***, AS List-H	ED4, 1W-1W, rare!! $$
Decca SXL 6607	No London CS	Penguin ***✧, AS List, (K. Wilkinson)	ED4, 2G-2G, rare! $$
Decca SXL 6608	No London CS	Penguin ***, (K. Wilkinson)	ED4, 1G-1G
Decca SXL 6609	London OS 26366	(K. Wilkinson)	ED4, 3G-1G
Decca SXL 6610-3 (SXLH 6610)		Penguin **(*)	ED4, (4 LP SET), $+
Decca SXL 6614	No London CS (=STS 15414)	Penguin ***	ED4, 4W-1W
Decca SXL 6615	No London CS (=STS 15415)	Penguin ***	ED4, 1W-1W
Decca SXL 6616	London CS 6830	Penguin **, Japan 300-CD	ED4, 1W-1W
Decca SXL 6617	London CS 6831	Penguin **(*)	ED4, 1W-1W, $
Decca SXL 6618	No London CS		ED4, 1W-1W
Decca SXL 6619	London OS 26367	(K. Wilkinson)	ED4, 1G-1G
Decca SXL 6620-2	London CSA 2312	TASEC, Penguin***, AS list-H, Japan 300	ED4, 2W-1W-2W-1W-1W-1W, $+
Decca SXL 6623	London CS 6839	Penguin ***	ED4, 2W-2W
Decca SXL 6624	London CS 6840	TASEC, Penguin **(*), (K. Wilkinson)	ED4, 3G-2G
Decca SXL 6625	No London CS		ED4, 1G-3G
Decca SXL 6626 (SET 531-3)	No London CS	Penguin **(*), (K. Wilkinson)	ED4, 1G-2G
Decca SXL 6627	London CS 6841	Penguin **(*), AS List, (K. Wilkinson)	ED4, 2G-2G
Decca SXL 6628	No London CS	Penguin ***	ED4, 1W-1W
Decca SXL 6629	London OS 26376	(K. Wilkinson)	ED4, 3G-3G

Decca Label & Serial Number DECCA 唱片公司, 編號	London Label & Serial Number LONDON 唱片公司, 編號	Remarks & Ratings 附註和評價	1st Labels & Reference Prices 首版和參考價格
Decca SXL 6630 (Decca D258D 12)	London CS 6843 (CSP 11)	Penguin ***	ED4, 6W-7Y
Decca SXL 6631 (SET 399-400)	London OS 26390 (OSA 1278)	Penguin ***, AS List-H	ED4, 3G-2G
Decca SXL 6632 (D92D 5)	London CS 6845 (CSA 2501)	Penguin ***(☆), Japan 300-CD, (K. Wilkinson)	ED4, 2W-3W (White Label)
Decca SXL 6633	London CS 6848		ED4, 1W-1W
Decca SXL 6634	London CS 6849		ED4, 4W-6W
Decca SXL 6635-6	London CSA 2236	Penguin ***, AS List, (K. Wilkinson)	ED4, 2G-3G-1G-1G, $
Decca SXL 6637	London OS 26379		ED4, 1G-1G, rare!!
Decca SXL 6638	No London CS		ED4, 1W-1W
Decca SXL 6639	No London CS	(K. Wilkinson)	ED4,1G-1G
Decca SXL 6640	No London CS	Penguin ***, (K. Wilkinson)	ED4, 1G-1G
Decca SXL 6641	No London CS	Penguin ***, (K. Wilkinson)	ED4, 4W-6W
Decca SXL 6642	London CS 6859		ED4, 4A-4A
Decca SXL 6643	London CS 6858		ED4, 2W-1W
Decca SXL 6644-8 (SXLJ 6644; D105D 5)	London CSP 6	Penguin **(*)	ED4, (5 LP SET), $$
Decca SXL 6649	London OS 26384	Penguin **(*)	ED4, 1G-2G
Decca SXL 6650	London OS 26391	Penguin **(*)	ED4, 1G-1G
Decca SXL 6651	London CS 6853 (CSA 2404)	Penguin ***, AS list-F, (K. Wilkinson)	ED4, 6W-3W
Decca SXL 6652	London CS 6854 (CSA 2404)	Penguin ***, AS list-F, (K. Wilkinson)	ED4, 5W-3W
Decca SXL 6653	London CS 6855 (CSA 2404)	Penguin **(*), AS list-F, Japan 300-CD, (K. Wilkinson)	ED4, 2W-2W
Decca SXL 6654	London CS 6856 (CSA 2404)	Penguin ***, AS list-F	ED4
Decca SXL 6655	London CS 6857 (CSA 2404)	Penguin ***, AS list-F	ED4
Decca SXL 6656	London CS 6860	Penguin **(*)	ED4, 1W-1W, $
Decca SXL 6657	No London CS	Penguin **(*)	ED4, 1G-1G
Decca SXL 6658	London OS 26373	Penguin ***	ED4
Decca SXL 6659	No London CS		ED4, 6G-2G
Decca SXL 6660-4 (SXLK 6660, ©=SDD 519; 520)	No London CS	Penguin ***, (SDD 520,TAS2017 & AS list)	ED4, 2-2-1-2-2-1-2-5-2- 1W, (5 LP SET) $$
Decca SXL 6665-7 (SXLM 6665)	London CSA 2313 (=CS 6862, 6863 & 6864)	Penguin ***, AS List-H	ED4, 1G-1G-5G-1G-6G- 4G, $
Decca SXL 6668 (SXL 6620-2)	London CS 6865 (CSA 2312)	TASEC, Penguin***	ED4
Decca SXL 6669	London CS 6866	Penguin ***	ED4, 2W-4W
Decca SXL 6670	No London CS (=STS 15416)	Penguin ***	ED4, 1W-1W
Decca SXL 6671-2	London CSA 2237		ED4, 1W-1W-1W-1W, rare! $

Decca Label & Serial Number DECCA 唱片公司, 編號	London Label & Serial Number LONDON 唱片公司, 編號	Remarks & Ratings 附註和評價	1st Labels & Reference Prices 首版和參考價格
Decca SXL 6673 (SXLN 6673)	London CS 6870	Penguin ***	ED4, 5W-5W
Decca SXL 6674	London CS 6873		ED4, 4A-1A
Decca SXL 6675	London CS 6836	Penguin **(*)	ED4, 2L-2W
Decca SXL 6676 (=SXL 6172)	London CS 6435, (ED2 1st)	Penguin **(*)	ED4
Decca SXL 6677	London CS 6837	Penguin **(*)	ED4, 1W-1W
Decca SXL 6678	London CS 6838	Penguin ***	ED4 2W-2W
Decca SXL 6679	London OS 26195	Penguin ***	ED4, 6W-4W
Decca SXL 6680	London CS 6878	Penguin ***, TAS 9-96+	ED4
Decca SXL 6681	London CS 6879	Penguin **(*)	ED4, 1W-1W
Decca SXL 6682	London CS 6880	Penguin **(*)	ED4, 1W-1W
Decca SXL 6683	London CS 6881	Penguin ***	ED4, 4G-2W
Decca SXL 6684 (SXLP 6684)	No London CS	(K. Wilkinson)	ED4, 1W-3W
Decca SXL 6686-7	London CSA 2238	Penguin **(*)	ED4, 1W-1W-1W-1W (gatefold), $
Decca SXL 6688-9	London CSA 2239 (=CS 6686, 6687)	Penguin **(*)	ED4, 3G-2G-3G-2G, $
Decca SXL 6690 (=SXLR 6690)	London OS 26424		ED4, 3G-3G
Decca SXL 6691*	London CS 6885	TASEC, Penguin ***, AS list, (K. Wilkinson)	ED4, 4W-2W, $
Decca SXL 6692	No London CS	Penguin ***	ED4, 4W-3W
Decca SXL 6693 (part of SXL 6174)	London CS 6440, (ED2 1st) (part)	Penguin ***, (K. Wilkinson)	ED4, 4W-1W
Decca SXL 6694	London CS 6891	Penguin **(*), (K. Wilkinson)	ED4, 2W-5W
Decca SXL 6695	No London CS		ED4, 1G-1G
Decca SXL 6696	No London CS	Penguin ***, (K. Wilkinson)	ED4, 1G-1G
Decca SXL 6697	London CS 6893	Penguin ***	ED4, 1W-1W
Decca SXL 6698	London CS 6894	Penguin **(*)	ED4
Decca SXL 6699	No London CS	Penguin ***, AS List	ED4, 1G-1G
Decca SXL 6700	London CS 6895		ED4, 2W-1W
Decca SXL 6701	London CS 6896	Penguin ***	ED4, 1W-1W
Decca SXL 6702	London CS 6897	Penguin***, AS List	ED4 4W-4W
Decca SXL 6703	London CS 6898	Penguin **(*), AS list-H	ED4, 6W-3W
Decca SXL 6704	London CS 6899	Penguin ***, AS list-H	ED4, 1W-2W
Decca SXL 6705	London CS 6920	Penguin ***	ED4, 1W-3W
Decca SXL 6706 (Decca D258D 12)	London CS 7256 (=part of CS 6921 & CSP 11)	Penguin ***, (K. Wilkinson)	ED4
Decca SXL 6706 (Decca D258D 12, part)	London CS 6921 (=CS 7256, CSP 11)	Penguin ***, (K. Wilkinson)	ED4, 7W-2W

Decca Label & Serial Number DECCA 唱片公司, 編號	London Label & Serial Number LONDON 唱片公司, 編號	Remarks & Ratings 附註和評價	1st Labels & Reference Prices 首版和參考價格
Decca SXL 6707	London CS 6923	Penguin **(*), (K. Wilkinson)	ED4, 1W-1W
Decca SXL 6708	No London CS		ED4, 1W-1W
Decca SXL 6709	London CS 6925	Penguin ***, (K. Wilkinson)	ED4
Decca SXL 6710	London CS 6844	Penguin ***	ED4
Decca SXL 6711	London OS 26220		ED4, 3G-2G
Decca SXL 6712 (SXLM 6665)	London CS 6862 (CSA 2313)	Penguin ***	ED4
Decca SXL 6713 (SXLM 6665)	London CS 6863 (CSA 2313)	Penguin **(*), Japan 300-CD	ED4, 7G-1G
Decca SXL 6714 (SXLM 6665)	London CS 6864 (CSA 2313)	Penguin ***, Japan 300-CD	ED4, 6G-5G
Decca SXL 6715	London CS 6936		ED4
Decca SXL 6716	London CS 6937		ED4, 1A-1A
Decca SXL 6717	London CS 6938		ED4, 2A-2A
Decca SXL 6718	London OS 26428	Penguin ***, (K. Wilkinson)	ED4, 3G-1G
Decca SXL 6719	No London CS	(K. Wilkinson)	ED4, 1G-1G
Decca SXL 6720	No London CS	Penguin **(*), AS List	ED4, 2W-2W
Decca SXL 6721	London CS 6940	Penguin **	ED4, 1W-1W, rare!! $$$
Decca SXL 6722	No London CS	Penguin ***	ED4, 3A-3G
Decca SXL 6723	London CS 6941	Penguin ***, (K. Wilkinson)	ED4, 2W-2W
Decca SXL 6724	No London CS (=STS 15417)	Penguin ***	ED4, 1W-5W
Decca SXL 6725	London CS 6943	Penguin ***	ED4, 2W-1W
Decca SXL 6726	London CS 6945	Penguin ***	ED4,1G-1G
Decca SXL 6727	London CS 6946		ED4, 7G-6G
Decca SXL 6728	London CS 6947	Penguin ***	ED4, 1W-1W
Decca SXL 6729	London CS 6948	Penguin **(*)	ED4, 1W-3W
Decca SXL 6730	London CS 6949	Penguin ***, AS List	ED4, 1W-3W
Decca SXL 6731	London CS 6950	Penguin **(*), AS List	ED4 1W-1W, $$
Decca SXL 6732	London CS 6951		ED4, 2W-3W
Decca SXL 6733	London CS 6952		ED4
Decca SXL 6734	London CS 6953	Penguin ***	ED4, 2W-1W, rare! $
Decca SXL 6735	London CS 6954		ED4, 2W-2W, $
Decca SXL 6736 (D92D 5)	London CS 6958 (CSA 2501)	Penguin ***, Japan 300	ED4, 2A-1A
Decca SXL 6737	London CS 6967		ED4, 2K-1K
Decca SXL 6738	No London CS		ED4, 1G-3G, rare!
Decca SXL 6739 (=SXLI 6739)	London CS 6961	Penguin ***	ED4, 1W-1W. rare!
Decca SXL 6740	No London CS		ED4, 2G-3G
Decca SXL 6741	London CS 6966	Penguin ***	ED4, 1W-2W
Decca SXL 6742	London CS 6968	Penguin ***, AS List	ED4

Decca Label & Serial Number DECCA 唱片公司, 編號	London Label & Serial Number LONDON 唱片公司, 編號	Remarks & Ratings 附註和評價	1st Labels & Reference Prices 首版和參考價格
Decca SXL 6743	London CS 6970	Penguin **(*), (K. Wilkinson)	ED4, 2W-1W
Decca SXL 6744-5	London CSA 2242	TAS-Old, Penguin ***	ED4, $
Decca SXL 6746	London CS 6977	(K. Wilkinson)	ED4, 2W-1W
Decca SXL 6747	London OS 26443		ED4, 1G-1G
Decca SXL 6748	London OS 26444	Penguin ***, AS list-H	ED4, 1G-2K
Decca SXL 6749	London CS 6978	Penguin ***, Grammy, (K. Wilkinson)	ED4, 2W-2W
Decca SXL 6750	London CS 6979		ED4, 1W-1W
Decca SXL 6751	London CS 6980	AS list	ED4, 1W-1W, $
Decca SXL 6752 (©=JB 139)	London CS 6981	Penguin ***	ED4
Decca SXL 6753 [=CSA 2246 (part)]	London CSA 2246 (part)	Penguin ***	ED4, 2W-1W
Decca SXL 6754	London CS 6983	(K. Wilkinson)	ED4, 4W-1W
Decca SXL 6755	London CS 6988	Penguin ***, (K. Wilkinson)	ED4, 4W-1W
Decca SXL 6756	London CS 6989		ED4, 1A-1A
Decca SXL 6757	London CS 6990	TAS2016, AS list-H	ED4, 1W-1W, $
Decca SXL 6758	No London CS	(K. Wilkinson)	ED4, 1W-3W
Decca SXL 6759	London CS 6992	Penguin ***, AS list-H, Japan 300-CD	ED4, 1W-2W, $
Decca SXL 6760 (11BB 188-96)	London CS 6926 (CSP 9)	Penguin **(*), (K. Wilkinson)	ED4
Decca SXL 6761 (11BB 188-96)	London CS 6927 (CSP 9)	Penguin ***, (K. Wilkinson)	ED4
Decca SXL 6762 (11BB 188-96)	London CS 6930 (CSP 9)	Penguin ***, (K. Wilkinson)	ED4
Decca SXL 6763 (11BB 188-96)	London CS 6931 (CSP 9)	Penguin **(*), (K. Wilkinson)	ED4
Decca SXL 6764 (11BB 188-96)	London CS 6932 (CSP 9)	Penguin ***, (K. Wilkinson)	ED4
Decca SXL 6765	No London CS		ED4, 1G-1G
Decca SXL 6766	No London CS	(K. Wilkinson)	ED4, 1W-1W
Decca SXL 6767 (15BB 218-20)	London CS 7062 (CSA 2314)	Penguin***, AS list (15BB 218-20), Japan 300-CD, (K. Wilkinson)	ED4
Decca SXL 6768 (15BB 218-20)	London CS 6964 (part)	Penguin**(*), AS list (15BB 218-20), Japan 300-CD, (K. Wilkinson)	ED4
Decca SXL 6769 (15BB 218-20)	London CS 6964 (part) & CS 7063	Penguin***, AS list (15BB 218-20), Japan 300-CD, (K. Wilkinson)	ED4
Decca SXL 6770	London CS 6995	Penguin **(*), AS List	ED4. 1W-5W
Decca SXL 6771	London CS 6996	(K. Wilkinson)	ED4, 2W-2W

Decca Label & Serial Number DECCA 唱片公司, 編號	London Label & Serial Number LONDON 唱片公司, 編號	Remarks & Ratings 附註和評價	1st Labels & Reference Prices 首版和參考價格
Decca SXL 6772 (©=SXDL 7606)	London OS 26453	Penguin ***, (K. Wilkinson)	ED4, 2G-1G
Decca SXL 6773	London CS 6997	Penguin***, AS list-H	ED4, 1W-1W, rare! $
Decca SXL 6774 (SET 410-1)	London CSA 2225, (=CS 6634, One of the CSA 2225)	Penguin **(*), (K. Wilkinson)	ED4, 2W-3W
Decca SXL 6775 (SET 410-1)	London CSA 2225, (=CS 6634, One of the CSA 2225)	Penguin **(*), (K. Wilkinson)	ED4
Decca SXL 6776	London CS 6993		ED4
Decca SXL 6777*	London CS 7003	TASEC98 -TOP 12 old, Penguin**, AS List (Speakers Corner), (K. Wilkinson)	ED4, 1W-3W, $
Decca SXL 6778 (SET 590-2)		Penguin **(*)	ED4, 1G-2G, Rare!
Decca SXL 6779	London CS 7004		ED4, 2W-1W
Decca SXL 6781	London OS 26473	Penguin **(*)	ED4, 4G-1G
Decca SXL 6782	London CS 7006		ED4, 1W-1W
Decca SXL 6783 (Decca D 39D 4)	London CS 7007 (CSA 2405)	Penguin **(*)	ED4, 1W-1W, $
Decca SXL 6784	London CS 7008	Penguin ***	ED4, 1A-2A
Decca SXL 6785	London CS 7009	Penguin ***	ED4, 1W-5W
Decca SXL 6786	No London CS	(K. Wilkinson)	ED4, 1V-3V
Decca SXL 6787	No London CS	Penguin**(*), (K. Wilkinson)	ED4, 1W-2W, rare!
Decca SXL 6788	No London CS	Penguin ***, (K. Wilkinson)	ED4, 1A-1A
Decca SXL 6789 (D92D 5)	London CS 7012 (CSA 2501)	Penguin ***	ED4, 1W-1W
Decca SXL 6790 (D92D 5)	London CS 7013 (CSA 2501)	Penguin ***	ED4, 3W-2W
Decca SXL 6791 (D92D 5)	London CS 7014 (CSA 2501)	Penguin ***	ED4
Decca SXL 6792 (=SXLR 6792)	London OS 26435		ED4, 1G-2K
Decca SXL 6793	No London CS	Penguin ***, (K. Wilkinson)	ED4, 1G-1G
Decca SXL 6794	No London CS		ED4, 2W-2W
Decca SXL 6795	London CS 6984 (Part)	Penguin ***, (K. Wilkinson)	ED4, 1W-1W
Decca SXL 6796	London CS 7017		ED4, 1W-1W
Decca SXL 6797	London CS 7018	Japan 300-CD	ED4, 6G-5G
Decca SXL 6798	London CS 7019	Penguin ***	ED4, 1W-1W
Decca SXL 6799	London CS 7020		ED4, 1W-1W
Decca SXL 6800	London CS 7021	(K. Wilkinson)	ED4, 1G-2G
Decca SXL 6801	London CS 7022	Penguin ***, (K. Wilkinson)	ED4, 6A-1A
Decca SXL 6802	London CS 7023	(K. Wilkinson)	ED4, 3W-1W, $
Decca SXL 6803	No London CS	Penguin ***, AS list (JB 122)	ED4, 4G-3G

Decca Label & Serial Number DECCA 唱片公司, 編號	London Label & Serial Number LONDON 唱片公司, 編號	Remarks & Ratings 附註和評價	1st Labels & Reference Prices 首版和參考價格
Decca SXL 6804 (Decca D258D 12)	London CS 7024 (CSP 11)	Penguin ***, Japan 300-CD, (K. Wilkinson)	ED4, 1A-1A
Decca SXL 6805	London OS 26574		ED4, 2G-1G
Decca SXL 6806-7	London CSA 2248	AS List	ED4, 4W-1W-2W-1W, $+
Decca SXL 6808 (Decca D258D 12)	London CS 7028 (CSP 11)	Penguin ***, (K. Wilkinson)	ED4, 1A-4A
Decca SXL 6809 (Decca D258D 12)	London CS 7029 (CSP 11)	Penguin ***, (K. Wilkinson)	ED4
Decca SXL 6810	London CS 7030	Penguin ***	ED4, 5A-5A
Decca SXL 6811	London CS 7031	Penguin ***, AS List	ED4, 1W-1W
Decca SXL 6812	London CS 7032	Penguin ***, AS List-H, (K. Wilkinson)	ED4
Decca SXL 6813	London CS 7033	Penguin **(*), (K. Wilkinson)	ED4, 1W-1W
Decca SXL 6814	London CS 7034	(K. Wilkinson)	ED4, 1W-1W
Decca SXL 6815	No London CS	Penguin **(*), (K. Wilkinson)	ED4, 1W-2W
Decca SXL 6816	No London CS	Penguin **, (K. Wilkinson)	ED4, 3K-1W
Decca SXL 6817	No London CS	Penguin *** ☆	ED4, 1W-1W
Decca SXL 6818	London CS 7038	Penguin **(*)	ED4, 1W-1W
Decca SXL 6819	London CS 7039	Penguin ***	ED4, 1W-1W
Decca SXL 6820	No London CS	Penguin ***	ED4, 1W-1W
Decca SXL 6821	London CS 6890		ED4, 1G-1G
Decca SXL 6822	London CS 7043	TASEC☆☆, Penguin ***, (K. Wilkinson)	ED4. 1W-1W, $$
Decca SXL 6823	London CS 7044	Penguin **(*)	ED4, 2W-2W
Decca SXL 6824	London CS 7045	Penguin **	ED4, 1W-2W
Decca SXL 6825 (SXLR 6825)	London OS 26497		ED4, 1G-1G
Decca SXL 6826	No London CS	Penguin ***	ED4, 1G-1G, rare!! $
Decca SXL 6827	London CS 7048	Penguin ***, AS List-H, (K. Wilkinson)	ED4, 1W-1W
Decca SXL 6828	London OS 26449	Penguin ***, (K. Wilkinson)	ED4
Decca SXL 6829 (11BB 188-96)	London CS 7049 (CSP 9)	Penguin ***, (K. Wilkinson)	ED4, 1W-1W
Decca SXL 6830 (11BB 188-96)	London CS 7050 (CSP 9)	Penguin **(*), (K. Wilkinson)	ED4
Decca SXL 6831	London CS 7051	Penguin ***	ED4, 1G-2V
Decca SXL 6832	London OS 26433	Penguin ***, (K. Wilkinson)	ED4, 2A-1A
Decca SXL 6833	London CS 7055		ED4, 1W-1W
Decca SXL 6834 (Decca D 39D 4)	London CS 7094 (CSA 2405)		ED4, 2G-1G

Decca Label & Serial Number DECCA 唱片公司, 編號	London Label & Serial Number LONDON 唱片公司, 編號	Remarks & Ratings 附註和評價	1st Labels & Reference Prices 首版和參考價格
Decca SXL 6835 (Decca D 39D 4)	London CS 7095 (CSA 2405)		ED4, 1G-1G
Decca SXL 6836 (Decca D 39D 4)	London CS 7096 (CSA 2405)		ED4, 1G-1G
Decca SXL 6837	London OS 26506		ED4, 2G-1G
Decca SXL 6838	London CS 7061	Penguin **(*), AS list-H	ED4, 1W-2W, $
Decca SXL 6839	London OS 26510	Penguin ***	ED4, 3G-1G
Decca SXL 6840	No London CS	Penguin ***	ED4, 3W-8W
Decca SXL 6841	London OS 26524		ED4, 1G-3G
Decca SXL 6842	London CS 7064	(K. Wilkinson)	ED4, 1Y-2Y
Decca SXL 6843	London CS 7065		ED4, 2F-2F
Decca SXL 6844	London CS 7066		ED4, 1G-3Y
Decca SXL 6845	London CS 7067		ED4, 4V-4V
Decca SXL 6846	No London CS	AS list-H	ED4
Decca SXL 6847	London OS 26527	Penguin ***, AS List, (K. Wilkinson)	ED4, 3G-3G
Decca SXL 6848	London CS 7072	Penguin ***, (K. Wilkinson)	ED4, 1W-2W
Decca SXL 6849	No London CS	(K. Wilkinson)	ED4, 1G-1G
Decca SXL 6851	London CS 7073	Penguin ***, (K. Wilkinson)	ED4, 3G-2G, rare!
Decca SXL 6852	No London CS	(K. Wilkinson)	ED4, 1G-2Y
Decca SXL 6853 (Decca D249D 4)	London CS 7075	AS list-H, (K. Wilkinson)	ED4, 4Y-4Y
Decca SXL 6854	London CS 7076	AS List, (K. Wilkinson)	ED4, 1W-1W
Decca SXL 6855	No London CS	Penguin ***	ED4, 1G-2G
Decca SXL 6856	London CS 7078	Penguin ***, AS list-H, (K. Wilkinson)	ED4, 3G-1G
Decca SXL 6857	London CS 7080		ED4, 3G-1G, rare!
Decca SXL 6858	No London CS		ED4, 3G-2G
Decca SXL 6859	No London CS		ED4, 2G-2G
Decca SXL 6860	No London CS		ED4
Decca SXL 6861	London CS 7082	Penguin ***, (K. Wilkinson)	ED4, (ED5, 1Y-6G)
Decca SXL 6862	London CS 7102		ED4, 1G-1G
Decca SXL 6863	London CS 7084	Penguin ***, AS List-H, (K. Wilkinson)	ED4
Decca SXL 6864	London OS 26557		ED4, 3W-3W
Decca SXL 6865	London CS 7085		ED4, 2G-1W
Decca SXL 6866	London OS 26558		ED4, 1Y-1Y
Decca SXL 6867	London CS 7086		ED4, 1G-1G
Decca SXL 6868	London CS 7087	Penguin ***	ED4, 2Y-1Y
Decca SXL 6869	London OS 26559	Penguin ***	ED4, I1-U1
Decca SXL 6870	London OS 26560	Penguin ***	ED4, 3G-2G
Decca SXL 6871 (Decca D258D 12)	London CS 7088 (CSP 11)	Penguin ***	

Decca Label & Serial Number DECCA 唱片公司, 編號	London Label & Serial Number LONDON 唱片公司, 編號	Remarks & Ratings 附註和評價	1st Labels & Reference Prices 首版和參考價格
Decca SXL 6872	No London CS	(K. Wilkinson)	ED4, 4Y-2Y
Decca SXL 6873	London CS 7097		ED4, 1G-1G
Decca SXL 6874	London CS 7098	AS list-H	ED4, 1G-1G, rare! $
Decca SXL 6875	London CS 7099	AS List	ED4, 1G-2Y, rare! $+
Decca SXL 6876	No London CS		ED4, 1G-2G
Decca SXL 6877	London CS 7101	Penguin ***, (K. Wilkinson)	ED4
Decca SXL 6878	No London CS		ED4, 1G-3V
Decca SXL 6879	London CS 7103	Penguin ***, Gramophone, (K. Wilkinson)	ED4, $
Decca SXL 6880	No London CS		ED4, 1Y-2Y
Decca SXL 6881	London CS 7104	Penguin ***, (K. Wilkinson)	ED4, 1G-5G
Decca SXL 6882	No London CS		ED4
Decca SXL 6883	London CS 7106		ED4, 1G-1G
Decca SXL 6884 (Decca D249D 4)	London CS 7107	Penguin ***, AS List, (K. Wilkinson)	ED4, 2G-2G
Decca SXL 6885 (©=SDD 275)	London ZM 1001		ED4, 1Y-2Y
Decca SXL 6886	London CS 7108		ED4, 1G-1G
Decca SXL 6887	London CS 7109	(K. Wilkinson)	ED4, 2G-3G
Decca SXL 6888 (=SXLR 6888)	London OS 26575	Penguin ***	ED4, Test pressing, 1Y-1Y
Decca SXL 6889 (Decca D258D 12)	London CS 7111 (CSP 11)	Penguin ***	ED4, 1G-4G
Decca SXL 6890 (Decca D151D 4)	London CS 7201, ED5 (CSA 2406)	Penguin ***, Grammy, (K. Wilkinson)	ED4, 1G-1G
Decca SXL 6891	London CS 7115		ED4, 1W-3W
Decca SXL 6892	London CS 7114		ED4, 2G-1G
Decca SXL 6893	No London CS	Penguin ***, (K. Wilkinson)	ED4, 2Y-6Y
Decca SXL 6894	No London CS		ED4, 1G-1G, rare! $
Decca SXL 6895	London CS 7118		ED4, 1B-1B
Decca SXL 6896	London CS 7119	Penguin ***, (K. Wilkinson)	ED4, 2G-3G
Decca SXL 6897	London CS 7120	AS List-H, (K. Wilkinson)	ED4, 1G-1G
Decca SXL 6898	London OS 26578		ED4
Decca SXL 6899	London CS 7121	Penguin **(*)	ED4, 1G-1G
Decca SXL 6900	London OS 26579	Penguin ***	ED4, 3Y-3Y
Decca SXL 6901	No London CS	Penguin **(*)	ED4, 1G-1G
Decca SXL 6902 (Decca D151D 4)	London CS 7200, (ED4) (CSA 2406)	Penguin ***, Grammy, (K. Wilkinson)	ED4, rare!
Decca SXL 6903	London CS 7127, (ED5)		ED5, 2G-2G
Decca SXL 6904	London CS 7128, (ED4)	AS List-H	ED4, 1G-1G
Decca SXL 6905	London CS 7129, (ED4)		ED4, 5G-4G

Decca Label & Serial Number DECCA 唱片公司, 編號	London Label & Serial Number LONDON 唱片公司, 編號	Remarks & Ratings 附註和評價	1st Labels & Reference Prices 首版和參考價格
Decca SXL 6906	London CS 7130, (ED4)	Penguin ***✫, AS list	ED4, 1G-2G
Decca SXL 6908	No London CS	AS List, (K. Wilkinson)	ED4, 1G-3G, $
Decca SXL 6909	London CS 7133, (ED4)	(K. Wilkinson)	ED4, 2G-1G
Decca SXL 6910	London CS 7134, (ED4)		ED4, 1G-1G
Decca SXL 6911	London CS 7135, (ED4)	Penguin ***	ED4
Decca SXL 6912	No London CS	Penguin ***	ED4, 2V-2V, rare! $
Decca SXL 6913 (Decca SET D95D 6)	London CS 7148, ED4	AS List (D95D 6)	ED4
Decca SXL 6919 (Decca D249D 4)	London CS 7144, (ED4)	Penguin ***, (K. Wilkinson)	ED4, rare! $
Decca SXL 6921	No London CS		ED4, 1G-2G
Decca SXL 6922	London CS 7150, (ED4)	Penguin ***	ED4
Decca SXL 6923	London OS 26611, (ED4)	(K. Wilkinson)	ED4
Decca SXL 6924 (Decca D151D 4)	London CS 7198, ED5 (CSA 2406)	Penguin **(*), Gramophone, (K. Wilkinson)	ED5
Decca SXL 6925 (Decca D151D 4)	London CS 7199, (ED5) (CSA 2406)	Penguin **(*), (K. Wilkinson)	ED4, 1W-1W, rare!
Decca SXL 6926	London CS 7159, (ED4)	Penguin ***	ED4, 4G-3G
Decca SXL 6927	London CS 7160, (ED4)	Penguin **(*), AS List	ED4, rare! $
Decca SXL 6928	No London CS	Penguin ***	ED5, 1G-2G, (1st)
Decca SXL 6929 (Decca D258D 12)	London CS 7162, (ED5, 1st) (CSP 11)	Penguin **(*)	ED5, 1G-2G, (1st)
Decca SXL 6930	London OS 26612, (ED5, 1st)	(K. Wilkinson)	ED5, 1G-3G
Decca SXL 6931	No London CS		ED4, 4G-2G, $
Decca SXL 6932	London CS 7163 (ED5, 1st)	AS List-H	ED5, 2G-1G, (1st)
Decca SXL 6933	London OS 26613, (ED5, 1st)	Penguin **(*), (K. Wilkinson)	ED5, 2G-1G, (1st)
Decca SXL 6935 (=SXLR 6935)	London OS 26617, (ED5, 1st)	Penguin ***	ED5, 2G-2G, (1st), rare!
Decca SXL 6936 (=SXLR 6936)	London OS 26618, (ED5, 1st)		Matrix: ESS 1814-15, 2G-2G (Spain), Very rare!!!
Decca SXL 6937	London CS 7167, (ED5, 1st)	Penguin ***✫, AS List-H, (K. Wilkinson)	ED5, 1G-1G, (1st)
Decca SXL 6938	London CS 7168, (ED4)	AS List-H	ED4, 4G-2G, (1st), rare! $
Decca SXL 6940	London OS 26615, (ED5, 1st)	Penguin ***	ED5, 2G-3G, (1st)
Decca SXL 6941 (Decca D249D 4)	London CS 7170, (ED5, 1st)	Penguin ***	ED5, 5G-1G
Decca SXL 6942	London OS 26591, (ED5, 1st)		ED5, 1G-1G
Decca SXL 6943	London OS 26592, (ED5, 1st)	Penguin ***	ED5, 1G-1G
Decca SXL 6944	London CS 7171, (ED5, 1st)	Penguin ***✫	ED5, 1G-1G, $
Decca SXL 6945	No London CS	Penguin ***✫, AS List, (K. Wilkinson)	ED4, 2G-2G
Decca SXL 6946	London CS 7173, (ED5, 1st)	AS List, (K. Wilkinson)	ED5, 1G-1G

Decca Label & Serial Number DECCA 唱片公司, 編號	London Label & Serial Number LONDON 唱片公司, 編號	Remarks & Ratings 附註和評價	1st Labels & Reference Prices 首版和參考價格
Decca SXL 6947	London CS 7174, (ED5, 1st)	Penguin ***, (K. Wilkinson)	ED5, 4G-2G, rare!
Decca SXL 6949	London CS 7177, (ED5, 1st)		ED5
Decca SXL 6950	London CS 7178, (ED5, 1st)	Penguin **(*)	ED5, 1G-1G
Decca SXL 6951	London CS 7179, (ED5, 1st)	Penguin ***	ED5, 1G-2V
Decca SXL 6952	London CS 7180, (ED5, 1st)	Penguin ***	ED5, 4F-2F
Decca SXL 6953	London CS 7181	Penguin **(*), (K. Wilkinson)	ED5, 1G-1G
Decca SXL 6954	London CS 7184	Penguin **(*)	ED5, 3A-2G
Decca SXL 6955	No London CS	Penguin ***	ED5, 2G-2G, $
Decca SXL 6956	No London CS		ED5, 1G-2V, rare! $
Decca SXL 6957	No London CS	Penguin ***	ED5, 2G-2G, rare!
Decca SXL 6959	London CS 7189	Penguin ***	ED5, 1G-1G
Decca SXL 6960 (Decca D258D 12)	London CS 7190 (CSP 11)	Penguin ***	ED5
Decca SXL 6961 (Decca D258D 12)	London CS 7191 (CSP 11)	Penguin ***	ED5
Decca SXL 6962 (Decca D258D 12)	London CS 7192 (CSP 11)	Penguin ***	ED5
Decca SXL 6963	London CS 7193	(K. Wilkinson)	ED5
Decca SXL 6964	No London CS	Penguin ***	ED5, rare!
Decca SXL 6965	London CS 7195	Penguin ***	ED5, 3G-4V, rare!
Decca SXL 6966	London CS 7196	Penguin ***, AS List-H	ED5
Decca SXL 6968	No London CS		ED5
Decca SXL 6969	London CS 7197	Penguin ***	Dutch Silver-Blue
Decca SXL 6970	London OS 26652	Penguin **(*)	ED5
Decca SXL 6971	London OS 26660	Penguin **(*)	Dutch Silver-Blue
Decca SXL 6972	No London CS	Penguin ***	ED5, 1G-2G
Decca SXL 6973	No London CS		ED5, rare!!
Decca SXL 6974	No London CS	Penguin ***	Dutch Silver-Blue
Decca SXL 6975	London CS 7204	Penguin ***✲, A List-H	Dutch Silver-Blue, $$
Decca SXL 6976	London CS 7206		Dutch Silver-Blue, rare! $
Decca SXL 6977	London CS 7205	AS List-H	Dutch Silver-Blue
Decca SXL 6978	London CS 7207		ED5
Decca SXL 6979	London CS 7208	Penguin **(*)	Dutch Silver-Blue
Decca SXL 6980	London CS 7209	Penguin ***	Dutch Silver-Blue
Decca SXL 6981	London CS 7210	Penguin ***, Gramophone	Dutch Silver-Blue
Decca SXL 6982	London CS 7211	Penguin ***, (K. Wilkinson)	Dutch Silver-Blue
Decca SXL 6983	London CS 7239	Penguin ***	Dutch Silver-Blue
Decca SXL 6984 (Decca D134D 2)	London OS 26666 (OSAD 12113)		Dutch Silver-Blue
Decca SXL 6985	No London CS		Dutch Silver-Blue
Decca SXL 6986 (D83D 3)	London OSA 13125 (part)	(K. Wilkinson)	ED5

Decca Label & Serial Number DECCA 唱片公司, 編號	London Label & Serial Number LONDON 唱片公司, 編號	Remarks & Ratings 附註和評價	1st Labels & Reference Prices 首版和參考價格
Decca SXL 6987 (D132D 4; OSA 1443)	London OSA 1443 (part)		Dutch Silver-Blue
Decca SXL 6988	London OS 26434		ED5, 2A-2A
Decca SXL 6989	London CS 7220	Penguin ***	Dutch Silver-Blue, rare!
Decca SXL 6990 (Part of SXL 6632 & 6736) [=London CS 6845 & 6958]	London CS 6845 & 6958	Penguin ***, (K. Wilkinson)	Dutch Silver-Blue
Decca SXL 6991	London OS 26437	Penguin ***	Dutch Silver-Blue
Decca SXL 6994 (Decca D258D 12)	London CS 7247 (CSP 11)	Penguin ***	Dutch Silver-Blue
Decca SXL 6995	London CS 7235	Penguin ***	Dutch Silver-Blue
Decca SXL 6996	London CS 7236	Penguin ***	Dutch Silver-Blue
Decca SXL 6997 (Decca D222D 6)	London CS 7240	Penguin ***	Dutch Silver-Blue
Decca SXL 6998	London CS 7241	Penguin **(*)	Dutch Silver-Blue
Decca SXL 6999	London OS 26661	Penguin ***	Dutch Silver-Blue
Decca SXL 7000	London OS 26662	Penguin ***	Dutch Silver-Blue
Decca SXL 7001	London OS 26663	Penguin ***	Dutch Silver-Blue
Decca SXL 7004	London CS 6984 (part)	Penguin **, (K. Wilkinson)	Dutch Silver-Blue
Decca SXL 7007	London CS 7251	Penguin ***✻, AS list-F, Japan 300, (K. Wilkinson)	Dutch Silver-Blue, $
Decca SXL 7008	London CS 7253	Penguin ***, AS List-H (D244D 3)	Dutch Silver-Blue
Decca SXL 7010	London CS 7254	Penguin ***	Dutch Silver-Blue
Decca SXL 7011 (Decca D258D 12)	London CS 7255 (CSP 11)	Penguin **	Dutch Silver-Blue
Decca SXL 7012 (Decca D258D 12)	London CS 7111 & CS 7247 (CSP 11)	Penguin ***	Dutch Silver-Blue
Decca SXL 7013	London OS 26669	Penguin **(*), (K. Wilkinson)	Dutch Silver-Blue
Decca SXLA 6452 (=SXL 6452-61)	London CSP 2		ED4, (10 LP SET, all 1W- 1W), $$$$
Decca SXLA 7506 (Australian issue)	Decca SWL 8016	Japan 300	
Decca SXLB 6470 (=SXL 6470-5)	London CSP 1		ED4, (6 LP SET), $+
Decca SXLC 6476 (=Decca SXL 9476-80, D 8D 6)	London TCH S-1	Penguin **(*)	ED4, (5 LP SET), $$
Decca SXLD 6515 (=SXL 6515-21, ©=Decca D6D 7)	London DVO S-1	Penguin ***✻, AS List-H (D6D 7), (K. Wilkinson)	ED4, (7 LP SET), $$
Decca SXLE 6558	London CSP 4		ED4, (4 LP SET)
Decca SXLF 6565 (=SXL 6565-7)	London CSA 2311	Penguin ***, AS list-H	ED4, (3 LP Set), $
Decca SXLG 6594 (=SXL 6594-7)	London CSA 2404	Penguin ***, AS List-F	ED4, (4 LP SET)

Decca Label & Serial Number DECCA 唱片公司, 編號	London Label & Serial Number LONDON 唱片公司, 編號	Remarks & Ratings 附註和評價	1st Labels & Reference Prices 首版和參考價格
Decca SXLH 6610 (=SXL 6610-3)		Penguin **(*)	ED4, (4 LP SET), $+
Decca SXLI 6739 (=SXL 6739)	London CS 6961	Penguin ***	ED4, 1W-1W. Rare!
Decca SXLJ 6644 (=SXL 6644-8)	London CSP 6	Penguin **(*)	ED4, (5 LP SET), $$
Decca SXLK 6660 (=SXL 6660-4 ©=SDD 519; 520)		Penguin ***, AS List (SDD 520)	ED4, 2-2-1-2-2-1-2-5-2- 1W, (5 LP SET) $$
Decca SXLM 6665 (=SXL 6665-7)	London CSA 2313 (=CS 6862, 6863 & 6864)	Penguin ***	ED4, 1G-1G-5G-1G-6G- 4G, $
Decca SXLN 6673 (=SXL 6673)	London CS 6870	Penguin ***	ED4, 5W-5W
Decca SXLP 6684 (=SXL 6684)		(K. Wilkinson)	ED4, 1W-3W
Decca SXLR 6690 (=SXL 6690)	London OS 26424		ED4, 3G-3G
Decca SXLR 6792 (=SXL 6792)	London OS 26435		ED4, 1G-2K
Decca SXLR 6825 (=SXL 6825)	London OS 26497		ED4, 1G-1G
Decca SXLR 6888 (=SXL 6888)	London OS 26575	Penguin ***	ED4, Test pressing, 1Y-1Y
Decca SXLR 6935 (=SXL 6935)	London OS 26617	Penguin ***	ED5, 2G-2G, rare!
Decca SXLR 6936 (=SXLR 6936)	London OS 26618		Matrix: ESS 1814-15, 2G-2G (Spain), Very rare!!!
Decca Ring 1-22 (=D100D 19 & SET 382-4 (SXL 2101-3); SET 312-6; 242-6 & SET 292-7)	London Ring S-1 (=OSA 1309; 1509; 1508 & 1604)	TASEC, Penguin ***☆, G.Top 100, Grammy, AS list, Japan 300	$$$$
Decca SET 201-3 (=SXL 6015-6 & D247D 3)	London OSA 1319 (=OSA 1249, part)	Penguin **(*)	ED1, 4E-2E-2E-1E-1E- 2E, $$
Decca SET 204-8 (=D41D 5)	London OSA 1502	Penguin ***, AS list-H	ED1, WBG, $$
Decca SET 209-11 (=Decca D55D 3)	London OSA 1324	Penguin **(*), Japan 300	ED1, WBG, $$
Decca SET 212-4 (©=GOS 663-5)	London OSA 1327	Penguin ***, Grand Prix du Disc, Japan 300, (K. Wilkinson)	ED1, $$
Decca SET 215-7	London OSA 1328		ED1, 2D-2D-4D-2D-3D- 2D, $
Decca SET 218-20 (D104D 3)	London OSA 1329	Penguin **, (K. Wilkinson)	ED1, 1D-1D-2D-2D-1D- 1D, $
Decca SET 221-3	London OSA 1331	Penguin **(*), (K. Wilkinson)	ED1, rare! $
Decca SET 221-3 (reissue)	London OSA 13126 (=OSA 1331)	(K. Wilkinson)	
Decca SET 224-6 (©=GOS 655-7)	London OSA 1332	Penguin **(*)	ED1, 1E-2E-1E-1E-2E- 1E, $

Decca Label & Serial Number DECCA 唱片公司, 編號	London Label & Serial Number LONDON 唱片公司, 編號	Remarks & Ratings 附註和評價	1st Labels & Reference Prices 首版和參考價格
Decca SET 227	London CS 6245 (=CS 6782)		ED1, 2E-2E
Decca SET 228-9	London OSA 1218	TAS2016, Top 100 20th Century, G.Top 100, Penguin ***, Grammy	ED1,$
Decca SET 230	London OSA 1105 (OS 25322)		ED1, 1D-1D, rare! $$
Decca SET 231 (©=SDD 284)	London CS 6249		ED1, 1E-1E, rare!! $$$
Decca SET 232-4 (©=GOS 509-11)	London OSA 1361		ED1, $$
Decca SET 236-8 (=SXL 6122-4)	London OSA 1364 (=OSA 1151-3)	AS list-H	ED1, rare!, $$
Decca SET 239-41	London OSA 1365	Penguin **(*)	ED1, $$
Decca SET 242-6	London OSA 1508	TASEC, G.Top 100, Penguin ***, Grammy, Japan 300, AS list-H	ED1, $$
Decca SET 247-8 (SXL 6073-4)	London OSA 1254	Penguin ***, (K. Wilkinson)	ED1, $
Decca SET 249-51	London OSA 1366	Penguin **(*)	ED1, $$
Decca SET 252-3	London OSA 1255	Penguin ***☆, AS List-H, (K. Wilkinson)	ED1, 1D-2E-5E-1D, $
Decca SET 254-5	London CSA 2213	Penguin ***	ED1, 1E-1E-1E-1E, $
Decca SET 254-5	London CS 6342-3 (=CSA 2213)	RM15	ED1, $
Decca SET 256-8	London OSA 1368		ED1, $
Decca SET 259-61	London OSA 1373		ED1, $
Decca SET 262-4	London OSA 1375	Penguin ***	ED1, $
Decca SET 265-7	London OSA 1376		ED1, $
Decca SET 268-9	London OSA 1257		ED1, 3G-1G-3G-2G
Decca SET 270-1	London OSA 1261	Penguin ***☆, (K. Wilkinson)	ED2, $
Decca SET 272-3	London OSA 1259		ED1, $
Decca SET 274-6	London OSA 1378	Penguin **(*), AS List, (K. Wilkinson)	ED1 + ED4, $
Decca SET 277-9	London OSA 1379		ED1, $
Decca SET 280-1	London OSA 1260	Penguin **(*)	ED2, 4G-4G-3G-3G, $
Decca SET 282-4	London OSA 1380		ED1, $$
Decca SET 285-7	London OSA 1381	Penguin **(*)	ED2, 2G-1G-1G-2G-2G-2G, $
Decca SET 288-91	London OSA 1431	Penguin ***, AS List-H	ED2, $
Decca SET 292-7	London OSA 1604	TASEC, Penguin ***, AS list-H, G. Top 100	ED2, $$
Decca SET 298-300	London OSA 1382	Penguin ***	ED1, $
Decca SET 301 (1BB 101-3)	London OSA 1156	Penguin ***, AS-DG list (1BB 101-3)	ED2, $
Decca SET 302 (©=SPA 476)	London OSA 1157	Penguin **(*)	ED2, 2G-3G, $
Decca SET 303-4	London CSA 2215		ED1, $

Decca Label & Serial Number DECCA 唱片公司, 編號	London Label & Serial Number LONDON 唱片公司, 編號	Remarks & Ratings 附註和評價	1st Labels & Reference Prices 首版和參考價格
Decca SET 305-8	London OSA 1432	Penguin ***	ED2, $
Decca SET 309-10	London OSA 1263		ED1, rare!, $$
Decca SET 311	London OSA 1158 (=OS 25968)	Penguin ***, TAS2017	ED1, 1G-1G, $
Decca SET 312-6	London OSA 1509	Penguin ***, AS list-H, G. Top 100	ED2, 1st, $$
Decca SET 317-9	London OSA 1383	Penguin ***	ED2, $
Decca SET 320-2	London OSA 1384	Penguin **(*)	ED2, $
Decca SET 323-4	London CSA 2216	Penguin **(*)	ED2, 2W-1W-1W-2L, $
Decca SET 325-6	London CSA 2217	Penguin ***	ED2, $
Decca SET 327-30	London OSA 1433		ED2, $
Decca SET 331	London OS 26005	TAS2016, Penguin *** & **(*)	ED2, 1G-1G, $
Decca SET 332	London CS 6499 (CSA 2233)	Penguin *(**), TAS2016	ED2, $$
Decca SET 333-4 (©=SPA 583-4)	London OSA 1265		ED2, $
Decca SET 335-6	London CSA 2219	Penguin **(*)	ED2, 1W-1W-1W-3W
Decca SET 337 (SET 280-1)	London OS 26013 (OSA 1260)	Penguin ***	
Decca SET 338-40	London OSA 1385	Penguin ***, AS List, (K. Wilkinson)	ED2, 1G-2G-6G-2G-- 1G-2G, $
Decca SET 341-2	London OSA 1267		ED2. 5G-3G-1G-3G
Decca SET 343-4	London OSA 1266		ED2, 1G-2G-2G-1G
Decca SET 345 (SET 265-7)	London OS 26026 (OSA 1376)		ED2
Decca SET 346-8	London OSA 1386		ED2
Decca SET 349-50	London OSA 1268		ED2, 2W-2W-2W-2W
DECCA SET 351	London OSA 1161 (=OS 26038, one of the OSA 1270)		ED3, 1G-1G, $
DECCA SET 352	London OSA 1162 (=OS 26040, one of the OSA 1270)		ED2
Decca SET 353 (SET 305-8)	London OS 26041 (OSA 1432)	Penguin ***	
Decca SET 354-5	London OSA 1269	TAS2016, Top 100 20th Century Classic, Penguin ***	ED2 & ED4, $
Decca SET 356 (1BB 101-3)	London OSA 1163	Penguin ***, AS-DG list (1BB 101-3),(K. Wilkinson)	ED2, 1G-5G
Decca SET 357-9	London OSA 1387		ED2, $
Decca SET 360-1	London CSA 2220	Penguin **(*)	ED2, $
Decca SET 362-3	London OSA 1271	Penguin ***	ED2, $
Decca SET 364-6	London OSA 1388	Penguin ***	ED2, $
Decca SET 367 (SET 298-30)	London OS 26059 (OSA 1382)	Penguin ***	ED2, 1G-1G
Decca SET 368-9	London OSA 1272		ED2, 1G-1G-1G-1G, $
Decca SET 370-1	London CSA 2221		ED2, $
Decca SET 372-3	London OSA 1273	Penguin ***	ED2, $

Decca Label & Serial Number DECCA 唱片公司, 編號	London Label & Serial Number LONDON 唱片公司, 編號	Remarks & Ratings 附註和評價	1st Labels & Reference Prices 首版和參考價格
Decca SET 374-5	London OSA 1275	Penguin ***, Grammy	ED2, $
Decca SET 376-8	London OSA 1389		ED2, $
Decca SET 379-81	London OSA 1390	TAS2016, Top 100 20th Century, Penguin ***, AS-DG list, (K. Wilkinson)	ED2
Decca SET 382-4 (=SXL 2101-3)	London OSA 1309	TASEC, Penguin ***, AS list-H, G.Top 100	ED2, $
Decca SET 385-6	London CSA 2223 (=CS 6600, CS 6601)		ED3, 1W-1W-1W-1W
Decca SET 387-9	London OSA 1391	Penguin ***, AS-DG list	ED3, 2G-1G-1G-1G-2G-1G, $
Decca SET 390 (SET 312-6)	London OS 26085 (OSA 1509)	Penguin ***	ED3
Decca SET 391 (SET 317-9)	London OS 26086 (OSA 1383)	Penguin ***	ED3
Decca SET 392-3	London OSA 1276		ED3, 1G-3W-2G-1G, Rare!! $$
Decca SET 394-6	London OSA 1392		ED3, $
Decca SET 397 (SET 338-40)	London OS 26097 (OSA 1385)	Penguin ***	ED3
Decca SET 398	London OS 26100	Penguin ***	ED3, $
Decca SET 399-400	London OSA 1278	Penguin **(*)	ED3, $
Decca SET 401-2	London OSA 1279	Penguin **(*)	ED3, $
Decca SET 403-4	London OSA 1280	Penguin **(*)	ED3, 3G-4G-2G-1G
Decca SET 406-8 (RING 1-22)	London RDN S-1		ED3, 2G-1G-1G-2G
Decca SET 409 (SET 282-4)		Penguin ***	ED3, $
Decca SET 410-11 (SXL 6774-5)	London CSA 2225 (CS 6634-5)		ED3
Decca SET 412-5	London OSA 1434	Penguin **(*), (K. Wilkinson)	ED3, 1W-2W-1W-1W, $$
Decca SET 416-7	London OSA 1281		ED3, $
Decca SET 418-21	London OSA 1435 (OSAL)	Penguin ***	ED3, $
Decca SET 422	London OS 26121	Penguin ***	ED3+ED4
Decca SET 423 (SET 346-8)	London OS 26128		ED3, 2G-1G
Decca SET 424-6 (=RCA LSC 6166)	London OSA 1394		ED3
Decca SET 427-9 (=RCA LSC 6158)	London OSA 1393	Penguin ***	ED3, $
Decca SET 430 (SET 320-2)	London OS 26140 (OSA 1384)	Penguin ***	ED4, $
Decca SET 431 (SET 327-30)	London OS 26139 (OSA 1433)	Penguin **(*)	ED3
Decca SET 432 (SET 357-9)	London OS 26138 (OSA 1387)		ED3, 1G-1G
Decca SET 433-4	London CSA 2226		ED3
Decca SET 435-6	London OSA 1283		ED3 + ED4, $
Decca SET 438 (1BB 101-3)	London OSA 1164	Penguin **(*)	ED3, $
Decca SET 439 (One of SET 439-440)	London OS 26130 (OSA 1282)	Penguin ***, AS-DG list (1BB 101-3)	ED4, 4G-4G,
Decca SET 439-40	London OSA 1282		

Decca Label & Serial Number DECCA 唱片公司, 編號	London Label & Serial Number LONDON 唱片公司, 編號	Remarks & Ratings 附註和評價	1st Labels & Reference Prices 首版和參考價格
Decca SET 440 (One of SET 439-440)	London OS 26113 (OSA 1282)		ED4, 2G-2G-2G-3G
Decca SET 443-4	London OSA 1285		
Decca SET 445	No London OS	Penguin **(*)	ED4, 3G-3G-3G-3G
Decca SET 446-9	London OSA 1436	Penguin ***	ED4, 1G-1G
Decca SET 450 (SET 364-6)	London OS 26162 (OSA 1388)	Penguin **(*)	ED4, 5G-3G-4G-3G-3G-5G-3G-3G
Decca SET 451 (SET 341-2)	London OS 26163 (OSA 1267)	Penguin ***	ED4
Decca SET 452 (SET 379-81)	London OS 26164 (OSA 1390)		ED4
Decca SET 453 (SET 274-6)	London OS 26165 (OSA 1378)		ED4
Decca SET 454-5	London OSA 1286 (=OS 26166-7)		ED4
Decca SET 456	London OS 26168		ED4, 1G-1G-3G-1G
Decca SET 457 (SET 228-9)	London OS 26169 (OSA 1218)	Penguin *** & **(*)	ED4, 3G-3G
Decca SET 458 (SET 368-9)	London OS 26170 (OSA 1272)	Penguin ***	ED4
Decca SET 459 (SET 354-5)	London OS 26171 (OSA 1269)		ED4
Decca SET 460-3	London OSA 1437	TAS Top 100 20th Century Classical	ED4
Decca SET 464	London OS 26176	Penguin ***	ED4, 1G-2G-1G-1G-1G-2G-2G-1G
Decca SET 465-7	London OSA 1396		ED4, 4G-4G
Decca SET 468-468A	London FBD-S 1 (=CS 6645, 6646)	Penguin **(*)	ED4, 4G-4G-8G-5G-6G-5G
Decca SET 469-70	London CSA 2227	Penguin ***	ED4, 2W-2W-3W-2W
Decca SET 471-2	London CSA 2228	Penguin ***, AS list-F, Grammy	ED4, (6.48129, Germany)
Decca SET 473-4	London CSA 2229	Penguin **(*)	ED4, (6.48128, Germany)
Decca SET 475 (SET 277-9)	London OS 26185 (OSA 1379)	Penguin **(*)	ED4, 1W-1W,1W-4W
Decca SET 476 (SET 376-8)	London OS 26184 (OSA 1389)		ED4, rare!
Decca SET 477-8	London OSA 1287		ED4, rare!
Decca SET 479-81	London OSA 1397	Penguin **(*)	ED4
Decca SET 482 (SET 382-4; SXL 2101-3)	London OS 26194 (OSA 1309)	TAS2017, Penguin **(*), Japan 300-CD	ED4, 2G-1G-1G-3G-4A-4G
Decca SET 483 (SET 401-2)	London OS 26193 (OSA 1279)	TASEC, Penguin ***, AS list-H	ED4
Decca SET 484-6	London OSA 1398	Penguin **(*)	ED4
Decca SET 487 (SET 418-21)	London OS 26200 (OSA 1435)		ED4
Decca SET 488 (SET 387-9)	London OS 26201 (OSA 1391)	Penguin ***	ED4
Decca SET 489 (SET 394-6)	London OS 26202 (OSA 1392)	Penguin ***	ED4
Decca SET 490 (SET343-4 & 403-4)	London OS 26203 (OSA 1266 & 1280)		ED4
Decca SET 491 (SET 372-3)	London OS 26204 (OSA 1273)		ED4
Decca SET 492-3	London OSA 1288	Penguin ***	ED4
Decca SET 494 (SET 435-6)	London OS 26213 (OSA 1283)	Penguin ***, AS List	ED4

Decca Label & Serial Number DECCA 唱片公司, 編號	London Label & Serial Number LONDON 唱片公司, 編號	Remarks & Ratings 附註和評價	1st Labels & Reference Prices 首版和參考價格
Decca SET 495 (SET 443-4)	London OS 26214 (OSA 1285)	Penguin **(*)	ED4
Decca SET 496 (SET 412-5)	London OS 26215 (OSA 1434)	Penguin **(*)	ED4
Decca SET 497-8	London OS 26219-20		ED4
Decca SET 499-500	London OSA 1290		ED4, 1G-1G-1G-2G
Decca SET 501-2	London OSA 1291	Penguin ***	ED4
Decca SET 503-5	London OSA 13101	Penguin ***, AS List	ED4
Decca SET 506-9	London OSA 1438	Penguin ***	ED4
Decca SET 510-2	London OSA 13102	Penguin ***, AS list-H, Japan 300	ED4
Decca SET 513 (SET 460-3)	London OS 26239 (OSA 1437)	Penguin **(*), (K. Wilkinson)	ED4
Decca SET 514-7	London OSA 1439	Penguin ***	
Decca SET 518-9	London CSA 2231	TASEC, Penguin ***, AS list-H	ED4, $
Decca SET 520-1	London OSA 1292	Penguin ***, Grammy	ED4, 1W-1W-1W-2W
Decca SET 522 (SET 446-9)	London OS 26253 (OSA 1436)		ED4, 1G-1G-1G-3G
Decca SET 523-4	London CSA 2232 (=CS 6742-3)	Penguin **(*)	ED4
Decca SET 525-6	London OSA 1293		ED4
Decca SET 527 (SET 479-81)	London OS 26257 (OSA 1397)	Penguin ***	ED4, 8G-2G-2G-2G
Decca SET 528-30	London OSA 13103		ED4
Decca SET 531-3	London OSA 13104	Penguin ***, (K. Wilkinson)	ED4
Decca SET 534-5 (7BB 183-7)	London OSA 1295	Penguin ***, (K. Wilkinson)	ED4, $
Decca SET 536 (SET 501-2)	London OSA 1291 (highlights)	Penguin ***✻, (K. Wilkinson), Grammy	ED4
Decca SET 537 (SET 492-3)	London OSA 1288 (highlights)	AS List (SET 201-2)	ED4
Decca SET 538 (SET 484-6)	London OS 26278 (OSA 1398)		ED4
Decca SET 539 (SET 510-2)			ED4
Decca SET 540-1	London OSA 1296	Penguin ***, (K. Wilkinson)	ED4
Decca SET 542-4	London OSA 13105		ED4, 3G-3G-3G-2G
Decca SET 545-7	London OSA 13106	Penguin ***	ED4
Decca SET 548-9	London OSA 1297	Penguin ***✻, AS list	ED4
Decca SET 550-4	London OSA 1510		ED4, rare!, $
Decca SET 555	London OS 26292	Penguin ***, (K. Wilkinson)	ED4
Decca SET 556 (SET 506-9)	London OS 26299 (OSA 1438)	Penguin ***, (K. Wilkinson)	ED4, 3W-5W
Decca SET 557 (SET 514-7)	London OS 26300 (OSA 1439)	Penguin ***	ED4
Decca SET 558 (SXL 2094-6)	London OS 26274 (OSA 1307)	Penguin **(*)	ED4
Decca SET 559 (SET 528-30)	London OS 26332 (OSA 13103)		ED4
Decca SET 560 (SET 499-50)	London OSA 1290 (highlights)	Penguin ***, (K. Wilkinson)	ED4, 3G-2G

Decca Label & Serial Number DECCA 唱片公司, 編號	London Label & Serial Number LONDON 唱片公司, 編號	Remarks & Ratings 附註和評價	1st Labels & Reference Prices 首版和參考價格
Decca SET 561-3	London OSA 13108	Penguin ***	ED4
Decca SET 564 (SET 503-5)	London OS 26343 (OSA 13101)	TASEC, Penguin ***, AS list, (K. Wilkinson)	ED4
Decca SET 565-6	London OSA 1299	Penguin ***	ED4
Decca SET 567-8	London OSA 12100	TASEC, Penguin ***, AS list (Speakers Corner), Japan 300	ED4
Decca SET 569 (SET 545-7)	London OS 26369 (OSA 13106)	Penguin ***✲	ED4, 1G-1G-1G-2G
Decca SET 570-1	London OSA 12102	Penguin ***, AS list	ED4
Decca SET 572	London OSA 1165 (AOSA 1165, =OS 26374)	Penguin ***, (K. Wilkinson)	ED4
Decca SET 573 (SET 561-3)	London OS 26377 (OSA 13108)	Penguin ***	ED4
Decca SET 574 (SET 550-4)		TASEC, Penguin ***, AS list, (K. Wilkinson)	ED4
Decca SET 575-8 (=D56D 4)	London OSA 1442	Penguin ***, (K. Wilkinson)	ED4
Decca SET 579 (SET 565-6)	London OS 26399 (OSA 1299)		ED4
Decca SET 580 (SET 542-4)	London OS 26401 (OSA 13105)	Penguin ***	ED4
Decca SET 581-3	London OSA 13109	Penguin ***	ED4
Decca SET 584-6	London OSA 13110	Penguin ***, AS-DG list, (K. Wilkinson)	ED4
Decca SET 587-9	London OSA 13111	Penguin ***✲, Japan 300	ED4
Decca SET 590-2 (=Decca 7.336-8, France)		Penguin ***	ED4
Decca SET 593-4		Penguin **(*)	ED4, 3G-3G-3G-3G-3G- 3G, rare!!
Decca SET 595 (SET 575-8)		Penguin ***, (K. Wilkinson)	ED4, 6G-5G-5G-6G
Decca SET 596-8	London OSA 13112		ED4
Decca SET 599 (SET 596-8)		Penguin ***, AS List, (K. Wilkinson)	ED4, $
Decca SET 600 (SET 540-1)	London OSA 1296 (highlights)	Penguin ***, (K. Wilkinson)	ED4
Decca SET 601	London CS 7083	Penguin **(*)	ED4
Decca SET 602	London OS 26610		ED4
Decca SET 605 (SET 584-6)	London OS 26455	Penguin ***, (K. Wilkinson)	ED4, 1G-1G
Decca SET 606-8	London OSA 13114	Penguin ***	ED4
Decca SET 609-11	London OSA 13116	Penguin **(*), (K. Wilkinson)	ED4
Decca SET 612-4	London OSA 13118	TASEC✲✲, Penguin *** ✲, AS list-F	ED4
Decca SET 615	London OSA 1170	Penguin ***, AS List	ED4

Decca Label & Serial Number DECCA 唱片公司, 編號	London Label & Serial Number LONDON 唱片公司, 編號	Remarks & Ratings 附註和評價	1st Labels & Reference Prices 首版和參考價格
Decca SET 616	London OSA 1168	Penguin ***, (K. Wilkinson)	ED4
Decca SET 617	London OSA 1169	Penguin **(*), AS List	ED4, 1G-5G
Decca SET 618	London OS 26525	Penguin **(*), (K. Wilkinson)	ED4, 1G-2G
Decca SET 619 (SET 587-9)		AS List-H, (K. Wilkinson)	ED4
Decca SET 621 (D11D 3 & 6.42316)	London OSA 13115 (part)	Penguin ***	ED4
Decca SET 622		Penguin ***, AS List, (K. Wilkinson)	ED4
Decca SET 623 (SET 606-8)		AS List (Carmen)	ED4, 1G-1G
Decca SET 624 (D2D 3)		Penguin **(*), (K. Wilkinson)	ED4
Decca SET 625 (D13D 5)	London OSA 1512 (part)		ED4
Decca SET 626 (D24D 3)	London OSA 13119 (part)	Penguin **(*), (K. Wilkinson)	ED4
Decca SET 627	London OSA 1173	AS List, (K. Wilkinson)	ED4, 1G-1G
Decca SET 628	London CS 7110	Penguin **(*), (K. Wilkinson)	
Decca SET 629	London OSA 1172 (=OS 26580)	Penguin ***, AS list (MFSL), (K. Wilkinson)	ED4
Decca SET 630	London OSA 1174	(K. Wilkinson)	ED4
Decca SET 631 (D82D 3)	London OSA 13124 (part)	AS List, (K. Wilkinson)	ED5
Decca SET 632 (D102D 3)	London OSA 13130 (part)	Penguin **(*), AS List, (K. Wilkinson)	
Decca SET 633 (D131D 2)	London OSA 12112 (part)	Penguin ***	
Decca 1BB 101-3 (=SET 301 + 356 + 438)	London OSA 1156, 1163, 1164	Penguin ***, AS-DG list	
Decca 2BB 104-6 (=RCA LSC 6163)	London OSA 1395	Penguin ***	
Decca 2BB 109-11 (=RCA LSC 6156)	London OSA 1399	Penguin **(*)	
Decca 2BB 112-4 (=RCA LDS 6152)	London OSA 13100		
Decca 3BB 107-8 (No Decca SXL)	London CSA 2230		
Decca 4BB 115-8 (Mono, =Decca LXT 2954/5/6/7)	London LLA 22 (Mono)		
Decca 5BB 123-4 (=RCA LDS 7022)	London OSA 1284	TASEC, Penguin ***, AS list	
Decca 5BB 221-2	London CSA 2241	Penguin ***, Japan 300, Stevenson, (K. Wilkinson)	
Decca 5BB 130-1 (=Decca SXL 2125-7)	London CSA 2301	RM16, AS list-F	
Decca 6BB 121-2* (11BB 188-96)	London CSP 8 (CSP 9)	TASEC, Penguin ***, AS list, (K. Wilkinson)	
Decca 6BB 171-2 (=JB 120)	London CSA 2240	Penguin ***, G.Top 100	
Decca 7BB 125-9 (=RCA LDS 6706)	London OSA 1511	Penguin **(*), (K. Wilkinson)	

Decca Label & Serial Number DECCA 唱片公司, 編號	London Label & Serial Number LONDON 唱片公司, 編號	Remarks & Ratings 附註和評價	1st Labels & Reference Prices 首版和參考價格
Decca 7BB 173-7; 178-82 & 183-7	London CSP 7	Penguin **(*)	
Decca 9BB 156-61, (=SKL 4081-2; 4119-20 & 4925-6)	London OSA 1209, 1215 &1277	Penguin ***✧, AS list	
Decca 9BB 162-7, (=SKL 4138-40; 4006-7 & 4624-5)	London OSA 1201, 1258 &1322	Penguin ***	
Decca 10BB 168-170	London 2 SPC 21101/02/03		
Decca 11BB 188-96	London CSP 9	Penguin **(*), (K. Wilkinson)	
Decca 13BB 207-212 (©=SDD 513-8)	London CSA 2243-5	Penguin ***	
Decca 14BB 213-7	London CSA 2301, CSA 2206, CS 6392	RM16, AS list-F	
Decca 15BB 218-20 (=SXL 6767; 6768; 6769)	London CSA 2314 (=CS 6964; 7062; 7063)	Penguin***, AS List	
Decca D 2D 3	London OSA 13117	Penguin ***	
Decca D 6D 7 (=SXLD 6515-21)	London DVO S-1	Penguin ***✧, AS List-H (D6D 7), (K. Wilkinson)	
Decca D 7D 4 (SXLE 6558)	London CSP 4		
Decca D 8D 6 (=SXLC 6476)	London TCH S-1	Penguin **(*)	
Decca D 9D 3 (=SXL 6583, 6623, 6720)		Penguin **(*)	
Decca D 11D 3	London OSA 13115	Penguin ***, AS List (K. Wilkinson)	
Decca D 13D 5	London OSA 1512	Penguin **(*), (K. Wilkinson)	
Decca D 24D 3	London OSA 13119	Penguin ***, AS list-H, (K. Wilkinson)	
Decca D 34D 2	London OSA 12107	Penguin ***	
Decca D 37D 3	London CSA 2315	Penguin **(*)	
Decca D 39D 4 (=SXL 6783, 6834, 6835, 6836)	London CSA 2405 (=CS 7007, CS 7094, CS 7095, CS 7096)		
Decca D 48D 3	London OSA 13120	TAS Top 100 20th Century Classic	
Decca D 50D 2	London OSA 12108		
Decca D 51D 2	London OSA 12109	Penguin ***✧, G.Top 100, AS list	
Decca D 63D 3	London OSA 13123		
Decca D 65D 3	London OSA 13107 (OS 26329-31)		
Decca D 78D 3	London CSA 2316		
Decca D 82D 3 (SET 631=highlights)	London OSA 13124	Penguin **, AS List, (K. Wilkinson)	
Decca D 83D 3	London OSA 13125 (OSAD 13125)	Penguin **(*), (K. Wilkinson)	
Decca D 86D 3	London OSA 13127		
Decca D 87D 2	London OSA 12111	Grammy, (K. Wilkinson)	
Decca D 88D 3	London OSA 13128	AS List, (K. Wilkinson)	

Decca Label & Serial Number DECCA 唱片公司, 編號	London Label & Serial Number LONDON 唱片公司, 編號	Remarks & Ratings 附註和評價	1st Labels & Reference Prices 首版和參考價格
Decca D 92D 5 (=SXL 6632,6736, 6789, 6790, 6791 & 6990)	London CSA 2501	Penguin ***✫	
Decca D 93D 3	London OSA 13129		
Decca D 95D 6	London CSP 10	AS List (D95D 6)	
Decca D 96D 3	London OSA 13113	Penguin **(*)	
Decca D100D 19 (=Decca Ring 1-22)	London Ring S-1 (=OSA 1309; 1509; 1508 & 1604)	TASEC, Penguin ***✫, G.Top 100, Grammy, Japan 300, AS list	
Decca D102D 3 (SET 632=part)	London OSA 13130	Penguin **(*)	
Decca D103D 3	London OSA 13131	Penguin **(*)	
Decca D117D 2	London CSA 2249	TASEC, AS List, rare !!!	
Decca D130D 3	LONDON OSA 13133		
Decca D131D 2 (SET 633=part)	London OSA 12112	Penguin **(*)	
Decca D132D 4	London OSA 1443		
Decca D133D 2	London CSA 2250		
Decca D134D 2	London OSA 12113 (OSAD 12113)		
Decca D135D 2	London OSA 12114	(K. Wilkinson)	
Decca D137D 2	London OSA 12115		
Decca D144D 2	London OSA 12116	TAS2017, Penguin ***	
Decca D151D 4 (=SXL 6890, 6902, 6924, 6925)	London CSA 2406 (=CS 7125-6, 7157-8, ©=CS 7198, 7199, 7200, 7201)	Penguin **(*), (K. Wilkinson)	
Decca D156D 3 (=6.35477)	LONDON OSA 13134	AS-DIV list	
Decca D162D 4	London OSA 1444		
Decca D176D 3	London OSA 13135	Penguin ***, AS-DG list, (K. Wilkinson)	
Decca D188D 7 (=L'Oiseau Lyre)		Penguin ***✫, G.Top 100, AS list	
Decca D190D 3	London CSA 2310	AS list-H (D190D 3)	
Decca D210D 3	London 3LDR 10025	Penguin ***✫, (K. Wilkinson)	
Decca D216D 4	London OSA 1445	Penguin ***	
Decca D219D 4	London OSA 1446	Penguin ***	
Decca D222D 6			
Decca D224D 2 (=London LDR 10036)		Penguin ***✫	
Decca D230D 3 (=London LDR 73004)		Penguin ***, (K. Wilkinson)	
Decca D232D 3 (=LDR 73005)		Penguin ***	

Decca Label & Serial Number DECCA 唱片公司, 編號	London Label & Serial Number LONDON 唱片公司, 編號	Remarks & Ratings 附註和評價	1st Labels & Reference Prices 首版和參考價格
Decca D235D 3	London OSA 13136	Penguin **(*)	
Decca D244D 3		Penguin ***, AS List	
Decca D249D 4 (=SXL 6853, 6884, 6919, 6941)		Penguin ***, AS List (*No.5), (K. Wilkinson)	
Decca D258D 12	London CSP 11	Penguin ***	
Decca D267D 4 (=London LDR 74001)		Penguin ***	
Decca D276D 3 (=London LDR 73009)		Penguin ***☆	
Decca HDN 100-2		Penguin ***	
Decca HDN 103-5		Penguin ***	
Decca HDN 106-8		Penguin ***	
Decca HDN 109-11		Penguin ***	
Decca HDN 112-15			
Decca HDNA 1-6		Penguin *** (***☆, for the entire series)	
Decca HDNB 7-12 (©=SDD 457, 458, 468)		Penguin *** (***☆, for the entire series)	
Decca HDNC 13-18 (©=SDD 414, 546-7)		Penguin *** (***☆, for the entire series)	
Decca HDND 19-22 (©=SDD 359)		Penguin *** (***☆, for the entire series)	
Decca HDNE 23-26 (©=SDD 358, part)		Penguin *** (***☆, for the entire series)	
Decca HDNF 27-30 (©=SDD 358, part)		Penguin *** (***☆, for the entire series)	
Decca HDNG 31-34 (©=SDD 413)		Penguin *** (***☆, for the entire series)	
Decca HDNH 35-40 (©=SDD 412, 431, 482-4)		Penguin *** (***☆, for the entire series)	
Decca HDNJ 41-46		Penguin *** (***☆, for the entire series)	
Decca HDNK 47-48		Penguin *** (***☆, for the entire series)	
Decca HDNL 49-51		Penguin **	
Decca HDNM 52-56		Penguin **(*)	
Decca HDNP 57-60		Penguin ***	
Decca HDNQ 61-66		Penguin ***	
Decca HDNS 67-69		Penguin **(*)	
Decca HDNT 70-75		Penguin **(*)	
Decca HDNU 76-81		Penguin ***	
Decca HDNV 82-84		Penguin ***	
Decca HDNW 90-1		Penguin ***	

Decca Label & Serial Number DECCA 唱片公司, 編號	London Label & Serial Number LONDON 唱片公司, 編號	Remarks & Ratings 附註和評價	1st Labels & Reference Prices 首版和參考價格
Decca HEAD 1-2		TASEC, Penguin ***, AS list, (K. Wilkinson)	
Decca HEAD 3		Penguin *** & **(*), AS List	
Decca HEAD 4		Penguin ***	
Decca HEAD 5		Penguin ***, AS List	
Decca HEAD 6		TASEC**, Penguin **(*), AS-DIV list, (K. Wilkinson)	
Decca HEAD 7			
Decca HEAD 8		Penguin ***	
Decca HEAD 9		TAS2017, Penguin ***	
Decca HEAD 10	London OSA 1166	TAS2017, Penguin **(*), (K. Wilkinson)	
Decca HEAD 11		TAS2016, AS List	
Decca HEAD 12		TAS2017, AS List, Penguin ***	
Decca HEAD 13		Penguin ***	
Decca HEAD 14		TAS2016, AS List	
Decca HEAD 15		TAS2016, Penguin ***	
Decca HEAD 16			
Decca HEAD 18		AS List	
Decca HEAD 19-20		Penguin ***, AS List	
Decca HEAD 21		AS List	
Decca HEAD 22		Penguin ***, AS List	
Decca HEAD 23			
Decca HEAD 24-5		AS List	

LIST: LONDON RECORDS CS, CSA, OS, OSA SERIES (No Decca SXL & SET issue)

美國LONDON系列發行中，沒在DECCA SXL, SET系列出版的唱片編號表

● London CS	London CS 6013* (=LXT 5348)	London CS 6028 [©=SDD 446 + 134]
London CS 6029, (Spain)	London CS 6030 (=SWL 8005, 10" LP)	London CS 6032 (=SWL 8005, 10" LP)
London CS 6034 (©=ECS 822; SDD 243)	London CS 6035 (©=ECS 822; SDD 243)	London CS 6039 (©=ECS 595, LXT 5460)
London CS 6050, (Spain); London CS 6053	London CS 6059; (=LXT 5446, ©=ECS 746)	London CS 6060 (©=ECS 692)
London CS 6080 (=LXT 5369)	London CS 6082 (=LXT 5280, ©=ECS 807)	London CS 6083 (=LXT 5290)
London CS 6084 (©=ECS 663, SPA 183)	London CS 6086 (=LXT 5305, ©=ECS 578)	London CS 6087 (=LXT 5325)
London CS 6088 (©=SPA 421, part)	London CS 6091 (=SWL 8017, 10" LP)	London CS 6097 [=SWL 8010 (10" LP)]
London CS 6102 (=SXL SKL 4043)	London CS 6108 (=LXT 5306, ©=SPA 221)	London CS 6109 (©=ECS 796)
London CS 6110 (©=ECS 643)	London CS 6111 (©=STS 15024)	London CS 6112;(=LXT 5278)
London CS 6117 (=LXT 5241)	London CS 6118 (=LXT 5245)	London CS 6119 (©=ECS 640)
London CS 6120 (=LXT 5232)	London CS 6121 (=LXT 5288)	London CS 6126*(©=ECS 576)
London CS 6128; (=SWL 8009, 10" LP)	London CS 6130 (Spain)	London CS 6139* ; (©=ECS 772, 773)
London CS 6140 (©=ECS 766)	London CS 6148	London CS 6152
London CS 6159 (©=STS 15151)	London CS 6169 (©=ECS 687)	London CS 6172 (=Part of SXL 2219)
London CS 6173 (©=SDD 201)	London CS 6181 (©=SDD 201)	London CS 6185 (©=SPA 314)
London CS 6201, No Decca SXL (Spain)	London CS 6202, No Decca SXL (Spain)	London CS 6220 (©=SDD 203)
London CS 6221 (©=SDD 204)	London CS 6246; (=SWL 8500, Decca 10" LP)	London CS 6247; (=SWL 8018, 10'' LP)
London CS 6325, No Decca SXL	London CS 6339; (=SWL 8502, 10" LP only)	London CS 6356; No Decca SXL (Spain)
London CS 6370 (=ARGO ZRG 5372)	London CS 6423; No Decca SXL	London CS 6424; No Decca SXL
London CS 6425; No Decca SXL	London CS 6730; (Decca=SPA 127)	London CS 6753; No Decca SXL
London CS 6805; No Decca SXL	London CS 6823; No Decca SXL	London CS 6824; No Decca SXL
London CS 6944; (©=SPA 257)	London CS 6955; No Decca SXL	London CS 6956; No Decca SXL
London CS 6987 (©=SPA 206)	London CS 7005; No Decca SXL	London CS 7015; No Decca SXL
London CS 7046; No Decca SXL	London CS 7068; No Decca SXL	London CS 7147; No Decca SXL
London CS 7149; (=Decca SET D95D 6)	London CS 7154; (=Decca SET D95D 6)	London CS 7155; (=Decca SET D95D 6)
London CS 7165; (=Decca SET D95D 6)	London CS 7166; (=Decca SET D95D 6)	London CS 7221; No Decca SXL
London CS 7238 (=L'. Lyre DSLO 47)	London CS 7242; No Decca SXL	London CS 7246; (=Decca D222D 6)
London CS 7252; No Decca SXL	London CS 7258; No SXL (=Decca D222D 6)	● London CSA

London CSA 2205; (©=ECS 530)	London CSA 2222; No Decca SET	London CSA 2224; No Decca SET
London CSA 2246; [=SXL 6753 (part)]	London CSA 2301; [5BB 130-1, SDD 186-7)]	London CSA 2303; (©=ESC 620-1)
London CSA 2308; (©=GOS 540-2)	London CSA 2309; ((©=SDDB 294-7)	London CSA 2401; No Decca SET
London CSA 2402 [=SXL 6059-62]	• London OS	London OS 25054; (=Decca SKL 4027)
London OS 25061; No Decca SXL	London OS 25082; No Decca SXL	London OS 25101; (©=ECS 826; SDD 212)
London OS 25102; No Decca SXL	London OS 25107; No Decca SXL	London OS 25114; No Decca SXL
London OS 25115; (©=SDD 382)	London OS 25116; (©=SDD 324)	London OS 25118; No Decca SXL
London OS 25119; No Decca SXL	London OS 25120; No Decca SXL	London OS 25121; No Decca SXL
London OS 25123; No Decca SXL	London OS 25141; No Decca SXL	London OS 25194; No Decca SXL
London OS 25202; No Decca SXL	London OS 25203; No Decca SXL	London OS 25204; No Decca SXL
London OS 25205 (©=GOS 551-3)	London OS 25229; No Decca SXL	London OS 25230; No Decca SXL
London OS 25234 (=Decca SKL 4121)	London OS 25271; (©=ARGO ZRG 5179)	London OS 25282; No Decca SXL
London OS 25321; (©=SDD 197)	London OS 25331; (©=ARGO ZNF 1; ZK 1)	London OS 25332; (©=ARGO ZRG 5277)
London OS 25333; (©=ARGO SPA 267)	London OS 25731; (©=ARGO 5325)	London OS 25735; ©=ARGO 5333)
London OS 25795; (©=ARGO 5362)	London OS 25800; (©=ZRG 5371; ECS 661)	London OS 25832; No Decca SXL
London OS 25902; No Decca SXL [Decca SKL 4925-6 (highlights)]	London OS 25903; No Decca SXL [Decca SKL 4006-7 (highlights)]	London OS 25904; No Decca SXL [Decca SKL 4081-2 (highlights)]
London OS 25906; (SKL 4542; ©=SPA 27)	London OS 25920; No Decca SXL	London OS 25950; No Decca SXL
London OS 25951; No Decca SXL	London OS 26025 (=Decca SXL 21213-M)	London OS 26028 [Decca SKL 4809]
London OS 26052; (©=SDD R459)	London OS 26054; No Decca SXL	London OS 26093; No Decca SXL
London OS 26114; No Decca SXL	London OS 26115; No Decca SXL	London OS 26153; No Decca SXL
London OS 26181 (=Decca SXL 20557-B)	London OS 26183; No Decca SXL	London OS 26205; No Decca SXL
London OS 26206; No Decca SXL	London OS 26207; No Decca SXL	London OS 26218; No Decca SXL
London OS 26248 (SET 520-1, part)	London OS 26251; No Decca SXL	London OS 26258; No Decca SXL
London OS 26276; No Decca SXL	London OS 26277; No Decca SXL	London OS 26304; No Decca SXL
London OS 26306; No Decca SXL	London OS 26316; No Decca SXL	London OS 26317; No Decca SXL

London OS 26320; No Decca SXL	London OS 26321; No Decca SXL	London OS 26346; No Decca SXL
London OS 26347; No Decca SXL	London OS 26381; No Decca SXL	London OS 26408; No Decca SXL
London OS 26431; No Decca SXL	London OS 26436; No Decca SXL	London OS 26442; No Decca SXL
London OS 26448; No Decca SXL	London OS 26493; No Decca SXL	London OS 26499; No Decca SXL
London OS 26537; (©=SDD 507)	London OS 26577; No Decca SXL	London OS 26594; No Decca SXL
London OS 26603; No Decca SXL	● London OSA	London OSA 1101; (=LXT 5338, only)
London OSA 1102; No Decca SXL	London OSA 1103; No Decca SXL	London OSA 1104; (©=SDD 314)
London OSA 1155; [=Decca SKL 4579]	London OSA 1171; No Decca SXL	London OSA 1201; No Decca SET, [=Decca SKL 4006-7, (9BB162-7)]
London OSA 1202[=Decca SKL 4038-9]	London OSA 1207; No Decca SET	London OSA 1209 [=Decca SKL 4081-2, (9BB 156-61)]
London OSA 1215; No Decca SET, [=Decca SKL 4119-20, (9BB 156-61)]	London OSA 1216; No Decca SET	London OSA 1217; No Decca SET, [=Decca SKL 4146-7]
London OSA 1248; No Decca SET, [=Decca SKL 4504-5]	London OSA 1250; (=ARGO ZPR 257-8)	London OSA 1251; (=ARGO ZPR 259-260)
London OSA 1252; (=ARGO ZPR 124-5)	London OSA 1256; (©=ARGO DPA 571-2)	London OSA 1258; No Decca SET, [=Decca SKL 4624-5, (9BB 162-7)]
London OSA 1262; No Decca SET, [=Decca SKL 4708-9]	London OSA 1277; No Decca SET, [=Decca SKL 4925-6)]	London OSA 1294; (©=GOS 617)
London OSA 1301; (©=GOS 583-4)	London OSA 1310; (©=GOS 525-7)	London OSA 1311; (©=GOS 566-7; Decca 6.35217 DX; LXT 5155-7)
London OSA 1312; (©=GOS 543-5; Decca 417 185-1 & SMA 25019)	London OSA 1315; No Decca SET, (=ARGO ZPR 126-8)	London OSA 1316; No Decca SET, (=ARGO ZPR 201-30)
London OSA 1317; No Decca SET, (©=GOS 607-8 & 6.35225 DX, Germany)	London OSA 1318: No Decca SET (=ARGO ZPR 251-3)	London OSA 1320; No Decca SXL (©= ARGO ZRG 5271)
London OSA 1323; No Decca SET, [=Decca SKL 4138-40 (9BB 162-7)]	London OSA 1326; No Decca SET, (=ARGO ZPR 186-8)	London OSA 1362; No Decca SET, (=ARGO ZPR 183-5)
London OSA 1363; No Decca SET, (=ARGO ZRG 313-5) No Decca SXL	London OSA 1367; No Decca SET, (=ARGO ZPR 135-7) No Decca SXL	London OSA 1374; No Decc SET, (=ARGO ZPR 161-3)
London OSA 1403; (©=GOS 574-6)	London OSA 1407; (=ARGO ZPR 132-4)	London OSA 1408; (=ARGO ZPR 244-7)
London OSA 1409; No Decca SET, (=ARGO ZPR 149-152)	London OSA 1410; No Decca SET, (=ARGO ZPR 153-6)	London OSA 1411; No Decca SET, (=ARGO ZPR 232-5)
London OSA 1412; No Decca SET, (=ARGO ZPR 138-41)	London OSA 1413; No Decca SET, (=ARGO ZPR 142-5)	London OSA 1414; No Decca SET, (=ARGO ZPR 197-200)

London OSA 1415; No Decca SET, (=ARGO ZPR 157-60)	London OSA 1427; No Decca SET, (=ARGO2 ZPR 221-4),	London OSA 1428; No Decca SET, (=ARGO ZPR 164-7)
London OSA 1429; No Decca SET, (=ARGO ZPR 168-71)	London OSA 1430; No Decca SET, (=ARGO ZRG 5407)	London OSA 1501; No Decca SXL, [Decca SKL 5188-9], (©=GOS 562-5)
London OSA 1503; (=ARGO ZPR 192-6)	London OSA 12101; (©=GOS 634-5)	London OSA 12103 [=Decca SKL 5158-9]
London OSA 12104 [Decca SKL 5188-9]	London OSA 12110 [Decca SKL 5277-8]	London OSA 13122; (©=GOS 660-2)
● London Treasury	London SRS 63509 (No Decca SET, SXL & London OSA)	London SRS 63516 (No Decca SET, SXL & London OSA)
London SRS 63523 (No Decca SET, SXL & London OSA)	London SRS 64503 (No Decca SET, SXL & London OSA)	London SRS 64504 (No Decca SET, SXL & London OSA)
London STS 15081-2 (=GOS 558-9)	London STS 15155-6; (©=GOS 602-3)	

[London - Decca Records] Index of Equivalent Recordings

[倫敦-笛卡 唱片] 同樣錄音版本的對照索引

London Label & Serial Number LONDON 唱片公司, 編號	Decca Label & Serial Number DECCA 唱片公司, 編號	Remarks & Ratings 附註和評價	1st Labels & Reference Prices 首版和參考價格
London CS 6001 (©=STS 15084)	Decca SXL 2060*, (BB) (©=SDD 159, SPA 451)	RM19, Penguin **(*), TAS 38-137+, (K. Wilkinson)	ED1, BB, 6D-5E, $ AS list (Speakers Corner)
London CS 6002-3 (=CSA 2201)	Decca SXL 2084-5 (©=SDD 371-2, DPA 581-2)	RM15, Penguin **(*)	ED1, BB, 1-1-5-1K, Pancake
London CS 6004	Decca SXL 2059, (BB) (©=SDD 118)	RM14	ED1, BB, 2K-2K, Pancake, $
London CS 6005 (©=STS 15002)	Decca SXL 2007, (BB) (©=SDD 109, SPA 376)	RM14	ED1, BB, 4K-6E, $
London CS 6006	Decca SXL 2020*, (BB) (©=SDD 216, ECS 797)	RM19, TASEC, Penguin ***	ED1, BB, 3E-2E, Pancake, $ AS list (Speakers Corner)
London CS 6007 (©=STS 15012)	Decca SXL 2047, (BB) (©=SDD 133)	RM15	ED1, BB, 2E-1K, $
London CS 6008 (©=STS 15596)	Decca SXL 2082, (BB)	RM17	ED1, BB, 1E-1E, $
London CS 6009	Decca SXL 2011*, (BB) (©=SDD 240, ECS 819)	RM15, TASEC44	ED1, BB, 1E-2E, $
London CS 6010 (©=STS 15015)	Decca SXL 2006, (BB) (©=SPA 88)	RM16, Penguin ***	ED1, BB, 2E-1K, $
London CS 6011 (©=STS 15263)	Decca SXL 2029, (BB) (©=SPA 183)	RM16, Penguin ***	ED1, BB, 1E-1E, Pancake, rare! $$$
London CS 6012	Decca SXL 2221* (©=SDD 282)	RM16, Penguin ***	ED1, BB, 1E-1E, Pancake, $
London CS 6013* (©=STS 15020)	No Decca SXL (=LXT 5348)	RM14	ED1, BB, 2K-2E, Pancake, $
London CS 6014	Decca SXL 2016, (BB) (©=SPA 73)	RM10	ED1, BB, 2K-2E, $
London CS 6015	Decca SXL 2008*, (BB)	RM15	ED1, BB, 6E-4K
London CS 6016 (©=STS 15001)	Decca SXL 2013, (BB) (©=SDD 117)	RM14	ED1, BB, 1K-1K, Pancake, $
London CS 6017 (CSA 2308) (©=STS 15139)	Decca SXL 2017, (BB) (©=SDD 246, ECS 817)	RM13, TASEC, Penguin **(*)	ED1, BB, 1E-1E, Pancake, $
London CS 6018 (©=STS 15126)	Decca SXL 2086, (BB) (©=SDD 151)	RM15	ED1, BB, 1E-1E, Pancake, $
London CS 6019	Decca SXL 2002*, (BB) (©=SPA 334)	RM14, Penguin **(*)	ED1, BB, 3E-3K, $
London CS 6020 (©=STS 15007)	Decca SXL 2005, (BB) (©=SDD 128)	RM15	ED1, BB, 2K-2E, Pancake

London Label & Serial Number LONDON 唱片公司, 編號	Decca Label & Serial Number DECCA 唱片公司, 編號	Remarks & Ratings 附註和評價	1st Labels & Reference Prices 首版和參考價格
London CS 6021 (©=STS 15047)	Decca SXL 2222 (©=ECS 691)	RM13, Penguin **(*)	ED1, BB, 10E-2E, $
London CS 6022 (©=STS 15003)	Decca SXL 2104, (BB) (©=SDD 119)	RM12	ED1, BB, 4E-1E, Pancake, $
London CS 6023	Decca SXL 2062*, (BB) (©=SDD 374, ECS 815, 816; DPA 619)	RM18	ED1, BB, 2E-2E, rare!, $
London CS 6024 (©=STS 15109)	Decca SXL 2061, (BB) (German & Spain pressing only, UK Decca ©=SDD 214)	RM16	ED1, BB, 1K-1K, Pancake, rare!! $$
London CS 6025 (©=STS 15006)	Decca SXL 2009*, (BB) (©=SDD 115)	RM15	ED1, BB, 1E-1E, $
London CS 6026 (©=STS 15594)	Decca SXL 2044, (BB) (©=SDD 221, ECS 809)	RM15, TAS 13-91+	ED1, BB, 1E-1E, $
London CS 6027 (©=STS 15085)	Decca SXL 2098, (BB) (©=SDD 174; ECS 828)	RM11	ED1, BB, 2E-1K
London CS 6028 (©=STS 15014)	[=Decca SXL 2260, part; ©=SDD 446 + 134]	RM20, Penguin ***	ED1, BB, 1E-1E, rare!! $$+
London CS 6029	Spain, No Decca SXL	RM18	ED1, BB, 1K-1K, rare!!! $$$$
London CS 6030 (©=STS 15027)	No Decca SXL (=LXT 5394)	RM9, TAS2017	ED1, BB, 2K-1K, Pancake, $$
London CS 6031 (CSA 2308)	Decca SXL 2042, (BB) (©=ECS 818)	RM13, TASEC	ED1, BB, 1K-3K
London CS 6032 (©=STS 15037)	No Decca SXL (=SWL 8005, 10" LP)	RM13	ED1, BB, 2K-2K, Pancake, $
London CS 6033	Decca SXL 2097, (BB) (©=SDD 124, SPA 318)	RM14, Penguin ***	ED1, BB, 3K-2E, $
London CS 6034 (©=STS 15028)	No Decca SXL, (=LXT 5169, ©=SDD 243; ECS 822)	RM15, AS list-H (STS 15028)	ED1, BB, 2E-1E, $
London CS 6035 (©=STS 15048)	No Decca SXL (LXT 5154, ©=SDD 242)	RM14	ED1, BB, 1K-1K, $
London CS 6036	Decca SXL 2113*, (BB) (©=SDD 281)	RM16, Penguin ***	ED1, BB, 1K-2K, Pancake, $
London CS 6037 (©=STS 15038)	Decca SXL 2003, (BB) (©=SDD 105)	RM14	ED1, BB, 1K-1K, Pancake, $$
London CS 6038 (©=STS 15221)	Decca SXL 2001*, (BB) (©=SDD 112, SPA 108)	RM17, Penguin ***, (K. Wilkinson)	ED1, BB, 4K-1E, $ AS list (Speakers Corner)
London CS 6039 (©=STS 15049)	No Decca SXL (©=ECS 595); Decca LXT 5460	RM15	ED1, BB, 2E-2K, rare!!!! $$$
London CS 6040 (CSA 2305, ©=STS 15029)	Decca SXL 2081, (BB) (©=SDD 140; ECS 768)	RM14, Penguin **	ED1, BB, 5E-4E, $
London CS 6041 (CSA 2305, ©=STS 15039)	Decca SXL 2024, (BB) (©=SDD 177, ECS 769)	RM14, Penguin **(*)	ED1, BB, 2E-1K, $

London Label & Serial Number LONDON 唱片公司, 編號	Decca Label & Serial Number DECCA 唱片公司, 編號	Remarks & Ratings 附註和評價	1st Labels & Reference Prices 首版和參考價格
London CS 6042 (CSA 2305, ©=STS 15050)	Decca SXL 2025, (BB) (©=SDD 195, ECS 770)	RM14, Penguin **(*)	ED1, BB, 1E-1E, Pancake, $
London CS 6043 (©=STS 15022)	Decca SXL 2027, (BB) (©=SDD 375)	RM19	ED1, BB, 1E-1E, Pancake, $
London CS 6044 (©=STS 15043)	Decca SXL 2019, (BB) (©=SPA 201)	RM13	ED1, BB, 2E-2K, $
London CS 6046 (©=STS 15199)	Decca SXL 2091*, (BB) (©=SDD 446, part; SPA 233)	RM18, TASEC65, TAS2017, Penguin **(*)	ED1, BB, 2E-3E, $ Japan 300
London CS 6047 (©=STS 15015)	Decca SXL 2026, (BB) (©=SDD 110, ECS 775)	RM14, Penguin **, (K. Wilkinson)	ED1, BB, 1E-1E, $
London CS 6048	Decca SXL 2015, (BB) (©=ECS 742, part)	RM12	ED1, BB, 2E-2E, $
London CS 6049 (©=STS 15040)	Decca SXL 2012*, (BB) (©=SDD 111; SPA 421)	RM19, TASEC, Penguin **(*)	ED1, BB, 2E-2E, $
London CS 6050	Spain; No Decca SXL	RM15	ED1, BB, 1K-1K, Pancake, rare!! $$
London CS 6051	Decca SXL 2028*, (BB) (©=SDD 230)	RM16, Penguin ***	ED1, BB, 2E-3E, $
London CS 6052 (©=STS 15018)	Decca SXL 2004, (BB) (©=SDD 138)	(K. Wilkinson)	ED1, BB, 6E-3E, $
London CS 6053	No Decca SXL	RM12	ED1, BB, 3E-1K, $
London CS 6054	Decca SXL 2010, (BB) (©=SPA 403)	RM12	ED1, BB, 2G-5G, $
London CS 6055	Decca SXL 2034, (BB) (©=SDD 188)	RM12	ED1, BB, 1K-2K
London CS 6058 (©=STS 15051)	Decca SXL 2021*, (BB) (©=SDD 139, SPA 203)	RM14, Penguin ***	ED1, BB, 3E-3E, $
London CS 6059	No Decca SXL (LXT 5446, ©=ECS 746)	RM13, TASEC	ED1, BB, 1K-1E, $$
London CS 6060 (©=STS 15041)	No Decca SXL (LXT 5457, ©=ECS 692)	RM15, Penguin **(*)	ED1, BB, 1K-1K, $
London CS 6061 (©=STS 15140)	Decca SXL 2045*, (BB) (©=SDD 153; SPA 467)	RM18, Penguin ***✼, AS list-F, (K. Wilkinson)	ED1, BB, 1E-1E, $
London CS 6062 (©=STS 15052)	Decca SXL 2037*, (BB) (©=SDD 141, ECS 755)	RM17	ED1, BB, 3E-2E, $
London CS 6063 (©=STS 15053)	Decca SXL 2158 (©=SDD 256)	RM16, Penguin ***	ED1, BB, 1D-1D, rare! $$
London CS 6064 (©=STS 15086)	Decca SXL 2076*, (BB) (©=SDD 181; SPA 505)	RM14, Penguin **(*), (K. Wilkinson)	ED1, BB, 5D-4D TAS-SM86+
London CS 6065 (©=STS 15008)	Decca SXL 2067, (BB) (©=SDD 121)	RM14	ED1, BB, 3E-4E
London CS 6066 (©=STS 15141)	Decca SXL 2046, (BB) (©=SDD 205)	RM15	ED1, BB, 1E-2E, $
London CS 6067 (©=STS 15054)	Decca SXL 2077*, (BB) (©=SDD 276, SPA 398)	RM15, Penguin **(*)	ED1, BB, 2E-1K, $$$

London Label & Serial Number LONDON 唱片公司, 編號	Decca Label & Serial Number DECCA 唱片公司, 編號	Remarks & Ratings 附註和評價	1st Labels & Reference Prices 首版和參考價格
London CS 6070 (©=STS 15055)	Decca SXL 2116 (©=SDD 104; ECS 671)	RM15	ED1, BB, 1E-3E
London CS 6074 (©=STS 15056)	Decca SXL 2112, (BB) (©=ECS 645)	RM14	ED1, BB, 2E-3D
London CS 6077 (©=STS 15057)	Decca SXL 2105, (BB)	RM13, (K. Wilkinson)	ED1, BB, 1D-1D, $
London CS 6078 (©=STS 15216)	Decca SXL 2207 (©=SDD 199; ECS 644)	RM16, Penguin **(*), (K. Wilkinson)	ED1, BB, 1D-1D
London CS 6079 (©=STS 15042)	Decca SXL 2136* (©=SDD 293, 373)	RM20, Penguin ***	ED1, BB, 1E-3E, rare!! $$
London CS 6080	No Decca SXL (=LXT 5369)	RM12	ED1, BB, 1E-1D
London CS 6081 (©=STS 15058)	Decca SXL 2220 (©=SDD 178)		ED1, BB, 2E-2D
London CS 6082 (©=STS 15026)	No Decca SXL (=LXT 5280, ©=ECS 807)	RM10	ED1, BB, 1D-1D, rare!! $$
London CS 6083 (©=STS 15125)	No Decca SXL (=LXT 5290)	RM13	ED1, BB, 1E-2E, $
London CS 6084 (©=STS 15142)	No Decca SXL (LXT 5302, ©=ECS 663, SPA 183)	RM12, Penguin **	ED1, BB, 1K-4K, rare!! $$
London CS 6085 (©=STS 15142)	No Decca SXL (LXT 5516, ©=ECS 578)		ED1, BB, 1E-1E, (Promote), rare!! $+
London CS 6086 (©=STS 15110)	No Decca SXL (LXT 5305, ©=ECS 578)	RM13	ED1, BB, 1E-1E, rare! $$
London CS 6087 (©=STS 15043)	No Decca SXL (=LXT 5325)	RM16	ED1, BB, 1D-1E, Pancake, rare! $+
London CS 6088 (©=STS 15044)	No Decca SXL (©=SPA 421, part)	RM12	ED1, BB, 1E-1D, Pancake, rare! $+
London CS 6089 (=STS 15030)	Decca SXL 2182	RM16, AS list-H (STS15030)	ED1, BB, 1D-2E, rare! $$
London CS 6090	Decca SXL 2110*, (BB) (©=SDD 185)	RM18, Penguin ***, AS list-F	ED1, BB, 2D-2E, $
London CS 6091	No Decca SXL =Decca SWL 8017 (10" LP)	RM12	ED1, BB, 2D-1E
London CS 6092	Decca SXL 2124	RM14	ED1, BB, 1K-1K
London CS 6093 (=CS 6777)	Decca SXL 2121	RM13	ED1, BB, 3K-2K, $
London CS 6094	Decca SXL 2190 (©=SPA 402)	RM14, Penguin **(*)	ED1, BB, 2D-1E, $
London CS 6095 (©=STS 15017)	Decca SXL 2109, (BB) (©=SDD 142)	RM13	ED1, BB, 3D-2E, $
London CS 6096 (©=STS 15111)	Decca SXL 2106, (BB) (©=SDD 226)	Penguin **(*)	ED1, BB, 1E-2E, rare! $$
London CS 6097 (CSA 2203, ©=STS 15569)	Decca SWL 8010 (10" LP) (Part of SXL 2092-3)	RM18, Penguin ***	ED1, BB, 1E-1E
London CS 6098 (©=STS 15010)	Decca SXL 2128* (©=SDD 125, SPA 384)	RM16, TAS 61-127++, Penguin *** (SPA 384),	ED1, BB, 1E-1E AS List-H, (K. Wilkinson)
London CS 6099	Decca SXL 2178 & SWL 8016	RM15, Penguin **(*)	ED1, BB, 2K-1K, $

London Label & Serial Number LONDON 唱片公司, 編號	Decca Label & Serial Number DECCA 唱片公司, 編號	Remarks & Ratings 附註和評價	1st Labels & Reference Prices 首版和參考價格
London CS 6100 (©=STS 15471)	Decca SXL 2114*, (BB) (©=SDD 191)	Penguin **(*)	ED1, BB, 2E-1D
London CS 6101 (©=STS 15031)	Decca SXL 2134 (©=SDD 217)	RM15, (K. Wilkinson)	ED1, BB, 1K-1K
London CS 6102	No Decca SXL (=SKL 4043)		ED1, BB, 1K-1K
London CS 6103 (CSA 2302, part)	Decca SXL 2115 (©=SDD 470)	RM14, Penguin **(*)	ED1, BB, 1E-1E
London CS 6104 (CSA 2302, part)	Decca SXL 2187 (©=SDD 471)	RM14, Penguin **(*)	ED1, 1D-1D
London CS 6105 (CSA 2302, part)	Decca SXL 2201 (©=SDD 472)	RM14, Penguin **(*)	ED1, 1D-1D
London CS 6106 (©=STS 15123)	Decca SXL 2183	RM16	ED1, BB, 5E-2E
London CS 6107 (©=STS 15087)	Decca SXL 2135 (©=SDD 122, 331, part)	RM14, (K. Wilkinson)	ED1, BB, 1E-1E, rare!! $
London CS 6108 (©=STS 15143)	No Decca SXL (LXT 5306, ©=SPA 221)	RM13	ED1, BB, 1E-1E, rare! $$
London CS 6109 (©=STS 15059)	No Decca SXL (LXT 5293, ©=ECS 796)	RM15	ED1, BB, 1E-1E
London CS 6110 (©=STS 15144)	No Decca SXL (LXT 5292, ©=ECS 643)	RM14	ED1, BB, 1E-1E
London CS 6111 (©=STS 15024)	No Decca SXL (=LXT 5278)	RM12	ED1, BB, 1E-2E
London CS 6112	No Decca SXL (=LXT 5271)	ED1, BB, 2E-1E	Very rare!!! $$
London CS 6116 (©=STS 15108)	Decca SXL 2141* (©=ECS 642)	RM13, Penguin **(*)	ED1, BB, 1M-1M, $
London CS 6117 (©=STS 15060)	No Decca SXL (=LXT 5241)	RM13	ED1, BB, 2E-1E
London CS 6118 (©=STS 15120)	No Decca SXL (=LXT 5245)		ED1, BB, 2M-1M
London CS 6119 (©=STS 15145)	No Decca SXL (LXT 5244, ©=ECS 640)	RM10	ED1, BB, 1E-1E, rare! $$
London CS 6120 (©=STS 15032)	No Decca SXL (=LXT 5232)	RM13	ED1, BB, 2E-1E
London CS 6121	No Decca SXL (=LXT 5288)		ED1, BB, 1E-1E, Pancake, $
London CS 6126*	No Decca SXL (LXT 5022, ©=ECS 576)	RM19, AS List (Speakers Corner)	ED1, BB, 1E-1E, Pancake, rare!!! $$
London CS 6127 (CSA 2204, ©=STS 15598)	Decca SXL 2153 (SXL 2107-8, ©=SDD 257)	RM18, Penguin **(*)	ED1, BB, 3E-2E
London CS 6128 (CSA 2201 & SXL 2084-5)	Decca SWL 8009 (10" LP)	RM15	ED1, BB, 1E-2E, $
London CS 6129 (©=STS 15083)	Decca SXL 2154 (©=SDD 175)	RM12, Penguin **(*)	ED1, BB, 3E-2E (gatefold) $

London Label & Serial Number LONDON 唱片公司, 編號	Decca Label & Serial Number DECCA 唱片公司, 編號	Remarks & Ratings 附註和評價	1st Labels & Reference Prices 首版和參考價格
London CS 6130	Spain; No Decca SXL	RM17, ED1, BB, 1E-1E,	Very rare!!! $$$
London CS 6131 (©=STS 15061)	Decca SXL 2156 (©=SDD 130)	RM12	ED1, BB, 5G-2G, $
London CS 6132 (©=STS 15361)	Decca SXL 2157 (©=SDD 200)	RM18, Penguin ***	ED1, BB, 1E-2D, rare!! $$
London CS 6133 (©=STS 15088)	Decca SXL 2196* (©=SDD 171; ECS 740; SPA 550)	RM19, Penguin ***, (K. Wilkinson)	ED1, BB, 1E-2E, $
London CS 6134	Decca SXL 2155* (©=ECS 670)	RM12	ED1, BB, 2E-2D, $$$
London CS 6138 (©=STS 15011)	Decca SXL 2188 (©=SDD 136, ECS 776)	RM16, Penguin ***, (K. Wilkinson)	ED1, BB, 2E-2E, rare!! $$
London CS 6139*	No Decca SXL (LXT 5100, ©=ECS 772, 773)	RM13	ED1, BB, 1M-1M, $
London CS 6140 (©=STS 15034)	No Decca SXL (LXT 5099, ©=ECS 766)	RM7	ED1, BB, 1D-1D, $
London CS 6141 (©=STS 15062)	Decca SXL 2214 (©=SDD 116)	RM10, Penguin **(*), Japan 300	ED1, BB, 1D-2D, $$
London CS 6142 (©=STS 15063)	Decca SXL 2204* (©=SDD 310)	RM15, Penguin **(*)	ED1, BB, 1E-1E, $
London CS 6143 (©=STS 15089)	Decca SXL 2274 (©=SDD 108, SPA 328)	RM14, Penguin ***	ED1, BB, 2E-2E , (Gatefold)
London CS 6145 (=CS 6778)	Decca SXL 2165 (©=SDD 103)	RM12	ED1, BB, 3E-3D
London CS 6146 (reissue=CS 6779)	Decca SXL 2174* (©=SDD 194; SPA 374)	RM16, Penguin **(*), AS list (Speakers Corner)	ED1, BB, 1E-2E
London CS 6147 (©=STS 15090)	Decca SXL 2164* (©=SDD 170)	RM19, Penguin *** �キ, G.Top 100, AS list-F	ED1, BB, 3E-1E, $
London CS 6148	Spain; No Decca SXL	ED1, BB, 3M-1M	Very rare!! $$$
London CS 6149 (©=STS 15268)	Decca SXL 2163 (©=SDD 474)	RM14, Penguin ***	ED1, BB, 2E-2E, $
London CS 6150 (©=STS 15016)	Decca SXL 2166 (©=SDD 131)	(K. Wilkinson)	ED1, BB, 1E-1E, Very rare!! $$$
London CS 6151	Decca SXL 2172 (©=SDD 137, SPA 385)	RM14, (K. Wilkinson)	ED1, BB, 2D-1D, $
London CS 6152	Spain; No Decca SXL	RM17, TAS2017	ED1, BB, 1M-1M, rare! $$+
London CS 6153 (©=STS 15046)	Decca SXL 2176 (©=SDD 428; SPA 505)	RM15, Penguin ***, R2D4, (K. Wilkinson)	ED1, BB, 1D-1D
London CS 6154 (©=STS 15362)	Decca SXL 2177 (©=SDD 452)	RM16, Penguin **(*)	ED1, BB, 2E-2E
London CS 6156	Decca SXL 2179 (©=SPA 452)	Penguin ***	ED1, BB, 2E-2E, $
London CS 6157 (©=STS 15407)	Decca SXL 2173*	RM16, Penguin ***, AS-DG list (Speakers Corner)	ED1, BB, 4D-2D

London Label & Serial Number LONDON 唱片公司, 編號	Decca Label & Serial Number DECCA 唱片公司, 編號	Remarks & Ratings 附註和評價	1st Labels & Reference Prices 首版和參考價格
London CS 6158 (©=STS 15150)	Decca LXT 5484 (No SXL, Mono only), **[Not Decca SXL 6218 (=LXT 6218, mono)]	RM14	ED1, BB. 2E-1E
London CS 6159 (©=STS 15151)	(Bartok issued only in LW 5349, mono 10")	No Decca SXL	ED1, BB, 1E-2E, $
London CS 6160 (©=STS 15064)	Decca SXL 2193 (©=SDD 106)	RM13	ED1, BB, 1E-1E, $
London CS 6161	Decca SXL 2241	Penguin **(*), Japan 300	ED1, BB, 1E-1E, $$
London CS 6163	Decca SXL 2194 (©=ECS 803)	RM16, Penguin ***	ED1, BB, 2E-1E, Very rare!, $$+, (ED2, 2E-1E, $+)
London CS 6165	Decca SXL 2197* (©=SDD 420; ECS 808; DPA 629)	RM16, AS list-H	ED2, BB, 2E-1E, $
London CS 6169 (©=STS 15035)	No Decca SXL (LXT 5177, ©=ECS 687)	RM11, Penguin ** & ***	ED1, BB, 1M-1M
London CS 6170 (©=STS 15004)	Decca SXL 2206 (©=SDD 120)	RM13	ED1, BB, 1E-1E
London CS 6172 (Part of Decca SXL 2219)	No Decca SXL, = DECCA LXT 5110	RM14	ED1, BB, 1M-1M
London CS 6173 (Part of Decca SXL 2219)	No Decca SXL, = DECCA LXT 5029	RM14	ED1, BB, 1M-1M
London CS 6174 (©=STS 15152)	Decca SXL 2231	RM15	ED1, BB, 1M-1M, $$
London CS 6177	Decca SXL 2195 (©=SPA 229)	RM13	ED1, BB, 1E-1E, $+
London CS 6178 (©=STS 15597)	Decca SXL 2238* (©=SDD 331, part)	RM19, Penguin ***, (K. Wilkinson)	ED1, BB, 2E-1E
London CS 6179	Decca SXL 2189	RM19, Penguin ***, TAS2016, AS List-H	ED1, BB, 2E-1E
London CS 6181 (©=STS 15099)	No Decca SXL (Decca=SDD 201)	RM14	ED1, BB, 1E-2E, $
London CS 6182	Decca SXL 2198* (©=DPA 549-50, part)	RM18, Penguin ***	ED1, BB, 1E-1E
London CS 6183 (©=STS 15067)	Decca SXL 2235 (©=SDD 107, SPA 237)	RM12	ED1, BB, 1E-1E
London CS 6184 (©=STS 15068)	Decca SXL 2228 (©=SDD 102; ECS 739)	RM14	ED1, BB, 1E-1E
London CS 6185	No Decca SXL (©=SPA 314)	RM16, Penguin ***	ED1, BB, 2E-2E, $
London CS 6186	Decca SXL 2229	RM13	ED1, BB, 1E-1E, $
London CS 6187	Decca SXL 2218*	RM18, *AS List (Speakers Corner), (K. Wilkinson)	ED1, BB, 3M-3E, $
London CS 6188; (SXL 2178, part)	Decca SXL 2178 (part)	RM16, Penguin **(*)	ED1, BB, 1E-1E, rare!! $$+
London CS 6189 (©=STS 15069)	Decca SXL 2244		ED1, BB, 2E-1E, $

London Label & Serial Number LONDON 唱片公司, 編號	Decca Label & Serial Number DECCA 唱片公司, 編號	Remarks & Ratings 附註和評價	1st Labels & Reference Prices 首版和參考價格
London CS 6190	Decca SXL 2237* (©=SDD 239; ECS 820, 821)	RM14	ED1, BB, 1E-2E
London CS 6191 (©=STS 15091)	Decca SXL 2246* (©=SDD 145, SPA 503)	RM20, Penguin ***, G.Top 100, TAS 44-178	ED2, BB, 2E-3E, $+, (ED1,? rare!) (K. Wilkinson)
London CS 6192 (©=STS 15045)	Decca SXL 2239		ED1, BB, 2E-1E, $
London CS 6193 (©=STS 15153)	Decca SXL 2240	RM15	ED1, BB, 1E-1E, rare!! $$
London CS 6194	Decca SXL 2243* (©=SDD 180)	RM16, Penguin **(*), AS-DG list (Speakers Corner)	ED1, BB, 3E-2E, $
London CS 6195	Decca SXL 2236 (©=SDD 223; SPA 458)	RM14, (K. Wilkinson)	ED1, BB, 2E-1E, $
London CS 6196	Decca SXL 2232*	RM18, (K. Wilkinson)	ED1, BB, 3E-1E, $$
London CS 6197 (©=STS 15491)	Decca SXL 2259 (©=SDD 272; ECS 788)	RM17, Penguin ***	ED1, BB, 1E-1E
London CS 6198 (©=STS 15009)	Decca SXL 2249* (©=SDD 123, SPA 377)	RM17, Penguin **(*)	ED1, BB, 1E-3E, $
London CS 6199 (©=STS 15070)	Decca SXL 2250 (©=SDD 127, SPA 406, part)	RM14, Penguin **(*)	ED1, BB, 1E-4E, $
London CS 6200	Decca SXL 2252* (©=SDD 144, ECS 782, 801)	RM16, TAS SM 67- 138++, Penguin ***, (Wilkinson)	ED1, BB, 1E-1E, rare! $$ AS list (Speakers Corner)
London CS 6201	Spain, No Decca SXL	RM15	ED1, BB, 4E-2E, rare! $
London CS 6202	Spain, No Decca SXL	RM14	ED1, BB, 1E-4E, rare! $
London CS 6203	Decca SXL 2262	(K. Wilkinson)	ED1, BB, 1E-1E
London CS 6204	Decca SXL 2266*	RM14, Penguin ***, AS List (Speakers Corner)	ED1, BB, 2E-1E, $
London CS 6205	Decca SXL 2263 (©=SDD 192, ECS 827)	RM16	ED1, BB, 2E-1E
London CS 6206 (©=STS 15441)	Decca SXL 2265* (©=SDD 411)	RM16, Penguin ***, Japan 300	ED1, BB, 1E-1E, rare! $
London CS 6207	Decca SXL 2270* (©=ECS 686)	RM17	ED1, BB, 1L-1L, $
London CS 6208	Decca SXL 2275 (©=SDD 231, ECS 801)	RM16, Penguin **(*)	ED1, BB, 2E-1L, $
London CS 6209	Decca SXL 2269 (©=SPA 119)	RM15, Penguin ***	ED1, BB, 1E-1E
London CS 6210 (©=STS 15092)	Decca SXL 2273	RM12	ED1, BB, 1L-2L, $
London CS 6211	Decca SXL 2261 (©=SDD 211)	RM16	ED1, BB, 2E-2E
London CS 6212	Decca SXL 2268 (©=SDD 496, SDD 151; ECS 735)	RM15, Penguin **(*)	ED1, BB, 1D-1D, $
London CS 6213 (©=STS 15094)	Decca SXL 2245		ED1, BB, 1E-1E
London CS 6214	Decca SXL 2272 (©=SDD 198)	RM13	ED1, BB, 4E-2E, $

London Label & Serial Number LONDON 唱片公司, 編號	Decca Label & Serial Number DECCA 唱片公司, 編號	Remarks & Ratings 附註和評價	1st Labels & Reference Prices 首版和參考價格
London CS 6215	Decca SXL 2279 (©=SDD 126, SPA 398)		ED1, BB, 1E-3E, rare!! $$
London CS 6216 (=CS 6780)	Decca SXL 2280	RM16, (K. Wilkinson)	ED1, BB, 2E-2E
London CS 6217 (=CS 6781)	Decca SXL 2276	RM14, Penguin **, (K. Wilkinson)	ED1, BB, 1E-1E, $
London CS 6218	Decca SXL 2285	RM17, Penguin ***, (K. Wilkinson)	ED1, BB, 2E-2E
London CS 6219	Decca SXL 2277 (©=SDD 238; ECS 820)	RM12	ED1, BB, 2L-1L, $
London CS 6220 (©=STS 15103),		RM10	ED1, BB, 1D-1D, $
London CS 6221 (©=STS 15104)	No Decca SXL (©=SDD 204)		ED1, BB, 1D-1D, rare! $
London CS 6222	Decca SXL 2291 (©=SDD 320)		ED1, BB, 2L-2L, $
London CS 6223	Decca SXL 2292* (©=SDD 399, part)	RM13, Penguin**(*)	ED1, BB, 1E-1E, $
London CS 6224	Decca SXL 2296* (©=SDD 321)	RM19, Penguin **(*), TAS 2017 (45rpm), Japan 300	ED1, BB, 3E-1E, $$ AS list-F (Speakers Corner)
London CS 6225	Decca SXL 2287 (©=SDD 239, 425 & 425)	RM13, Penguin **(*)	ED1, BB, 2E-2D, $+
London CS 6226	Decca SXL 2278 (©=SDD 277)	RM14, Penguin **(*)	ED1, BB, 5E-6R, $
London CS 6227	Decca SXL 2303 (©=SDD 388)	RM16, Penguin ***	ED1, BB, 6E-4E, $
London CS 6228 (©=STS 15101)	Decca SXL 2289* (©=SPA 87)	RM17, Penguin ***, AS List-F (Speakers Corner)	ED1, BB, 2E-1E, very rare!! $$$ (ED2, 6W-4W, $$)
London CS 6230	Decca SXL 2284		ED1, 1D-1D, $
London CS 6231	Decca SXL 2286 (©=SDD 291)	RM16, Penguin ***	ED1, BB, 1D-1D, $$ (White Back, 1D-1D, $)
London CS 6232	Decca SXL 2288 (©=SDD 473)		ED1, BB, 6T-5T
London CS 6234	Decca SXL 2297 (©=SDD 249)	RM16, Penguin **(*) & ***	ED1, 1D-1D, $
London CS 6235 (©=STS 15115)	Decca SXL 2293 (©=SPA 110)	(K. Wilkinson)	ED1, 6W-1E, rare! $
London CS 6236	Decca SXL 2302* (©=SDD 169, SPA 120)	RM19, Penguin ***, (K. Wilkinson)	ED1, 1E-1E, rare!! $-$$, (ED1, 2E-2E)
London CS 6237	Decca SXL 2298*	RM16, Penguin ***	ED1, BB, 1E-1E, $
London CS 6240	Decca SXL 2306 (SXL 2306-7)		ED1, BB, 1E-1E, rare! $$
London CS 6241	Decca SXL 2311	RM18, TAS2016, AS List-H	ED1, BB, 1D-2D
London CS 6242	Decca SXL 2307 (SXL 2306-7)	RM15	ED1, BB, 1D-1D, rare! $
London CS 6243 (©=STS 15541)	Decca SXL 6004 (©=SDD 129; ECS 754)	RM14	ED1, BB, 1E-1E

London Label & Serial Number LONDON 唱片公司, 編號	Decca Label & Serial Number DECCA 唱片公司, 編號	Remarks & Ratings 附註和評價	1st Labels & Reference Prices 首版和參考價格
London CS 6244	Decca SXL 2305 (©=SDD 400)	RM15, Penguin ***	ED1, BB, 3E-1E
London CS 6245 (=CS 6782)	Decca SET 227		ED1, 2E-1E (Gatefold)
London CS 6246	No Decca SXL (=SWL 8500, Decca 10" LP)	RM16	ED1, BB, 1E-1E, $
London CS 6247	No Decca SXL (=SWL 8018, Decca 10'' LP)	RM15	ED1, BB, 1E-1E, $
London CS 6248 (©=STS 15356)	Decca SXL 2312* (©=SDD 425)	RM15, Penguin **(*), (K. Wilkinson)	ED1, BB, 3D-1D, $
London CS 6249	Decca SET 231 (©=SDD 284)		ED1, BB, 1E-1E, $
London CS 6251	Decca SXL 6002		ED1, 3E-4E, (Gatefold)
London CS 6252	Decca SXL 2313*	RM20, TASEC Top-12, Penguin ***, AS list	ED1, BB, 2E-3E, $
London CS 6322	Decca SXL 6000*	RM17, TASEC65, Penguin ***, AS list	ED1, BB, 2E-2E, $
London CS 6323	Decca SXL 6001	RM18, TASEC65, Penguin **(*), AS list	ED1, BB, 1G-1G, $
London CS 6324	Decca SXL 6006	RM18, TAS-OLD, Penguin ***, (Wilkinson)	ED1, BB, 2E-2E
London CS 6325 (©=STS 15271)	No Decca SXL	RM17	ED1, BB, 1G-1G, $$
London CS 6327	Decca SXL 6018 (©=SDD 179; ECS 767)	RM15	ED1, BB, 2G-2W, $
London CS 6328	Decca SXL 6025 (©=SDD 421)	RM14	ED1, BB, 5W-2G
London CS 6329	Decca SXL 6023*	RM19, Penguin ***, TAS2016, G.Top 100	ED1, BB, 2G-3G, $ (K. Wilkinson)
London CS 6330	Decca SXL 6024 (©=SPA 202)	RM16, Penguin ***	ED1, BB, 1G-1G, $
London CS 6331 (©=STS 15154)	Decca SXL 6027 (©=SPA 228, part)	RM14, Penguin **(*)	ED1, BB, 2E-1E
London CS 6332 (©=STS 15364)	Decca SXL 6026* (©=SDD 417)	RM17, TAS2016, Penguin ***, (Wilkinson)	ED1, BB, 1D-1D, $
London CS 6333 (CSA 2306)	Decca SXL 6020 (©=SDD 182)	RM13	ED2, 2G-2W, (1st), rare! $ [FFrr Logo]
London CS 6334 (CSA 2306)	Decca SXL 6021 (©=SDD 183)	RM14	ED2, 1G-1G, (1st), rare! $ [FFrr Logo]
London CS 6335 (CSA 2306)	Decca SXL 6022* (©=SDD 184)	RM14	ED2, 1G-1G, (1st), rare!!, $ [FFrr Logo]
London CS 6336	Decca SXL 6028 (©=SDD 422)	RM14, Penguin **(*)	ED1, BB, 2D-3D, $
London CS 6337	Decca SXL 6035 (©=SDD 465)	RM20, Penguin ***, AS List-H	ED1, BB, 1E-1E, $$
London CS 6338 (©=STS 15046)	Decca SXL 6036* (©=SDD 156; ECS 795)	RM18, Penguin ***, TAS2017 (ADEC 6036)	ED1, BB, 1E-1E, $ [FFrr Logo]
London CS 6339	No Decca SXL (=SWL 8502, 10" LP only)	RM 6	ED1, 1E-1E, rare! $

London Label & Serial Number LONDON 唱片公司, 編號	Decca Label & Serial Number DECCA 唱片公司, 編號	Remarks & Ratings 附註和評價	1st Labels & Reference Prices 首版和參考價格
London CS 6340 [From CS 6340, cover changed]	Decca SXL 6040	RM17, Penguin **(*)	ED1, BB, 2E-2E, [FFrr Logo]
London CS 6341 (©=STS 15272)	Decca SXL 6041 (©=SDD 498)	Penguin ***	ED1, BB, 1E-1E, $ [FFrr Logo]
London CS 6345 (©=STS 15524)	Decca SXL 6141 (©=SPA 227)	RM15	ED1, BB, 1E-1E, $, [FFrr Logo]
London CS 6346	Decca SXL 6049	RM16, Penguin ***	ED1, BB, 1E-1E, [FFrr Logo]
London CS 6347	Decca SXL 6050	RM16, Penguin ***	ED1, BB, 1E-1E, [FFrr Logo]
London CS 6348	Decca SXL 6051	RM16, Penguin ***	ED1, BB, 1E-1E, [FFrr Logo]
London CS 6349	Decca SXL 6052	RM16, Penguin ***	ED1, BB, 1E-1E, [FFrr Logo]
London CS 6350	Decca SXL 6053	RM16, Penguin ***	ED1, BB, 2E-1E, [FFrr Logo]
London CS 6351 (©=STS 15071)	Decca SXL 6054 (©=SDD 155; SPA 495)	Penguin ***, AS list-H (SDD 155)	ED1, BB, 2E-2E, [FFrr Logo]
London CS 6352	Decca SXL 6055 (©=SDD 290 & 340)	Penguin **(*)	ED1, BB, 1E-1E, $ [FFrr Logo]
London CS 6354	Decca SXL 6056	Penguin **	ED1, BB, 1E-1E, $ [FFrr Logo]
London CS 6356	Spain; No Decca SXL		ED1, BB, 1G-2W, $ [FFrr Logo]
London CS 6357	Decca SXL 6043 (©=SDD 270)	Penguin ***	ED1, BB, 1E-1E [FFrr Logo]
London CS 6358	Decca SXL 6044*	TAS2016, Penguin ***, (K. Wilkinson)	ED1, BB, 3G-3G [FFrr Logo] AS List-H (D6D 7)
London CS 6359	Decca SXL 6057	Penguin **(*)	ED1, BB, 1E-2E, rare! $ [FFrr Logo]
London CS 6360	Decca SXL 6058	Penguin ***	ED1, BB, 3E-3E, [FFrr Logo]
London CS 6365	Decca SXL 6063		ED1, BB, 1E-1E, $, [FFrr Logo]
London CS 6366	Decca SXL 6064		ED1, BB, 1E-2E, rare! $, [FFrr Logo]
London CS 6367	Decca SXL 6065*	Penguin ***	ED1, 2E-1E, rare! $ [FFrr Logo]
London CS 6368	Decca SXL 6066 (©=SDD 244)	TASEC (CSA 2308)	ED1, BB, 3E-2E, rare! $$ [FFrr Logo]
London CS 6369	Decca SXL 6067	Penguin **(*)	ED1, 2E-1E, rare! $ [FFrr Logo]
London CS 6370	No Decca SXL (= ARGO ZRG 5372)		ED1, 1G-1G, rare! $, [FFrr Logo]
London CS 6371	Decca SXL 6076*	Penguin ***	ED1, 4E-2E, rare! $, [FFrr Logo]

London Label & Serial Number LONDON 唱片公司, 編號	Decca Label & Serial Number DECCA 唱片公司, 編號	Remarks & Ratings 附註和評價	1st Labels & Reference Prices 首版和參考價格
London CS 6374 (©=STS 15212)	Decca SXL 6082 (©=SDD 228)	Penguin **(*)	ED1, 1E-1E, [FFrr Logo]
London CS 6375	Decca SXL 6084	Penguin ***	ED1, 3G-3G, [FFrr Logo]
London CS 6376	Decca SXL 6085		ED1, 6F-5F, [FFrr Logo]
London CS 6377	Decca SXL 6088* (©=SDD 445)	Penguin **(*), TAS2016	ED1, 2G-2G, $$, [FFrr Logo]
London CS 6378	Decca SXL 6086 (©=SDD 172; ECS 762)		ED1, rare! $ (ED2, 1G-1G), [FFrr Logo]
London CS 6379 [Last ED1 issue]	Decca SXL 6087, ED1, (©=SDD 289, 290)	Penguin **(*)	ED1, BB, 1G-2G, rare!! $+, [FFrr Logo]
London CS 6381	Decca SXL 6089, ED1, (SXLJ 6644; D105D 5)	Penguin ***	ED2, 2G-2G, (1st), rare!
London CS 6382	Decca SXL 6090, ED1, (SXLJ 6644; D105D 5)	Penguin ***	ED2, 1G-1G, (1st)
London CS 6383	Decca SXL 6091, ED1, (©=SDD 480)	Penguin **(*)	ED2, 1E-1E, (1st), rare!! $
London CS 6384	Decca SXL 6092 (©=SDD 254)	Penguin ***	ED2, 2W-1W, (1st), rare!!
London CS 6385	Decca SXL 6093, ED1, (©=SDD 285)	Penguin ***	ED2, 1W-1W, (1st), rare!! $
London CS 6386	Decca SXL 6094, ED1		ED2, 2G-1G, (1st), $
London CS 6387	Decca SXL 6095, ED1		ED2, 1G-1G, (1st)
London CS 6388	Decca SXL 6096, ED1, (©=SDD 101)		ED2,1G-1G
London CS 6389	Decca SXL 6097, ED1		ED2, 3L-7L, $
London CS 6390	Decca SXL 6099, ED1		ED2, 3E-3E
London CS 6391	Decca SXL 6100, ED1 (©=SPA 282)		ED2, 2G-1G
London CS 6392	Decca SXL 6101, ED1 (©=Jubilee JB 9)	Penguin ***	ED2, 1E-1E, (ED3, 1E-1E)
London CS 6393	Decca SXL 6102, ED1 (©=SDD 318)	Penguin **(*)	ED2, 1E-1E
London CS 6394 (©=STS 15207)	Decca SXL 6103, ED1 (©=SDD 250)	Penguin ***	ED2, 2E-2E
London CS 6395	Decca SXL 6104, ED1 (©=SDD 319)	Penguin ***	ED2, 1E-1E
London CS 6396	Decca SXL 6105, ED1 (©=SDD 532, SDDA 261-9)	(K. Wilkinson)	ED2, 4L-6G
London CS 6397 (©=STS 15210)	Decca SXL 6109 (©=SDD 225)	Penguin **(*)	ED2, 2E-3E
London CS 6398	Decca SXL 6110, ED1	Penguin ***, TAS2017, (K. Wilkinson)	ED2, 3E-2W
London CS 6399 (Reissue=CS 6783)	Decca SXL 6111*, ED1	Penguin ***, TAS 72++, AS-DG (Speakers Corner)	ED2, 1E-1E

London Label & Serial Number LONDON 唱片公司, 編號	Decca Label & Serial Number DECCA 唱片公司, 編號	Remarks & Ratings 附註和評價	1st Labels & Reference Prices 首版和參考價格
London CS 6400	Decca SXL 6112, ED1 (©=SDD 427)	(K. Wilkinson)	ED2, 1E-1E
London CS 6401	Decca SXL 6113*, ED1	Penguin ***	ED2, 1E-3E (Gatefold)
London CS 6402	Decca SXL 6115, ED1	Penguin ***, AS List-H (D6D 7), (K. Wilkinson)	ED2, 1E-1E
London CS 6403	Decca SXL 6108, ED1 (©=SDD 364)	Penguin ***	ED2, 2E-1E
London CS 6404	Decca SXL 6118, ED1 (©=SDD 533, SDDA 261-9)	(K. Wilkinson)	ED2, 2L-2L
London CS 6405	Decca SXL 6119, ED1		ED2, 2E-2L, $
London CS 6406	Decca SXL 6120 (©=SDD 399, part)	Penguin **(*)	ED2, 1L-1L
London CS 6407	Decca SXL 6121, ED1		ED2, 1L-1L, $
London CS 6408	Decca SXL 6125, ED1	Penguin ***	ED2, 1L-1L
London CS 6409	Decca SXL 6164, ED1		ED2, 2W-1W
London CS 6410	Decca SXL 6129, ED1 (©=SDD 534, SDDA 261-9)	(K. Wilkinson)	ED2, 1E-2W
London CS 6411	Decca SXL 6130, ED1		ED2 1E-1E
London CS 6412	Decca SXL 6131, ED1 (D121D 10)	Penguin ***	ED2, 1W-1W
London CS 6413	Decca SXL 6132, ED1 (D121D 10)	Penguin ***	ED2, 1W-1W
London CS 6414	Decca SXL 6133, ED1 (D121D 10)	Penguin **(*)	ED2, 1W-1W
London CS 6415	Decca SXL 6134, ED1	Penguin ***	ED2, 3W-2W
London CS 6416	Decca SXL 6135, ED1	Penguin ***	ED2, 3W-2W
London CS 6417	Decca SXL 6136*, ED1 (©=JB 55)	Penguin ***, Japan 300, (K. Wilkinson)	ED1, 1E-2W AS-DG list (Speakers Corner)
London CS 6418	Decca SXL 6137, ED1	Penguin ***	ED2, 1W-1W
London CS 6419	Decca SXL 6138, ED1 (©=JB 121, part)	Penguin ***, AS List (JB 121)	ED2, 1W-1W
London CS 6420	Decca SXL 2308, ED1	Penguin ***	ED2, rare!
London CS 6422	Decca SXL 6143, ED1	Penguin ***, Japan 300-CD	ED2, 1W-2W
London CS 6423;	No Decca SXL		ED2, 1D-1D, (Promote),$
London CS 6424	No Decca SXL		ED2, 2G-1G, rare!! $
London CS 6425	No Decca SXL		ED2, 2G-1G, rare!! $
London CS 6426	Decca SXL 6159, ED2 1st	Penguin **(*)	ED2, 1W-1W
London CS 6427	Decca SXL 6162, ED2 1st		ED2, 1W-1W
London CS 6428	Decca SXL 6163, ED2 1st	Penguin **(*)	ED2, 1W-1W
London CS 6429	Decca SXL 6157, ED1	Penguin ***	ED2, 1W-2W, 1st
London CS 6430	Decca SXL 2283		ED2, BNLPS-69/7, 1G-1G
London CS 6431 (©=STS 15220)	Decca SXL 6148, ED1 (©=SDD 309)	Penguin **(*)	ED2, 1L-1L, rare!

London Label & Serial Number LONDON 唱片公司, 編號	Decca Label & Serial Number DECCA 唱片公司, 編號	Remarks & Ratings 附註和評價	1st Labels & Reference Prices 首版和參考價格
London CS 6432 (©=STS 15245)	Decca SXL 6151, ED1 (©=SDD 322)	Penguin ***	ED2, 1L-1L, rare! $
London CS 6433 (©=STS 15247)	Decca SXL 6150, ED1 (©=SDD 325)	Penguin ***	ED2, 1L-1L
London CS 6434	Decca SXL 6158, ED1	Penguin ***, (K. Wilkinson)	ED2, 1W-1W
London CS 6435	Decca SXL 6172, ED2 1st (=SXL 6676)		ED2, 2W-3W
London CS 6436	Decca SXL 6166, ED2 1st		ED2, 1G-1G
London CS 6437	Decca SXL 6167, ED1		ED2, 2G-2G
London CS 6438	Decca SXL 6168, ED1 (©=SPA 204; Jubilee JB 10)	Penguin **(*), AS List	ED2, 1W-1W, $
London CS 6439	Decca SXL 6165, ED1		ED2, 2L-4L
London CS 6440	Decca SXL 6174, ED2 1st (Part of SXL 6639)	Penguin ***, (K. Wilkinson)	ED2, 1G-1G
London CS 6441	Decca SXL 6173, ED2 1st (©=SDD 376)		ED2, 1W-1W
London CS 6442 (©=STS 15387)	Decca SXL 6170, ED1 (©=SDD 383)	Penguin ***	ED2, 1L-1L
London CS 6443	Decca SXL 6169, ED2 1st (©=SDD 440)		ED2, 1L-1L
London CS 6444	Decca SXL 6160, ED1 (©=SDD 535, SDDA 261-9)	Penguin **(*), (K. Wilkinson)	ED2, 2W-3W
London CS 6445	Decca SXL 6179, ED2 1st		ED2, 1W-2W
London CS 6446	Decca SXL 6181, ED2 1st	Penguin ***	ED2, 2E-2E
London CS 6448 (One of CSA 2214)	Decca SXL 6182, ED2 1st (©=SDD 278)		ED2, 4L-5L
London CS 6449 (One of CSA 2214)	Decca SXL 6183, ED2 1st (©=SDD 279)		ED2, 1W-1W
London CS 6450	Decca SXL 6184, ED2 1st (©=SDD 443)		ED2, 2W-1W, rare! $
London CS 6451 (©=STS 15211)	Decca SXL 6189, ED1 (©=SDD 227)	Penguin ***	ED2, 2W-1W
London CS 6452	Decca SXL 6187, ED1	Penguin **(*)	ED2, 1W-1W
London CS 6453	Decca SXL 6186, ED1		ED1, 1W-2W, rare!
London CS 6454	Decca SXL 6188, ED1	Penguin ***, AS List-H	ED2, rare! $
London CS 6456	Decca SXL 6204, ED1 (©=ECS 824; SPA 230)	TASEC	ED2, 2W-4W
London CS 6457	Decca SXL 6205, ED2 1st (©=ECS 759)		ED2, 1W-2W
London CS 6458	Decca SXL 6203, ED2 1st	Penguin**(*), AS list-H	ED2, 1W-2W
London CS 6459	Decca SXL 6197, ED2 1st (D121D 10)	Penguin ***	ED2, 2W-2W
London CS 6460	Decca SXL 6198, ED2 1st (D121D 10)	Penguin ***	ED2, 2W-3W

London Label & Serial Number LONDON 唱片公司, 編號	Decca Label & Serial Number DECCA 唱片公司, 編號	Remarks & Ratings 附註和評價	1st Labels & Reference Prices 首版和參考價格
London CS 6461	Decca SXL 6199, ED2 1st (D121D 10)	Penguin ***	ED2, 2W-4W
London CS 6462	Decca SXL 6202, ED1	Penguin **(*)	ED2, 2G-2G
London CS 6463	Decca SXL 6206, ED1		ED2, 1G-1G
London CS 6464	Decca SXL 6196, ED2 1st		ED2, 1W-1W, $
London CS 6465	Decca SXL 6208, ED1 (©=SDD 531)		ED2, 1W-2W, rare! $
London CS 6469 (=CS 6784)	Decca SXL 6212, ED1	Penguin ***, AS list-F, TAS 65-176++ (K. Wilkinson)	ED2, 1W-1W
London CS 6470	Decca SXL 6213, ED1 (©=SDD 323; ECS 760)		ED2, 2W-1W
London CS 6471	Decca SXL 6214, ED1	Penguin **(*)	ED2, 3W-2W
London CS 6472	Decca SXL 6215, ED1	Penguin ***	ED2, 1W-1W
London CS 6473	Decca SXL 6217, ED2 1st (©=SDD 536, SDDA 261-9)	Penguin ***, (K. Wilkinson)	ED2, 1W-1W
London CS 6474	Decca SXL 6218, ED1 (©=SDD 538, SDDA 261-9)	(K. Wilkinson)	ED2, 1W-1W
London CS 6477	Decca SXL 6219, ED2 1st (©=SDD 537, SDDA 261-9)	Penguin ***	ED2, 1W-4W
London CS 6479	Decca SXL 6225*, ED1	TAS2016	ED2, 1G-1G, rare! $
London CS 6480 (©=STS 15289)	Decca SXL 6227, ED2 1st (©=SDD 464)	Penguin ***, (K. Wilkinson)	ED2, 2W-5W
London CS 6481	Decca SXL 6226, ED2 1st		ED2, 1W-2W, rare! $
London CS 6482	Decca SXL 6228, ED1 (©=SDD 539, SDDA 261-9)	(K. Wilkinson)	ED2, 7W-1W
London CS 6483	Decca SXL 6232, ED1	Penguin ***	ED2, 2G-2G, $
London CS 6485	Decca SXL 6256, ED2 1st	Penguin **(*)	ED2, 7W-1W
London CS 6486	Decca SXL 6235, ED2 1st		ED2, 2G-2G
London CS 6487	Decca SXL 6209, ED2 1st (©=SDD 486)	TASEC =* Linn Recut 01, Penguin ***	ED2, 4L-5L (K. Wilkinson)
London CS 6488	Decca SXL 6236, ED2 1st	Penguin **(*)	ED2, (ED4, 6Y-6Y)
London CS 6489	Decca SXL 6246, ED1 (D121D 10)	Penguin ***	ED2, 1W-3L
London CS 6490	Decca SXL 6247, ED1 (D121D 10)	Penguin ***	ED2, 1W-1W
London CS 6491	Decca SXL 6248, (D121D 10) *[(Last ED1 issue) From SXL 6249 ED2 is the 1st issue]	Penguin ***	ED2, 1W-1W
London CS 6494	Decca SXL 6252, ED2 1st	Penguin ***	ED2, 1W-1W
London CS 6495	Decca SXL 6253, ED2 1st	Penguin ***, AS List-H (D6D 7), (K. Wilkinson)	ED2, 1W-2L
London CS 6499 (CSA 2233)	Decca SET 332*, ED2 1st	Penguin *(**), TAS2016	ED2, 2G-1G, (Gatefold)
London CS 6500	Decca SXL 6260, ED2 1st	Penguin ***�લ	ED2, 1G-5G
London CS 6501	Decca SXL 6259, ED2 1st	Penguin ***�..., (K. Wilkinson)	ED2, 2G-2G

London Label & Serial Number LONDON 唱片公司, 編號	Decca Label & Serial Number DECCA 唱片公司, 編號	Remarks & Ratings 附註和評價	1st Labels & Reference Prices 首版和參考價格
London CS 6502	Decca SXL 6258, ED2 1st (©=SDD 330)	Penguin ***	ED2, 2G-1G
London CS 6503 (=CS 6785)	Decca SXL 6263, ED2 1st (©=SPA 127)	Penguin ***, AS List	ED2, 4G-1G, $
London CS 6508	Decca SXL 6268, ED2 1st		ED2, 1W-2W
London CS 6509	Decca SXL 6269, ED2 1st	Penguin **(*)	ED2, 3W-2W
London CS 6510	Decca SXL 6270, ED2 1st		ED2, 2W-2W
London CS 6511	Decca SXL 6273, ED2 1st	Penguin ***, AS List-H (D6D 7), (K. Wilkinson)	ED2, 3G-2G, $
London CS 6512	Decca SXL 6274, ED2 1st	Penguin ***	ED2, 1W-3W
London CS 6513	Decca SXL 6275, ED2 1st, (D121D 10)	Penguin ***	ED2, 1W-1W
London CS 6519	Decca SXL 6285*, ED2 1st	Penguin **(*), (K. Wilkinson)	ED2, 1W-1W
London CS 6521 (©=STS 15358)	Decca SXL 6287*, ED2 1st	Penguin ***, AS List (Speakers Corner)	ED2, 1G-1G, rare! $ (K. Wilkinson)
London CS 6522	Decca SXL 6286, ED2 1st	Penguin**(*)	ED2, 3G-1G
London CS 6523	Decca SXL 6288, ED2 1st	Penguin ***, AS List-H (D6D 7), (K. Wilkinson)	ED2, 4W-1W
London CS 6524	Decca SXL 6289, ED2 1st	Penguin ***, AS List-H (D6D 7), (K. Wilkinson)	ED2, 3W-1W
London CS 6525	Decca SXL 6290, ED2 1st	Penguin ***, AS List-H (D6D 7), (K. Wilkinson)	ED2, 2W-1W
London CS 6526	Decca SXL 6257, ED2 1st	Penguin ***, AS List-H (D6D 7), (K. Wilkinson)	ED2, 1W-1W
London CS 6527	Decca SXL 6291, ED2 1st (©=SPA 87)	Penguin ***, TAS-OLD, AS list-F (D6D 7)	ED2, 1W-1W Japan 300, (K. Wilkinson)
London CS 6529	Decca SXL 6298, ED2 1st	Penguin **(*)	ED2, 2W-2W
London CS 6532	Decca SXL 6297, ED2 1st		ED2, 1W-1W, rare! $
London CS 6533	Decca SXL 6303, ED2 1st	Penguin **(*)	ED2, 2W-2W
London CS 6534	Decca SXL 6301, ED2 1st	Penguin **(*)	ED2, 2W-2W
London CS 6535	Decca SXL 6300, ED2 1st		ED2, 3W-2W, $
London CS 6536	Decca SXL 6302	Penguin ***	ED2, 2W-1W, $
London CS 6537	Decca SXL 6304, ED2 1st		ED2, 1W-1W
London CS 6538	Decca SXL 6308, ED2 1st	AS List	ED2, 1W-1W, $
London CS 6539	Decca SXL 6309, ED2 1st		ED2, 3W-2W
London CS 6540 (©=STS 15294)	Decca SXL 6310, ED2 1st (=SDD 451)		ED2, 1W-2W
London CS 6541 (CSA 2308)	Decca SXL 6313, ED2 1st		ED2, 3W-2W
London CS 6542	Decca SXL 6312, ED2 1st	AS list-H	ED2, 1W-1W
London CS 6543	Decca SXL 6311, ED2 1st		ED2, 1W-2W
London CS 6549	Decca SXL 6321, ED2 1st (©=SDD 542)	Penguin **(*), (K. Wilkinson)	ED2, 3W-4W
London CS 6550	Decca SXL 6322, ED2 1st	Penguin **(*), AS List, TAS 78/146+, Japan 300	ED2, 1W-1W, rare!

London Label & Serial Number LONDON 唱片公司, 編號	Decca Label & Serial Number DECCA 唱片公司, 編號	Remarks & Ratings 附註和評價	1st Labels & Reference Prices 首版和參考價格
London CS 6552	Decca SXL 6325, ED2 1st	Penguin ***, AS list-F	ED2, 2W-2W, (Gatefold)
London CS 6553	Decca SXL 6323, ED2 1st	Penguin **(*)	ED2, 1W-1W, (Gatefold)
London CS 6554	Decca SXL 6324, ED2 1st		ED2, 1W-1W, (Gatefold)
London CS 6555	Decca SXL 6332, ED2 1st	Penguin **(*)	ED2, 1L-1L
London CS 6556	Decca SXL 6329, ED2 1st	Penguin **	ED2, 1G-1G
London CS 6559	Decca SXL 6328, ED2 1st	Penguin **(*)	ED2, 3W-1W
London CS 6562	Decca SXL 6334, ED2 1st	Penguin ***, Japan 300-CD	ED2, 1W-2W
London CS 6563	Decca SXL 6335, ED2 1st	Penguin **	ED2 1W-4W
London CS 6567	Decca SXL 6340, ED2 1st	Penguin ***, AS List-H (JB 86)	ED2, 1W-3W
London CS 6569	Decca SXL 6342, ED2 1st		ED2, 1W-2W
London CS 6570	Decca SXL 6344, ED2 1st		ED2-1W-2W
London CS 6573	Decca SXL 6346, ED2 1st	Penguin***	ED2, 2W-1W
London CS 6574	Decca SXL 6348*, ED2 1st	Penguin ***	ED2, 4W-2W
London CS 6578	Decca SXL 6352, ED2 1st		ED2, 2W-1W
London CS 6579	Decca SXL 6353, ED2 1st	Penguin **(*)	ED2, 1W-1W
London CS 6580	Decca SXL 6354, (ED2) 1st	Penguin **(*)	ED2, 1W-1W
London CS 6581	Decca SXL 6355*, (ED2) 1st	Penguin ***, TAS2016, AS-DG list, (K. Wilkinson)	ED2, 1G-1G, rare!! $$
London CS 6582 (CSA 2310)	Decca SXL 6356, (ED2) 1st (D190D 3)	Penguin ***, AS list-H (D190D 3)	ED2, 1W-1W
London CS 6583	Decca SXL 6357, (ED2) 1st		ED2, 1W-1W
London CS 6584	Decca SXL 6358, (ED2) 1st		ED2, 1G-2G
London CS 6585	Decca SXL 6359, (ED2) 1st		ED2, 1G-1G, $
London CS 6586 (London CSA 2247)	Decca SXL 6360, (ED2) 1st		ED2, 1G-1G
London CS 6587	Decca SXL 6363, (ED1, 1G-1G)	Penguin *** (K. Wilkinson)	ED2, 1G-1G
London CS 6591	Decca SXL 6364, (ED2) 1st	Penguin *(**)	ED2, 1G-1G
London CS 6592	Decca SXL 6365, (ED2) 1st	Penguin ***	ED2 ?, (ED3, 1G-1G)
London CS 6593	Decca SXL 6367, (ED2) 1st	Penguin **(*)	ED2, 1W-1W
London CS 6594	Decca SXL 6368, (ED2) 1st	Penguin **(*) & ***, (K. Wilkinson)	ED2 ?, ED3, 1W-1W
London CS 6598	Decca SXL 6372, (ED3, 1st)	Penguin **(*)	ED3, 1W-1W
London CS 6599	Decca SXL 6373, (ED3, 1st)		ED3, 1W-1W
London CS 6602	Decca SXL 6374, (ED3, 1st)	Penguin ***	ED3, 2W-2W
London CS 6603	Decca SXL 6375, (ED3, 1st)	(K. Wilkinson)	ED3, 5W-1W
London CS 6604	Decca SXL 6378, (ED3, 1st)		ED4, 1W-3W (Promo)
London CS 6605	Decca SXL 6383, (ED3, 1st) (©=JB 47)	Penguin ***	ED3, 1S-1S
London CS 6606 (CSA 2224)	Decca SXL 6380, (ED3, 1st)		ED3, 2W-2W
London CS 6607 (CSA 2224)	Decca SXL 6381, (ED3, 1st)		ED3, 2W-2W

London Label & Serial Number LONDON 唱片公司, 編號	Decca Label & Serial Number DECCA 唱片公司, 編號	Remarks & Ratings 附註和評價	1st Labels & Reference Prices 首版和參考價格
London CS 6608	Decca SXL 6382, (ED3, 1st) (©=JB 101)	Penguin ***, TAS 30-141+	ED3, 2G-2G
London CS 6609	Decca SXL 6379, (ED3, 1st)	TAS-OLD	ED3, 1G-1G
London CS 6611	Decca SXL 6387, (ED3, 1st) (©=SDD 540)	Penguin ***, (K. Wilkinson)	ED3, 1W-1W
London CS 6612 (©=London 414 440-1)	Decca SXL 6390, (ED3, 1st)	Penguin ***, TAS2017, AS-DG List (414 440-1)	ED3, 1W-1W
London CS 6613	Decca SXL 6388, (ED3, 1st)	Penguin ***	ED4, 1W-1W, (Gatefold)
London CS 6614	Decca SXL 6389, (ED3, 1st)		ED3, 1W-1W
London CS 6615	Decca SXL 6395, (ED3, 1st)		ED3, 1W-2W
London CS 6616	Decca SXL 6394, (ED3, 1st)		ED3, 1W-1W
London CS 6617	Decca SXL 6393, (ED3, 1st)	Penguin ***	ED3, 3W-1W
London CS 6618	Decca SXL 6405, (ED3, 1st)	Penguin ***, AS list (JUBILEE 410 171)	ED3, 1W-1W
London CS 6619	Decca SXL 6396, (ED3, 1st)	Penguin ***, Japan 300-CD	ED3, 3W-3W
London CS 6620	Decca SXL 6398*, (ED3, 1st)	Penguin ***, AS List (Speakers Corner)	ED3, 1W-1W
London CS 6621	Decca SXL 6397, (ED3, 1st)		ED3, 4W-2W
London CS 6622	Decca SXL 6399, (ED3, 1st)	Penguin ***	ED3, 1W-1W
London CS 6624	Decca SXL 6401, (ED3, 1st)	Penguin ***	ED3, 1W-1W
London CS 6625	Decca SXL 6402, (ED3, 1st)		ED3, 1W-1W
London CS 6626	Decca SXL 6403, (ED3, 1st)		ED3, 3W-1W
London CS 6627	Decca SXL 6407, (ED3, 1st)		ED3, 1W-1W
London CS 6628	Decca SXL 6408, (ED3, 1st)	Penguin ***	ED3, 1W-1W, [Last ED3 from CS series]
London CS 6632	Decca SXL 6410, (ED3, 1st)	Penguin ***	ED4, 1G-1G, (1st)
London CS 6633	Decca SXL 6411, (ED3, 1st) (©=SDD 486)	Penguin*** &**(*) (K. Wilkinson)	ED4, 2W-2W, (1st)
London CS 6636	Decca SXL 6414, (ED3, 1st) (©=SDD 410)	Penguin ***	ED4, 1W-1W, (1st)
London CS 6637	Decca SXL 6415, (ED3, 1st)		ED4, 1L-1L, (1st)
London CS 6638	Decca SXL 6416, (ED3, 1st)		ED4, 1W-1W, (1st)
London CS 6639	Decca SXL 6417, (ED3, 1st)		ED4, 1W-1W, (1st)
London CS 6641	Decca SXL 6419, (ED3, 1st)	Penguin ***	ED4, 1W-1W, (1st)
London CS 6643	Decca SXL 6422, (ED3, 1st)		ED4, 3W-3W
London CS 6644	Decca SXL 6423, (ED3, 1st) (©=SDD 442)		ED4, 3W-2W, rare! $
London CS 6649	Decca SXL 6426, (ED3, 1st)	Penguin **(*), Japan 300	ED4, 1W-3W, Very rare! $$
London CS 6656	Decca SXL 6436, (ED3, 1st)		ED4, 2W-2W
London CS 6657	Decca SXL 6435, (ED4, 1st)	Penguin ***	ED4, 3W-2W
London CS 6658	Decca SXL 6437, (ED3, 1st)	Penguin **(*)	ED4, 1G-2G
London CS 6659	Decca SXL 6439, (ED3, 1st)	Penguin ***	ED4, 3W-1W

London Label & Serial Number LONDON 唱片公司, 編號	Decca Label & Serial Number DECCA 唱片公司, 編號	Remarks & Ratings 附註和評價	1st Labels & Reference Prices 首版和參考價格
London CS 6660	Decca SXL 6438, (ED3, 1st)	Penguin **(*), AS List-H	ED4, 1W-1W
London CS 6661	Decca SXL 6440, (ED3, 1st)	AS List	ED4, 2W-2W, $
London CS 6663	Decca SXL 6442, (ED4, 1st)		ED4, 1W-1W
London CS 6664	Decca SXL 6444, (ED4, 1st)	Penguin **(*), AS list-H	ED4, 1W-1W
London CS 6665	Decca SXL 6445, (ED4, 1st)	TAS2017, Top 100 20th Century, Penguin **(*)	ED4, 2W-1W
London CS 6668	Decca SXL 6447, (ED4, 1st)	Penguin **(*)	ED4, 4W-2W
London CS 6670	Decca SXL 6448, ED3, 1W-1W, [*Last ED3 label in SXL Series]	Penguin ***, AS list-H	ED4, 1W-1W, (Gatefold)
London CS 6671	Decca SXL 6450, (ED4, 1st)	Penguin ***, Japan 300, (K. Wilkinson)	ED4, 4W-3G
London CS 6672	Decca SXL 6462, (ED4, 1st)		ED4, 2W-2W
London CS 6673	Decca SXL 6463, (ED4, 1st) (©=SDD 423)	Penguin ***	ED4, 2W-1W
London CS 6674	Decca SXL 6464, (ED4, 1st) (©=SDD 419)		ED4, 1W-2W, rare!
London CS 6675	Decca SXL 6465*, (ED4, 1st)	Penguin **(*)	ED4, 2W-2W
London CS 6676	Decca SXL 6466, (ED4, 1st)		ED4, 1W-1W
London CS 6677	Decca SXL 6467, (ED4, 1st)		ED4, 2W-2W
London CS 6679	Decca SXL 6469, (ED4, 1st)	TAS2017, Penguin**(*), AS list-H	ED4, 2W-2W
London CS 6680	Decca SXL 6482, (ED4, 1st)	Penguin ***, AS list-H & AS list-F	ED4, 2K-4K
London CS 6682	Decca SXL 6483, (ED4, 1st) (SXLJ 6644; D105D 5)	Penguin **(*), Gramophone	ED4, 4W-2W
London CS 6693	Decca SXL 6485, (ED4, 1st)	Penguin ***	ED4, 1W-2W
London CS 6694	Decca SXL 6484, (ED4, 1st)		ED4, 2W-2W
London CS 6695	Decca SXL 6489, (ED4, 1st)		ED4, 6W-3W
London CS 6696 (CSA 2310)	Decca SXL 6486, (ED4, 1st) (D190D 3)	Penguin **(*), AS list-H (D190D 3)	ED4, 1W-1W
London CS 6697 (CSA 2310)	Decca SXL 6487, (ED4, 1st) (D190D 3)	Penguin ***, AS list-H (D190D 3)	ED4, 2W-2W
London CS 6698	Decca SXL 6488, (ED4, 1st)		ED4, 2W-3W
London CS 6699	Decca SXL 6491, (ED4, 1st)	Penguin **(*)	ED4,1W-1W
London CS 6706	Decca SXL 6494, (ED4, 1st)	Penguin ***	ED4, 1W-1W
London CS 6707	Decca SXL 6495, (ED4, 1st)	Penguin ***	ED4, 1W-1W
London CS 6710	Decca SXL 6493, (ED4, 1st)	Penguin ***, AS list-F	ED4, 2W-2W
London CS 6711 (London CSA 2247)	Decca SXL 6496, (ED4, 1st)	(K. Wilkinson)	ED4, 1W-2W
London CS 6714	Decca SXL 6502		ED4, 3W-2W
London CS 6715	Decca SXL 6503		ED4, 2W-2W
London CS 6716	Decca SXL 6504	Penguin **(*)	ED4, 1W-3W

London Label & Serial Number LONDON 唱片公司, 編號	Decca Label & Serial Number DECCA 唱片公司, 編號	Remarks & Ratings 附註和評價	1st Labels & Reference Prices 首版和參考價格
London CS 6717	Decca SXL 6505	Penguin **(*), Japan 300-CD	ED4, 4W-6W
London CS 6718	Decca SXL 6507	Penguin **(*), AS List-H	ED4, 1D-1D
London CS 6719	Decca SXL 6508	Penguin **(*)	ED4, 2W-1D
London CS 6721	Decca SXL 6510	Penguin ***	ED4, 1G-1G
London CS 6723	Decca SXL 6512	Penguin ***, AS List-H, (K. Wilkinson)	ED4, 1W-1W
London CS 6727	Decca SXL 6523	Penguin ***	ED4, 1W-1W
London CS 6730	No Decca SXL (Decca=SPA 127)	Penguin ***	ED4, 4W-5W, rare!
London CS 6731	Decca SXL 6526	Penguin ***	ED4, 2W-3W
London CS 6732	Decca SXL 6527	Penguin *** (K. Wilkinson)	ED4, 3G-1A
London CS 6733	Decca SXL 6528 (*Alice De Larrocha, piano)	Penguin ***	ED4, 2W-3W
London 410 287-1	*Another Penguin ***✲ from Larrocha	Penguin ***✲	
London 410 289-1	*Another Penguin ***✲ from Larrocha	Penguin ***✲	
London CS 6734	Decca SXL 6529*	TASEC✲✲, TAS Top100 20th Century Classic,	ED4, 2W-4W Penguin **(*), AS List-H
London CS 6735	Decca SXL 6531		ED4, 1G-1G
London CS 6736	Decca SXL 6532		ED4, 1W-1W, $
London CS 6737	Decca SXL 6533		ED4, 2W-1W
London CS 6738	Decca SXL 6535	Penguin ***	ED4, 4W-2W
London CS 6739	Decca SXL 6536		ED4, 1W-2W
London CS 6740	Decca SXL 6538	Penguin ***	ED4, 1W-1W
London CS 6741	Decca SXL 6539	Penguin ***	ED4, 2W-2W
London CS 6744	Decca SXL 6541		ED4, 1G-1G
London CS 6745	Decca SXL 6542	Penguin ***	ED4, 1W-6W
London CS 6746	Decca SXL 6543	Penguin ***	ED4, 2G-2G
London CS 6747	Decca SXL 6544	Penguin ***	ED4, 1W-5W
London CS 6748	Decca SXL 6545		ED4, 1W-1W
London CS 6749	Decca SXL 6546	Penguin **(*)	ED4, 1W-1W
London CS 6750	Decca SXL 6547		ED4, 4W-3W
London CS 6752	Decca SXL 6550*	TAS2017, Penguin ***, AS-DIV list	ED4, 1W-1W
London CS 6753	No Decca SXL		ED4, 1W-2W
London CS 6754	Decca SXL 6551		ED4, 2W-2W
London CS 6772	Decca SXL 6552 (SXLJ 6644; D105D 5)	Penguin **(*)	ED4, 1W-1W
London CS 6773	Decca SXL 6553 (SXLJ 6644; D105D 5)	Penguin **(*)	ED4, 2W-2W
London CS 6774	Decca SXL 6554	Penguin ***, Japan 300, (K. Wilkinson)	ED4, 9W-9W

London Label & Serial Number LONDON 唱片公司, 編號	Decca Label & Serial Number DECCA 唱片公司, 編號	Remarks & Ratings 附註和評價	1st Labels & Reference Prices 首版和參考價格
London CS 6775	Decca SXL 6555	Penguin **(*), Gramophone, (Wilkinson)	ED4, 5W-5W
London CS 6776	Decca SXL 6556	Penguin ***, Japan 300, (K. Wilkinson)	ED4, 9W-5W
London CS 6777 (=CS 6093 & SXL 2121)	Decca SXL 2121 (reissue)		ED4
London CS 6778 (=CS 6145 & SXL 2165)	Decca SXL 2165 (reissue)		ED4
London CS 6779 (=CS 6146 & SXL 2174)	Decca SXL 2174 (reissue)	RM16, Penguin **(*), AS list	ED4
London CS 6780 (=CS 6216 & SXL 2280)	Decca SXL 2280 (reissue)	(K. Wilkinson)	ED4
London CS 6781 (=CS 6217 & SXL 2276)	Decca SXL 2276 (reissue)		ED4
London CS 6782 (=CS 6245)	Decca SET 227 (reissue)		ED4
London CS 6783 (=CS 6399 & SXL 6111)	Decca SXL 6111 (reissue)	Penguin ***, AS-DG list, TAS 72++	ED4
London CS 6784 (=CS 6469 & SXL 6212)	Decca SXL 6212 (reissue)	Penguin ***, AS list-F , (K. Wilkinson)	ED4, 2W-9W
London CS 6785 (=CS 6503 & SXL 6263)	Decca SXL 6263 (reissue)	Penguin ***, AS List	ED4
London CS 6786	Decca SXL 6562		ED4, 1W-1W
London CS 6787	Decca SXL 6563		ED4
London CS 6789	Decca SXL 6569	Penguin ***☆, AS List-H, (K. Wilkinson)	ED4, 3W-3W
London CS 6790	Decca SXL 6571	Grammy, (K. Wilkinson)	ED4, 5W-5W, (Gatefold)
London CS 6791	Decca SXL 6572		ED4, 4G-3G
London CS 6793	Decca SXL 6574	(K. Wilkinson)	ED4, 1W-1W
London CS 6794	Decca SXL 6575	Penguin ***	ED4, 3W-3W
London CS 6795	Decca SXL 6573	Penguin ***, AS List-H, Japan 300-CD	ED4, 5W-5W
London CS 6800	Decca SXL 6581		ED4, 1W-1W
London CS 6801	Decca SXL 6580 (©=JB 140)	Penguin ***☆	ED4, 7W-5W
London CS 6803	Decca SXL 6583	Penguin **(*), AS List	ED4, 1W-2W
London CS 6805; No Decca SXL			ED4
London CS 6806	Decca SXL 6576		ED4, 4W-3W
London CS 6809	Decca SXL 6557	Penguin ***	ED4, 1W-1W
London CS 6812	Decca SXL 6588	TAS-OLD, Penguin ***, (K. Wilkinson)	ED4, 1G-1G
London CS 6814	Decca SXL 6589 (©=SDD 541)	Penguin ***, (K. Wilkinson)	ED4, 1W-1W
London CS 6816	Decca SXL 6592	TASEC, Penguin ***	ED4, 3W-5W
London CS 6818	Decca SXL 6599	Penguin **(*), AS List-H	ED4, 1W-1W

London Label & Serial Number LONDON 唱片公司, 編號	Decca Label & Serial Number DECCA 唱片公司, 編號	Remarks & Ratings 附註和評價	1st Labels & Reference Prices 首版和參考價格
London CS 6819	Decca SXL 6601	Penguin ***✲, AS list-H	ED4, 2W-1W
London CS 6820	Decca SXL 6602	Penguin ***	ED4, 2W-3W
London CS 6821	Decca SXL 6603	Penguin ***, (K. Wilkinson)	ED4, 1W-2W
London CS 6822	Decca SXL 6604	Penguin ***	ED4, 7W-3W
London CS 6823;	No Decca SXL		ED4
London CS 6824	No Decca SXL		ED4, 3W-2W
London CS 6830	Decca SXL 6616	Penguin **, Japan 300	ED4, 1W-1W
London CS 6831	Decca SXL 6617	Penguin **(*)	ED4,1W-1W
London CS 6836	Decca SXL 6675	Penguin **(*)	ED4, 2L-2W
London CS 6837	Decca SXL 6677	Penguin **(*)	ED4, 1W-1W
London CS 6838	Decca SXL 6678	Penguin ***	ED4 2W-2W
London CS 6839	Decca SXL 6623	Penguin ***	ED4 2W-5G
London CS 6840	Decca SXL 6624	TASEC, Penguin **(*), (K. Wilkinson)	ED4, 3G-2G
London CS 6840	Decca SXL 6624	TASEC, Penguin **(*), (K. Wilkinson)	ED4
London CS 6841	Decca SXL 6627	Penguin **(*), AS List, (K. Wilkinson)	ED4, 2G-2G
London CS 6843 (CSP 11)	Decca SXL 6630 (Decca D258D 12)	Penguin ***	ED4, 6W-7Y
London CS 6844	Decca SXL 6710	Penguin ***	ED4
London CS 6845 & 6958	Decca SXL 6990 (Part of SXL 6632 & 6736)	Penguin ***, (K. Wilkinson)	
London CS 6845 (CSA 2501)	Decca SXL 6632 (D92D 5)	Penguin ***(✲), Japan 300-CD, (K. Wilkinson)	ED4, 2W-3W
London CS 6848	Decca SXL 6633		ED4, 1W-1W
London CS 6849	Decca SXL 6634		ED4, 4W-6W
London CS 6853 (CSA 2404)	Decca SXL 6651	Penguin ***, AS list-F, (K. Wilkinson)	ED4, 2W-2W
London CS 6854 (CSA 2404)	Decca SXL 6652	Penguin ***, AS list-F, (K. Wilkinson)	ED4
London CS 6855 (CSA 2404)	Decca SXL 6653	Penguin **(*), AS list-F, (K. Wilkinson)	ED4 Japan 300-CD
London CS 6856 (CSA 2404)	Decca SXL 6654	Penguin ***, AS list-F	ED4
London CS 6857 (CSA 2404)	Decca SXL 6655	Penguin ***, AS list-F	ED4
London CS 6858	Decca SXL 6643		ED4, 2W-1W
London CS 6859	Decca SXL 6642		ED4, 4A-4A
London CS 6860	Decca SXL 6656	Penguin **(*)	ED4, 1W-1W
London CS 6862 (CSA 2313)	Decca SXL 6712 (SXLM 6665)	Penguin ***	ED4, 1G-1G
London CS 6863 (CSA 2313)	Decca SXL 6713 (SXLM 6665)	Penguin **(*), Japan 300-CD	ED4, 7G-1G
London CS 6864 (CSA 2313)	Decca SXL 6714 (SXLM 6665)	Penguin ***, Japan 300-CD	ED4, 6G-5G
London CS 6865 (CSA 2312)	Decca SXL 6668 (SXL 6620-2)	TASEC, Penguin***	ED4

London Label & Serial Number LONDON 唱片公司, 編號	Decca Label & Serial Number DECCA 唱片公司, 編號	Remarks & Ratings 附註和評價	1st Labels & Reference Prices 首版和參考價格
London CS 6866	Decca SXL 6669	Penguin ***	ED4, 2W-4W
London CS 6870	Decca SXL 6673 (SXLN 6673)	Penguin ***	ED4, 5W-5W
London CS 6873	Decca SXL 6674		ED4, 4A-1A
London CS 6878	Decca SXL 6680	Penguin ***, TAS 9-96+	ED2, rare! $
London CS 6879	Decca SXL 6681	Penguin **(*)	ED4, 1W-1W
London CS 6880	Decca SXL 6682	Penguin **(*)	ED4, 1W-1W
London CS 6881	Decca SXL 6683	Penguin ***	ED2, 4G-2W, rare! $
London CS 6885	Decca SXL 6691*	TASEC, Penguin ***, AS list, (K. Wilkinson)	ED4, 6W-3W
London CS 6890	Decca SXL 6821		ED4, 1G-1G
London CS 6891	Decca SXL 6694	Penguin **(*), (K. Wilkinson)	ED4, 2W-5W
London CS 6893	Decca SXL 6697	Penguin ***	ED4, 1W-1W
London CS 6894	Decca SXL 6698	Penguin **(*)	ED4
London CS 6895	Decca SXL 6700		ED4, 2W-1W
London CS 6896	Decca SXL 6701	Penguin ***	ED4, 1W-1W
London CS 6897	Decca SXL 6702	Penguin***, AS List	ED4, 4W-4W
London CS 6898	Decca SXL 6703	Penguin **(*), AS list-H	ED4, 6W-3W
London CS 6899	Decca SXL 6704	Penguin ***, AS list-H	ED4, 1W-2W
London CS 6920	Decca SXL 6705	Penguin ***	ED4, 1W-3W
London CS 6921 (=CS 7256, CSP 11)	Decca SXL 6706 (Decca D258D 12, part)	Penguin ***, (K. Wilkinson)	ED4, 7W-2W
London CS 6923	Decca SXL 6707	Penguin **(*), (K. Wilkinson)	ED4, 1W-1W
London CS 6925	Decca SXL 6709	Penguin ***, (K. Wilkinson)	ED4
London CS 6926 (CSP 9)	Decca SXL 6760 (11BB 188-96)	Penguin **(*), (K. Wilkinson)	ED4
London CS 6927 (CSP 9)	Decca SXL 6761 (11BB 188-96)	Penguin ***, (K. Wilkinson)	ED4
London CS 6930 (CSP 9)	Decca SXL 6762 (11BB 188-96)	Penguin ***, (K. Wilkinson)	ED4
London CS 6931 (CSP 9)	Decca SXL 6763 (11BB 188-96)	Penguin **(*), (K. Wilkinson)	ED4
London CS 6932 (CSP 9)	Decca SXL 6764 (11BB 188-96)	Penguin ***, (K. Wilkinson)	ED4
London CS 6936	Decca SXL 6715		ED4
London CS 6937	Decca SXL 6716		ED4, 1A-1A
London CS 6938	Decca SXL 6717		ED4, 2A-2A
London CS 6940	Decca SXL 6721	Penguin **	ED4, 1W-1W, rare!!
London CS 6941	Decca SXL 6723	Penguin ***, (K. Wilkinson)	ED4, 2W-2W
London CS 6943	Decca SXL 6725	Penguin ***	ED4, 2W-1W
London CS 6944	No Decca SXL (©=SPA 257)	Penguin ***	ED4,1G-1G

London Label & Serial Number LONDON 唱片公司, 編號	Decca Label & Serial Number DECCA 唱片公司, 編號	Remarks & Ratings 附註和評價	1st Labels & Reference Prices 首版和參考價格
London CS 6945	Decca SXL 6726	Penguin ***	ED4,1G-1G
London CS 6946	Decca SXL 6727		ED4, 7G-6G
London CS 6947	Decca SXL 6728	Penguin ***	ED4, 1W-1W
London CS 6948	Decca SXL 6729	Penguin **(*)	ED4, 1W-3W
London CS 6949	Decca SXL 6730	Penguin ***, AS List	ED4, 1W-3W
London CS 6950	Decca SXL 6731	Penguin **(*), AS List	ED4 1W-1W
London CS 6951	Decca SXL 6732		ED4, 2W-3W
London CS 6952	Decca SXL 6733		ED4
London CS 6953	Decca SXL 6734	Penguin ***	ED4, 2W-1W
London CS 6954	Decca SXL 6735		ED4, 2W-2W, $
London CS 6955	No Decca SXL		ED4 1W-1W
London CS 6956	No Decca SXL		ED4 1W-3W
London CS 6958 (CSA 2501)	Decca SXL 6736 (D92D 5)	Penguin ***, Japan 300	ED4, 2A-1A
London CS 6961	Decca SXL 6739 (=SXLI 6739)	Penguin ***	ED4
London CS 6964 (CSA 2314)	Decca SXL 6768 & 6769 (15BB 218-20)	Penguin**(*), Japan 300-CD, (K. Wilkinson)	ED4 AS list (15BB 218-20)
London CS 6966	Decca SXL 6741	Penguin ***	ED4, 1W-2W
London CS 6967	Decca SXL 6737		ED4, 2K-1K
London CS 6968	Decca SXL 6742	Penguin ***, AS List	ED4
London CS 6970	Decca SXL 6743	Penguin **(*), (K. Wilkinson)	ED4, 2W-1W
London CS 6977	Decca SXL 6746	(K. Wilkinson)	ED4, 2W-1W
London CS 6978	Decca SXL 6749	Penguin ***, Grammy, (K. Wilkinson)	ED4, 2W-2W
London CS 6979	Decca SXL 6750		ED4, 1W-1W
London CS 6980	Decca SXL 6751	AS list	ED4, 1W-1W
London CS 6981	Decca SXL 6752 (©=JB 139)	Penguin ***	ED4
London CS 6983	Decca SXL 6754	(K. Wilkinson)	ED4, 4W-1W
London CS 6984	Decca SXL 6795 (part), (=SXL 6795 + 7004)	Penguin ***, (K. Wilkinson)	ED4
London CS 6987	No Decca SXL (©=SPA 206)	Penguin ***	ED4, 3W-4G
London CS 6988	Decca SXL 6755	Penguin ***, (K. Wilkinson)	ED4, 4W-1W
London CS 6989	Decca SXL 6756		ED4, 1A-1A
London CS 6990	Decca SXL 6757	TAS2016, AS list-H	ED4, 1W-1W
London CS 6992	Decca SXL 6759	Penguin ***, AS list-H, Japan 300-CD	ED4, 1W-2W
London CS 6993	Decca SXL 6776		ED4
London CS 6995	Decca SXL 6770	Penguin **(*), AS List	ED4 1W-5W
London CS 6996	Decca SXL 6771	(K. Wilkinson)	ED4, 2W-2W
London CS 6997	Decca SXL 6773	Penguin***, AS list-H	ED4, 1W-1W

London Label & Serial Number LONDON 唱片公司, 編號	Decca Label & Serial Number DECCA 唱片公司, 編號	Remarks & Ratings 附註和評價	1st Labels & Reference Prices 首版和參考價格
London CS 7003	Decca SXL 6777*	TASEC98 -TOP 12 Old, Penguin** , (K. Wilkinson)	ED4 1W-3W AS List (Speakers Corner)
London CS 7004	Decca SXL 6779		ED4, 2W-1W
London CS 7005	No Decca SXL		ED4, 2A-3A
London CS 7006	Decca SXL 6782		ED4, 1W-1W
London CS 7007 (CSA 2405)	Decca SXL 6783 (Decca D 39D 4)	Penguin **(*)	ED4, 1W-1W
London CS 7008	Decca SXL 6784	Penguin ***	ED4, 1A-2A
London CS 7009	Decca SXL 6785	Penguin ***	ED4, 1W-5W, rare! $
London CS 7012 (CSA 2501)	Decca SXL 6789 (D92D 5)	Penguin ***	ED4, 1W-1W
London CS 7013 (CSA 2501)	Decca SXL 6790 (D92D 5)	Penguin ***	ED4, 3W-2W
London CS 7014 (CSA 2501)	Decca SXL 6791 (D92D 5)	Penguin ***	ED4
London CS 7015	No Decca SXL		ED4, 3W-3W
London CS 7017	Decca SXL 6796		ED4, 1W-1W
London CS 7018	Decca SXL 6797	Japan 300-CD	ED4, 6G-5G
London CS 7019	Decca SXL 6798	Penguin ***	ED4, 1W-1W
London CS 7020	Decca SXL 6799		ED4, 1W-1W
London CS 7021	Decca SXL 6800	(K. Wilkinson)	ED4, 1G-2G
London CS 7022	Decca SXL 6801	Penguin ***, (K. Wilkinson)	ED4, 6A-1A
London CS 7023	Decca SXL 6802	(K. Wilkinson)	ED4, 3W-1W
London CS 7024 (CSP 11)	Decca SXL 6804 (Decca D258D 12)	Penguin ***, Japan 300-CD, (K. Wilkinson)	ED4, 1A-1A
London CS 7028 (CSP 11)	Decca SXL 6808 (Decca D258D 12)	Penguin ***, (K. Wilkinson)	ED4, 1A-4A
London CS 7029 (CSP 11)	Decca SXL 6809 (Decca D258D 12)	Penguin ***, (K. Wilkinson)	ED4
London CS 7030	Decca SXL 6810	Penguin ***	ED4, 5A-5A
London CS 7031	Decca SXL 6811	Penguin ***, AS List	ED4, 1W-1W
London CS 7032	Decca SXL 6812	Penguin ***, AS List-H, (K. Wilkinson)	ED4
London CS 7033	Decca SXL 6813	Penguin **(*), (K. Wilkinson)	ED4, 1W-1W
London CS 7034	Decca SXL 6814	(K. Wilkinson)	ED4, 1W-1W
London CS 7038	Decca SXL 6818	Penguin **(*)	ED4, 1W-1W
London CS 7039	Decca SXL 6819	Penguin ***	ED4, 1W-1W
London CS 7043	Decca SXL 6822	TASEC**, Penguin ***, (K. Wilkinson)	ED4, 2W-2W
London CS 7044	Decca SXL 6823	Penguin **(*)	ED4, 2W-2W
London CS 7045	Decca SXL 6824	Penguin **	ED4, 1W-2W
London CS 7046	No Decca SXL		ED4 3W-2W (Black label)
London CS 7048	Decca SXL 6827	Penguin ***, AS List-H, (K. Wilkinson)	ED4, 1W-1W

London Label & Serial Number LONDON 唱片公司, 編號	Decca Label & Serial Number DECCA 唱片公司, 編號	Remarks & Ratings 附註和評價	1st Labels & Reference Prices 首版和參考價格
London CS 7049 (CSP 9)	Decca SXL 6829 (11BB 188-96)	Penguin ***, (K. Wilkinson)	ED4, 1W-1W
London CS 7050 (CSP 9)	Decca SXL 6830 (11BB 188-96)	Penguin **(*), (K. Wilkinson)	ED4
London CS 7051	Decca SXL 6831	Penguin ***	ED4, 1G-2V
London CS 7055	Decca SXL 6833		ED4, 1W-1W
London CS 7061	Decca SXL 6838	Penguin **(*), AS list-H	ED4, 1W-2W
London CS 7062 (CSA 2314)	Decca SXL 6767 (15BB 218-20- Part)	Penguin***, Japan 300-CD, (K. Wilkinson)	ED4 AS list (15BB 218-20)
London CS 7063 (CSA 2314)	Decca SXL 6769 (15BB 218-20- Part)	Penguin***, Japan 300-CD, (K. Wilkinson)	ED4 AS list (15BB 218-20)
London CS 7064	Decca SXL 6842	(K. Wilkinson)	ED4, 1Y-2Y
London CS 7065	Decca SXL 6843		ED4, 2F-2F
London CS 7066	Decca SXL 6844		ED4, 1G-3Y
London CS 7067	Decca SXL 6845		ED4, 4V-4V
London CS 7068	No Decca SXL		ED4, 2W-3W
London CS 7072	Decca SXL 6848	Penguin ***, (K. Wilkinson)	ED4, 1W-2W
London CS 7073	Decca SXL 6851	Penguin ***, (K. Wilkinson)	ED4, 3G-2G
London CS 7075	Decca SXL 6853 (Decca D249D 4)	AS list-H, (K. Wilkinson)	ED4, 4Y-4Y
London CS 7076	Decca SXL 6854	AS List, (K. Wilkinson)	ED4, 1W-1W
London CS 7078	Decca SXL 6856	Penguin ***, AS list-H, (K. Wilkinson)	ED4, 3G-1G
London CS 7080	Decca SXL 6857		ED4, 3G-1G
London CS 7082	Decca SXL 6861	Penguin ***, (K. Wilkinson)	ED4
London CS 7083	Decca SET 601		ED4, 1G-1G
London CS 7084	Decca SXL 6863	Penguin ***, AS List-H, (K. Wilkinson)	ED4
London CS 7085	Decca SXL 6865		ED4, 2G-1W
London CS 7086	Decca SXL 6867		ED4, 1G-1G
London CS 7087	Decca SXL 6868	Penguin ***	ED4, 2Y-1Y
London CS 7088 (CSP 11)	Decca SXL 6871 (Decca D258D 12)	Penguin ***	ED4
London CS 7094 (CSA 2405)	Decca SXL 6834 (Decca D 39D 4)		ED4, 2G-1G
London CS 7095 (CSA 2405)	Decca SXL 6835 (Decca D 39D 4)		ED4, 1G-1G
London CS 7096 (CSA 2405)	Decca SXL 6836 (Decca D 39D 4)		ED4, 1G-1G
London CS 7097	Decca SXL 6873		ED4, 1G-1G
London CS 7098	Decca SXL 6874	AS list-H	ED4, 1G-1G
London CS 7099	Decca SXL 6875	AS List	ED4, 1G-2Y

London Label & Serial Number LONDON 唱片公司, 編號	Decca Label & Serial Number DECCA 唱片公司, 編號	Remarks & Ratings 附註和評價	1st Labels & Reference Prices 首版和參考價格
London CS 7101	Decca SXL 6877	Penguin ***, (K. Wilkinson)	ED4
London CS 7102	Decca SXL 6862		ED4, 1G-1G
London CS 7103	Decca SXL 6879	Penguin ***, Gramophone, (K. Wilkinson)	ED4
London CS 7104	Decca SXL 6881	Penguin ***, (K. Wilkinson)	ED4, 1G-5G
London CS 7106	Decca SXL 6883		ED4, 1G-1G, rare! $
London CS 7107	Decca SXL 6884 (Decca D249D 4)	Penguin ***, AS List, (K. Wilkinson)	ED4, 2G-2G
London CS 7108	Decca SXL 6886		ED4, 1G-1G
London CS 7109	Decca SXL 6887	(K. Wilkinson)	ED4, 2G-3G
London CS 7110	Decca SET 628	Penguin ***, AS List (MFSL), (K. Wilkinson)	ED4
London CS 7111 (CSP 11)	Decca SXL 6889 (Decca D258D 12)	Penguin ***	ED4, 1G-4G
London CS 7114	Decca SXL 6892		ED4, 2G-1G
London CS 7115	Decca SXL 6891		ED4, 1W-3W
London CS 7118	Decca SXL 6895		ED4, 1B-1B
London CS 7119	Decca SXL 6896	Penguin ***, (K. Wilkinson)	ED4, 2G-3G
London CS 7120	Decca SXL 6897	AS List-H, (K. Wilkinson)	ED4, 1G-1G
London CS 7121	Decca SXL 6899, (ED4)	Penguin **(*)	ED4, 1G-1G
London CS 7127	Decca SXL 6903, (ED5)		ED5, 2G-2G
London CS 7128	Decca SXL 6904, (ED4)	AS List-H	ED4, 1G-1G
London CS 7129	Decca SXL 6905, (ED4)		ED4, 5G-4G
London CS 7130	Decca SXL 6906, (ED4)	Penguin ***✲, AS list	ED4 1G-2G
London CS 7132	Decca SXL 6568, (ED4)		ED4, 1W-1W
London CS 7133	Decca SXL 6909, (ED4)	(K. Wilkinson)	ED4, 2G-1G
London CS 7134	Decca SXL 6910, (ED4)		ED4, 1G-1G
London CS 7135	Decca SXL 6911, (ED4)	Penguin ***	ED4
London CS 7144	Decca SXL 6919, (ED4) (Decca D249D 4)	Penguin ***, (K. Wilkinson)	ED4
London CS 7147	No Decca SXL		ED4, 2G-2G
London CS 7148	Decca SXL 6913, (ED4) (Decca SET D95D 6)	AS List (D95D 6)	ED4, rare!
London CS 7149	No Decca SXL (Decca SET D95D 6)	AS List (D95D 6)	ED4
London CS 7150	Decca SXL 6922, (ED4)	Penguin ***	ED4, rare!
London CS 7154	No Decca SXL (Decca SET D95D 6)	AS List (D95D 6)	ED4 1G-3G
London CS 7155	No Decca SXL (Decca SET D95D 6)	AS List (D95D 6)	ED4

London Label & Serial Number LONDON 唱片公司, 編號	Decca Label & Serial Number DECCA 唱片公司, 編號	Remarks & Ratings 附註和評價	1st Labels & Reference Prices 首版和參考價格
London CS 7159	Decca SXL 6926, (ED4)	Penguin ***	ED4, 4G-3G
London CS 7160	Decca SXL 6927, (ED4)	Penguin **(*), AS List	ED4
London CS 7162 (CSP 11)	Decca SXL 6929, (ED5, 1st) (Decca D258D 12)	Penguin **(*)	ED5, 1G-2G, (1st)
London CS 7163	Decca SXL 6932, (ED5, 1st)	AS List-H	ED5, 2G-1G, (1st)
London CS 7165	No Decca SXL (Decca SET D95D 6)	AS List (D95D 6)	ED4
London CS 7166	No Decca SXL (Decca SET D95D 6)	AS List (D95D 6)	ED4, 4G-4G
London CS 7167	Decca SXL 6937	Penguin *** ✲, AS List-H, (K. Wilkinson)	ED5, 1G-1G
London CS 7168	Decca SXL 6938, (ED4)	AS List-H	ED4, 4G-2G, rare!
London CS 7170	Decca SXL 6941, (ED5, 1st) (Decca D249D 4)	Penguin ***	ED5, 5G-3G
London CS 7171	Decca SXL 6944, (ED5, 1st)	Penguin *** ✲	ED5, 1G-1G
London CS 7173	Decca SXL 6946, (ED5, 1st)	AS List, (K. Wilkinson)	ED5, 1G-1G
London CS 7174	Decca SXL 6947, (ED5, 1st)	Penguin ***, (K. Wilkinson)	ED5, 4G-2G
London CS 7177	Decca SXL 6949, (ED5, 1st)		ED5
London CS 7178	Decca SXL 6950, (ED5, 1st)	Penguin **(*)	ED5, 1G-1G
London CS 7179	Decca SXL 6951	Penguin ***	ED5, 1G-2V
London CS 7180	Decca SXL 6952	Penguin ***	ED5, 4F-2F
London CS 7181	Decca SXL 6953	Penguin **(*), (K. Wilkinson)	ED5, 1G-1G
London CS 7184	Decca SXL 6954	Penguin **(*)	ED5, 3A-2G
London CS 7189	Decca SXL 6959	Penguin ***	ED5, 1G-1G
London CS 7190 (CSP 11)	Decca SXL 6960 (Decca D258D 12)	Penguin ***	ED5
London CS 7191 (CSP 11)	Decca SXL 6961 (Decca D258D 12)	Penguin ***	ED5
London CS 7192 (CSP 11)	Decca SXL 6962 (Decca D258D 12)	Penguin ***	ED5
London CS 7193	Decca SXL 6963	(K. Wilkinson)	ED5
London CS 7195	Decca SXL 6965	Penguin ***	ED5, 3G-4V
London CS 7196	Decca SXL 6966	Penguin ***, AS List-H	ED5
London CS 7197	Decca SXL 6969	Penguin ***	ED5
London CS 7198 (CSA 2406)	Decca SXL 6924, ED5 (Decca D151D 4)	Penguin **(*), (K. Wilkinson)	ED5 Gramophone
London CS 7199 (CSA 2406)	Decca SXL 6925, ED4 (Decca D151D 4)	Penguin **(*), (K. Wilkinson)	ED5
London CS 7200 (CSA 2406)	Decca SXL 6902, (Decca D151D 4)	Penguin ***, Grammy, (K. Wilkinson)	ED4

London Label & Serial Number LONDON 唱片公司, 編號	Decca Label & Serial Number DECCA 唱片公司, 編號	Remarks & Ratings 附註和評價	1st Labels & Reference Prices 首版和參考價格
London CS 7201 (CSA 2406)	Decca SXL 6890, ED4 (Decca D151D 4)	Penguin ***, Grammy, (K. Wilkinson)	ED5
London CS 7204	Decca SXL 6975	Penguin ***✳, A List-H	ED5
London CS 7205	Decca SXL 6977	AS List-H	ED5
London CS 7206	Decca SXL 6976		ED5
London CS 7207	Decca SXL 6978		ED5
London CS 7208	Decca SXL 6979	Penguin **(*)	ED5, 2G-1G
London CS 7209	Decca SXL 6980	Penguin ***	Dutch Silver-Blue
London CS 7210	Decca SXL 6981	Penguin ***	ED5
London CS 7211	Decca SXL 6982	Penguin ***, (K. Wilkinson)	Dutch Silver-Blue
London CS 7220	Decca SXL 6989	Penguin ***	ED5, 2G-1G, rare!! $
London CS 7221	No Decca SXL		ED5, rare!
London CS 7235	Decca SXL 6995	Penguin ***	Dutch Silver-Blue
London CS 7236	Decca SXL 6996	Penguin ***	Dutch Silver-Blue
London CS 7238	No Decca SXL, (=L'Oiseau Lyre DSLO 47)	AS-List 2017	ED5
London CS 7239	Decca SXL 6983	Penguin ***	ED5
London CS 7240	Decca SXL 6997 (Decca D222D 6)	Penguin ***	ED5
London CS 7241	Decca SXL 6998	Penguin **(*)	Dutch Silver-Blue
London CS 7242	No Decca SXL		ED5, 1V-1V, rare!
London CS 7246	No Decca SXL (Decca D222D 6)	Penguin ***	ED5
London CS 7247 (CSP 11)	Decca SXL 6994 (Decca D258D 12)	Penguin ***	Dutch Silver-Blue
London CS 7251	Decca SXL 7007	Penguin ***✳, AS list-F, Japan 300, (K. Wilkinson)	Dutch Silver-Blue, $
London CS 7252	No Decca SXL		ED5, 3G-1V
London CS 7253	Decca SXL 7008	Penguin ***, AS List-H (D244D 3)	ED5
London CS 7254	Decca SXL 7010	Penguin ***	Dutch Silver-Blue
London CS 7255 (CSP 11)	Decca SXL 7011 (Decca D258D 12)	Penguin **	Dutch Silver-Blue
London CS 7256 (=part of CS 6921 & CSP 11)	Decca SXL 6706 (Decca D258D 12)	Penguin ***, (K. Wilkinson)	Dutch Silver-Blue
London CS 7257 (=CS 7111 & 7247; CSP 11)	Decca SXL 6889 & 6994 (Decca D258D 12)	Penguin ***	Dutch Silver-Blue
London CS 7258	No Decca SXL (=Decca D222D 6)	Penguin ***	ED5, 1V-2G, rare!
London CSA	London CSA 2101 (CS 6568, 6575)	Decca SXL 6343	ED2, 1W-1W (Gatefold), $

London Label & Serial Number LONDON 唱片公司, 編號	Decca Label & Serial Number DECCA 唱片公司, 編號	Remarks & Ratings 附註和評價	1st Labels & Reference Prices 首版和參考價格
London CSA 2201 (=CS 6002-3)	Decca SXL 2084-5 (©=SDD 371-2, DPA 581-2)	RM15, Penguin **(*), Japan 300	ED1, BB, 1K-1K-5K-1K, (Pancake), $
London CSA 2202 (=CS 6056-7, ©=STS 15096-7)	Decca SXL 2064-5* (©=SDD 161-2)	RM10	ED1, BB, 2K-2K-3K-2K, $
London CSA 2203 (=CS 6068 & CS 6069, ©=STS 15433)	Decca SXL 2092-3* (©=SDD 378-9, DPA 569-70)	RM19, Penguin ***	ED1, BB, 1E-1E-1E-1E, $
London CSA 2204 (=CS 6075-6)	Decca SXL 2107-8* (©=SDD 354-5, DPA 603-4)	RM18, Penguin **(*)	ED1, BB,1E-1E-2E-2D, $
London CSA 2205 (=CS 6114-5)	No Decca SXL (©=ECS 530)	RM14	ED1, BB, 1E-1E-1E-4K, $$
London CSA 2206	Decca SXL 2300-1 (©=SDD 386-7, DPA 589-90)		ED1, BB, 1E-1E-1E-1E, $$
London CSA 2213	Decca SET 254-5	Penguin ***	ED1, 1E-1E-1E-1E, $
London CSA 2214 (=CS 6448 & CS 6449)	Decca SXL 6182 & SXL 6183		ED2, 1W-1W-1W-1W, $
London CSA 2215	Decca SET 303-4		ED1, BB, $
London CSA 2216	Decca SET 323-4	Penguin **(*)	ED2, 2W-1W-1W-2L, $
London CSA 2217	Decca SET 325-6*	Penguin ***	ED2
London CSA 2219	Decca SET 335-6	Penguin **(*)	ED2
London CSA 2220	Decca SET 360-1	Penguin **(*)	ED2, 4W-1W-1W-6W
London CSA 2221	Decca SET 370-1		ED2
London CSA 2222 (=CS 6588, CS 6589)	No Decca SXL, SET		ED3, 1W-1W-1W-1W
London CSA 2223 (=CS 6600, CS 6601)	Decca SET 385-6*		ED3, 1W-1W-1W-1W
London CSA 2224			ED3, 1W-1W-1W-1W, rare!
London CSA 2225 (CS 6634-5)	Decca SET 410-11 (SXL 6774-5)	Penguin **(*), (K. Wilkinson)	ED3, $
London CSA 2226	Decca SET 433-4		ED4
London CSA 2227	Decca SET 469-70	Penguin ***, AS list-F,	ED4, Grammy
London CSA 2228	Decca SET 471-2	Penguin **(*)	ED4
London CSA 2229	Decca SET 473-4	Penguin **(*)	ED4, 1W-1W
London CSA 2230	Decca 3BB 107-8, No Decca SXL, SET		ED4, 1W-1W, rare!!
London CSA 2231	Decca SET 518-9	Penguin ***, Grammy	ED4
London CSA 2232 (=CS 6742-3)	Decca SET 523-4		ED4, 3G-3G-2G-3G
London CSA 2233 (=CS 6499 + OS 26005)	Decca SET 331 & 332	TASEC†, Penguin *** & **(*)	ED2, $
London CSA 2235	Decca SXL 6586-7	Penguin ***	ED4, 4W-3W-6W-3W
London CSA 2236	Decca SXL 6635-6	Penguin ***, AS List, (K. Wilkinson)	ED4, 2G-3G-1G-1G
London CSA 2237	Decca SXL 6671-2		ED4, 1W-1W-1W-1W

London Label & Serial Number LONDON 唱片公司, 編號	Decca Label & Serial Number DECCA 唱片公司, 編號	Remarks & Ratings 附註和評價	1st Labels & Reference Prices 首版和參考價格
London CSA 2238	Decca SXL 6686-7	Penguin **(*)	ED4, 1W-1W-1W-1W (2LP-Box)
London CSA 2239 (=CS 6686, 6687)	Decca SXL 6688-9	Penguin **(*)	ED4, 3G-2G-3G-2G, $
London CSA 2240	Decca 6BB 171-2 (=JB 120)	Penguin ***, G.Top 100	ED4, 3W-3W-2W-2W
London CSA 2241	Decca 5BB 221-2	Penguin ***, Japan 300, Stevenson, (K. Wilkinson)	ED4, 3A-4A-5A-3A
London CSA 2242	Decca SXL 6744-5	TAS-Old, Penguin ***	ED4
London CSA 2243-5	Decca 13BB 207-212 (©=SDD 513-8)	Penguin ***	ED4, 6 LP-Box Set, $$+
London CSA 2246	No Decca SET, = SXL 6753 (part)		ED4
London CSA 2247 (=CS 6586 + CS 6711)	Decca SXL 6360 + SXL6496	(K. Wilkinson)	ED4, rare!!
London CSA 2248	Decca SXL 6806-7	AS List	ED4, 4W-1W-2W-1W
London CSA 2249	Decca D117D 2	TASEC, TAS2017, AS List	ED4, 1G-1G-1G-1G, $$, rare !!!
London CSA 2250	Decca D133D 2		ED4
London CSA 2301 (©=STS 15366-7)	Decca SXL 2125-7, (©=5BB 130-1 & SDD 186-7)	RM16, AS list-F	ED1, BB, 1-1E-1-1E-1E-2E, $
London CSA 2302 (=CS 6103-5)	Decca SXL 2115, 2187 & 2201 (©=SDD 470-2)	RM14, Penguin **(*)	ED1, BB, $
London CSA 2303 (©=STS 15146-8)	No Decca SXL (©=ESC 620-1)	RM14, Penguin **	ED1, BB, (1E), Very rare!! $$$
London CSA 2304 (=CS 6135-7)	Decca SXL 2160-2* (©=SDD 301-3)	RM14, Penguin **(*)	ED4, 4-5G-7-4G-4-10G, $$
London CSA 2305 (CS 6040; 6041; 6042)	Decca SXL 2024; 2025; 2081	RM14	ED1, BB, 4K-4E-2E-2K- 1E-1E, rare!! $$+
London CSA 2306 (CS 6333, 6334, 6335)	Decca SXL 6020, 6021 & 6022		ED1, 2G-1G-1-1G-1-1G, $$
London CSA 2307 (CS 6496-8)	Decca SXL 6242-4 (©=SDDC 298-300)	Penguin ***	ED2, 3W-2W-1E-2E-6T-1W
London CSA 2308	No Decca SET, [=Decca SXL 2011, 2017, 2042, 6066 (©=GOS 540-2)]	TASEC	ED2, 3L-3L-2L-2L-4E- 2E + (3W-3W), $$
London CSA 2309 (=CS 6595-7)	Decca SXL 6369-71 (©=SDDB 294-7)	Penguin ***☆	ED4, 3S-3S-4G-4G-4G-3G
London CSA 2310 (CS 6582, 6696, 6697)	Decca D190D 3	AS list-H (D190D 3)	ED4
London CSA 2311	Decca SXL 6565-7 (SXLF 6565)	Penguin ***, AS list-H	ED4
London CSA 2312	Decca SXL 6620-2	TASEC, Penguin***, AS list-H, Japan 300-CD	ED4

London Label & Serial Number LONDON 唱片公司, 編號	Decca Label & Serial Number DECCA 唱片公司, 編號	Remarks & Ratings 附註和評價	1st Labels & Reference Prices 首版和參考價格
London CSA 2313 (CS 6862, 6863, 6864)	Decca SXL 6665-7 (SXLM 6665)	Penguin ***, AS List-H	ED4
London CSA 2313 (CS 6862, 6863, 6864)	Decca SXLM 6665	Penguin ***	ED4
London CSA 2314 (CS 6964, 7062, 7063)	Decca 15BB 218-20 (=SXL 6767, 6768, 6769)	Penguin***, AS List	ED4
London CSA 2315	Decca D 37D 3	Penguin **(*)	ED4, $
London CSA 2316 (=CS 7069-71)	Decca D 78D 3		ED4, $
London CSA 2401	No Decca SXL, SET	2E-2E-2D-1E-1-1E- 1E-3K,	ED1, BB, $$$
London CSA 2402	Decca SXL 6059-62	1-1W-2-6W-2-2W-2- 2W	ED2, rare!!! $$+
London CSA 2403	Decca SXL 6238-41		ED2, 2G-2W-1E-3M- 1W-1W-2E-3E, rare!!! $$$
London CSA 2404	Decca SXLG 6594, [=Decca SXL 6651, 6652, 6653, 6654, 6655]	Penguin ***, AS list-F	ED4
London CSA 2405 [=CS 7007, CS 7094, CS 7095, CS 7096]	Decca D 39D 4 [=SXL 6783, 6834, 6835, 6836]		ED4
London CSA 2406 [=CS 7125-6, 7157-8, ©=CS 7198, 7199, 7200, 7201]	Decca D151D 4 [=SXL 6890, 6902, 6924, 6925]	Penguin **(*), (K. Wilkinson)	ED4 & ED5, $+
London CSA 2501	Decca D 92D 5 [=SXL 6632, 6736, 6789, 6790, 6791 & 6990]	Penguin ***✫	ED4, $
London CSP 1	Decca SXL SXLB 6470, (=SXL 6470-5)		7-LP Compilation Box Set
London CSP 2	Decca SXL 6452-61 (=SXLA 6452)		10-LP Compilation Box, $$$
London CSP 4	Decca SXLE 6558 (SXL 6558-61, ©=Decca D7D 4)		5-LP Compilation Box Set
London CSP 4	Decca SXL 6558-61 (SXLE 6558 ©=Decca D7D 4)		
London CSP 6	Decca SXL 6644-8 (SXLJ 6644; D105D 5)	Penguin **(*)	5-LP Compilation Box Set, rare!
London CSP 7	Decca 7BB 173-7; 178-82 & 183-7	Penguin **(*)	16-LP Compilation Box Set
London CSP 8 (=OS 26290-1, CSP 9)	Decca 6BB 121-2 (11BB 188-96)	TASEC, Penguin ***, AS list, (K. Wilkinson)	2-LP Box Set
London CSP 9	Decca 11BB 188-96	Penguin **(*), (K. Wilkinson)	9-LP Compilation Box Set
London CSP 10	Decca D 95D 6	AS List (D95D 6)	6-LP Box Compilation Set, rare!

London Label & Serial Number LONDON 唱片公司, 編號	Decca Label & Serial Number DECCA 唱片公司, 編號	Remarks & Ratings 附註和評價	1st Labels & Reference Prices 首版和參考價格
London CSP 11	Decca D258D 12	Penguin ***	12-LP Compilation Box Set, ED5
London DVO S-1	Decca SXL 6515-21 (SXLD 6515 ©=Decca D6D 7)	Penguin ***✲, AS List-H (D6D 7), (K. Wilkinson)	7-LP Compilation Box Set
London FBD-S 1 (=CS 6645, 6646)	Decca SET 468-468A	Penguin ***	ED4
London LDR 73004	Decca D230D 3	Penguin ***, (K. Wilkinson)	ED5
London OS 25005	Decca SXL 2030* (©=SDD 248, ECS 794)	Penguin ***✲	ED1, BB, 1K-1K, Pancake, $
London OS 25020	Decca SXL 2043 (©=SDD 287)		ED1, BB, 4E-4E, Pancake
London OS 25021	Decca SXL 2122		ED1, BB, 2E-4E, Pancake, $
London OS 25038	Decca SXL 2049 (©=SDD 207)		ED1, BB, 3K-1E, Pancake
London OS 25039	Decca SXL 2224 (©=SDD 215; ECS 780)		ED1, BB, 1K-1E, Pancake, $
London OS 25040 (OSA 1304)	Decca SXL 2129-31 (part, ©=SDD 332)		ED1, BB, 2E-2D
London OS 25044	Decca SXL 2068 (©=SDD 143, 426)		ED1, BB, 3E-2E, $
London OS 25045 (OSA 1402)	Decca SXL 2035 (©=SDD 237) (SXL 2087-90)	Penguin **(*), G.Top 100	ED1, BB, 1K-2K, $
London OS 25046 (highlights)	Decca [©=SDD 218 (SXL 2215-7, ©=GOS 501-3)]		ED1, BB, 1E-1E
London OS 25047 (OSA 1312)	Decca SXL 2058 (©=SDD 208)		ED1, BB, 1K-1K, $
London OS 25054	No Decca SXL [=Decca SKL 4027]		ED1, BB, 1E-1E
London OS 25061 (=OSA 1101, in LXT 5338 Jacket)	No Decca SXL, (=Decca LXT 5338)		ED1, BB, 1D-1D, Very rare!! $$
London OS 25065	Decca SXL 2083 (©=SPA 313)	Penguin ***	ED1, BB, rare!, $$
London OS 25075	Decca SXL 2048* (©=SDD 308, 391; SPA 535)	Penguin **(*)	ED1, BB, 2E-2E
London OS 25076 (OSA 1303)	Decca SXL 2014 (SXL 2208-10)		ED1, BB
London OS 25077 (OSA 1205)	Decca SXL 2133 (SXL 2022-3)	Penguin **(*), (K. Wilkinson)	ED1, BB, 1K-1K
London OS 25081	Decca SXL 2111 (©=SDD 390)		ED1,BB, 2E-1E, rare! $
London OS 25082	No Decca SXL		ED1, BB
London OS 25083 (OSA 1307)	Decca SXL 2192 (SXL 2094-6)		ED1, BB
London OS 25084 (OSA 1314)	Decca SXL 2202 (SXL 2054-6)		ED1, BB
London OS 25085 (OSA 1405)	Decca SXL 2069-72, (part) ©=SDD 292	Penguin **(*)	ED1, BB, 1D-2E, Pancake

London Label & Serial Number LONDON 唱片公司, 編號	Decca Label & Serial Number DECCA 唱片公司, 編號	Remarks & Ratings 附註和評價	1st Labels & Reference Prices 首版和參考價格
London OS 25101	No Decca SXL (©=SDD 212; ECS 826)	Penguin **(*)	ED1, BB, $
London OS 25102	No Decca SXL		ED1, BB, 1E-3E
London OS 25103	Decca SXL 2145 (©=SDD 209)		ED1, BB, 1E-1E, $$
London OS 25106	Decca SXL 2132 (©=SDD 224)	Penguin ***, (K. Wilkinson)	ED1, BB, 1E-1E, $$
London OS 25107	No Decca SXL		ED1, 2E-1E, rare!! $
London OS 25111	Decca SXL 2159 (©=SDD 146, JB 97)	Penguin ***☀, (K. Wilkinson)	ED1, BB, 2E-3D
London OS 25114	No Decca SXL		ED1, BB
London OS 25115 (OSA 1401)	No Decca SXL (©=SDD 382)	Penguin **(*)	ED1, BB
London OS 25116	No Decca SXL (©=SDD 324)		ED1, BB, 2M-2M
London OS 25118	No Decca SXL		ED1, BB, 2E-2E
London OS 25119	No Decca SXL		ED1, BB, 2G-1M
London OS 25120	No Decca SXL		ED1, BB, $
London OS 25121	No Decca SXL		ED1, BB, rare! $
London OS 25122	Decca SXL 2213		ED1, BB, 3M-4M, $
London OS 25123	No Decca SXL		ED1. BB 3M-1M, rare!! $
London OS 25126 (OSA 1309 & 1203)	Decca SXL 2230 (SET 382-4 & SXL 2031-2)	Penguin ***	ED1, BB, 2E-2E
London OS 25138	Decca SXL 2184	Penguin **(*)	ED1, BB, 1E-1E, rare!
London OS 25139	Decca SXL 2123		ED1, BB, 2D-2G, rare!! $
London OS 25141	No Decca SXL		ED1, BB, 1D-1D, $
London OS 25155	Decca SXL 2200	Penguin ***	ED1, BB, 2E-2E
London OS 25193 (OSA 1308)	Decca SXL 2175 (SXL 2078-80)		ED1, BB
London OS 25194 (OSA 1310)	No Decca SXL		ED1, BB
London OS 25196 (OSA 1306)	Decca SXL 2267 (SXL 2039-41, ©=SDD 333)	Penguin ***	ED1, BB
London OS 25201 (OSA 1208)	Decca SXL 2248 (SXL 2170-1)	Penguin **(*)	ED1, BB, 1E-1E
London OS 25202 (OSA 1501)	No Decca SXL		ED1, BB, 1E-4L, $
London OS 25203 (OSA 1311)	No Decca SXL		ED1, BB
London OS 25204 (OSA 1403)	No Decca SXL		ED1, BB
London OS 25205	(Highlights of London SRS 63509 & GOS 551-3)		ED1, BB, 3L-2E
London OS 25205 (London SRS 63509)	Decca SXL 2000 (©=GOS 551- 3; LXT 5159-61; London SRS 63509)		
London OS 25206 (OSA 1313)	Decca SXL 2242 (SXL 2167-9)	TASEC44, Penguin ***, AS list, Japan 300-CD	ED1, BB, 3L-1E, rare!
London OS 25218 (OSA 1210)	Decca SXL 2258 (SXL 2180-1, ©=SDD 334)		ED1, BB, 1E-2E

London Label & Serial Number LONDON 唱片公司, 編號	Decca Label & Serial Number DECCA 唱片公司, 編號	Remarks & Ratings 附註和評價	1st Labels & Reference Prices 首版和參考價格
London OS 25219	Decca SXL 2247	(K. Wilkinson)	ED1, BB, 1E-2E
London OS 25225	Decca SXL 2251 (©=SDD 193)	Penguin ***	ED1, BB, 2L-2L
London OS 25229	No Decca SXL		ED1, BB, 1L-1L
London OS 25230	No Decca SXL		ED1, BB, rare!
London OS 25231	Decca SXL 2233 (©=ECS 635)	Penguin ***	ED1, BB, 2E-3E
London OS 25232 (OSA 1214)	Decca SXL 2256	Penguin ***, G.Top 100, . (K. Wilkinson)	ED1, 1E-1E
London OS 25233 (OSA 1214)	Decca SXL 2257	Penguin ***, G.Top 100, (K. Wilkinson)	ED1, 1E-1E
London OS 25234 (=Decca SKL 4121)	No Decca SXL, (=Decca SKL 4121)		ED1, BB, 1S-1S
London OS 25242	Decca SXL 2264 (©=Jubilee 410 171)	Penguin ***, (K. Wilkinson)	ED1, BB, 2E-2E AS List-H (Jubilee 410 171)
London OS 25244	Decca SXL 2271		ED1, BB, 1E-2E, $
London OS 25271	No Decca SXL (©=ARGO ZRG 5179)		ED1, BB, 2D-2D
London OS 25280	Decca SXL 2294 (©=JB 38)	Penguin **(*), R2D4	ED1, BB
London OS 25281	Decca SXL 2295		ED1, BB,1D-1D, rare!! $$
London OS 25282	No Decca SXL		ED1, BB, rare! $
London OS 25312	Decca SXL 2299	(K. Wilkinson)	ED1, BB, 2E-2E, rare!! $
London OS 25316	Decca SXL 2304 (©=SDD 222)		ED1, 2E-2E, $
London OS 25320	Decca SXL 6003 (©=SDD 189)		ED1, BB, 1E-1E, $
London OS 25321	No Decca SXL (©=SDD 197)		ED1, BB, 3W-1E
London OS 25327	Decca SXL 6007	Penguin ***	ED1, BB
London OS 25330	Decca SXL 2310		ED1, BB, $
London OS 25331	No Decca SXL (©=ARGO ZNF 1; ZK 1)	Penguin ***	ED1, BB, 3D-4D, $
London OS 25332	No Decca SXL (©=ARGO ZRG 5277)		ED1, 1E-8E, rare! $
London OS 25333	No Decca SXL (©=ARGO SPA 267)	Penguin ***	ED1, BB, 1D-2D, $
London OS 25334 (OSA 1330)	Decca SXL 6012 (SXL 2185-6; 2253-5; 2281-2)		ED1, BB, 3E-3E
London OS 25701 (OSA 1324)	Decca SXL 2314 (SET 209-11)	Penguin **(*)	ED1
London OS 25702 (OSA 1327)	Decca SXL 2315 (SET 212-4)	Gramophone, Japan 300, (K. Wilkinson)	ED1
London OS 25703 (OSA 1329)	Decca SXL 2316 (SET 218-20)	(K. Wilkinson)	ED1
London OS 25710 (OSA 1332)	Decca SXL 6008 (SET 224-6)		ED1
London OS 25711 (OSA 1329)	Decca SXL 6009 (SET 218-20)	(K. Wilkinson)	ED1
London OS 25712 (OSA 1329)	Decca SXL 6010 (SET 218-20)	(K. Wilkinson)	ED1
London OS 25713 (OSA 1317)	Decca SXL 6011 (GOS 607-8)		ED1
London OS 25714 (OSA 1328)	Decca SXL 6013 (SET 215-7)		ED1, BB, 3G-1G
London OS 25715 (OSA 1331)	Decca SXL 6017 (SET 221-3)	(K. Wilkinson)	ED1

London Label & Serial Number LONDON 唱片公司, 編號	Decca Label & Serial Number DECCA 唱片公司, 編號	Remarks & Ratings 附註和評價	1st Labels & Reference Prices 首版和參考價格
London OS 25726	Decca SXL 6005 (©=SDD 206)		ED1
London OS 25729	Decca SXL 6030		ED1
London OS 25731	No Decca SXL (©=ARGO 5325)	Penguin ***, (K. Wilkinson)	ED1, 4G-3G
London OS 25735	No Decca SXL (©=ARGO 5333)		ED1, rare!
London OS 25742	Decca SXL 6033	(K. Wilkinson)	ED1
London OS 25757	Decca SXL 6037		ED1, BB, 1E-1E
London OS 25768	Decca SXL 6039 (©=SDD 462)	Penguin **(*)	ED1, BB
London OS 25769	Decca SXL 6038		ED1
London OS 25776 (OSA 1254)	Decca SXL 6073 (SET 247-8)	Penguin *** (K. Wilkinson)	
London OS 25777 (OSA 1254)	Decca SXL 6074 (SET 247-8)	Penguin *** (K. Wilkinson)	
London OS 25778	Decca SXL 6042		ED1, BB, 2D-1E
London OS 25782	Decca SXL 6045 (©=SDD 176)	Penguin ***	ED1, BB, 1D-1D
London OS 25783	Decca SXL 6046		ED1, BB, rare! $
London OS 25795	No Decca SXL (©=ARGO 5362)		ED1, BB
London OS 25797	Decca SXL 6069		ED1, BB, 2G-2G
London OS 25798	Decca SXL 6068		ED1, BB, 1E-1E
London OS 25799	Decca SXL 6075 (©=SDD 313)		ED1, (ED2, 2G-2G, Promote)
London OS 25800	No Decca SXL (©=ARGO ZRG 5371; ECS 661)		ED1
London OS 25807	Decca SXL 6077	(K. Wilkinson)	
London OS 25821	Decca SXL 6081*	Penguin ***	ED1,1E-1E, (Gatedfold), $
London OS 25832	No Decca SXL		ED1
London OS 25833	Decca SXL 6083		
London OS 25847	Decca SXL 6098 (©=DPA 594, part)	Penguin ***	ED1, 1G-1G
London OS 25866	Decca SXL 6106	(K. Wilkinson)	ED1
London OS 25869	Decca SXL 6107		ED1
London OS 25874 (OSA 1361)	Decca SXL 6080 (SET 232-4)		ED1
London OS 25876	Decca SXL 6116 (©=SDD 213, 574)	Penguin ***	ED1
London OS 25886 (OSA 1366)	Decca SXL 6127 (SET 249-51)	Penguin ***	ED2
London OS 25887 (OSA 1365)	Decca SXL 6128 (SET 239-41)		ED1
London OS 25893	Decca SXL 6139	Penguin **(*)	ED2
London OS 25894	Decca SXL 6140		ED2
London OS 25896	Decca SXL 2191 (©=SDD 360)		ED1, 1E-1E
London OS 25898 (OSA 1508)	Decca SXL 6142 (SET 242-6)	Penguin ***	ED2, 1G-1G
London OS 25899	Decca SXL 6144		ED2
London OS 25902 (OSA 1202)	No Decca SXL [Decca SKL 4925-6 (highlights)]	Penguin ***	

London Label & Serial Number LONDON 唱片公司, 編號	Decca Label & Serial Number DECCA 唱片公司, 編號	Remarks & Ratings 附註和評價	1st Labels & Reference Prices 首版和參考價格
London OS 25903 (OSA 1201)	No Decca SXL [Decca SKL 4006-7 (highlights)]		
London OS 25904 (OSA 1209)	No Decca SXL [Decca SKL 4081-2 (highlights)]	Penguin *** ✣, AS list	
London OS 25905	Decca SXL 6146	Penguin ***	ED1, 1W-1W
London OS 25906	No Decca SXL (=Decca SKL 4542; ©=SPA 27)		
London OS 25910	Decca SXL 6149		ED2
London OS 25911	Decca SXL 6147		ED2
London OS 25912	Decca SXL 6152	Penguin *** ✣	ED2
London OS 25920	No Decca SXL		ED2
London OS 25921	Decca SXL 6153 (©=SDD 385)		ED2
London OS 25922 (OSA 1373)	Decca SXL 6154 (SET 239-41)		ED2
London OS 25923 (OSA 1249 & 1319)	Decca SXL 6155 (SXL 6015-6 & SET 201-3)	Penguin ***	ED2
London OS 25924 (OSA 1368)	Decca SXL 6156 (SET 256-8)		ED2
London OS 25927	Decca SXL 6161		
London OS 25929	Decca SXL 6171 (=SDD 241)	Penguin ***	ED2, 1W-2G
London OS 25936	Decca SXL 6176		
London OS 25937	Decca SXL 6175	Penguin ***, (K. Wilkinson)	ED2
London OS 25938 (OSA 1502)	Decca SXL 6178		ED1
London OS 25939	Decca SXL 6190	Penguin ***	ED1
London OS 25940	Decca SXL 6192	Penguin **(*)	ED2
London OS 25941	Decca SXL 6191		ED2
London OS 25942	Decca SXL 6185		ED2
London OS 25943	Decca SXL 6193		ED2
London OS 25946	Decca SXL 6207		ED2
London OS 25947 (OSA 1375)	Decca SXL 6210 (SET 262-4)	Penguin ***	ED2
London OS 25948	Decca SXL 6201		ED2
London OS 25949	Decca SXL 6195		ED2
London OS 25950	No Decca SXL		ED2
London OS 25951	No Decca SXL		ED2
London OS 25955	Decca SXL 6221		ED2
London OS 25978	Decca SXL 6230 (©=SDD 245)		ED2, 1G-1G
London OS 25981	Decca SXL 6249		ED2
London OS 25991 (OSA 1218 & 1604)	Decca SXL 6261 (SET 228-9 & 292-7)		ED2
London OS 25992	Decca SXL 6255		ED2
London OS 25994	Decca SXL 6262	Penguin ***	ED2
London OS 25995	Decca SXL 6267		ED2
London OS 25996	Decca SXL 6266 (©=SDD 384)	Penguin **(*) (SDD 384)	ED2
London OS 26004 (OSA 1305)	Decca SXL 2309 (SXL 2150-2)	Penguin ***, (K. Wilkinson)	ED2

London Label & Serial Number LONDON 唱片公司, 編號	Decca Label & Serial Number DECCA 唱片公司, 編號	Remarks & Ratings 附註和評價	1st Labels & Reference Prices 首版和參考價格
London OS 26005	Decca SET 331	TAS2016, Penguin *** & **(*)	ED2
London OS 26007 (OSA 1381)	Decca SXL 6271 (SET 285-7)	Penguin **(*)	ED2
London OS 26008	Decca SXL 6272 (SET 288-91)	Penguin **(*), AS List-H (excerpts)	ED2
London OS 26009 (OSA 1259)	Decca SXL 6276 (SET 272-3)		ED2
London OS 26013 (OSA 1260)	Decca SET 337 (SET 280-1)	Penguin ***	ED2
London OS 26014	Decca SXL 6299		ED2
London OS 26018	Decca SXL 6306		ED2
London OS 26021	Decca SXL 6305		ED2
London OS 26025	(=Decca SXL 21213-M, Germany)		
London OS 26026 (OSA 1376)	Decca SET 345 (SET 265-7)		
London OS 26028 (OSA 1258)	No Decca SXL [Decca SKL 4809 (highlights)]	Penguin ***	
London OS 26030	Decca SXL 6314		ED2
London OS 26032	Decca SXL 6316		ED2
London OS 26039	Decca SXL 6326		ED2
London OS 26041 (OSA 1432)	Decca SET 353 (SET 305-8)	Penguin ***	
London OS 26042	Decca SXL 6327		ED2,1G-1G
London OS 26043	Decca SXL 6333		ED2
London OS 26052	No Decca SXL (©=SDD R459)	Penguin **(*)	ED2
London OS 26053	Decca SXL 6336		ED2
London OS 26054	No Decca SXL		ED2
London OS 26059 (OSA 1382)	Decca SET 367 (SET 298-30)	Penguin ***	
London OS 26063	Decca SXL 6347		
London OS 26064	Decca SXL 6345		
London OS 26067	Decca SXL 6349		ED2
London OS 26075	Decca SXL 6361		ED3
London OS 26080	Decca SXL 6451		ED4
London OS 26081	Decca SXL 6376		ED2, 1R-2R, rare!
London OS 26085 (OSA 1509)	Decca SET 390 (SET 312-6)	Penguin ***	
London OS 26086 (OSA 1383)	Decca SET 391 (SET 317-9)	Penguin ***	
London OS 26087	Decca SXL 6377	Penguin ***	
London OS 26093	No Decca SXL		ED3, 1G-1G
London OS 26097 (OSA 1385)	Decca SET 397 (SET 338-40)	Penguin ***	
London OS 26098	Decca SXL 6392 (©=ECS 790, part)		ED3, 1G-1G
London OS 26099	Decca SXL 6391	Penguin ***, (K. Wilkinson)	
London OS 26100	Decca SET 398	Penguin ***	
London OS 26103	Decca SXL 6400	Penguin ***	
London OS 26106	Decca SXL 6386		

London Label & Serial Number LONDON 唱片公司, 編號	Decca Label & Serial Number DECCA 唱片公司, 編號	Remarks & Ratings 附註和評價	1st Labels & Reference Prices 首版和參考價格
London OS 26107	Decca SXL 6404	Penguin **(*)	
London OS 26110	Decca SXL 6406	Penguin **(*), AS List	ED4, 1G-1G
London OS 26111	Decca SXL 6409	Penguin ***	
London OS 26113 (OSA 1282)	Decca SET 440 (One of SET 439-440)		
London OS 26114	No Decca SXL		ED4, 3G-1G
London OS 26115	No Decca SXL		ED4, 1G-1G
London OS 26121	Decca SET 422		
London OS 26128	Decca SET 423 (SET 346-8)		
London OS 26130 (OSA 1282)	Decca SET 439 (One of SET 439-440)		
London OS 26138 (OSA 1387)	Decca SET 432 (SET 357-9)		
London OS 26139 (OSA 1433)	Decca SET 431 (SET 327-30)		
London OS 26140 (OSA 1384)	Decca SET 430 (SET 320-2)	Penguin **(*)	
London OS 26141	Decca SXL 6428		
London OS 26146	Decca SXL 6443	Penguin ***	
London OS 26147	Decca SXL 6446		
London OS 26153	No Decca SXL		
London OS 26161	Decca SXL 6449	Penguin ***, AS List-H, (K. Wilkinson)	
London OS 26162 (OSA 1388)	Decca SET 450 (SET 364-6)	Penguin ***	
London OS 26163 (OSA 1267)	Decca SET 451 (SET 341-2)		
London OS 26164 (OSA 1390)	Decca SET 452 (SET 379-81)		
London OS 26165 (OSA 1378)	Decca SET 453 (SET 274-6)		
London OS 26168	Decca SET 456	Penguin *** & **(*)	
London OS 26169 (OSA 1218)	Decca SET 457 (SET 228-9)	Penguin ***	
London OS 26170 (OSA 1272)	Decca SET 458 (SET 368-9)		
London OS 26171 (OSA 1269)	Decca SET 459 (SET 354-5)	TAS Top 100 20th Century	
London OS 26176	Decca SET 464		ED4
London OS 26181	No Decca SXL (=Decca SXL 20557-B)		
London OS 26182	Decca SXL 6490	Penguin ***	ED4, 1G-1G
London OS 26183	No Decca SXL		ED4, 1G-1G
London OS 26184 (OSA 1389)	Decca SET 476 (SET 376-8)		ED4
London OS 26185 (OSA 1379)	Decca SET 475 (SET 277-9)		ED4
London OS 26186	Decca SXL 6497	Penguin ***, AS list (JB 122), (K. Wilkinson)	ED4
London OS 26192	Decca SXL 6498		ED4
London OS 26193 (OSA 1279)	Decca SET 483 (SET 401-2)	Penguin **(*)	
London OS 26194 (OSA 1309)	Decca SET 482 (SET 382-4; SXL 2101-3)	TASEC, Penguin ***, AS list-H	
London OS 26195	Decca SXL 6679	Penguin ***	ED4
London OS 26199	Decca SXL 6501		ED4

London Label & Serial Number LONDON 唱片公司, 編號	Decca Label & Serial Number DECCA 唱片公司, 編號	Remarks & Ratings 附註和評價	1st Labels & Reference Prices 首版和參考價格
London OS 26200 (OSA 1435)	Decca SET 487 (SET 418-21)	Penguin ***	
London OS 26201 (OSA 1391)	Decca SET 488 (SET 387-9)	Penguin ***	
London OS 26202 (OSA 1392)	Decca SET 489 (SET 394-6)		
London OS 26203 (OSA 1266 & 1280)	Decca SET 490 (SET343-4 & 403-4)		
London OS 26204 (OSA 1273)	Decca SET 491 (SET 372-3)	Penguin ***	
London OS 26205	No Decca SXL		ED4, 1G-1G, rare!
London OS 26206	No Decca SXL		ED4, 1G-1G
London OS 26207	No Decca SXL		ED4, 1G-1G
London OS 26213 (OSA 1283)	Decca SET 494 (SET 435-6)	Penguin **(*)	
London OS 26214 (OSA 1285)	Decca SET 495 (SET 443-4)	Penguin **(*)	
London OS 26215 (OSA 1434)	Decca SET 496 (SET 412-5)		
London OS 26216	Decca SXL 6506		ED4
London OS 26218	No Decca SXL		ED4, 1G-1G
London OS 26219-20	Decca SET 497-8		ED4
London OS 26220	Decca SXL 6711		ED4
London OS 26239 (OSA 1437)	Decca SET 513 (SET 460-3)	Penguin ***	
London OS 26240	Decca SXL 6522		ED4
London OS 26241	Decca SXL 6524		ED4, 2G-3L
London OS 26246	Decca SXL 6525		ED4
London OS 26248	(OSA 1292 & SET 520-1, part)		
London OS 26249	Decca SXL 6530		ED4
London OS 26250	Decca SXL 6534	Penguin **(*)	ED4
London OS 26251	No Decca SXL		ED4, 1G-1G
London OS 26253 (OSA 1436)	Decca SET 522 (SET 446-9)	Penguin **(*)	ED4
London OS 26254 (OSA 1396)	Decca SXL 6540 (SET 465-7)	Penguin **(*)	ED4
London OS 26257 (OSA 1397)	Decca SET 527 (SET 479-81)		ED4
London OS 26258	No Decca SXL		ED4
London OS 26262	Decca SXL 6548	Penguin ***(*)	ED4
London OS 26274 (OSA 1307)	Decca SET 558 (SXL 2094-6)		ED4
London OS 26276	No Decca SXL		ED4, 2G-1G
London OS 26277	No Decca SXL		ED4, 2G-2G
London OS 26278 (OSA 1398)	Decca SET 538 (SET 484-6)		ED4
London OS 26292	Decca SET 555	Penguin ***, (K. Wilkinson)	ED4
London OS 26299 (OSA 1438)	Decca SET 556 (SET 506-9)	Penguin ***	
London OS 26300 (OSA 1439)	Decca SET 557 (SET 514-7)	Penguin **(*)	
London OS 26301	Decca SXL 6577	(K. Wilkinson)	
London OS 26302	Decca SXL 6578	(K. Wilkinson)	
London OS 26303	Decca SXL 6579		
London OS 26304	No Decca SXL		ED4, 1B-1B
London OS 26305	Decca SXL 6584	Penguin ***✲, (K. Wilkinson)	
London OS 26306	No Decca SXL		

London Label & Serial Number LONDON 唱片公司, 編號	Decca Label & Serial Number DECCA 唱片公司, 編號	Remarks & Ratings 附註和評價	1st Labels & Reference Prices 首版和參考價格
London OS 26315	Decca SXL 6585		
London OS 26316	No Decca SXL		
London OS 26317	No Decca SXL		
London OS 26320	No Decca SXL		
London OS 26321	No Decca SXL		
London OS 26328	Decca SXL 6590	Penguin **(*)	
London OS 26332 (OSA 13103)	Decca SET 559 (SET 528-30)	Penguin ***, (K. Wilkinson)	ED4
London OS 26338	Decca SXL 6600	Penguin ***, (K. Wilkinson)	
London OS 26343 (OSA 13101)	Decca SET 564 (SET 503-5)	Penguin ***	
London OS 26346	No Decca SXL		ED4, 1G-1G
London OS 26347	No Decca SXL		
London OS 26366	Decca SXL 6609	(K. Wilkinson)	
London OS 26367	Decca SXL 6619	(K. Wilkinson)	
London OS 26369 (OSA 13106)	Decca SET 569 (SET 545-7)	Penguin ***, AS list	
London OS 26373	Decca SXL 6658	Penguin ***	
London OS 26376	Decca SXL 6629	(K. Wilkinson)	ED4, 3G-3G
London OS 26377 (OSA 13108)	Decca SET 573 (SET 561-3)	TASEC, Penguin ***, AS list, (K. Wilkinson)	
London OS 26379	Decca SXL 6637		ED4, 1G-1G, rare!
London OS 26381	No Decca SXL		ED4, 1G-3G
London OS 26384	Decca SXL 6649	Penguin **(*)	ED4
London OS 26390 (OSA 1278)	Decca SXL 6631 (SET 399-400)	Penguin ***, AS List-H	ED4
London OS 26391	Decca SXL 6650	Penguin **(*)	ED4
London OS 26399 (OSA 1299)	Decca SET 579 (SET 565-6)	Penguin ***	
London OS 26401 (OSA 13105)	Decca SET 580 (SET 542-4)	Penguin ***	
London OS 26408	No Decca SXL		ED4, 1G-1G
London OS 26424	Decca SXL 6690 (=SXLR 6690)		ED4, 3G-3G
London OS 26428	Decca SXL 6718	Penguin ***, (K. Wilkinson)	ED4, 3G-1G
London OS 26431	No Decca SXL		ED4, 1K-1K
London OS 26433	Decca SXL 6832	(K. Wilkinson)	ED4, 2A-1A
London OS 26434	Decca SXL 6988		ED5
London OS 26435	Decca SXL 6792 (=SXLR 6792)		ED4, 2K-2K
London OS 26436	No Decca SXL		
London OS 26437	Decca SXL 6991	Penguin ***	
London OS 26442	No Decca SXL	(K. Wilkinson)	ED4, 4G-1G, (Gatefold)
London OS 26443	Decca SXL 6747		ED4
London OS 26444	Decca SXL 6748	Penguin ***, AS list-H	ED4
London OS 26448	No Decca SXL		

London Label & Serial Number LONDON 唱片公司, 編號	Decca Label & Serial Number DECCA 唱片公司, 編號	Remarks & Ratings 附註和評價	1st Labels & Reference Prices 首版和參考價格
London OS 26449	Decca SXL 6828	Penguin ***, (K. Wilkinson)	
London OS 26453	Decca SXL 6772	Penguin ***, (K. Wilkinson)	ED4, 2G-31G
London OS 26455	Decca SET 605 (SET 584-6)	Penguin ***	
London OS 26473	Decca SXL 6781	Penguin **(*)	ED4
London OS 26493	No Decca SXL		ED4, 1K-1K
London OS 26497	Decca SXL 6825 (SXLR 6825)		ED4
London OS 26499	No Decca SXL		ED4, 1G-1G
London OS 26506	Decca SXL 6837		ED4
London OS 26510	Decca SXL 6839	Penguin ***	ED4
London OS 26524	Decca SXL 6841		ED4
London OS 26525	Decca SET 618	AS List-H, (K. Wilkinson)	ED4, 2G-1G
London OS 26527	Decca SXL 6847	Penguin ***, AS List, (K. Wilkinson)	ED4
London OS 26537	No Decca SXL (©=SDD 507)		ED4, 1W-1W
London OS 26557	Decca SXL 6864		ED4
London OS 26558	Decca SXL 6866		ED4
London OS 26559	Decca SXL 6869	Penguin ***	ED5
London OS 26560	Decca SXL 6870	Penguin ***	ED4, 3G-2G
London OS 26574	Decca SXL 6805		ED4
London OS 26575	Decca SXL 6888 (=SXLR 6888)	Penguin ***	
London OS 26577	No Decca SXL		ED4
London OS 26578	Decca SXL 6898		ED4, 1V-1V
London OS 26579	Decca SXL 6900	Penguin ***	ED4
London OS 26591	Decca SXL 6942		ED5
London OS 26592	Decca SXL 6943	Penguin ***	ED5
London OS 26594	No Decca SXL		
London OS 26603	No Decca SXL		ED4, 1G-1G
London OS 26610	Decca SET 602	Penguin ***, (K. Wilkinson)	ED4
London OS 26611	Decca SXL 6923	(K. Wilkinson)	ED4, (ED5, 2G-2G)
London OS 26612	Decca SXL 6930		ED5
London OS 26613	Decca SXL 6933	Penguin **(*), (K. Wilkinson)	ED5
London OS 26615	Decca SXL 6940	Penguin ***	ED5
London OS 26617	Decca SXL 6935 (=SXLR 6935)	Penguin ***	ED5, 2G-2G
London OS 26618	Decca SXL 6936 (=SXLR 6936)		ED5, rare!!
London OS 26652	Decca SXL 6970	Penguin **(*)	
London OS 26660	Decca SXL 6971	Penguin **(*)	ED5
London OS 26661	Decca SXL 6999	Penguin ***	
London OS 26662	Decca SXL 7000	Penguin ***	
London OS 26663	Decca SXL 7001	Penguin ***	ED5

London Label & Serial Number LONDON 唱片公司, 編號	Decca Label & Serial Number DECCA 唱片公司, 編號	Remarks & Ratings 附註和評價	1st Labels & Reference Prices 首版和參考價格
London OS 26666 (OSAD 12113)	Decca SXL 6984 (Decca D134D 2)		
London OS 26669	Decca SXL 7013	Penguin **(*), (K. Wilkinson)	
London OSA			
London OSA 1101 (=OS 25061); (=Decca LXT 5338, Mono only)	No Decca SXL, (=Columbia & Alhambra Records SCLL 14006)		ED1, BB, 1D-1D, Very rare!! $$
London OSA 1102 (=OS 25104)	No Decca SXL, (=Columbia & Alhambra Records SCLL 14002)		ED1, BB, Very rare!!! $$$
London OSA 1103 (=OS 25105)	No Decca SXL, (=Columbia & Alhambra Records SCLL 14003)		ED1, BB, 1M-1M, Very rare!!! $$$
London OSA 1104 (=OS 25108)	(©=SDD 314, Mono=LXT 5024)	Penguin **(*)	ED1, BB, 2E-1E, rare!! $
London OSA 1105 (OS 25322)	Decca SET 230		ED1, 1D-1D, $$
London OSA 1151 (OSA 1364)	Decca SXL 6122 (SET 236-8)	AS list (SET 236-8)	ED1
London OSA 1152 (OSA 1364)	Decca SXL 6123 (SET 236-8)	AS list (SET 236-8)	ED1
London OSA 1153 (OSA 1364)	Decca SXL 6124 (SET 236-8)	AS list (SET 236-8)	ED1, 1E-1E, $
London OSA 1154	Decca SXL 6079 (©=SDD 429)		ED1
London OSA 1155	No Decca SET, (=Decca SKL 4579)	Penguin ***	
London OSA 1156	Decca SET 301 (1BB 101-3)	Penguin ***, AS-DG list (1BB 101-3)	ED2
London OSA 1156, 1163, 1164	Decca 1BB 101-3	Penguin ***, AS-DG list	
London OSA 1157	Decca SET 302 (©=SPA 476)	Penguin **(*)	ED2
London OSA 1158 (=OS 25968)	Decca SET 311	Penguin ***, TAS2017	ED2
London OSA 1159 (=OS 25974)	Decca SXL 6233	Penguin ***	ED2
London OSA 1160	Decca SXL 6254		ED2, rare!
London OSA 1161 (=OS 26038, one of the OSA 1270)	DECCA SET 351		ED3, 1G-1G
London OSA 1162 (=OS 26040, one of the OSA 1270)	DECCA SET 352		ED4, 1G-2G
London OSA 1163	Decca SET 356 (1BB 101-3)	Penguin ***, (K. Wilkinson)	AS-DG list (1BB 101-3)
London OSA 1164	Decca SET 438 (1BB 101-3)	Penguin ***, AS-DG list (1BB 101-3)	
London OSA 1165 (=OS 26374)	Decca SET 572	Penguin ***	ED4, 2G-1G
London OSA 1166	Decca HEAD 10	TAS2017, Penguin **(*), (K. Wilkinson)	ED4, 1W-2W
London OSA 1168	Decca SET 616	Penguin **(*), AS List	ED4, 1G-5G

London Label & Serial Number LONDON 唱片公司, 編號	Decca Label & Serial Number DECCA 唱片公司, 編號	Remarks & Ratings 附註和評價	1st Labels & Reference Prices 首版和參考價格
London OSA 1169	Decca SET 617	Penguin **(*), (K. Wilkinson)	ED4
London OSA 1170	Decca SET 615	Penguin ***, (K. Wilkinson)	ED4
London OSA 1171	No Decca SXL		
London OSA 1172 (=OS 26580)	Decca SET 629	(K. Wilkinson)	ED4, 3V-3V
London OSA 1173	Decca SET 627	Penguin **(*), (K. Wilkinson)	ED4, 2G-2G
London OSA 1174	Decca SET 630	AS List, (K. Wilkinson)	ED5
London OSA 1201	No Decca SET, [=Decca SKL 4006-7, (9BB 162-7)]	Penguin **(*)	ED2, 6G-5G-5G-3G
London OSA 1202	No Decca SET, [=Decca SKL 4038-9]		ED1, BB, 3E-1E-3F-1K
London OSA 1203	Decca SXL 2031-2 (©=GOS 577-8)	Penguin ***	ED1, BB, 1E-1E-1E-2F, Pancake
London OSA 1204	Decca SXL 2074-5 (©=GOS 581-2)	Penguin ***	ED1, BB, 5E-1K-1E-4K, $$+
London OSA 1205	Decca SXL 2022-3 (©=SDD 113-4)	Penguin **(*), (K. Wilkinson)	ED1, 1E-1E-2E-3E, $
London OSA 1207	No Decca SET		ED1, BB, $
London OSA 1208	Decca SXL 2170-1 (=Decca D5D 2)	Penguin **(*)	
London OSA 1209	No Decca SET, [=Decca SKL 4081-2, (9BB 156-61)]	Penguin ***☆, AS list	ED3, 3L-5L-7L-2L
London OSA 1210	Decca SXL 2180-1		ED1, BB, 3E-3E-3E-3E, $+
London OSA 1212 (Part of OSA 1330)	Decca SXL 2185-6 (Part of SXL 2253-5)	Japan 300	ED1, 1E-1E-1E-1E, $
London OSA 1213 (Part of OSA 1330)	Decca SXL 2281-2 (Part of SXL 2253-5)		ED1, $
London OSA 1214	Decca SXL 2256-57*	Penguin ***, G.Top 100, (K. Wilkinson)	ED1, BB, 1E-1E-1E-1E
London OSA 1215	Decca SKL 4119-20, (9BB 156-61)	Penguin ***	ED1, 1D-1D-1D-1D
London OSA 1216	No Decca SET		ED1, BB, 3L-2S-1L-2L, $
London OSA 1217	No Decca SET, [=Decca SKL 4146-7]	Penguin **(*)	ED1, BB, 5E-1E-1E-4E
London OSA 1218	Decca SET 228-9	TAS2016, G.Top 100, Penguin ***, Grammy	ED1 Top 100 20th Century Classic,
London OSA 1248	No Decca SET, [=Decca SKL 4504-5]		ED1, BB, 5E-1E-1E-4E
London OSA 1249 (OSA 1319)	Decca SXL 6015-6 (SET 201- 3, part)	Penguin **(*)	ED1
London OSA 1250	No Decca SET, (=ARGO ZPR 257-8)		

London Label & Serial Number LONDON 唱片公司, 編號	Decca Label & Serial Number DECCA 唱片公司, 編號	Remarks & Ratings 附註和評價	1st Labels & Reference Prices 首版和參考價格
London OSA 1251	No Decca SET, (=ARGO ZPR 259-260)		
London OSA 1252	No Decca SET, (=ARGO ZPR 124-5)		
London OSA 1254 (=OS 25776, 25777)	Decca SXL 6073-4 & SET 247-8	Penguin ***, (K. Wilkinson)	
London OSA 1254 (=OS 25776, 25777)	Decca SET 247-8 (=Decca SXL 6073-4)	Penguin ***, (K. Wilkinson)	ED1, $
London OSA 1255	Decca SET 252-3	Penguin ***☆, AS List-H, (K. Wilkinson)	ED1
London OSA 1256	No Decca SET, (©=ARGO DPA 571-2)	Penguin **(*)	ED1, 1G-1G-2G-1G
London OSA 1257	Decca SET 268-9		ED1
London OSA 1258	No, Decca SET, [=Decca SKL 4624-5, (9BB 162-7)]	Penguin ***	
London OSA 1259	Decca SET 272-3		ED2, 1E-1E-1E-2E
London OSA 1260	Decca SET 280-1	Penguin **(*)	ED2
London OSA 1261	Decca SET 270-1	Penguin ***☆, (K. Wilkinson)	ED2
London OSA 1262	No Decca SET, [=Decca SKL 4708-9]	Penguin ***	ED2, 1G-1G-1G-1G,
London OSA 1263	Decca SET 309-10		ED2
London OSA 1265	Decca SET 333-4 (©=SPA 583-4)		ED2, rare! $
London OSA 1266	Decca SET 343-4		ED2
London OSA 1267	Decca SET 341-2		ED2
London OSA 1268	Decca SET 349-50		ED2
London OSA 1269	Decca SET 354-5*	TAS2016, Top 100 20th Century, Penguin ***	ED2
London OSA 1270 (OS 26038 & 26040)	Decca SET 351 & 352		ED3, 1G-1G
London OSA 1271	Decca SET 362-3	Penguin ***	ED3
London OSA 1272	Decca SET 368-9		
London OSA 1273	Decca SET 372-3	Penguin ***	
London OSA 1275	Decca SET 374-5	Penguin ***, Grammy	ED4
London OSA 1276	Decca SET 392-3		ED3
London OSA 1277	No Decca SET, [=Decca SKL 4925-6)]	Penguin ***	ED3
London OSA 1278	Decca SET 399-400	Penguin **(*)	ED3
London OSA 1279	Decca SET 401-2	Penguin **(*)	ED3
London OSA 1280	Decca SET 403-4		ED3
London OSA 1281	Decca SET 416-7	Penguin ***	ED3, 1G-1G-1G-4G
London OSA 1282	Decca SET 439-40		ED4
London OSA 1283	Decca SET 435-6	Penguin **(*)	ED4, 3G-3G-5G-3G

London Label & Serial Number LONDON 唱片公司, 編號	Decca Label & Serial Number DECCA 唱片公司, 編號	Remarks & Ratings 附註和評價	1st Labels & Reference Prices 首版和參考價格
London OSA 1284	Decca 5BB 123-4 (=RCA LDS 7022)	Penguin ***, TASEC, AS list	ED4
London OSA 1285	Decca SET 443-4	Penguin **(*)	ED4
London OSA 1286 (=OS 26166-7)	Decca SET 454-5		ED4
London OSA 1287	Decca SET 477-8	Penguin **(*)	ED4, 1G-1G-2G-2G
London OSA 1288	Decca SET 492-3	Penguin ***, AS List	ED4
London OSA 1288 (highlights)	Decca SET 537 (SET 492-3)		
London OSA 1290	Decca SET 499-500	Penguin ***	
London OSA 1290 (highlights)	Decca SET 560 (SET 499-50)	Penguin ***	
London OSA 1291	Decca SET 501-2	Penguin ***, AS List	
London OSA 1291 (highlights)	Decca SET 536 (SET 501-2)	AS List (SET 201-2)	
London OSA 1292	Decca SET 520-1		
London OSA 1293	Decca SET 525-6	Penguin ***	
London OSA 1294	No Decca SET, (©=GOS 617-8)		ED4, $
London OSA 1295	Decca SET 534-5 (7BB 183-7)	Penguin ***☆, (K. Wilkinson), Grammy	ED4
London OSA 1296	Decca SET 540-1		ED4
London OSA 1296 (highlights)	Decca SET 600 (SET 540-1)	Penguin **(*)	ED4
London OSA 1297	Decca SET 548-9		ED4, 1G-3G-1G-2G
London OSA 1299	Decca SET 565-6*	TASEC, Penguin ***, AS List (Speakers Corner),	ED4 Japan 300
London OSA 1301	No Decca SXL (©=GOS 583-4)		ED1, BB, (all-1K), (Pancake) $
London OSA 1302	Decca SXL 2225-7	1E-1E-1E-2E-3F-1K,	ED1, BB, (Pancake) $
London OSA 1303	Decca SXL 2208-10 (©=GOS 600-1)	Penguin ***	ED1, BB, 1E-2K-2K-3E-1-2E, $
London OSA 1304	Decca SXL 2129-31 (©=GOS 614-6)		ED1, BB, 5E-3E-3-3E- 3-2E, $
London OSA 1305	Decca SXL 2150-2	TAS2016, Penguin ***☆, G.Top 100, (K. Wilkinson)	ED1, BB, 1E-2E-3D-2E-2-2E, $
London OSA 1306	Decca SXL 2039-41 (©=GOS 594-6)	Penguin *** & **(*)	ED1, BB, 2E-2E-2K-2E-2K-2K
London OSA 1307	Decca SXL 2094-96 (©=GOS 591-3)	Penguin **(*)	ED1, BB, 1E-1E-1K-1E-1E-1E, $
London OSA 1308	Decca SXL 2078-80		ED1, BB, 1-2E-1-2E- 2E-3D, $
London OSA 1309	Decca SET 382-4 (=SXL 2101-3)	TASEC, Penguin ***, AS list-H, G.Top 100	ED1, BB, 1E-1E-1E-1E-1E-1E
London OSA 1309	Decca SXL 2101-3 (SET 382-4)	TASEC, AS list-H	ED1, BB, 1E-1E-1E-1E-1E-1E
London OSA 1310	No Decca SET, (©=GOS 525-7)		ED1, 2-1-1-1E, 1x ED2, 1-1E, $

London Label & Serial Number LONDON 唱片公司, 編號	Decca Label & Serial Number DECCA 唱片公司, 編號	Remarks & Ratings 附註和評價	1st Labels & Reference Prices 首版和參考價格
London OSA 1311	No Decca SET (©=GOS 566-7)		ED1, BB, 1-1E-2-1E-1-1E, $$
London OSA 1312	No Decca SET (©=GOS 543-5)		ED1, BB, (all 1M), rare!! $$$
London OSA 1313	Decca SXL 2167-9	TASEC44, Penguin ***, AS list-H, Japan 300-CD	ED1, BB, $
London OSA 1314 (=OSA 1406, 4LP-SET)	Decca SXL 2054-6 (=Decca D4D 3)	Penguin **(*)	ED1, BB, 5F-5E-7E-7E-5K-7D, $+
London OSA 1315	No Decca SET, (=ARGO ZPR 126-8)		
London OSA 1316	No Decca SET (=ARGO ZPR 201-30)		
London OSA 1317	No Decca SET, (©=GOS 607-8 & 6.35225 DX, Germany)	Penguin **(*)	ED2, 2E-1E-1E-1E-1E-1E, $
London OSA 1318	No Decca SET		
London OSA 1319 (=OSA 1249, part)	Decca SET 201-3 (=SXL 6015-6 & D247D 3)	Penguin **(*)	ED1, (Red Box)
London OSA 1320	No Decca SXL (©= ARGO ZRG 5271)	Penguin **(*)	ED1 & ED2, 3-1-1-3-2-1L, $
London OSA 1323	No Decca SET, [=Decca SKL 4138-40, (9BB 162-7)]	Penguin ***	ED1, rare!
London OSA 1324	Decca SET 209-11 (=Decca D55D 3)	Penguin **(*), Japan 300	ED1, BB, 3E-2D-3-1-3-2D, $
London OSA 1326	No Decca SET (=ARGO ZPR 186-8)		
London OSA 1327	Decca SET 212-4 (©=GOS 663-5)	Penguin ***, Japan 300, (K. Wilkinson)	ED1, $
London OSA 1328	Decca SET 215-7		ED1
London OSA 1329	Decca SET 218-20 (D104D 3)	Penguin **, (K. Wilkinson)	ED1
London OSA 1330 (=OSA 1212+1213)	Decca SXL 2253-5 (©=GOS 588-10; SDD 418, part)	Japan 300-CD	ED1, BB, $
London OSA 1331	Decca SET 221-3	Penguin **(*), (K. Wilkinson)	ED1, BB, rare!
London OSA 1332	Decca SET 224-6 (©=GOS 655-7)	Penguin **(*)	ED1, 1-2-1-1-2-1E
London OSA 1361	Decca SET 232-4 (©=GOS 509-11)		ED1, 3-3E-1-1-1-1W, $
London OSA 1362	No Decca SET, (=ARGO ZPR 183-5)		
London OSA 1363	No Decca SET, (=ARGO ZRG 313-5)		
London OSA 1364 (=OSA 1151-3)	Decca SET 236-8 (=SXL 6122-4)	AS list-H	ED1

London Label & Serial Number LONDON 唱片公司, 編號	Decca Label & Serial Number DECCA 唱片公司, 編號	Remarks & Ratings 附註和評價	1st Labels & Reference Prices 首版和參考價格
London OSA 1365	Decca SET 239-41	Penguin **(*)	ED1, BB
London OSA 1366	Decca SET 249-51	Penguin **(*)	
London OSA 1367	No Decca SET, (=ARGO ZPR 135-7)		
London OSA 1368	Decca SET 256-8		ED1, BB,
London OSA 1369	No Decca SET		
London OSA 1372	No Decca SET		
London OSA 1373	Decca SET 259-61		
London OSA 1374	No Decca SET, (=ARGO ZPR 161-3)		
London OSA 1375	Decca SET 262-4	Penguin ***	ED1, $
London OSA 1376	Decca SET 265-7		ED1, $
London OSA 1378	Decca SET 274-6	Penguin **(*), AS List, (K. Wilkinson)	ED1 + ED4, $
London OSA 1379	Decca SET 277-9		ED2, 5G-1G-1G-1G-1G-1G, $
London OSA 1380	Decca SET 282-4		
London OSA 1381	Decca SET 285-7	Penguin **(*)	
London OSA 1382	Decca SET 298-300	Penguin ***	
London OSA 1383	Decca SET 317-9	Penguin ***	
London OSA 1384	Decca SET 320-2	Penguin **(*)	ED2, 3G-4G3G-5W--3G-3G
London OSA 1385	Decca SET 338-40	Penguin ***, AS List, (K. Wilkinson)	ED2
London OSA 1386	Decca SET 346-8		
London OSA 1387	Decca SET 357-9		
London OSA 1388	Decca SET 364-6	Penguin ***	
London OSA 1389	Decca SET 376-8		ED2, 2G-1G-1G-2G-2G-1G, $
London OSA 1390	Decca SET 379-81	TAS2016, Top 100 20th Century Classical,	Penguin ***, AS-DG list (K. Wilkinson)
London OSA 1391	Decca SET 387-9	Penguin ***, AS-DG list	ED3, 2G-1G-1G-1G-2G-1G
London OSA 1392	Decca SET 394-6		ED3
London OSA 1393	Decca SET 427-9 (=RCA LSC 6158)	Penguin ***	ED4
London OSA 1394	Decca SET 424-6 (=RCA LSC 6166)	Penguin ***	ED4
London OSA 1395	Decca 2BB 104-6 (=RCA LSC 6163)	Penguin ***	ED4
London OSA 1396	Decca SET 465-7	Penguin **(*)	ED4
London OSA 1397	Decca SET 479-81	TAS2017, Penguin **(*), Japan 300-CD	ED4
London OSA 1398	Decca SET 484-6		ED4

London Label & Serial Number LONDON 唱片公司, 編號	Decca Label & Serial Number DECCA 唱片公司, 編號	Remarks & Ratings 附註和評價	1st Labels & Reference Prices 首版和參考價格
London OSA 1399	Decca 2BB 109-11 (=RCA LSC 6156)	Penguin **(*)	ED4
London OSA 1401	Decca SXL 2117-20 (©=GOS 604-6)	Penguin ***	ED1, BB, 1E-1K-1K-1K-1K-1E-1K-1K, (Pancake), $
London OSA 1402	Decca SXL 2087-90 (©=GOS 585-7)	Penguin ***☼, G.Top 100	ED1, BB, 5E-4F-4F-3E-3F-2K-4F-4K, $$$
London OSA 1403	No Decca SET, (©=GOS 574-6)		ED1, BB, 1E-1E-1K-2K-1E-1E-1E-1E, (Pancake), $
London OSA 1404	Decca SXL 2050-3 (©=GOS 571-3)	Penguin ***	ED1, BB, 2E-3E-2E-1K-2E-1E-1K-1K, $
London OSA 1405	Decca SXL 2069-72 (©=GOS 597-9)	Penguin **(*)	ED1, BB (4LP-SET)
London OSA 1406 (=OSA 1314)	Decca SXL 2054-6 (=Decca D4D 3)		ED1, BB (4LP-SET) $
London OSA 1407	No Decca SET, (=ARGO ZPR 132-4)		ED1, BB (4LP-SET) $
London OSA 1408	No Decca SET, (=ARGO ZPR 244-7)		ED1, BB (4LP-SET) $
London OSA 1409	No Decca SET, (=ARGO ZPR 149-152)		ED1, BB (4LP-SET) $
London OSA 1410	No Decca SET, (=ARGO ZPR 153-6)		ED1, BB (4LP-SET) $
London OSA 1411	No Decca SET, (=ARGO ZPR 232-5)		ED1, BB (4LP-SET) $
London OSA 1412	No Decca SET, (=ARGO ZPR 138-41)		ED1, BB (4LP-SET) $
London OSA 1413	No Decca SET, (=ARGO ZPR 142-5)		ED1, BB (4LP-SET) $
London OSA 1414	No Decca SET, (=ARGO ZPR 197-200)		ED1, BB (4LP-SET) $
London OSA 1415	No Decca SET, (=ARGO ZPR 157-60)		ED1, BB (4LP-SET) $
London OSA 1427	No Decca SET, (=ARGO2 ZPR 221-4)		ARGO2 ZPR 221-ZPR 221-4, rare! $
London OSA 1428	No Decca SET, (=ARGO ZPR 164-7)		
London OSA 1429	No Decca SET, (=ARGO ZPR 168-71)		
London OSA 1430	No Decca SET, (=ARGO ZRG 5407)		
London OSA 1431	Decca SET 288-91	Penguin ***, AS List-H	ED2, 2G-1G-1G-2G-2G-2G

London Label & Serial Number LONDON 唱片公司, 編號	Decca Label & Serial Number DECCA 唱片公司, 編號	Remarks & Ratings 附註和評價	1st Labels & Reference Prices 首版和參考價格
London OSA 1432	Decca SET 305-8	Penguin ***	ED2, 2G-3G-3G-1G-1G-1G-3G-2G
London OSA 1433	Decca SET 327-30		ED2
London OSA 1434	Decca SET 412-5		ED3
London OSA 1435 (OSAL)	Decca SET 418-21	Penguin ***	ED3+ED4
London OSA 1436	Decca SET 446-9	Penguin **(*)	ED4
London OSA 1437	Decca SET 460-3	Penguin ***	ED4
London OSA 1438	Decca SET 506-9	Penguin ***, AS list-H, Japan 300	ED4
London OSA 1439	Decca SET 514-7	TASEC, Penguin ***, AS list-H	ED2, rare! $
London OSA 1440 (highlights)	Decca SXL 6421	Penguin ***, AS list-H & AS list-F	ED3
London OSA 1441	No Decca SET		ED4, $
London OSA 1442	Decca SET 575-8 (=D56D 4)		ED4
London OSA 1443	Decca D132D 4		
London OSA 1443 (part)	Decca SXL 6987 (D132D 4; OSA 1443)		
London OSA 1444	Decca D162D 4		
London OSA 1445	Decca D216D 4	Penguin ***	ED5
London OSA 1446	Decca D219D 4	Penguin ***	ED4
London OSA 1501	No Decca SXL (©=GOS 562-5)		ED1, BB, 1D-1D-1D-1D-1D-1D-2E-1D-1D-1D, rare!! $$
London OSA 1502	Decca SET 204-8 (=D41D 5)	Penguin ***, AS list-H	ED1, BB, 5E-5E-5E-5E-5E-5E-5E-7E-5E-7E, $
London OSA 1503	No Decca SET, (=ARGO ZPR 192-6)		ED1, BB (5-LP BOX)
London OSA 1508	Decca SET 242-6	TASEC, G.Top 100, Penguin ***, Grammy,	ED1 Japan 300, AS list-H
London OSA 1509	Decca SET 312-6	Penguin ***, AS list-H, G. Top 100	ED2
London OSA 1510	Decca SET 550-4	Penguin ***, (K. Wilkinson)	ED4
London OSA 1511	Decca 7BB 125-9 (=RCA LDS 6706)	Penguin **(*), (K. Wilkinson)	
London OSA 1512	Decca D 13D 5	Penguin **(*), (K. Wilkinson)	
London OSA 1512 (part)	Decca SET 625 (D13D 5)	Penguin **(*), (K. Wilkinson)	
London OSA 1604	Decca SET 292-7	TASEC, Penguin ***, AS list-H, G. Top 100	ED2
London OSA 1604 (part)	Decca SXL 6220 (SET 292-7)	TASEC, Penguin ***, AS list-H	ED2

London Label & Serial Number LONDON 唱片公司, 編號	Decca Label & Serial Number DECCA 唱片公司, 編號	Remarks & Ratings 附註和評價	1st Labels & Reference Prices 首版和參考價格
London OSA 12100	Decca SET 567-8	Penguin ***✲	ED4
London OSA 12101	No Decca SET, (©=GOS 634-5)	Penguin **(*)	ED4
London OSA 12102	Decca SET 570-1	Penguin ***, (K. Wilkinson)	ED4, 2G1G-1G-2G
London OSA 12103	No Decca SET, [=Decca SKL 5158-9]	Penguin ***	ED4
London OSA 12104	No Decca SET, [Decca SKL 5188-9]	Penguin **(*)	ED4
London OSA 12107	Decca D 34D 2	Penguin ***	ED4
London OSA 12108	Decca D 50D 2		ED4
London OSA 12109	Decca D 51D 2	Penguin ***✲, G.Top 100, AS list	ED4
London OSA 12110	No Decca SET, [=SKL 5277-8]	Penguin **	ED4
London OSA 12111	Decca D 87D 2	Grammy, (K. Wilkinson)	ED4, 2G-2G-1G-2G
London OSA 12112	Decca D131D 2 (SET 633=part)	Penguin **(*)	ED4, $
London OSA 12112 (part)	Decca SET 633 (D131D 2)	Penguin **(*)	
London OSA 12113 (OSAD 12113)	Decca D134D 2		
London OSA 12114	Decca D135D 2	(K. Wilkinson)	
London OSA 12115	Decca D137D 2		
London OSA 12116	Decca D144D 2	TAS2017, Penguin ***	
London OSA 13100	Decca 2BB 112-4 (=RCA LDS 6152)		
London OSA 13101	Decca SET 503-5	Penguin ***	ED4
London OSA 13102	Decca SET 510-2	Penguin **(*), (K. Wilkinson)	ED4
London OSA 13103	Decca SET 528-30	Penguin ***, (K. Wilkinson)	ED4
London OSA 13104	Decca SET 531-3	Penguin ***, (K. Wilkinson)	ED4, rare! $
London OSA 13105	Decca SET 542-4	Penguin ***	ED4
London OSA 13106	Decca SET 545-7	Penguin ***✲, AS list	ED4
London OSA 13107 (OS 26329-31)	Decca D 65D 3		
London OSA 13108	Decca SET 561-3	TASEC, Penguin ***, AS list, (K. Wilkinson)	ED4
London OSA 13109	Decca SET 581-3	Penguin ***, AS-DG list, (K. Wilkinson)	ED4, 1G-2G-1G-1G-1G-1G
London OSA 13110	Decca SET 584-6	Penguin ***✲, Japan 300	ED4, 4G-4G-3G-3G-3G-3G
London OSA 13111	Decca SET 587-9	Penguin ***	
London OSA 13112	Decca SET 596-8	Penguin ***, AS List, (K. Wilkinson)	

London Label & Serial Number LONDON 唱片公司, 編號	Decca Label & Serial Number DECCA 唱片公司, 編號	Remarks & Ratings 附註和評價	1st Labels & Reference Prices 首版和參考價格
London OSA 13113	Decca D 96D 3	Penguin **(*)	
London OSA 13114	Decca SET 606-8	Penguin **(*), (K. Wilkinson)	
London OSA 13115	Decca D 11D 3	Penguin ***, AS List (K. Wilkinson)	ED4, 1G-1G-2G-6G- 2G-3G
London OSA 13115 (part)	Decca SET 621 (D11D 3 & 6.42316)	Penguin ***, AS List, (K. Wilkinson)	
London OSA 13116	Decca SET 609-11*	TASEC✼✼, AS list-F, Penguin ***✼	ED4, 2G-3G-2G-1G- 4G-2G
London OSA 13117	Decca D 2D 3	Penguin ***	
London OSA 13118	Decca SET 612-4	Penguin ***, AS List	
London OSA 13119	Decca D 24D 3	Penguin ***, AS list-H, (K. Wilkinson)	ED4, 1G-1G-2G-1G- 2G-2G
London OSA 13119 (part)	Decca SET 626 (D24D 3)	AS List, (K. Wilkinson)	
London OSA 13120	Decca D 48D 3	TAS Top 100 20th Century	
London OSA 13122	No Decca SXL, (©=GOS 660-2)		
London OSA 13123	Decca D 63D 3		
London OSA 13124	Decca D 82D 3 (SET 631=highlights)	Penguin **, AS List, (K. Wilkinson)	
London OSA 13124 (part)	Decca SET 631 (D82D 3)	Penguin **(*), AS List, (K. Wilkinson)	
London OSA 13125 (OSAD 13125)	Decca D 83D 3	Penguin **(*), (K. Wilkinson)	
London OSA 13125 (part)	Decca SXL 6986 (D83D 3)	(K. Wilkinson)	
London OSA 13126 (=OSA 1331)	Decca SET 221-3 (reissue)	(K. Wilkinson)	
London OSA 13127	Decca D 86D 3		ED4, 2G-1G-1G-3G
London OSA 13128	Decca D 88D 3	AS List, (K. Wilkinson)	ED4, 4G-1G-1G-2G- 2G-1G
London OSA 13129	Decca D 93D 3		
London OSA 13130	Decca D102D 3 (SET 632=part)	Penguin **(*)	
London OSA 13130 (part)	Decca SET 632 (D102D 3)	Penguin ***	
London OSA 13131	Decca D103D 3	Penguin **(*)	
LONDON OSA 13133	Decca D130D 3		
LONDON OSA 13134	Decca D156D 3 (=6.35477)	AS-DIV list	
London OSA 13135	Decca D176D 3	Penguin ***, AS-DG list, (K. Wilkinson)	ED4, 2G-1G-1G-1G-2G-2G, $
London OSA 13136	Decca D235D 3	Penguin **(*)	
London FBD-S 1 (=CS 6645, 6646)	Decca SET 468-468A	Penguin ***	
London RDN S-1	Decca SET 406-8 (RING 1-22)	Penguin ***	

London Label & Serial Number LONDON 唱片公司, 編號	Decca Label & Serial Number DECCA 唱片公司, 編號	Remarks & Ratings 附註和評價	1st Labels & Reference Prices 首版和參考價格
London Ring S-1 [=OSA 1309; 1509; 1508 & 1604]	Decca Ring 1-22 [=D100D 19 & SET 382-4 (SXL 2101-3); SET 312-6; 242-6 & SET 292-7]	TASEC, Penguin ***✳, G.Top 100, AS list	Grammy, Japan 300
London SRS 63507	Decca SXL 2215-7, (©=Ace of Diamond GOS 501-3)		
London SRS 63509	[=Decca GOS 551-3 & SXL 2000 (Never issued)]		
London SRS 64503	Decca Ace of Diamond GOS 554-7		No Decca SET, SXL & London OSA
London SRS 63516	Decca Ace of Diamond GOS 568-70		No Decca SET, SXL & London OSA
London SRS 64504	Decca Ace of Diamond GOS 619-21		No Decca SET, SXL & London OSA
London SRS 63523	Decca Ace of Diamond GOS 646-8		No Decca SET, SXL & London OSA
London STS 15019	Decca SXL 2223 (©=SDD 157, ECS 758)		No London CS
London STS 15065	Decca SXL 2205 (©=Decca 16.41387, Germany)		No London CS
London STS 15077	Decca SXL 6330	Penguin ***	No London CS
London STS 15078	Decca SXL 6338 (©=SDD 450)	Penguin **(*)	No London CS
London STS 15081-2	No Decca SXL (©=GOS 558-9)	TASEC, Penguin ***, AS List	No London CS
London STS 15155-6	No Decca SXL (©=GOS 602-3, DPA 593-4, part)	Penguin **(*) & ***	No London CS
London STS 15162	Decca SXL 6315	Penguin **(*)	No London CS
London STS 15164	Decca SXL 6341		No London CS
London STS 15166	Decca SXL 6413		No London CS
London STS 15167	Decca SXL 6424		No London CS
London STS 15168	Decca SXL 6331		No London CS
London STS 15169	Decca SXL 6339	Penguin ***	No London CS
London STS 15170	Decca SXL 6366	Penguin ***	No London CS
London STS 15171	Decca SXL 6420	Penguin ***	No London CS
London STS 15173	Decca SXL 6264	Penguin ***	No London CS
London STS 15301	Decca SXL 6499	Penguin ***	No London CS
London STS 15302	Decca SXL 6500	Penguin ***	No London CS
London STS 15304	Decca SXL 2290 (©=SDD 251)	Penguin ***	No London CS
London STS 15414	Decca SXL 6614	Penguin ***	No London CS
London STS 15415	Decca SXL 6615	Penguin ***	No London CS
London STS 15416	Decca SXL 6670	Penguin ***	No London CS
London STS 15417	Decca SXL 6724	Penguin ***	No London CS
London TCH S-1	Decca SXL 6476-80 (SXLC 6476 ©=Decca D8D 6)	Penguin **(*)	
London ZM 1001	Decca SXL 6885 (©=SDD 275)		ED4

LIST: DECCA RECORDS SXL SERIES
(No London CS & OS issue)
英國DECCA SXL系列發行中，沒在LONDON CS, OS系列出版的唱片編號表

Decca SXL 2057	Decca SXL 2100	Decca SXL 2199
Decca SXL 2205 (©=Decca 16.41387)	Decca SXL 2211 (©=SDD 154)	Decca SXL 2212* (©=SDD 168)
Decca SXL 2215-7 (©=GOS 501-3)	Decca SXL 2223 (©=SDD 157)	Decca SXL 2234 (©=SDD 286)
Decca SXL 2260 (©=SDD 134)	Decca SXL 2290 (©=SDD 251)	Decca SXL 6014 (Only Mono issue)
Decca SXL 6029	Decca SXL 6031 (No UK Decca)	Decca SXL 6032 (=LXT 6032)
Decca SXL 6060 (CS 6362, in CSA 2402)	Decca SXL 6078	Decca SXL 6114
Decca SXL 6177	Decca SXL 6180	Decca SXL 6182
Decca SXL 6183	Decca SXL 6194	Decca SXL 6231 (©=SDD 461)
Decca SXL 6234	Decca SXL 6237	Decca SXL 6245
Decca SXL 6251	Decca SXL 6264	Decca SXL 6265
Decca SXL 6281	Decca SXL 6296	Decca SXL 6307 (=TELDEC 16.41759)
Decca SXL 6315	Decca SXL 6318	Decca SXL 6319 (©=SDD 416)
Decca SXL 6320	Decca SXL 6330	Decca SXL 6331
Decca SXL 6337 (©=SDD 424)	Decca SXL 6338 (©=SDD 450)	Decca SXL 6339
Decca SXL 6341	Decca SXL 6350	Decca SXL 6351
Decca SXL 6362	Decca SXL 6366	Decca SXL 6384
Decca SXL 6385	Decca SXL 6413	Decca SXL 6418
Decca SXL 6420	Decca SXL 6424	Decca SXL 6427
Decca SXL 6429	Decca SXL 6430	Decca SXL 6431
Decca SXL 6432	Decca SXL 6433	Decca SXL 6434
Decca SXL 6441	Decca SXL 6468	Decca SXL 6481 (©=SDD 441)
Decca SXL 6499	Decca SXL 6500	Decca SXL 6513
Decca SXL 6514	Decca SXL 6537	Decca SXL 6549
Decca SXL 6564	Decca SXL 6570	Decca SXL 6582
Decca SXL 6598	Decca SXL 6605	Decca SXL 6606
Decca SXL 6607	Decca SXL 6608	Decca SXL 6614
Decca SXL 6615	Decca SXL 6618	Decca SXL 6625
Decca SXL 6626 (SET 531-3)	Decca SXL 6628	Decca SXL 6638
Decca SXL 6639	Decca SXL 6640	Decca SXL 6641
Decca SXL 6657	Decca SXL 6659	Decca SXL 6660-4 (SXLK 6660)

Decca SXL 6670	Decca SXL 6684 (SXLP 6684)	Decca SXL 6692
Decca SXL 6695	Decca SXL 6696	Decca SXL 6699
Decca SXL 6708, Decca SXL 6713	Decca SXL 6719	Decca SXL 6720
Decca SXL 6722	Decca SXL 6724	Decca SXL 6738
Decca SXL 6740	Decca SXL 6758	Decca SXL 6765
Decca SXL 6766	Decca SXL 6786	Decca SXL 6787
Decca SXL 6788	Decca SXL 6793	Decca SXL 6794
Decca SXL 6803	Decca SXL 6815	Decca SXL 6816
Decca SXL 6817	Decca SXL 6820	Decca SXL 6826
Decca SXL 6840	Decca SXL 6846	Decca SXL 6849
Decca SXL 6852	Decca SXL 6855	Decca SXL 6858
Decca SXL 6859	Decca SXL 6860	Decca SXL 6872
Decca SXL 6876	Decca SXL 6878	Decca SXL 6880
Decca SXL 6882	Decca SXL 6893	Decca SXL 6894
Decca SXL 6901	Decca SXL 6908	Decca SXL 6912
Decca SXL 6921	Decca SXL 6928	Decca SXL 6931
Decca SXL 6945	Decca SXL 6955	Decca SXL 6956
Decca SXL 6957	Decca SXL 6964	Decca SXL 6968
Decca SXL 6972	Decca SXL 6973	Decca SXL 6974
Decca SXL 6985	Decca SET 445	Decca SET 622

TAS - Harry Pearson's Complete Old & New Super LP List

[COLLECTOR'S ILLUSTRATED VINYL BIBLE]
Compiled by Alfred Wu

Chapter 1

The HP Super LP List from "The Absolute Sound (TAS)", includes: Best of the Bunch Classical & Popular, Special Merit of the Classical, Operas, Collections, Informal (Popular, Jazz, Rock & Soundtrack).

*Harry Pearson (January 5, 1937 – November 4, 2014)

《TAS主編哈利·皮爾遜的全部新舊發燒天碟榜單》
〔黑膠唱片聖經收藏圖鑑，吳輝舟編著〕

第一章：美國音響權威雜誌《絕對音響，The Absolute Sound (TAS)》已故主編哈利·皮爾遜精選發燒黑膠天碟，全部新舊英文榜單（包含：古典、收藏專輯、流行、爵士及電影原聲帶）

*TAS 已故主編 哈利·皮爾遜：1937 年 1 月 5 日出生，2014 年 11 月 4 日逝世

Chapter 1.1 (List only, without Photos & Comments) [HP Super LP List]

includes: Best of the Bunch Classical, Special Merit of the Classical, Operas and Collections.

HP 黑膠發燒天碟古典與收藏專輯榜單，依唱片公司排列

Label : AFKA SK 298
《Pieces De Clavecin》
XVIII Century French Harpsichord Music of C. Balbastre, F. Couperin and J. Duphly,
Harpsichord: Mark Kroll. **In the HP's Old list of Golden Baker's Dozen.
Rating: TASEC **

Label : Analogue Productions AP 001 (=VANGUARD VSD 2095)
Virgil Thomson: 《Suite from The River》 《The Plow that Broke the Plains》
Leopold Stokowski conducted the Symphony of the Air.
Original recording: VANGUARD VSD 2095
Rating: TASEC

Label : Analogue Productions AP 002 (= VANGUARD VSD 2090)
《Songs of the Auvergne》 Volume I, arranged by Canteloube. Soprano: Netania Davrath.
Sung in the Auvergne dialect, Orchestra conducted by Pierre de la Roche.
Rating: TAS 65-Old, Penguin 3*+ (Original recording: VANGUARD VSD 2090)

Label : Analogue Productions AP 003 (=VANGUARD SRV 275 SD)
Gould: 《Latin-American Symphonette, No. 4, (1940)》
Gottschalk: 《A Night In The Tropics (1859)》 《Grande Tarentelle for Piano & Orchestra》 Piano:
Reid Nibley, Utah Symphony Orchestra-Maurice Abravanel, @1962.
Rating: TASEC (TAS list is VANGUARD SRV 275 SD)

Label : ARCHIV 198 166
《Dance Music From The Time of Praetorius》
Fritz Neumeyer & Collegium Terpsichore.
*Michael Praetorius (1571-1621), German composer.
Rating: TASEC, (AS List-Arthur Salvatore list)

Label : ARGO ZK 1 (original issue is ZNF 1)
Benjamin Britten: 《Noye's Fludde》
with Owen Branniganand and English Chamber Orchestra, conducted by Benjamin Britten, @1961.
ZNF 1 is the original issue from the HP's list: ARGO ZK 1
US issue is LONDON OS 25331
Rating: TASEC, (AS List)

Label : ARGO ZNF 6 (=ZK 098)
Holst: 《Choral Hymns from the Rig Veda, Op. 26, No. 3》 《SAVITRI, Op. 25》
A Chamber opera in one act, English Chamber Orchestra & Purcell Singers with Janet Baker,
Thomas Hemsley, Robert Tear, conducted by Imogen Holst, @1966.
Rating: TAS 98-OLD, (AS List)

Label : ARGO ZRG 505
Vivaldi: 《Gloria》 ; Pergolesi: 《Magnificat》
The Academy of St.Martin.i.t.Field, Leader: Neville Marriner, directed by David Willcocks.
Recorded in the Chapel of King's College, Cambridge, @1966.
Rating: TAS 44-OLD

Label : ARGO ZRG 5365
《Evensong for Ash Wednesday》
The Choir of King's College, Cambridge, conducted by David Willcocks.
Rating: TASEC-COLLECTION, Penguin 3*

Label : ARGO ZRG 5420
Reubke: 《The 94th Psalm-Sonata for Organ》
Max Reger: 《Toccata & Fugues, Op. 59, No. 5 & 6》 《Organ Fantasia-Straf' Mich Nicht.., Op. 40, No. 2》
Organ: Simon Preston. Recorded at Westminster Abbey in 1964.
Rating: TAS 07-OLD

Label : ARGO ZRG 701
Roberto Gerhard: 《Symphony No. 4》
BBC Symphony Orchestra conducted by Colin Davis.
Violin: Yfrah Neaman, @1972.
Rating: TASEC, (AS list), Penguin 3*

Label : ARGO ZRG 756
Messiaen: 《Chronochromie》
Koechlin: 《Les Bandar-Log, Op. 176-Symphony Poem》
Boulez: 《Le Soleil Des Eaux》 , BBC Symphony Orchestra conducted by Dorati & Boulez. @1965
Rating: TAS 73-OLD, (AS list)

Label : ARGO ZRG 787
Maurice Durufle: 《REQUIEM, For Soloists, Choirs and Organ》
《Prelude et Fugue sur le nom d'Alain》
Organ: Stephen Cleobury; Treble: Robert King; Baritone: C. Keyte; George Guest conducts
Choir of St. John College, Cambridge. Recorded by James Lock & Colin Moorfoot in 1975.
Rating: TAS 73-OLD

Label : ARK 4170-S
《The Fulton Gold Series》 , Vol. I (Test record)
A collection of varied types of music, as well as a variety of performing ensembles from the
tape library of Robert W. Fulton. Produced by Fulton Musical Industries.
Rating: TAS 27-OLD

Label : ATHENA ALSW 10001 (=TURNABOUT TV 34145 S)
Rachmaninoff: 《Symphonic Dances No. 45》 《Vocalise No. 14》
Donald Johanos-Dallas Symphony Orchestra, @1988.
**Also in the HP's Old list of Golden Baker's Dozen.
Rating: TASEC**, TAS 50, AS list

Label : BIS 163-164
《LA SPAGNA》
Atrivm Mvsicae De Madrid-Gregorio Paniagua.
Rating: TASEC-COLLECTION, AS list

Label : Canada Broad SM 5000 (=Catabile CSPS 1617)
Copland: 《Appalachian Spring》 ; Varese: 《Octandre》 ; Britten: 《Sinfinietta Op. 1》
Armenian Raffi-Stratford Ensemble (Since 1980 is Canadian Chamber Ensemble).
(The same recording is Cantabile CSPS 1617, @1980)
Rating: TASEC, AS List

Label : Candide 31099（Q）
Rachmaninoff: 《Symphony No. 1 in D minor, Op. 13》
Leonard Slatkin-Saint Louis Symphony Orchestra.
Produced & recorded by Nichrenz & Marc Aubort @1977.
(Original VOX recording, Quadraphonic)
Rating: TAS 20-OLD

Label : Cantabile CSPS 1349 (=RA 10 100)
Ravel: 《Trois poemes de Stephane Mallarme》 , 3 Mallarme Songs
Wolf: 《2 Songs from "Spanisches Liederbuch" 》
Schoenberg: 《Chamber Symphony No. 1 in E major, Op. 9》
Maureen Forrester (contralto), The Stratford Ensemble Raffi Armenian. @1978.
Rating: TAS 22-OLD

Label : Cantabile CSPS 1617 (=CBC SM 5000)
Copland: 《Appalachian Spring》 ; Varese: 《Octandre》
Britten: 《Sinfinietta Op. 1》 , Armenian Raffi-Stratford Ensemble(Since 1980 is Canadian Chamber Ensemble).
(Same recording as Canada Broadcast CBC SM 5000)
Rating: TAS 31, TASEC, AS List

Label : CAPITOL SP 8364
Toch: 《Symphony No. 3》 ; Hindemith: 《Mathis der Maler》
William Steinberg conducts the Pittsburgh Symphony Orchestra.
**Also in the Old list of Golden Baker's Dozen
Rating: TASEC**

Label : CAPITOL SP 8407 (=EMI-CFP 134)
Stravinsky: 《Firebird & Petrushka Ballet Suites》
Berlin Philharmonic Orchestra-Stokowski, @1958.
Rating: TASEC

Label : CAPITOL SP 8461
《For My True Love》
Guitar: Laurindo Almeida; Mezzo soprano: Salli Terri; Flute: Martin Ruderman
Rating: TASEC-COLLECTION

Label : CAPITOL SP 8663 (=EMI CSD 1399, ESD 7028)
Gilbert & Sullivan: 《Pineapple Poll》
Royal Philharmonic Orchestra-Charles Mackerras. (Recorded in 1962)
Rating: TASEC, Penguin 3*

Label : CAPITOL SPAR 8448 (=SPBO 8700)
Shostakovich: 《Symphony No. 11, (1905)》
Leopold Stokowski conducted Houston Symphony Orchestra.
SPBO 8700 is the reissue of SPAR 8448, @1960.
**Also in the Old Golden Dozen List ·
Rating: TAS-OLD**, (2LP-gatefold)

Label : CAPITOL SPAR 8448
Shostakovich: 《Symphony No. 11, (1905)》
Leopold Stokowski conducted Houston Symphony Orchestra.
**Also in the Old Golden Dozen List.
(The reissues are SPBO 8700, @1960 & EMI Eminence AE-1-34446, @1965)
Rating: TAS-OLD**, 2LP-Box, @1958.

Label : CAPITOL SPAR 8470 (=CFP 40311)
Carl Orff: 《Carmina Burana》
Stokowski conducted the Houston Symphony Orchestra & The Houston Chorale, @1959.
Rating: TASEC*

Label : CAPRICE CAP 1127
Allan Pettersson: 《Symphony No. 12》
"Los muertas de la plaza-The Dead in the Square" for mixed choir and orchestra, Stockholm
Philharmonic Orchestra and Chorus-Carl Larsson.
Rating: TAS 25-OLD

Label : CBS-COLUMBIA M 30383
《Everything You Always Wanted to Hear on the Moog*》
Music from Bolero、Espana、Malaguena、Carmen,
The Mighty Moog, Semi-conducted by Andrew Kazdin & Thomas Z. Shepard, (1979 ED).
Rating: TAS 17-OLD

Label : CBS-COLUMBIA M 32739
Geoge Crumb: 《Voice of the Whale-Vox Balaenae》 (1971), for Flute, Piano, Cello & Antique
Cymbals. 《Nightof the 4 Moons》 (1969), for Benjo, Alto Flute & Piccolo, Cello, Percussion and
Mezzo-Soprano.
Rating: TAS 07-OLD, (@1973)

Label : CBS-COLUMBIA M 32838 (= UK, CBS 76 306)
《Boulez conducts Ravel》 , Vol. 3
La Valse; Menuet Antique; Ma Mere L'oye (Mother Goose)
New York Philharmonic Orchestra, @1974.
Complete Works SET is Columbia No. 79 404
Rating: TAS 07-OLD

Label : CBS-COLUMBIA M 33508 (= UK, CBS 76 418 & HM 43508)
Stravinsky: 《Firebird》 Complete Ballet (1910 version)
Pierre Boulez-New York Philharmonic, @1975, Germany.
Rating: TAS 13-OLD (M 33508)

Label : CBS-COLUMBIA M 33523 (= UK, CBS 76 425 & HM 43523)
Ravel: Complete Ballet 《Daphnis & Chloe》
Pierre Boulez-New York Philharmonic Orchestra, @1975.
Rating: TAS 11-OLD

Label : CBS-COLUMBIA M2 30576
Harry Partch: 《Delusion of the Fury》
A Ritual of Dream & Delusion, Ensemble of unique instruments.
Rating: TASEC, AS list

Label : CBS-COLUMBIA MS 6012
Beethoven: 《Symphony No. 6, "Pastrorale", Op. 68》
Columbia Symphony Orchestra-Bruno Walter, @1958.
Rating: TASEC, Penguin 3*+, Stereophile R2D4

Label : CBS-COLUMBIA MS 6036 (=CBS / SONY 20AC 1808)
Beethoven: 《Symphony No. 3 "Eroica"》
Bruno Walter-Columbia Symphony Orchestra.
TAS List is CBS/SONY 20AC 1808 (Japan), the original issue: Columbia MS 6036, @1959.
Rating: TAS 98-OLD

Label : CBS-COLUMBIA MS 6361 (=CBS / SONY 20AC 1822)
Dvorak: 《Symphony No. 4(No. 8), Op. 88》
Bruno Walter conducted Columbia Symphony Orchestra. @1962
TAS List is CBS/SONY 20AC 1822 (Japan), the original issue: MS 6361 (=UK SBRG 72097)
Rating: TASEC

Label : CBS-COLUMBIA MS 6394 (=CBS/SONY 20AC 1830)
Gustav Mahler: 《Symphonie No. 1, " Titan"》, Columbia Symphony Orchestra-Bruno Walter.
TAS List is CBS/SONY 20AC 1830 (Japan), the original issue: COLUMBIA MS 6394
Rating: TAS 98-OLD, (Stereophile R2D4)

Label : CBS-COLUMBIA MS 6488 (UK=SBRG 72142 & CBS/SONY 20AC 1821)
Brahms: 《Alto Rhapsody》 & 《Song of Destiny》
Mahler: 《Songs of a Wayfarer》, Mildred Miller (Mezzo-Soprano), Bruno Walter conducted
Columbia Symphony Orchestra, @1963.
Rating: TASEC

Label : CBS-COLUMBIA MS 6494 (UK=SBRG 72138)
Mozart: 《Symphonies: No. 38 & No. 40》, Columbia Symphony Orchestra-Bruno Walter. Also in the 4 LP-Box: CBS S 77 413 (Germany) 《Mozart Last 6 Symphonies: No. 35; 36; 38; 39; 40; 41》, @1963.
Rating: TAS 98-OLD

Label : CBS-COLUMBIA MS 6562
Hindemith: 《Mathis Der Mahler》, 《Symphonic Metamorphoses of Themes by Weber》
The Philadelphia Orchestra-Eugene Ormandy, @1964.
Rating: TAS 73-OLD

Label : CHANDOS ABRD 1055
Bach-Stokowski: 《Symphonic Transcriptions》
Robert Pikler-Sydney Symphony Orchestra, @1982.
**Also in the HP's Old list of Golden Baker's Dozen
Rating: TASEC**

Label : CHESKY CR 02 (= Quintessen reissue PMC 7006)
Rachmaninoff: 《Piano Concerto No. 2, C Minor Op. 18》
Piano: Earl Wild, Horenstein-Royal Philharmonic Orchestra.
Producer: Charles Gerhardt, recorded by Kenneth Wilkinson at Walthamstow Town Hall in
1965. One of the Readers Digest SET : RDA 29, reisuued in1986.
Rating: TAS 50-OLD (RDA 29)

Label : CHESKY RC 04 (=RCA LSC 2446)
Rimsky-Korsakov: 《Scheherazade Op. 35》 Chicago Symphony Orchestra-Fritz Reiner.
Producer: Richard Mohr, @1960. Recorded by Lewis Layton at Orchestra Hall Chicago.
Rating: TASEC (=RCA LSC 2446**)

Label : CHESKY RC 05 (=RCA LSC 2436)
Respighi: Symphonic Poem 《Fountains Of Rome》、《Pines Of Rome》, Chicago Symphony Orchestra-Reiner. Producer: Richard Mohr. Recording engineer: Lewis Layton recorded at OHC in 1959, @1960.
Rating: TASEC (=RCA LSC 2436**), Penguin 3*

Label : CHESKY CR 06
Brahms: 《Symphony No. 4, in E minor, Op. 98》, Royal Philharmonic Orchestra-Fritz Reiner.
Producer: Charles Gerhardt, recorded by Kenneth Wilkinson at Walthamstow Town Hall in
1962. One of the Readers Digest RDA 47 Set, reissued in 1988.
Rating: TAS-Super Disc CD List

Label : CHESKY CR 07
Bizet: 《Symphony No. 1 in C》 ; Tchaikovsky: 《Francesca da Rimini, Op. 32》
Charles Munch-Royal Philharmonic Orchestra.
Producer: Charles Gerhardt, recorded by Kenneth Wilkinson at Walthamstow Town Hall in
1963. One of the Readers Digest RDA 47 Set, reissued in1988.
Rating: TAS-HP's Old CD list

Label : CHESKY RC 08 (=RCA LSC 2367)
Gershwin: 《Rhapsody in Blue》 《An American in Paris》, Piano: Earl Wild
Boston Pops Orchestra-Arthur Fiedler. Recorded by Lewis Layton at BSH in 1959, @1960.
**LSC 2367 also in the Old list of Golden Baker's Dozen.
Rating: TASEC (=RCA LSC 2367**)

Label : CHESKY RC 09 (=RCA LSC 2230)
《 SPAIN 》
Goyescas: 〈Intermezzo〉, Falla: 〈Dances from The Three-Cornered Hat〉、〈La Vida Breve〉,
Iberia: 〈Navarra〉、〈Fete-Dieu A Seville〉、〈Triana〉, Chicago Symphony Orchestra- Fritz Reiner. (Lewis Layton-Orchestra Hall Chicago)
Rating: TAS-OLD (=RCA LSC 2230)

Label : CHESKY RC 10 (=RCA LSC 2150)
Prokofiev: 《Lieutenant Kije, Op. 60》
Stravinsky: Symphonic Poem 《Song of the Nightingale》
Chicago Symphony Orchestra-Fritz Reiner. (Lewis Layton-Orchestra Hall Chicago, @1958)
Rating: TASEC (=RCA LSC 2150**)

Label : CHESKY RC 11 (=RCA LSC 2183)**
【 The Reiner Sound 】
Ravel: 《Rapsodie Espagnole》 《Pavan for a Dead Princess》
Rachmaninoff: 《Isle of the Dead》, Chicago Symphony Orchestra-Fritz Reiner.
Recorded by Lewis Layton at OHC, @1958. **Also in the Old list of Golden Baker's Dozen
Rating: TAS-OLD (=RCA LSC 2183**)

Label : CHESKY RC 15 (=RCA LSC 1893)
Ravel: Complete Ballet 《Daphnis & Chloe》, Boston Symphony Orchestra-Charles Munch.
Recorded by Leslie Chase at BSH in 1955, issued in 1959.
HP's List is this Chesky reissue from RCA LSC 1893
★Victrola reissue is VICS 1297 not VICS 1271
Rating: TASEC, JM10++

Label : CHESKY RC 30 (=RCA VCS 2659)
《The Power of the Orchestra》
Mussorgsk: <Night on the Bald Mountain> & <Pictures at an Exhibition>
Royal Philharmonic Orchestra-René Leibowitz. Producer: Charles Gerhardt, recorded by
Kenneth Wilkinson, 1962 in the Kingsway Hall, London.
Rating: TASEC-COLLECTION (=RCA VCS 2659)

Label : CRYSTAL CLEAR CCS 7001
《THE FOX TOUCH》Vol. I
J.S. Bach: Toccata & J. Jongen: Toccata from the symphonie Concertante, Organist: Virgil
Fox. Direct to Disc recording in 1977 by Bert Whyte.
Rating: TAS 22-OLD (D2D)

Label : CRYSTAL CLEAR CCS 7003
Rimsky-Korsakaov: 《Capriccio Espagnol, Op. 34》
Tchaikovsky: 《Capriccio Italien, Op. 45》
Arthur Fiedler and the Boston POPS. Direct to Disc recording in 1978 by Bert Whyte.
Rating: TAS 22-OLD (D2D)

Label : DECCA 6BB 121/2 (=LONDON CSP 8; MFSL 2-516)
Beethoven: 《Symphony No. 9》
Chicago Symphony Orchestra & Chorus-George Solti.
Record Engineer: Kenneth Wilkinson & Goldon Parry in 1972.
Rating: TASEC, (=MFSL 2-516, AS List)

Label : DECCA ECLIPSE ECS 576 (=LONDON CS 6126)
Borodin: 《Symphony No. 2 in B Minor》《Symphony No. 3 in A Minor (Unfinished)》
《Prince Igor Overture》, Ansermet conducted L'Orchestre de la Suisse Romande.
TAS list is the origianl issue: LONDON CS 6126. (No SXL issue)
Rating: TASEC (=LONDON CS 6126)

Label : DECCA ECLIPSE ECS 746 (=London CS 6059)
Prokofiev: 《Violin Concertos No. 1 in D Major Op. 19》& 《Violin Concertos No. 2 in G Minor Op. 63》,
Violin: Ruggiero Ricci, Ernest Ansermet-L'Orchestre de la Suisse Romande.
(No SXL, Original issue is LONDON CS 6059)
Rating: TASEC

Label : DECCA GOS 558-9 (=London STS 15081-2)
Britten: 《Prince of Pagoda, Op. 57》, Covent Garden Orchestra-Benjamin Britten, @1968.
**Also in HP's list of Golden Baker's Dozen 2007.
Rating: TASEC**, As List, Penguin 3*

Label : DECCA HEAD 1 & 2 (=London OSA 1298)
Messiaen: 《La Transfiguration de Notre Seigneur Jesus Christ》
Antal Dorati-National Symphony Orchestra, Washington DC, @1973.
Recorded by Kenneth Wilkinson & Colin Moorfoot.
Rating: TASEC, AS List

Label : DECCA HEAD 6
Roberto Gerhard: 《The Plague》
Antal Dorati conducted the National Symphony Orchestra & Chorus Washington D.C.
Recorded by Kenneth Wilkinson, Colin Moorfoot & Michael Mailes at Washington DC in 1973.
☆☆In the HP's Best of the Bunch List & **Also in the list of Golden Baker's Dozen 2007
Rating: TASEC☆☆**, AS List

Label : DECCA PFS 4095 (=LONDON SPC 21006)
Mussorgsky-Stokowski: 《Pictures at an Exhibition》
Debyssy-Stokowski: 《The English Cathedral》
New Philharmonia Orchestra-Leopold Stokowsky.
Rating: TAS 98-OLD

Label : DECCA PFS 4395 (=LONDON SPC 21168)
Tchaikovsky: 《1812 Overture & Nutcracker Suite》
Performing on the ARP Synthesizer, Keyboards: Jack Kraft.
Recording Engineer: Larry Alexander (@1977)
Rating: TAS 14-OLD

Label : DECCA Ring 1-19
Wagner: 《Ring des Nibelungen》, (22 LPs-Deluxe Set)
Georg Solti-Vienna philharmonic Orchestra. Produced by John Culshow & recorded by James
Brown & Gordon Parry. Rheingold (LONDON OSA 1309=DECCA SET 382-4) &
Goetterdammerung (OSA 1604=DECCA SET 292-7) are in the HP's List.
Rating: TASEC, Gramophone TOP 100

Label : DECCA SET 292-7 (=LONDON OSA 1604)
Wagner: 《Goetterdammerrung》
Georg Solti & The Vienna Philharmonic Orchestra.
(HP's List is LONDON OSA 1604, recorded in 1964)
Rating: TASEC-OPERA

Label : SET 382-4 (=LONDON OSA 1309)
Wagner: 《Das Rheingold》
Georg Solti & The Vienna Philharmonic rchestra, @1968.
(HP's List is LONDON OSA 1309, Original ECCA issue is SXL 2101-3, @1958)
Rating: TASEC-OPERA

Label : DECCA SET 514-7
Mussorgsky: 《Boris Godunov》
Vienna State Opera Chorus & The Vienna Philharmonic Orchestra-Herbert Von Karajan.
Rating: TASEC-OPERA

Label : DECCA SET 561-3 (=LONDON OSA 13108)
Puccini: 《Turandot》
Zubin Mehta-London Philharmonic Orchestra, @1973.
Rating: TASEC-OPERA, AS List, Penguin 3*

Label : DECCA SET 565-6 (=LONDON OSA 1299)
Puccini: 《La Boheme》
Berlin Philharmonic Orchestra- Herbert Von Karajan.
Rating: TASEC-OPERA, Penguin 3*

Label : DECCA SET 609-11 (=LONDON OSA 13116)
Gershwin: 《Porgy & Bess》
Lorin Maazel conducted Cleveland Orchestra & Chorus. World Premiere Complete Recording.
☆☆In the HP's Best of the Bunch List.
Rating: TASEC☆☆, AS List, Penguin 3*+

Label : DECCA SPA 122 (=RCA LSC 2405)
Sibelius: 《Symphony No. 5》 and 《Karelia Suite》
London Symphony Orchestra-Alexander Gibson.
Recorded by Kenneth Wilkinson at Kingsway Hall in 1959,
Original issue is RCA LSC 2405,
Decca reissued in 1971 (No SXL issue).
Rating: TASEC

Label : DECCA SPA 175 (=RCA LSC 2225)
《Danse Macabre》
New Symphony Orchestra of London-Alexander Gibson,
Kenneth Wilkinson recorded at Kingsway Hall in 1957.
Rating: TASEC-COLLECTION, (LSC 2225)

Label : DECCA SXDL 7604 (=London LDR 71104 D)
《Song of Auvergne,Volume I》, Kiri te Kanawa (soprano),
English Chamber Orchestra-Jeffrey
Tate, recorded by John Dunkerly at Kingsway Hall in August
1982.
Rating: TAS 36-OLD (HP's old List is London LDR 71104 D),
Penguin 3*+

Label : DECCA SXL 2011 (=LONDON CS 6009)
Stravinsky: 《Petrushka》
Ernest Ansermet-L'orchestre de la Suisse Romande.
HP's List is LONDON CS 6009
Rating: TASEC44

**Label : DECCA SXL 2012 (=LONDON CS 6049 &
SDD 111)**
Grieg: 《Peer Gynt》: Incidental music to Ibsen's play
Oivin Fjeldstad-London Symphony Orchestra.
Rating: TASEC*, (Robert Moon's rating-RM19)

**Label : DECCA SXL 2017 (=LONDON CS 6017, PART
of LONDON CSA 2308)**
Stravinsky: 《The Firebird》, Ansermet-L'orchestre de la
Suisse Romande.
Rating: TASEC (Part of HP's list CSA 2308)

**Label : DECCA SXL 2020 (=LONDON CS 6006, ECS
797 & SDD 216)**
【ESPANA】Rimsky-Korsakov: "Capriccio Espagnol";
Granados: "Andalusia"; Chabrier:
"Espana"; Moszkowsky: "Spanish Dances", Ataulfo
Argenta-London Symphony Orchestra.
Rating: TASEC*, RM19, AS List, Penguin 3*

Label : DECCA SXL 2091 (=LONDON CS 6046)
Falla: 《Night in the Garden of Spain》
Rodrigo: 《Concerto for Guitar and Orchestra》
Guitar: Narciso Yepes, Altaufo Argenta conducted The
National Orchestra of Spain.
HP's List is LONDON CS 6046
Rating: TASEC65*

**Label : DECCA SXL 2101-3 (=SET 382-4 & LONDON
OSA 1309)**
Wagner: 《Das Rheingold》, Geroge Solti-Vienna
Philharmonic Orchestra.
This is the original DECCA issue; 2nd issue is DECCA SET
382-4, @1968.
HP's list is LONDON OSA 1309
Rating: TASEC-OPERA

Label : DECCA SXL 2167-9 (=LONDON OSA 1313)
Verdi: 《AIDA》, Vienna Philharmonic Orchestra-Herbert Von
Karajan.

(HP's List is LONDON OSA 1313)
Rating: TASEC44-OPER

Label : DECCA SXL 2313 (=LONDON CS 6252)
Ferdinand Herold: 《La fille mal Gardee》
Orchestra of the Royal Opera House, Covent Garden-John
Lanchberry.
✽✽In the HP's Best of the Bunch List. Recorded by Arthur
Lilly, @1962.
Rating: TASEC*✽✽, (AS List, RM20)

Label : DECCA SXL 6000 (=LONDON CS 6322)
Khachaturian: 《SPARTACUS》 & 《GAYANEH》 – Ballet Suite
Khachaturian-Vienna Philharmonic Orchestra, recorded by
James Brown, @1962.
Rating: TASEC

Label : DECCA SXL 6001 (=LONDON CS 6323)
Khachaturian: 《Symphony No. 2 "The Bell" 》
Vienna Philharmonic Orchestra conducted by Khachaturian.
Recording Engineer: James Brown, @1962.
Rating: TASEC65 (HP's List is LONDON CS 6323)

Label : DECCA SXL 6006 (=LONDON CS 6324)
Holst: 《The Hymn of Jesus, Op. 37》, BBC Symphony
Orchestra & Chorus.
《The perfect fool, Op. 39-Ballet music》《Egdon Heath,
Op. 47》, London Philharmonic
Orchestra, conduted by Andrian Boult. @1962.
Rating: TAS 73-OLD

**Label : DECCA SXL 6204 (=LONDON CS 6456, ECS
824)**
Ravel: Ballet 《Daphnis et Chloe》
L'Orchestre de la Suisse Romande.-Ernest Ansermet. @1965
Rating: TASEC*

Label : DECCA SXL 6209 (=LONDON CS 6487)
Bartok: 《Piano Concerto No. 3》; Ravel: 《Piano Concerto
in G Major》
Piano: Julius Katchen, Istvan Kertesz-London Symphony
Orchestra.
Rating: TASEC (HP's List is LINN RECORDS RECUT REC
001)

**Label : DECCA SXL 6291 (=LONDON CS 6527,
London Jpn K38C 70003)**
Dvorak: 《Symphony No. 9 "New World", Op. 95》
《Overture "Othello", Op. 93》,
London Symphony Orchestra–Istvan Kertesz, recorded by
Kenneth Wilkinson, @1967.
Rating: TAS–OLD, (Old HP's List is London Jpn K38C 70003
(Japan), Penguin 3*+

Label : DECCA SXL 6379 (=LONDON CS 6609)
Richard Strauss: 《Also Sprach Zarathustra》
Los Angeles Philharmonic Orchestra-Zubin Mehta, @1968.
Rating: TAS-OLD

Label : DECCA SXL 6529 (=LONDON CS 6734)
Holst: 《The Planets, Op. 32》, Los Angeles Philharmonic
Orchestra conducted by Zubin
Mehta and Los Angeles Master Chorale by Roger Wagner,
@1971.
✽✽In the HP's Best of the Bunch List, also in the list of TAS
Top100-20th Century Classical
Music Recordings.
Rating: TASEC✽✽, (Best of the Bunch)

Label : DECCA SXL 6570
Alun Hoddinott: 《Symphony No. 3, Op. 61》 《Sinfonietta No. 3, Op. 71》
《The Sun, The Great Luminary of The Universe Op. 76》
David Atherton-London Symphony Orchestra, recorded by Colin Moorfoot in 1972.
Rating: TAS 73-OLD

Label : DECCA SXL 6588 (=LONDON CS 6812)
Offenbach: 《Le Papillon-Ballet-Pantomime》 Richard Bonynge-London Symphony Orchestra.
Recorded in 1972 by Kenneth Wilkinson at Kingsway Hall.
Rating: TAS 100-OLD

Label : DECCA SXL 6592 (=LONDON CS 6816)
Elgar: 《Enigma Variations Op. 36》; Ives: 《Symphony No. 1》
Los Angeles Philharmonic Orchestra conducted by Zubin Mehta, recorded by Gordon Parry &
James Lock, @1973. HP's List is LONDON CS 6816.
Rating: TASEC

Label : DECCA SXL 6606
Alun Hoddinott: 《Symphony No. 5, Op. 81》 《Concerto For Horn Op. 65, Horn: Tuckwell》
《Concerto For Piano No. 2, Op. 21, Piano: Martin Jones》, Royal Philharmonic Orchestra
conducted by Andrew David. Recorded by Colin Moorfoot at Kingsway Hall in 1973.
Rating: TAS 73-OLD

Label : DECCA SXL 6620-2 (=LONDON CSA 2312)
Prokofiev: 《Romeo And Juliet》 Lorin Maazel-Cleveland Orchestra.
Recorded by Colin Moorfoot, Gorden Parry & Jack Law in 1973.
Rating: TASEC, TAS 03

Label : DECCA SXL 6624 (=LONDON CS 6840; Telefunken 6.41724)
Grieg & Schumann: 《Piano Concertos in A minor》, Piano: Radu Lupu.
Andre Previn-London Symphony Orchestra. Recorded by Kenneth Wilkinson at
Kingsway Hall, 1973. HP's List is LONDON CS 6840
Rating: TASEC, AS List

Label : DECCA SXL 6668 (Part of SXL 6620-2)
Prokofiev: 《Romeo And Juliet》, Lorin Maazel-Cleveland Orchestra.
Recorded by Colin Moorfoot, Gorden Parry & Jack Law in 1973.
Rating: TASEC, (Part of HP's list SXL 6620-2)

Label : DECCA SXL 6691 (=LONDON CS 6885)
Stravinsky: 《Le Sacre du Printemos》, Chicago Symphony Orchestra-Solti, @1974.
Recorded by Kenneth Wilkinson & James Lock.
Rating: TASEC, AS List

Label : DECCA SXL 6744-5 (=LONDON CSA 2242)
Mahler: 《Symphony No. 2 in C Minor, Resurrection》
Vienna Philharmonic Orchestra-Zubin Mehta. Recorded by James Lock、Colin Moorfoot &
Jack Law at Vienna Sofiensaal in 1975. (Old HP's List is CSA 2242)
Rating: TAS 100-OLD

Label : DECCA SXL 6777 (=LONDON CS 7003)
Prokofiev: 《Symphony No. 6》, Walter Weller-London Philharmonic Orchestra.
Record Engineer: Kenneth Wilkinson. **Also in the HP's Old Golden Baker's Dozen List.
Rating: TASEC* 98**, AS List

Label : DECCA SXL 6822 (=LONDON CS 7043)
Respighi: Symphonic Poem 《Feste romane-Roman Festival》、《Pini di Roma-Pines Of Rome》
The Cleveland Orchestra-Lorin Maazel. Record Engineer: Kenneth Wilkinson.
✧✧In the HP's Best of the Bunch List.
Rating: TASEC✧✧, AS List

Label : DELL'ARTE DA 9006 (45rpm) (=EVEREST SDBR 3011)
Tchaikovsky: 《Francesca Da Rimini, Fantasia for Orchestra Op. 32》
Stadium Symphony Orchestra of New York-Stokowsky.
(45 rpm reissued from part of Everest SDBR 3011)
Rating: TAS-OLD, Penguin 3*+, Gramophone Top 100

Label : DG 2709 043
Bizet: 《CARMEN》, Bernstein-The Metropolitan Opera Orchestra & Chorus.
Rating: TASEC-OPERA, Penguin 3*

Label : EMI ASD 299 (=ESD 7114)
Saint Saens: 《Carnival of the Animals》
Prokofiev: 《Peter & The Wolf》, Philharmonia Orchestra-Efrem Kurtz, @1959.
Rating: TASEC*

Label : EMI ASD 517 (=ASDF 273, Fr CVB 1737, ANGEL S 35993)
Poulenc: 《Concert Champetre for Harpsichord & Orchestra》
《Concerto in D Minor for two pianos and orchestra》, Harpsichord: Aimee Van De Wiele,
Piano: F. Polenc & J. Fevrier, Paris Conservatoire Orchestra-Georges Pretre.
(Original: Fr CVB1737, =Fr 2C06912100; ASDF 273, =Angel S35993)
Rating: TAS-OLD

Label : EMI ASD 2329 (=One of the EMI SLS 822)
Vaughan Williams: 《Symphony No. 6》 《The Lark Ascending》
Adrian Boult conducted the New Philharmonia Orchestra, @1967.
Rating: TASEC, Stereophile R2D4

Label : EMI ASD 2336-7 (=SXDW 3053)
Busoni: 《Piano Concerto》 《Chamber Fantasy-Carmen》 《Turandots Frauengemach》
《9 Variations-Chopin Prelude》, Royal Philharmonic Orchestra -Daniell Revenaugh, @1968.
Piano: John Ogdon.
Rating: TASEC, Penguin 3*

Label : EMI ASD 2375 (=One of the EMI SLS 822)
Vaughan Williams: 《Symphony No. 4》 《Norfolk Rhapsody No. 1》
Adrian Boult conducted the New Philharmonia Orchestra, @1968.
Rating: TASEC, TAS 17

Label : EMI ASD 2393 (=One of the EMI SLS 822)
Vaughan Williams:《Symphony No. 3, "A Pastoral Symphony"》
New Phiharmonia Orchestra-Adrian Boult, @1968.
Rating: TASEC

Label : EMI ASD 2422 (ANGEL S-36751)
Vaughan Williams:《Sancta Civitas-The Holy City》《Benedicite》
Bach Choir; Boys of King's College Choir, Cambridge & London Symphony Orchestra
conducted by David Wilcocks. @1968.
Rating: TASEC

Label : EMI ASD 2439-40 (=Part of the EMI SLS 822)
Vaughan Williams: 《Symphony No. 1, "A Sea Symphony"》
Adrian Boult conducted London Philharmonic Orchestra, @1968.
Rating: TASEC

Label : EMI ASD 2469 (=One of the EMI SLS 822)
Vaughan Williams:《Symphony No. 8》《Concerto for 2 Pianos》
Adrian Boult conducted London Philharmonic Orchestra, @1969.
Rating: TASEC

Label : EMI ASD 2486
Sibelius:《En Saga》 《Night Ride and Sunrise》《Luonnotar》《The Oceanides》
London Symphony Orchestra-Antal Dorati, @1970.
Rating: TASEC*, AS List

Label : EMI ASD 2538 (=One of the EMI SLS 822)
Vaughan Williams:《Symphony No. 5》《Serenade To Music》
Adrian Boult conducted London Philharmonic Orchestra, @1970.
Rating: TASEC

Label : EMI ASD 2581 (=One of the EMI SLS 822)
Vaughan Williams:《Symphony No. 9》《Fantasia On the Old 104th》
Adrian Boult conducted London Philharmonic Orchestra, @1970.
Rating: TASEC

Label : EMI ASD 2600
Herber Howells:《Hymnus Paradisi》
David Willcocks conducted New Phiharmonia Orchestra, The Bach Choir,King's College Choir, Cambrige, @1970.
Rating: TASEC, Penguin 3*

Label : EMI ASD 2631 (=One of the EMI SLS 822)
Vaughan Williams:《Symphony No. 7, Sinfonia Antartica》
Adrian Boult conducted London Philharmonic Orchestra, @1970.
Rating: TASEC, Stereophile R2D4

Label : EMI ASD 2673 (ANGEL S-36773)
Vaughan Williams:《JOB》- a Masque for Dancing
Adrian Boult conducted London Symphony Orchestra, @1971.
Rating: TASEC, AS List, Penguin 3*

Label : EMI ASD 2740 (One of the EMI SLS 822)
Vaughan Williams:《Symphony No. 2-A London Symphony》
Adrian Boult conducted London Philharmonic Orchestra,

@1971.
Rating: TASEC

Label : EMI ASD 2878
Malcolm Arnold:《Symphony No. 5, Op. 74》《4 Cornish Dances, Op. 91》
《Peterloo Overture Op. 97》, Malcolm Arnold conducted City of Birmingham Symphony
Orchestra, @1973, recorded by Neville Boyling.
Rating: TASEC

Label : EMI ASD 2889 (ANGEL S-36954)
Rachmaninoff:《Symphony No. 2 in e minor, Op. 27》
Andre Previn Conduct London Symphony Orchestra, @1973. Christopher Bishop & Robert Gooch recorded at Kingsway Hall.
Rating: TASEC, Penguin 3*

Label : EMI ASD 2892 (=ANGEL S 36953=EMI Fr C 069 12 166)
Florent Schmitt:《Psalm 47, Op. 38》《La Tragedie De Salome, Op. 50》
Jean Martinon conducted French National Radio Orchestra & Chorus, @1973.
Rating: TASEC

Label : ANGEL S 36953 (=EMI ASD 2892=EMI Fr C 069 12 166)
Florent Schmitt:《Psalm 47, Op. 38》《La Tragedie De Salome, Op. 50》
Jean Martinon conducted French National Radio Orchestra & Chorus, @1973.
Rating: TASEC

Label : EMI ASD 2892 (=EAC 40126, Japan)
Florent Schmitt:《Psalm 47, Op. 38》《La Tragedie De Salome, Op. 50》
Jean Martinon conducted French National Radio Orchestra & Chorus.
Rating: TASEC

Label : EMI ASD 2894 (ANGEL S-36890)
Tchaikovsky:《1812 Overture》《Romeo and Juliet》《Marche Slavet》
London Symphony Orchestra-Andre Previn.
Recorded by Christopher Bishop & Christopher Parker in 1973.
Rating: TAS 13-OLD

Label : EMI ASD 2913
Moeran:《Symphony in G minor》
Neville Dikles conducted The English Sinfonia Orchestra, recorded by Neville Boyling, @1973.
Rating: TASEC, Penguin 3*+

Label : EMI ASD 2917 (=Angel S 36980)
Shostakovitch:《Symphony No. 8 in C minor, Op. 65》
Andre Previn conducted London Symphony Orchestra, @1973.
Recorded by Christopher Bishop & Christopher Parker.
Rating: TASEC, Penguin 3*

Label : EMI ASD 2924
Walton:《Cello Concerto》; Shostakovich:《Cello Concerto No. 1》
Cello: Paul Tortelier, Paavo Berglund conducted Bournemouth Symphony Orchestra.
Recoded by Stuart Eltham, @1973.
Rating: TASEC, Penguin 3*

Label : EMI ASD 2935 (ANGEL SFO-36962)
Prokofiev: 《Peter and the Wolf》 ; Britten: 《Young People's Guide》
Mia Farrow & Andre Previn-London Symphony Orchestra, @1973.
Rating: TAS 17-OLD, Penguin 3*

Label : EMI ASD 2961
Sibelius: 《The Tempest-Incidental Music, Op.109》 《In Memoriam-Funeral March, Op.59》
Royal Liverpool Philharmonic Orchestra-Charles Groves.
Rating: TASEC*, AS List

Label : EMI ASD 2964
Honegger: 《Symphony No. 3-Liturgique》
Bartok: 《Music For String, Percussion and Celesta》
Leningrad Philharmonic Orchestra-Mravinsky, @1971.
Recorded by Melodiya (U.S.S.R.)
Rating: TAS 07-OLD

Label : EMI ASD 2970 (=MFSL 2-501)
Elgar: 《Fallstaff-Symphonic Study》 《The Sanguine Fan-Ballet》
《Fantasia And Fugue In C Minor (Transcription from J.S.Bach)》
Adrian Boult conducted London Philharmonic Orchestra.
Recorded by Christopher Parker & Stuart Eltham, @1974.
Rating: TASEC

Label : EMI ASD 2989
Ibert: 《Divertissement》 ; Honegger: 《Pacific 231》 ;
Poulenc: 《Les Biche》 ;
Satie: 《Gymnopedies1& 3 (Orch. Debussy)》 , Louis Frémaux-City of Birmingham Symphony
Orchestra, recorded by Neville Boyling, @1974.
Rating: TASEC, Penguin 3*+

Label : EMI ASD 3002
Holst: 《The Planets, Op. 32》 , London Symphony Orchestra conducted by Andre Previn,
recorded by Christopher Parker, @1974.
Rating: TASEC, AS List, Penguin 3*

Label : EMI ASD 3006
Grace Williams: 《Fantasia on Welsh Nursery Tunes》 《Trumpet Concerto》 《Fairest of Stars》
《Carillons for Oboe and Orchestra》 , London Symphony Orchestra-Charles Groves, @1974.
Rating: TASEC*

Label : EMI ASD 3013
Rachmaninov: 《Five Etudes Tableaux(Orch. Respighi)》
Tchaikovsky: 《The Voyevode-Symphonic Ballad Op. 78》 《The Storm-Overture, Op. 76》 Yuri
Krasnapolsky-New Philharmonia Orchestra, @1974.
Rating: TASEC*

Label : EMI ASD 3018
Tchaikovsky: 《Manfred Symphony, Op. 58, (1885)》 , Andre Previn conducted London
Symphony Orchestra, recorded by Christopher Parker, @1974.
Rating: TASEC*, AS List

Label : EMI ASD 3092
Sibelius: 《Lemminkanen-Four Legends from The Kalevala Op. 22》

Royal Liverpool Philharmonic Orchestra-Charles Groves, recorded by Stuart Eltham, @1975.
Rating: TASEC

Label : EMI ASD 3093
Rimsky-Korsakaov: 《Capriccio Espagnol》 《Procession of the Nobles from "Mlada" 》
Tchaikovsky: 《Capriccio Italien》 《Gopak from "Mazeppa" 》 《Marche Slave》 ,
Adrian Boult-London Philharmonic Orchestra, recorded by Christopher Parker in 1975.
Rating: TAS 11-OLD

Label : EMI ASD 3117 (=MFSL 1-506)
Carl Orff: 《Carmina Burana》 , London Symphony Orchestra-Andre Previn.
Recorded by Christopher Bishop & Christopher Parker in 1975.
Rating: TAS 13-OLD

Label : EMI ASD 3131 (Part of EMI ESDW 720)
《Andre Previn's Music Night》 , London Symphony Orchestra conducted by Andre Previn.
Recorded by Christopher Parker, @1975.
Rating: TASEC-COLLECTION

Label : EMI ASD 3137 (ANGEL S-37120)
Rachmaninov: 《Symphony No. 1, Op. 13》
Andre Previn-London Symphony Orchestra, recorded by Christopher Parker, @1975.
Rating: TASEC

Label : EMI ASD 3139 (ANGEL S-37140)
Delius: 《North Country Sketches》 《Life's Dance》 《A Song of the Summer》
Charles Groves-Royal Philharmonic Orchestra, recorded by Stuart Eltham, @1975.
Rating: TASEC*

Label : EMI Angel ASD 3154 (ANGEL S-37142)
Britten: 《Four Sea Interludes》 《Passacaglia》 from "Peter Grimes" , 《Sinfonia da requiem》
London Symphony Orchestra-Andre Previn. Recorded by Christopher Parker, @1976
Rating: TASEC, Penguin 3*+

Label : EMI ASD 3266 (ANGEL S-37218)
Elgar: 《Symphony No. 2 in E flat major, Op. 63》 , Adrian Boult conducted London
Philharmonic Orchestra. Recorded by Christopher Parker, @1976.
Rating: TASEC, Penguin 3*

Label : EMI ASD 3284 (ANGEL S-37169)
Rachmaninov: 《The Bells, Op. 35》 《Vocalise, Op. 34》
Previn-London Symphony Orchestra & Chorus. Recorded by Christopher Parker, @1976.
Rating: TASEC

Label : EMI ASD 3294 (ANGEL S-37300)
Virgil Thomson: 《The Plow That Broke The Plains》 《Autumn》 《The River》 , Film Music.
Los Angeles Chamber Orchestra-Neville Marriner, recorded by Christopher Bishop & Carson
Taylor in 1976.
Rating: TAS 11-OLD

Label: EMI ASD 3345
Elgar:《Coronation Ode Op. 44》《National Anthem》
《Land of Hope and Glory》
King's College Choir; Cambridge Uni. Musical Society; Royal
Military Music School Band with
The New Philharmonia Orchestra-Philip Ledger, recorded by
Christopher Parker, @1977.
Rating: TASEC, Penguin 3*

Label : EMI ASD 3348
Walton:《Te Deum》 《Orb And Sceptre-Coronation
March》《Gloria》
《Crown Imperial-Coronation March》, Louis Fremaux
conducted City of Birmingham
Symphony Orchestra, recorded by Neville Boyling at Town
Hall Birmingham in 1977.
Rating: TAS 24-OLD, AS List

Label : EMI ASD 3353 (=MHS 4766)
Malcolm Arnold:《Symphony No. 2, Op. 40》 《8 English
Dances》
Charles Groves-Bournemouth Symphony Orchestra.
Recorded by Neville Boyling at The Guildhall, Southampton
in 1977.
Rating: TAS 11-OLD

Label : EMI ASD 3377 (=1C 063-02 879)
Mendelssohn:《Sommernachtstraum, Op. 61》
London Symphony Orchestra-Andre Previn. Recorded by
Christopher Parker, @1977.
Rating: TASEC

Label : EMI ASD 3416
Bliss:《Thngs to Come-Music from the film》《A Colour
Symphony, Op. 24, F.106》
Charles Groves-Royal Philharmonic Orchestra. Recorded by
Stuart Eltham, @1977.
Rating: TASEC-Soundtrack

Label : EMI ASD 3486
Havergal Brian:《Symphony No. 8 & No. 9》
Royal Liverpool Philharmonic Orchestra-Charles Groves.
Recorded by John Willan & John Kurlander, @1978.
Rating: TASEC

Label : EMI ASD 3857 (=ANGEL SZ 37627)
Elgar:《Enigma Variations, Op. 36》
Vaughan Williams:《Fantasia on a Theme of Thomas Tallis》
《Overture to 'The Wasps'》
Andre Previn-London Symphony Orchestra, recorded by
Christopher Parker, issued in 1980.
Rating: TAS 50-OLD

Label : EMI ASD 3871
Prokofiev:《Piano Concerto No. 2 in Gm, Op. 16》 《Piano
Concerto No. 3 in C, Op. 26》
Pianist: Dmitri Alexeev, Yuri Temirkano-Royal Philharmonic
Orchestra, @1977.
Rating: TAS 36-OLD

**Label : EMI-Melodiya C10 16029-30 (=One of the ASD
3871)**
Prokofiev:《Piano Concerto No. 2 in Gm, Op. 16》
Pianist: Dmitri Alexeev, Yuri Temirkano-Royal Philharmonic
Orchestra, @1977 EMI.
Old HP's List EMI ASD 3871 included 2 Melodiya recordings
(Concertos No. 2 & No. 3).
Rating: TAS 36-OLD (EMI ASD 3871)

**Label : EMI-Melodiya C10 18227-8 (=One of the ASD
3871)**
Prokofiev:《Piano Concerto No.3 in C, Op.26》
《Sarcasms-5 Pieces for Piano Op.17》
Pianist: Dmitri Alexeev, Yuri Temirkano-Royal Philharmonic
Orchestra, @1977 EMI.
Old HP's List EMI ASD 3871 included 2 Melodiya recordings
(Concertos No. 2 & No. 3).
Rating: TAS 36-OLD

Label : EMI ASD 3911 (=ANGEL SZ 37661)
Shostakovitch:《Symphony No.13 in B flat minor, Op.113,
〈Babi Yar〉Poems by Yevtushenko》
Andre Previn – London Symphony Orchestra, recorded by
Christopher Parker, @1979.
**Also in the Old list of Golden Baker's Dozen
Rating: TAS*EC**, AS List, Penguin 3*

Label : EMI CFP 134 (=CAPITOL SP 8407)
Stravinsky:《Firebird & Petrushka Ballet Suites》
Berlin Philharmonic Orchestra-Stokowski, @1958.
Rating: TASEC

**Label : EMI-CFP CFP 174 (1st pressing is World
Record Club ST 657)**
Rimsky-Korsakov:《SCHEHERAZADE》
Violin Solo: Alan Loveday, Rudolf Kempe conducted Royal
Philharmonic Orchestra, @1967.
Rating: TAS 13-OLD

**Label : EMI-CFP 40028 (=Columbia SAX 2387,
ANGEL S 35892, Ger 1C 03700519)**
Brahms:《Piano Concerto No. 1 in D minor, Op. 16》
Piano: Claudio Arrau, Giulini-Philhamonia Orchestra, @1961.
Rating: TAS 98-OLD

**Label : EMI-CFP 40034 (=Columbia SAX 2466, Ger
1C 03700568)**
Brahms:《Piano Concerto No. 2 in B Flat Major, Op. 83》
Piano: Claudio Arrau, Giulini-Philhamonia Orchestra, @1963.
Rating: TAS 98-OLD

**Label : EMI-CFP 40036 (Original recording: Part of
Columbia SAX 2477)**
Ravel:《Bolero》《Pavane pour une infante defunte》
《Alborada del gracioso》《La valse》
Paris Conservatoire Orchestra-Cluytens, @1963.
Rating: TAS 12-OLD

Label : EMI-CFP 40286 (=MHS 4659)
Vaughan Williams:《Symphony No. 2, "A London
Symphony"》
Vernon Handley conducted London Philharmonic, @1978.
Rating: TAS 40-OLD

**Label : EMI-CFP 40311 (HP's list is CAPITOL SPAR
8470)**
Carl Orff:《Carmina Burana》
Stokowski conducted The Houston Symphony Orchestra &
The Houston Chorale.
Rating: TASEC

**Label : EMI CSD 1399 (=ESD 7028, CAPITOL SP
8663)**
Gilbert & Sullivan:《Pineapple Poll》, Royal Philharmonic
Orchestra-Charles Mackerras.
In the HP's list is EMI CSD 1399
Rating: TASEC, Penguin 3*

Label : EMI CSD 3713 (=ESD 7057, Klavier KS 521, MHS 7151)
Arthur Sullivan: 《The Tempest-Incidental music》 《The Merchant of Venice-Suite》
《In Memoriam-Overtur》 , City of Birmingham Symphony Orchestra-Vivian Dunn, @1972.
Rating: TAS 10-OLD, AS List

Label : EMI CSD 3739
《Hymns For All Seasons》 with The Philip Jones Brass Ensemble, Ian Hare (organ),
King College Choir-David Willcocks. Balance Engineer: Neville Boyling, @1973.
Rating: TAS 17-OLD

Label : EMI CSD 3752
《Anthems from King's》 , King's College Choir conducted by David Willcocks with
James Lancelot on organ. Recording Engineer: Christopher Parker, @1974.
Rating: TAS 17-OLD

Label : EMI CSD 3778 (Part of EMI SLS 845)
Handel: 《Messiah》 , The Academy of St.Martin-in-the-Fields, King's College-David Willcocks.
Balance Engineer: Neville Boyling, @1973.
Rating: TAS 65-OLD

Label : EMI ESD 7001
【Serenade For Strings】 Dag Wiren: 《Serenade for Strings, Op. 11》 ;
Nielsen: 《Little Suite for String, Op. 1》 ; Grieg: 《2 Norwegian Melodies, Op. 63》
Tchaikovsky: 《Elegy in G major》 ; Dvorak: 《Notturno (Nocturne), Op. 40》
Bournemouth Sinfonietta-Kenneth Montgomery, @1976.
Rating: TASEC

Label : EMI ESD 7011 (Part of ESDW 720)
《ANDRE PREVIN IN CONCERT》 , London Symphony Orchestra-Andre Previn.
Previn's famous recordings from 1971 to 1975.
Rating: TAS 11-OLD

Label : EMI ESD 7028 (=EMI CSD 1399, CAPITOL SP 8663)
Gilbert & Sullivan: 《Pineapple Poll》 , Royal Philharmonic Orchestra-Charles Mackerras.
ESD 7028 is the reissue of HP's List EMI CSD 1399.
Rating: TASEC, Penguin 3*

Label : EMI ESD 7038 (HP's List is EMI TWO 404)
Saint-Saens: 《Organ Symphony No. 3 in C minor, op. 78》
Organ: Christopher Robinson,
Louis Fremaux-City of Birmingham Symphony Orchestra, recorded by Stuart Eltham, @1973.
Rating: TASEC*, Penguin 3*

Label : EMI-ESD 7040 (HP's List is TWO 350)
Massenet: Ballet music 《Le Cid》 《The Last Sleep of the Virgin from La Vierge》
《Scenes Pittoresques》 , Louis Fremaux-City of Birmingham Symphony Orchestra.
Recorded by Stuart Eltham, @1971.
Rating: TASEC, Penguin 3*

Label : EMI ESDW 720
《The Andre Previn Music Festival》 , Andre Previn-London

Symphony Orchestra.
Excerpts from ASD 2784, 3131 & 3338, recorded in 1972, 1975 & 1977.
Rating: TAS 31-OLD

Label : EMI Fr C 069 02764 (=EG 29 0261 1)
Prokofiev: 《Piano Concerto No. 1 & No. 2》
Piano: Michel Beroff, Kurt Masur-Gewandhaus Orchester Leipzig, @1974.
Rating: TAS 40-OLD

Label : EMI OASD 7603
John Antill: 《Corroboree – Symphonic Ballet》 - The first complete recording.
John Lanchbery & Sydney Symphony Orchestra.
**Also in the HP's old Golden Baker's Dozen List.
Rating: TASEC**, AS List

Label : EMI SAN 324(ANGEL) (=ANGEL S 36861 , Wilson Audio WEMI 01)
Walton: 《Belshazzar's Feast》 《Improvisations on an Impromptu of Benjamin Britten》
London Symphony Orchestra & Chor-Andre Previn, Recorded by Christopher Parker, @1972.
Rating: TAS 73-OLD

Label : EMI SLS 822 (=SLS 1547083)
Vaughan Williams : 【The Nine Symphonies】
London Philharmonic Orchestra & New Philharmonia Orchestra, conducted by Adrian Boult.
Rating: TASEC, Penguin 3*, Stereophile R2D4

Label : EMI SLS 834 (=ASD 2849 & 2850)
Tchaikovsky: 《The Nutcracker》 – Complete ballet
London Symphony Orchestra-Andre Previn, recorded by Christopher Parker, @1972.
Rating: TASEC, Penguin 3*

Label : EMI SLS 897 (=ASD 3021-2)
Shostakovich: 《Symphony No. 7 "Leningrad" Symphony》
Bournemouth Symphony Orchestra Paavo Berglund, recorded by Stuart Eltham, @1975.
Rating: TASEC

Label : EMI SLS 939 (=ANGEL SAN 244-5)
Elgar: 《The Kingdom》 -Oratorio, Adrian Boult conducted London Philharmonic & Choir.
Recorded by Christopher Parker at Kingsway Hall, @1969.
Rating: TASEC, Penguin 3*

Label : EMI SLS 982 (=ANGEL SB 3814)
Berlioz: 《Requiem》 , Robert Tear (tenor), Louis Fremaux conducted City of Birmingham
Symphony Orchestra, recorded by Stuart Eltham, @1972.
Rating: TASEC

Label : EMI SLS 998
Elgar: 《Caractacus, Op. 35, Cantata》 , The Royal Liverpool Philharmonic Orchestra & Choir,
conducted by Charles Groves, recorded by Christopher Parker, @1977.
Rating: TASEC*, Penguin 3*

Label : EMI SLS 5070 (=ASD 3296-98)
Tchaikovsky: 《Swan Lake – complete ballet》 , Solo Violin: Ida Haendel, London Symphony
Orchestra-Andre Previn, recorded by Christopher Parker, @1976.
Rating: TAS 11-OLD

Label : EMI SLS 5082
Vaughan Williams: 《CHORAL MUSIC》, Willcocks David conducted London Symphony
Orchestra & King's College; Andrian Boult conducted London Philharmonic Orchestra etc.
Rating: TASEC, Penguin 3* (7LP-Box Set)

Label : EMI SLS 5099 (=Ger-EMI 151 2900)
Tchaikovsky: 《Symphony No. 1-No. 6》、《Manfred》
Mstislav Rostropovich-London Philharmonic Orchestra, @1977.
Rating: TAS 19-OLD (7LP-Box Set)

Label : EMI ANGEL 37293 SZ (=One of SLS 5099)
Tchaikovsky: 《Symphony No. 1 in Gm, (Winter Dream)》
Rostropovich-London Philharmonic Orchestra, @1977.
Rating: TAS 19-OLD

Label : EMI ANGEL 37294 SZ (=One of SLS 5099)
Tchaikovsky: 《Symphony No. 2 (Little Russian)》
Rostropovich-London Philharmonic Orchestra, @1977.
Rating: TAS 19-OLD

Label : EMI ANGEL 37295 S (=One of SLS 5099)
Tchaikovsky: 《Symphony No. 3 in D, (Polish)》
Rostropovich-London Philharmonic Orchestra, @1977.
Rating: TAS 19-OLD

Label : EMI ANGEL 37296 S (=ASD 3647, =One of SLS 5099)
Tchaikovsky: 《Symphony No. 4 in F minor》
Rostropovich-London Philharmonic Orchestra, @1977.
Rating: TAS 19-OLD

Label : EMI ANGEL 37298 S (=ASD 3641, =One of SLS 5099)
Tchaikovsky: 《Symphony No. 5 in E minor, Op. 64》
Rostropovich-London Philharmonic Orchestra, @1977.
Rating: TAS 19-OLD

Label : EMI ANGEL 37299 S (=ASD 3515, One of SLS 5099)
Tchaikovsky: 《Symphony No. 6 in Bm (Pathetique)》
Rostropovich-London Philharmonic Orchestra, @1977.
Rating: TAS 19-OLD

Label : EMI SLS 5110 (=ANGEL SB 3851)
Prokofiev: 《Ivan The Terrible, Film music, Op. 116》
《Sinfonietta in A Major, Op. 48》
The Ambrosian Chorus and Philharmonic Orchestra-Riccardo Muti. (Arranged in the form
of an oratoria by Abram Stasevich) HP's list: Special Merit-Film & Broadway Score.
Rating: TASEC-FILM MUSIC (2LP-Box)

Label : EMI SLS 5117
Messiaen: 《Turangalila Symphony》, Piano by Michel Beroff; Ondes Martenot by Jeanne
Loriod, London Symphony Orchestra-Andre Previn, recorded by Christopher Parker, @1978.
Rating: TASEC, AS List, Penguin 3*

Label : EMI SLS 5177
Shostakovich: 《Symphony No. 6, Op. 54》 《No. 11 Op. 103 (The Year 1905)》
Bournemouth Symphony Orchestra Paavo Berglund, recorded by Stuart Eltham, @1980.
**Also in the Old list of Golden Baker's Dozen
Rating: TAS 65-OLD**, Penguin 3*

Label : EMI SXLP 30146 (=Columbia SAX 2463, No ASD Issue)
Debusy: 《La Mer》、《Nocturnes》,
Carlo Maria Giulini-Philhamonia Orchestra, @1963.
Rating: TAS 98-OLD

Label : EMI-Columbia TWO 350 (=EMI ESD 7040 & Klavier Records KS 522)
Massenet: Ballet music 《Le Cid》 《The Last Sleep of the Virgin from La Vierge》
《Scenes Pittoresques》, Louis Fremaux-City of Birmingham Symphony Orchestra.
Recorded by Stuart Eltham, @1971.
Rating: TASEC, Penguin 3*

Label : EMI-Columbia TWO 404 (=EMI ESD 7038 & Klavier Records KS 526)
Saint-Saens: 《Organ Symphony No. 3 in C minor, op. 78》
Organ: Christopher Robinson,
Louis Fremaux-City of Birmingham Symphony Orchestra, recorded by Stuart Eltham, @1973.
Rating: TASEC*, Penguin 3*

Label : EMI TWOX 1062
Vivaldi: 《The Four Seasons》, Tomoko Sunazaki: Prima (solo violin part) & other 5 Koto
players, Koto New Ensemble-Seiichi Mitsuishi. Recorded by Toshiba Emi Studio 2 in 1976.
Rating: TAS 33-OLD

Label : ENIGMA K 53553 (=MHS 4428)
Prokofiev: 《Peter And The Wolf》; Saint-Saens: 《Carnival of the Animals》
Narrator: Angela Rippon, Royal Philharmonic Orchestra conducted by Owain Arwel Hughes.
Rating: TAS 73-OLD

Label : ENIGMA K 53585 (=Nonesuch H 71401)
Stravinsky: Ballets 《Apollo》 《Orpheus》
Orchestra of St. John's Smith Square-John Lubbock, @1979.
Rating: TAS 44-OLD

Label : EPIC BC 1256 (Original=ERATO STU 70010)
Maurice Durufle: 《Requiem》 - for Soloists, Choirs, Orchestra and Organ
Durufle conducted Orchestre des Concerts Lamoureux.
Rating: TASEC, Grand Prix du Disque

Label : ERATO EDO 250-2
《Jehan Alain Organ Works》 (Works from 1929 to 1939).
Marie-Claire Alain played the Organ Works from her brother Jehan.
Rating: TASEC

Label : ERATO STU 70010 (=EPIC BC 1256)
Maurice Durufle: 《Requiem》 - for Soloists, Choirs, Orchestra and Organ
Durufle conducted Orchestre des Concerts Lamoureux.
Rating: TASEC, Grand Prix du Disque

Label : Harmonia Mundi HM 1003
《Danses Anciennes De Hongrie Et De Transylvanie》
Clemencic Consort conducted by Rene Clemencic.
Rating: TASEC-COLLECTION, AS List

Label : Harmonia Mundi HM 1015
《Musique De La Grece Antique》
Gregorio Paniagua-Atrium Musicae De Madrid.
Rating: TASEC-COLLECTION, AS List

Label : Harmonia Mundi HM 1036
《La Fete De L'Ane》, Clemencic Consort conducted by Rene Clemencic.
**Also in the Old list of Golden Baker's Dozen
Rating: TASEC-COLLECTION**, AS List

Label : Harmonia Mundi HM 1050
《La Folia》, Gregorio Paniagua-Atrium Musicae De Madrid.
Rating: TAS-OLD, AS List

Label : Hungaroton SLPX 11978
Vivaldi: 《Lute Conconcertos & Trios》, Liszt Ference Chamber Orchestra.
Rating: TASEC*

Label : Klavier Records KS 522 (=EMI TWO 350)
Massenet: Ballet music 《Le Cid》《The Last Sleep of the Virgin from La Vierge》
《Scenes Pittoresques》, Louis Fremaux-City of Birmingham Symphony Orchestra,
recorded by Stuart Eltham, @1971.
Rating: TASEC, Penguin 3*

Label : KLAVIER KS 526 (=EMI TWO 404, ESD 7038)
Saint-Saens: 《Organ Symphony No. 3 in C minor, op. 78》
Organ:Christopher Robinson
Louis Fremaux-City of Birmingham Symphony Orchestra, recorded by Stuart Eltham, @1973.
Rating: TASEC*

Label : LONDON CS 6006 (HP's list is DECCA SXL 2020)
【ESPANA】Rimsky-Korsakov: "Capriccio Espagnol" ; Granados: "Andalusia" ; Chabrier:
"Espana" ; Moszkowsky: "Spanish Dances", Ataulfo Argenta-London Symphony Orchestra.
Rating: TASEC*, RM19, AS List, Penguin 3*

Label : LONDON CS 6009 (=SXL 2011)
Stravinsky: 《Petrushka》, Ernest Ansermet-L'orchestre de la Suisse Romande.
Rating: TASEC44 (HP's list is LONDON CS 6009)

Label : LONDON CS 6017 (=DECCA SXL 2017, Part of LONDON CSA 2308)
Stravinsky: 《The Firebird》, Ernest Ansermet-L'orchestre de la Suisse Romande.
Rating: TASEC, (Part of HP's list CSA 2308)

Label : LONDON CS 6031 (=DECCA SXL 2042, Part of LONDON CSA 2308)
Stravinsky: 《Le Sacre Du Printemps》, Ernest Ansermet-L'orchestre de la Suisse Romande.
Rating: TASEC, (Part of HP's list CSA 2308)

Label : LONDON CS 6046 (=DECCA SXL 2091)
Falla: 《Night in the Garden of Spain》
Rodrigo: 《Concerto for Guitar and Orchestra》
Guitar: Narciso Yepes, Altaufo Argenta conducted The National Orchestra of Spain.
Rating: TASEC65* (HP's List is LONDON CS 6046)

Label : LONDON CS 6049 (=DECCA SXL 2012, SDD 111)
Grieg: 《Peer Gynt》Incidental music to Ibsen's play
Oivin Fjeldstad-London Symphony Orchestra.
Rating: TASEC* (HP's list is DECCA SXL 2012)

Label : LONDON CS 6059 (=DECCA ECS 746, No SXL)
Prokofiev: 《Violin Concertos No. 1 in D Major Op. 19》 & 《No. 2 in G Minor Op. 63》
Violin: Ruggiero Ricci, Ansermet-L'Orchestre de la Suisse Romande.
Rating: TASEC (HP's list is ECS 746)

Label : LONDON CS 6126 (=DECCA ECS 576, LONDON STS 15149, No SXL issue)
Borodin: 《Symphony No. 2 in B Minor》《Symphony No. 3 in A Minor (Unfinished)》
《Prince Igor Overture》, Ansermet-L'Orchestre de la Suisse Romande. (No SXL issue)
Rating: TASEC (HP's list is LONDON CS 6126)

Label : LONDON CS 6252 (=DECCA SXL 2313)
Ferdinand Herold: 《La fille mal Garde》, Orchestra of the Royal Opera House, Covent
Garden-John Lanchberry, recorded by Arthur Lilly, @1962.
☆☆In the HP's Best of the Bunch List is Decca SXL 2313
Rating: TASEC☆☆, AS List, RM20

Label : LONDON CS 6322 (=DECCA SXL 6000)
Khachaturian: 《SPARTACUS》 & 《GAYANEH》 – Ballet Suite Khachaturian-Vienna Philharmonic Orchestra, recorded by James Brown, @1962.
Rating: TASEC (HP's List is DECCA SXL 6000)

Label : LONDON CS 6323 (=DECCA SXL 6001)
Khachaturian: 《Symphony No. 2 "The Bell"》
Vienna Philharmonic Orchestra conducted by Khachaturian.
Recording Engineer: James Brown, @1962.
Rating: TASEC65 (HP's List is LONDON CS 6323)

Label : LONDON CS 6324 (=DECCA SXL 6006)
Holst: 《The Hymn of Jesus, Op. 37》, BBC Symphony Orchestra & Chorus.
《The perfect fool, Op. 39-Ballet music》《Egdon Heath, Op. 47》, London Philharmonic
Orchestra, conduted by Andrian Boult. @1962.
Rating: TAS 73-OLD

Label : LONDON CS 6456 (=DECCA SXL 6204, ECS 824)
Ravel: Ballet 《Daphnis et Chloe》
L'Orchestre de la Suisse Romande.-Ernest Ansermet. @1965
Rating: TASEC*

Label : LONDON CS 6487 (=DECCA SXL 6209)
Bartok: 《Piano Concerto No. 3》 ; Ravel: 《Piano Concerto in G Major》
Piano: Julius Katchen, Istvan Kertesz-London Symphony Orchestra.
Rating: TASEC (HP's List is LINN RECORDS RECUT REC 001)

Label : LONDON CS 6527 (=DECCA SXL 6291)
(HP's List is Japan late issue London Jpn K38C 70003)
Dvorak: 《Symphony No. 9, Op. 95 "New World"》《Overture, Op. 93 "Othello"》
London Symphony Orchestra-Kertesz, recorded by Kenneth Wilkinson, @1967.
Rating: TAS-OLD, (TAS 78/140+), Penguin 3*+

Label : LONDON CS 6609 (=DECCA SXL 6379)
Richard Strauss: 《Also Sprach Zarathustra》
Los Angeles Philharmonic Orchestra-Zubin Mehta, @1968.
Rating: TAS-OLD

Label : LONDON CS 6734 (=DECCA SXL 6529)
Holst: 《The Planets, Op. 32》, Los Angeles Philharmonic Orchestra conducted by Zubin
Mehta and Los Angeles Master Chorale by Roger Wagner, @1971.
✴✴In the HP's Best of the Bunch List, also in the list of TAS Top100-20th Century Classical
Music Recordings.
Rating: TASEC✴✴, (Best of the Bunch)

Label : LONDON CS 6812 (=DECCA SXL 6588)
Offenbach: 《Le Papillon-Ballet-Pantomime》, Richard Bonynge-London Symphony Orchestra.
Recorded in 1972 by Kenneth Wilkinson at Kingsway Hall.
Rating: TAS 100-OLD

Label : LONDON CS 6816 (=DECCA SXL 6592)
Elgar: 《Enigma Variations Op. 36》; Ives: 《Symphony No. 1》, Los Angeles Philharmonic
Orchestra conducted by Zubin Mehta, recorded by Gordon Parry & James Lock, @1973.
Rating: TASEC (HP's List is LONDON CS 6816)

Label : LONDON CS 6840 (=DECCA SXL 6624)
Grieg & Schumann: 《Piano Concertos in A minor》Piano: Radu Lupu, Andre Previn-London
Symphony Orchestra. Recorded by Kenneth Wilkinson at Kingsway Hall, 1973.
Rating: TASEC, AS List (HP's List is LONDON CS 6840)

Label : LONDON CS 6885 (=DECCA SXL 6691)
Stravinsky: 《Le Sacre du Printemos》,Chicago Symphony Orchestra-Georg Solti.
Recorded by Kenneth Wilkinson & James Lock, @1974.
Rating: TASEC, AS List

Label : LONDON CS 7003 (=DECCA SXL 6777)
Prokofiev: 《Symphony No. 6》, Walter Weller-London Philharmonic Orchestra.
Record Engineer: Kenneth Wilkinson. ✴✴Also in the HP's Old Golden Baker's Dozen List.
Rating: TASEC* 98**, AS List

Label : LONDON CS 7043 (=DECCA SXL 6822)
Respighi: Symphonic Poem 《Feste romane-Roman Festival》、《Pini di Roma-Pines Of Rome》
The Cleveland Orchestra-Lorin Maazel. Record Engineer: Kenneth Wilkinson.
Rating: TASEC✴✴(In the HP's Best of the Bunch List.), AS List

Label : LONDON CS 6840 (=DECCA SXL 6624; Telefunken 6.41724)
Grieg & Schumann: 《Piano Concertos in A minor》, Piano: Radu Lupu.
Andre Previn-London Symphony Orchestra. Recorded by Kenneth Wilkinson at
Kingsway Hall, 1973.
Rating: TASEC, AS List (HP's List is LONDON CS 6840)

Label : LONDON CS 6885 (=DECCA SXL 6691)
Stravinsky: 《Le Sacre du Printemos》, Chicago Symphony Orchestra-Solti, @1974.
Recorded by Kenneth Wilkinson.
Rating: TASEC, AS List

Label : LONDON CSA 2249 (=Decca D117D2)
Mahler: 《Symphony No. 3 in D Minor, Maureen Forrester (soloist), Los Angeles Philharmonic

Orchestra conducted by Zubin Mehta.
Rating: TASEC, TAS 2

Label : LONDON CSA 2308 (=CS 6541, 6544, 6545, 6546)
"STRAVINSKY WORKS", Ernest Ansermet-L'orchestre de la suisse romande.
《Petrushka》、《The Firebird》、《Le Baiser De La Fee》、《Le Sacre Du Printemps》
**Previous pressings: <Petrushka, London CS 6009=Decca SXL 2011>; <Firebird, London CS
6017=Decca SXL 2017>; <Le Baiser De La Fee, London CS 6368=Decca SXL 6066> & <Le
Sacre Du Printemps, London CS 6031=Decca SXL 2042>
Rating: TASEC, TAS 4 (4LP-Box)

Label : LONDON KING K38C 70003 Jpn (=LONDON CS 6527, DECCA SXL 6291)
Dvorak: 《Symphony No. 9 "New World", Op. 95》 London Symphony Orchestra-Istvan Kertesz (1967).
Rating: TAS 98-OLD (HP's old list is: London Jpn KING K38C 70003), Penguin 3*+

Label : LONDON LDR 71104 D (=DECCA SXDL 7604)
《Song of Auvergne,Volume I》, Kiri te Kanawa (soprano), English Chamber Orchestra-Jeffrey
Tate, recorded by John Dunkerly at Kingsway Hall in August 1982.
Rating: TAS 36-OLD (HP's old List is London LDR 71104 D), Penguin 3*+

Label : LONDON OSA 1299 (=DECCA SET 565-6)
Puccini: 《La Boheme》, Berlin Philharmonic Orchestra-Herbert Von Karajan.
Rating: TASEC-OPERA, (TAS List is DECCA SET 565-6), Penguin 3*

Label : LONDON OSA 1309 (=DECCA SET 382-4 & SXL 2101-3)
Wagner : 《Das Rheingold》, Georg Solti & The Vienna Philharmonic Orchestra.
Rating: TASEC-OPERA, TAS 3 (3LP-Box)

Label : LONDON OSA 1313 (=DECCA SXL 2167-9)
Verdi: 《AIDA》, The Vienna Philharmonic Orchestra-Hertbert Von Karajan.
Rating: TASEC 44-OPERA, (TAS List is LONDON OSA 1313)

Label : LONDON OSA 1604 (=DECCA SET 282-7)
Wagner: 《Goetterdaemmerrung》, Georg Solti & The Vienna Philharmonic Orchestra.
Rating: TASEC-OPERA, TAS 6

Label : LONDON OSA 13108 (=SET 561-3)
Puccini: 《Turandot》, Zubin Mehta-London Philharmonic Orchestra, @1973.
Rating: TASEC-OPERA (TAS List is DECCA SET 561-3), AS List, Penguin 3*

Label : LONDON OSA 13116 (=SET 609-11)
Gershwin: 《Porgy & Bess》, World Premiere Complete Recording.
Lorin Maazel-Cleveland Orchestra & Chorus. ✴✴In the HP's Best of the Bunch List.
Rating: TASEC✴✴ (TAS List is DECCA SET 609-11), AS List, Penguin 3*+

Label : LONDON SPC 21006 (=Decca PFS 4095, London STS 15558)
Mussorgsky-Stokowski: 《Pictures at an Exhibition》
Debussy-Stokowski: 《The English Cathedral》
New Philharmonia Orchestra-Leopold Stokowsky.
Rating: TAS 12-OLD

Label : LYRINX LYR 011 (=SYRINX 0977-011)
Mozart: Flute Quartets 《N° 1 IN D MAJOR, K285》 《N° 2 IN G MAJOR, K285a》
《N° 3 IN UT MAJOR, K285b》 N° 4 IN A MAJOR, K298》,
Alain Marion (flute) with Etle Trio
Acordes De Paris – Charles Frey (violin); Jean Verdier (alto); Jean Grout (cello).
Rating: TAS-OLD

Label : LYRITA SRCS 33
Arthur Bliss: 《Meditations on a Theme by John Blow》 《Music for Strings》
City of Birmingham Symphony Orchestra-Hugo Rignold, @1966.
Rating: TASEC* (Also in the TAS list: Top 100-20th Century Classical Music Recordings.)

Label : LYRITA SRCS 34
Holst: 《Lyric Movement for Viola & Orchestra》 《Brook Green Suite》 《Nocturne for String 》
《Fugal Concerto for Flute, Oboe》 《St.Paul's Suit》
English Chamber Orchestra-Imogen Holst, @1967.
Rating: TAS 07-OLD, Audio Award

Label : LYRITA SRCS 35 (=MHS 1198)
Arnold Bax: 《Symphony No. 6》, New Philharmonia Orchestra-Norman Del Mar, @1967.
Rating: TASEC (TAS List is US issue MHS 1198)

Label : LYRITA SRCS 46
Robert Still: 《Symphonies No. 4, (1964)》, Royal Philharmonic-Myer Fredman
《Symphonies No. 3, (1960)》, London Symphony Orchestra-Eugene Goossens, @1971.
Rating: TAS 73-OLD

Label : LYRITA SRCS 75
Finzi: 《Intimations of Immortality》, Ode for tenor solo, chorus & orchestra,
Guildford Philharmonic Choir and Orchestra-Vernon Handley, @1975.
Rating: TASEC

Label : LYRITA SRCS 79
Malcolm Willianson: 《Piano Concerto No. 3, E flat (1962)》 《Organ Concerto (1961)》, Organ
& Piano: M. Willianson, London Philharmonic conducted by A. Boult & L. Dommett.
Recorded by K.Wilkinson at Kingsway Hall in 1974, organ at Guildford Cathedral.
Rating: TAS 44-OLD, @1975

Label : LYRITA SRCS 101
Alan Rawsthorne: 《Piano Concerto No. 1 (1942) & No. 2 (1951)》 Piano: Malcolm Binns,
Nicholas Braithwaite conducted London Symphony Orchestra, @1979.
Rating: TASEC

Label : LYRITA SRCS 109
Malcolm Arnold: 《8 English (1950-51), 4 Scottish, Op.59 (1957) & 4 Cornish Dances, Op.91》

London Philharmonic Orchestra-Malcolm Arnold. Recorded by John Dunkerley in 1977.
☆☆In the HP's Best of the Bunch List & also in the list of Golden Baker's Dozen 2007.
Rating: TASEC☆☆**, AS List, Penguin 3*

Label : LYRITA SRCS 116
Elizabeth Maconchy: 《Serenata Concertante for Violin & Orchestra》、《Symphony for Double
String Orchestra》, Violin: Manoug Parikian, London Symphony Orchestra -Vernon Handley.
In the HP's Old list of Golden Baker's Dozen, @1982.
Rating: TASEC**

Label : LYRITA SRCS 124
George Lloyd: 《Symphony No. 5》, Philharmonia Orchestra-Edward Downes, @1982.
Rating: TASEC

Label : LYRITA SRCS 125
Vaughan Williams: 《The Sons of Light》; Hubert Parry: 《Ode on the Nativity》
London Philharmonic Orchestra-David Willcocks. Recorded by Kenneth Wilkinson & John
Pellowe at Kingsway Hall, March 1980, @1982.
Rating: TAS 50-OLD

Label : LYRITA SRCS 126
Walter Leigh: 《Concertino for Harpsichord & String Orchestra(1934)》
《Music for String Orchestra(1931-2)》 《Overture & Dance (The Frogs-1936)》
《The Midsummer Night's Dream-Suite (1936)》, Harpsichord: Pinnock Trevorr, @1985.
Rating: TASEC*

Label : MARK LEVINSON MAL 1
【Organ Music】 Bach: 《The Six Schubler Chorales》 《Prelude in Eb Major-Organo Pleno》;
Anonymous: 《Rejoice In The Lord》; Tallis: 《Magnifica》; Greene: 《Lord, Let Me Know Mine
End》; Morales: 《O Sacrum Convivium》, Organ: Myrtle Regier & Britt Wheeler, Battle Chapel
Choir, director-Charles Krigbaum. (France, 1976)
Rating: TAS 20-OLD

Label : MARK LEVINSON MAL 5
Bach: 《Art of Fugue, BWV. 1080》, Organ: Charles Kirgbaum, @1976.
Rating: TAS 20-OLD

Label : MERCURY LPS 2-901
《THE CIVIL WAR, ITS MUSIC AND ITS SOUNDS》, From Sumter to Gettysburg, Vol. 1,
Eastman Wind Ensemble-Fredrick Fennel.
Rating: TASEC-INFORMAL, (2LP deluxe set)

Label : MERCURY SR 90001 (=SRI 75060, UK=AMS 16053)
Bizet: 《Carmen Suite》 《L'Arlesienne Suite No. 1 & No. 2》
Paul Paray & Detroit Symphony Orchestra.
Rating: TAS 25-OLD (HP's old list is Golden Imports SRI 75060)

Label : MERCURY SR 90005 (Part of SRI 75033)
Ravel: 《Bolero》 《Ma Mere L'oye》; Chabrier: 《Bourree Fantasque》
Paul Paray & Detroit Symphony Orchestra.
Rating: TAS 98-OLD (Part of Old TAS List SRI 75033)

Label : MERCURY SR 90006 (UK=AMS 16009, SRI 75030)
Prokofiev: 《The Love For Three Oranges》 《Scythian Suite》
Antal Dorati conducted London Symphony Orchestra.
Rating: TASEC*※※, (Best of the Bunch List), AS List

Label : MERCURY SR 90010 (UK=AMS 16094)
Debusy: 《La Mer》 -3 Symphonic Sketches, 《Iberia》 - Images for Orchestra, No. 2,
Paul Paray-Detroit Symphony Orchestra.
Rating: TASEC73

Label : MERCURY SR 90012 (UK=AMS 16004, SR90331 is the reissue of SR 90012)
Saint-Saens: 《Symphony No. 3 in C Minor》
Paul Paray-Detroit Symphony Orchestra. Organ: Marcel Dupre
Rating: TASEC65

Label : MERCURY SR 90043 (UK=AMS 16037)
L.Anderson: 《Music of Leroy Anderson, Vol: 2》
Eastman-Rochester "Pops" Orchestra -Fredrick Fennell.
Rating: TASEC, Penguin 3*

Label : MERCURY SR 90103 (UK=AMS 16093, SRI 75049)
Roger Sessions: 《The Black Maskers-Suite》; Colin McPhee: 《 "Tabuh-Tabuhan" Toccata for Orchestra》, Howard Hanson-Eastman Rochester Orchestra.
Rating: TAS 44, TAS 73-OLD, AS List

Label : MERCURY SR 90132 (UK=AMS 16025)
Bartok: 《Hungarian Sketches》 & 《Romanian Folk Dances》
Kodaly: 《Hary Janos Suite》, Minneapolis Symphony Orchestra-Dorati.
Rating: TASEC* / N07

Label : MERCURY SR 90134 (UK=AMS 16016)
【FIESTA IN HI-FI】 McBride: 《Mexican Rhapsody》; Nelson: 《Savannah River Holiday》
Mitchell: 《Kentucky Mountain Portaits》; Vardell: 《Loe Clark Steps Out》
Eastman-Rochester Orchestra-Howard Hanson.
Rating: TASEC-COLLECTION

Label : MERCURY SR 90144 (UK=AMS 16089)
【HI-FI A LA ESPANOLA 】 Eastman-Rochester "Pops" Orchestra-Frederick Fennell.
Rating: TASEC*※※, (Best of the Bunch List) / N14

Label : MERCURY SR 90150
Howard Hanson: 《Song of Democracy》 《Elegy》; Richard Lane: 《4 Songs》
Patricia Berlin (mezzo-soprano), Eastman-Rochester Orchestra-Hanson.
Rating: TAS 65-OLD** (also in the Old list of Golden Baker's Dozen)

Label : MERCURY SR 90153 (UK=AMS 16036, SRI 75023)
Respighi: 《Brazilian Impressions》 、 《The Birds》
London Symphony Orchestra-Antal Dorati.
Rating: TASEC / N01, Penguin 3*

Label : MERCURY SR 90168 (UK=AMS 16030)
C. Frank: Piece Heroique-Three Chorales 《No. 1 in E Major;

No. 2 in B Minor; No. 3 in A Minor》, Organ: Marcel Dupre.
Rating: TASEC 65

Label : MERCURY SR 90169 (UK=AMS 16097)
Charles-Marie Widor: 《Allegro-Symphony No. 6 Op. 42》 《Salve Regin》
Macrcel Dupre: 《Prelude and Fugue in Gm Op. 7》 《Triptyque Op. 51》, Organ: Marcel Dupre.
Rating: TASEC※※ (In the HP's Best of the Bunch List) / N09

Label : MERCURY SR 90172 (UK=AMS 16021)
Aaron Copland: 《RODEO-4 dance Episodes 》 《EL SALON MEXICO》 《DANZO CUBANO》
Minneapolis Symphony Orchestra-Antal Dorati.
Rating: TASEC / N16

Label : MERCURY SR 90173 (UK=AMS 16023)
【Winds in Hi-Fi】 Percy Grainger: <Lincolnshire Posy>; Bernard Rogers: <Japanese Dances>; Darius Milhaud: <Suite Francaise>; Richard Strauss: <Serenade in E Flat, Op. 7>.
Eastman Wind Ensemble-Frederick Fennell.
Rating: TASEC 65

Label : MERCURY SR 90175 (UK=AMS 16007)
Howard Hanson: 《The Composer and His Orchestra》
Eastman Rochester Orchestra conducted by Howard Hanson.
Rating: TASEC** (In the HP's Old list of Golden Baker's Dozen) / N25

Label : MERCURY SR 90177
Florent Schmitt: 《La Tragedie De Salome》; R. Strauss: 《Slaome-Dance of the Seven Veils》;
Lalo: 《Namouna-Suite No. 1》, Paul Paray-Detroit Symphony Orchestra.
Rating: TAS 65-OLD

Label : MERCURY SR 90191 (UK=AMS 16013)
【Ouvertures Francaises】 Berlioz: <Le Carnival Romain> & <Le Corsaire>; Bizet: <Patrie>;
Lalo: <Le Roi D`ys>, Paul Paray-Detroit Symphony Orchestra.
Rating: TASEC-COLLECTION

Label : MERCURY SR 90192
H. Hanson: 《Symphony No. 2, Op. 30 "Romantic" 》 《The Lament For Beowulf, Op. 25》
Howard Hanson-Eastman Rochester Orchestra & Eastman School of Music chorus.
Rating: TASEC 65

Label : MERCURY SR 90197 (UK=AMS 16043, SRI 75028)
【BRITISH BAND CLASSIC, Vol. II】 Gordon Jacob: Suite-William Byrd; Holst: Hammersmith (Prelude and Scherzo, Op. 52); William Walton: Crown Imperial (A Coronation March),
Eastman Wind Ensemble-Frederick Fennell.
Rating: TASEC / N10 / Penguin 3*+

Label : MERCURY SR 90199 (UK=AMS 16028, Philips 6582 010 & SRI 75009)
Respighi: 【Ancient Dances and Airs】 《Suite No.1,2,3》, based on Italian & French music for the lute, Antal Dorati conducted Philharmonia Hungarica.
Rating: TASEC* / N29 / Penguin 3*+ / R2D4

Label : MERCURY SR 90204 (UK=AMS 16061)
Sibelius: 《Symphony No. 2 in D Major》, Detroit Symphony Orchestra-Paul Paray.
Rating: TASEC*

Label : MERCURY SR 90219 (UK=AMS 16060, SRI 75102)
Percy Grainger: 《Country Gardens And Other Favorites》 Frederick Fennell-Eastman-Rochester Pops Orchestra, @1959.
The reissue Mercury WING SR W 18060 was also in
Rating: TASEC 41+++/ 53+++ / N12, (Old HP's List is Golden Imports SRI 75102)

Label : MERCURY SR 90223 (UK=AMS 16098, SRI 75017)
Ernest Bloch: 《Concerto Grosso No. 1, (1925)》 《Concerto Grosso No. 2, (1952)》
Howard Hanson-Eastman Rochester Orchestra.
Rating: TASEC* (Also in the TAS list: Top 100-20th Century Classical Music Recordings)

Label : MERCURY SR 90226 (UK=AMS 16038, SRI 75058)
Stravinsky: Complete Ballet 《FIREBIRD》, Antal Dorati-London Symphony Orchestra.
☆☆In the HP's Best of the Bunch List & also in the list of Golden Baker's Dozen 2007.
Rating: TASEC*☆☆, N17, AS List, Penguin 3*+

Label : MERCURY SR 90248 (reissue=SR 90499)
Antal Dorati: 《Symphony(1957)》 《Nocturne & Capriccio for Oboe and String Quart》
Minneapolis Symphony Orchestra-Antal Dorati.
Rating: TASEC

Label : MERCURY SR 90256 (UK=AMS 16070)
【Ballet for Band】 Sullivan: Pineapple Poll; Rossin: La Boutique Fantasque; Gounod: Faust,
Frederick Fennell-Eastman Wind Ensemble.
Rating: TASEC-COLLECTION

Label : MERCURY SR 90276 (UK=AMS 16103, SRI 75096)
Richard Wagner: 《Wager For Band》 Lohengrin、Das Rheingold、Parsifal,
Frederick Fennell-Eastman Wind Ensemble.
Rating: TASEC** (Also in the HP's Old list of Golden Baker's Dozen)

Label : MERCURY SR 90278 (UK=AMS 16117)
Alban Berg: 《 "Lulu" Suite》 《Three Excerpts From "Wozzeck" Op. 7》
AntalDorati-London Symphony Orchestra.
Rating: TASEC

Label : MERCURY SR 90281 (UK=AMS 16120)
Debussy: 《3 Nocturnes for Orchestra-Nuages、Fêtes、Sirenes》
Ravel: 《 "Daphnis et Chloé" Suite No. 2》, Paul Paray-Detroit Symphony Orchestra.
Rating: TAS-OLD / N26

Label : MERCURY SR 90283 (UK=AMS 16109)
Rachmaninoff: 《Piano Concerto No. 3 in D minor Op. 30》
Piano: Byron Janis, Antal Dorati-London Symphony Orchestra.
Rating: TASEC*☆☆, N18, Penguin 3* (Best of the Bunch & Golden Baker's Dozen 2007 List)

Label : MERCURY SR 90300 (UK=AMS 16130)
Prokofiev: 《Piano Concerto No. 3》; Rachmaninoff: 《Piano Concerto No. 1》
Piano: Byron Janis, Kyril Kondrashin conducted Moscow Philharmonic Orchestra.
Rating: TASEC44, TAS 34++54+++, (also in the Top 100-20th Century Classical Recording)

Label : MERCURY SR 90303 (UK=AMS 16133, SRI 75045)
Dvorak: 《Cello Concerto in B minor, Op. 104》; Bruch: 《Kol Nidrei, Op. 47》
Cello: Janos Starker, London Symphony Orchestra conducted by Antal Dorati.
Rating: TASEC* / N28

Label : MERCURY SR 90310 (UK=AMS 16139, SRI 75106)
《Balalaika Favorites》, Osipov State Russian Folk Orchestra.
Rating: TASEC☆☆(Best of the Bunch List – Popular) / N06 / Penguin 3*+

Label : MERCURY SR 90313
Ravel: 《La Valse》 《Rapsodie Espagnole》 《Pavane Pour Une Infante Défunte》 《Alborada del Gracioso》; Ibert: 《Escales-Ports of Call》, Detroit Symphony Orchestra-Paul Paray.
Rating: TASEC*☆☆ (Best of the Bunch List), AS List / N05

Label : MERCURY SR 90316
【VIENNA 1908-1914】 Schoenberg: <Five Pieces for Orchestra, Op.16>; Webern: <Five Pieces for Orchestra, Op.10>; Alban Berg: <Three Pieces for Orchestra, Op.6>.
London Symphony Orchestra conducted by Antal Dorati.
Rating: TASEC-COLLECTION/ N03 / AS List

Label : MERCURY SR 90379
Willaim Schuman: 《New England Triptych》; Peter Mennin: 《Symphony No. 5》
Charles T. Griffes: 《Poem for Flute & Orchestra》, Hanson-Eastman Rochester Orchestra.
Rating: TAS 11-OLD

Label : MERCURY SR 90488 (=SRI 75021)
Rodrigo: 《Concerto Andaluz, for 4 guitars & orchestra》 《Concerto de Aranjuez for solo guitar & orchestra》, The Romeros & Angel Romero(guitar solo), Victor Alessandro conducted San Antonio Symphony Orchestra.
Rating: TASEC* / N40

Label : MERCURY SRI 75033 (=SR 90005 + SR 90313)
Ravel: 《Bolero》 《La Valse》 《Rapsodie Espagnole》 《Pavane Pour Une Infante Défunte》 《Alborada del Gracioso》, Detroit Symphony Orchestra-Paul Paray.
Rating: TAS 98-OLD

Label : MERCURY SRI 75060 (=SR 90001)
Bizet: 《Carmen Suite》 《L'Arlesienne Suite No. 1 & No. 2》 Paul Paray & Detroit Symphony Orchestra.
Rating: TAS 25-OLD (HP's old list is Golden Imports SRI 75060)

Label : MOBILE FIDELITY MFSL 1-522 (=RCA LSC 2609)
Richard Strauss: 《Also Sprach Zarathustra, Op. 30》
Chicago Symphony Orchestra-Fritz Reiner. (1/2 Speed Reissue from RCA LSC 2609)
Rating: TAS 36-OLD (HP's old list is: MFSL 1-522)

Label : Musical Heritage Society MHS 1198 (=Lyrita SRCS 35)
Arnold Bax: 《Symphony No. 6》, New Philharmonia Orchestra-Norman Del Mar ·
Rating: TASEC (HP's list is MHS 1198, US reissue from Lyrita)

Label : Musical Heritage Society MHS 1472
Mussorgsky: 《Pictures at an Exhibition》,
Transcripted for organ and performed by Calvin Hampton, (1972).
Rating: TAS 09-OLD

Label : Musical Heritage Society MHS 1758
《Christmas at Colorado State University, Volume I》, Colorado State University Chamber
Singers conducted by Edward Anderson. (Volume II is MHS 3295; Volume III is MHS 4257).
Rating: TAS 10-OLD

Label : MHS-Musical Heritage Society MHS 4261
《Celebrate with the Harvard Glee Club》 -2 Renaissance Masses For Equal Voices
The Harvard Glee Club directed by F. John Adams. (1980)
Rating: TAS 100-OLD

Label : NEW WORLD NW 319
【PULSE】: Works for Percussion & String – Cage: 3rd Constructio; Cowell: 7 Paragraphs &
Pulse; Seeger: Suite No. II; Harrison: String Trio, The New Music Consort, @1984.
Rating: TASEC*

Label : NONESUCH H 71028
Mozart: 《Concerto For Two Pianos In E Flat, K.365; For Three Pianos In F Major, K.242》
Piano: Pierre Sancam, Jean-Bernard Pommier, Catherin, Orchestra of the Association of
Lamoureux- Dimitri Chorofas. Original recording of Club Francais Du Disque, Paris.
Rating: TASEC

Label : NONESUCH H 71250
Charles Dodge: 《Earth's Magnetic Field》 Realization in Computed Electronic Sound,
Produced at the Columbia University Computer Center.
Rating: TAS-OLD

Label : NONESUCH H 71291
《Percussion Music》Works by Edgard Varese, Michael Colgrass, Henry Cowell,
David Saperstein, and Kil-Sung Oak, The New Jersey Percussion Ensemble-Raymond
DesRoches. Recorded byJoanna Nickrenz & Marc Aubort (Elite Recordings) in 1974.
Rating: TASEC-COLLECTION

Label : NONESUCH H 71293
George Crumb: 《Makrokosmos, Volume I (1972)》12 Fantasy-Pieces after the Zodiac for
Amplified Piano. Piano: David Burge.
Rating: TASEC

Label : NONESUCH H 71311
George Crumb: 《Makrokosmos, Volume III (1974)》 -for two amplified pianos and percussion
Piano: Gilbert Kalish &James Freeman; Percussion: Raymond DesRoches & Richard Fitz.
Rating: TASEC

Label : NONESUCH H 71353
Charles Wuorinen: 《Percussion Symphony (1976)》 The New Jersey Percussion Ensemble-
Raymond DesRoches. Recorded by Joanna Nickrenz & Marc Aubort in 1978.
Rating: TAS 73-OLD

Label : NONESUCH H 71354
《Sing We Noel》 - Christmas Music from England & Early American
The Boston Camerata-Joel Cohen (1978).
Rating: TASEC**COLLECTION (Also in the HP's Old list of Golden Baker's Dozen)

Label : NONESUCH H 71401 (=ENIGMA K 53585)
Stravinsky: Ballets 《Apollo》 《Orpheus》
Orchestra of St. John's Smith Square-John Lubbock, ℗1979 ©1982
Rating: TAS 44-OLD (Old HP's List is Enigma Records K 53585 1979)

Label : NONESUCH HB 73023 (=Unicorn Records RHS 302-3 or UN2-75004X)
Mahler: 《Symphony No. 3》, Jascha Horenstein-London Symphony Orchestra.
Producer: Harold Lawrence, recorded by Bob Auger in July 1970. @1971
Rating: TAS 02-OLD

Label : OCORA 558907
《HEARING SOLAR WINDS》 David Hykes & The Harmonic Choir.
Recorded at a 12th century Cistercian monastery "The Abbey of Thoronet" in France 1983.
Rating: TAS 73-OLD (French)

Label : OPUS 3 8014
《Maytan and Friends》
Framnas Symphonic Wind Ensemble plays work's of Robert E. Jager, Norman Della Joio,
Alfred Reed, Vaclav Nelhybel and Percy Granger, conducted by Dave Maytan. (1980-Sweden)
Rating: TAS 65-OLD

Label : Orion ORS 78282
Reubke: 《The 94th Psalm-Sonata for Organ》 《Trio in E-flat major for organ》
Karg-Elert: 《Jesu, Geh' Voran》, Organist: David McVey, @1977.
Rating: TASEC (Very rare !!!)

Label : PENN STATE GLEE CLUB AJC 8
《PENN STATE GLEE CLUB》 Men's collegiate chorus of the Pennsylvania State
University, directed by Bruce Trinkley & assistant director Douglas Smith. A private record
recorded during the American bicentennial (1975-1976). Presented by The Penn
State Alumni Association in a concert of American Music.
Rating: TAS 14-OLD

Label : PHILIPS 835 507 AY (=Columbia MS 6036 & CBS/Sony 20AC 1808)
Beethoven: 《Symphony No. 3 "Eroica"》, Bruno Walter-Columbia Symphony Orchestra.
Rating: TAS-OLD (TAS List is CBS/SONY 20AC 1808)

Label : PHILIPS 6700 019
Berlioz: 《Requiem, Op. 5》, Wandsworth School Boy's Choir (Russel Burgess) with London
Symphony Orchestra & Choir-Colin Davis. Recorded in Westminster Cathedral, 1970.
Rating: TAS 72-OLD

Label : RCA AGL1-1332 (=LSC 2230)
《Great Music Of SPAIN》
Falla: 〈Dances from The Three-Cornered Hat〉〈La Vida Breve〉; Goyescas: 〈Intermezzo〉;
Iberia: 〈Navarra〉〈Fete-Dieu A Seville〉〈Triana〉, Fritz Reiner-Chicago Symphony Orchestra.
Rating: TAS-OLD, (Recorder by Lewis Layton at OHC)

Label : RCA ARL1-2044 (=LSC 1831)
Brahms: 《Piano Concerto No. 1》, Artur Rubinstein (piano), Fritz Reiner-Chicago Symphony
Orchestra. (1st stereo issue of LM 1831, LSC 1831, reissued only from Classic Records).
Rating: TAS 12-OLD

Label : RCA LDS 6065 (=VICS 1066)
《The Royal Ballet, Gala Performances》
Tchaikovsky: The Nutcracker Suite, Swan Lake, The Sleeping Beauty; Rossini/ Respighi:
La Boutique; Delibes: Coppelia; Adam: Giselle; Schumann: Carnaval; Chopin: Les Sylphides.
The Royal Opera House Orchestra-Ernst Ansermet, Recorded by Kenneth Wilkinson, 1957)
Rating: TASEC, JM10++

Label : RCA LDS 6164 (=LSC 6199)
Bizet: 《CARMEN》, Leontyne Price, Franco Corelli, Merrill, Freni, The Vienna Philharmonic
Orchestra & Vienna State Opera Chorus-Herbert von Karajan.
Rating: TASEC-OPERA

Label : RCA LDS 7022 (=Decca 5BB 123-4 & London OSA 1284)
Puccini: 《TOSCA》, Leontyne Price, Giuseppe Di Stefano, Giuseppe Taddei, The Vienna
Philharmonic Orchestra & Vienna State Opera Chorus-Herbert von Karajan.
Rating: TASEC-OPERA, TAS 2, Penguin 3*

Label : RCA LDS 7022 (=Decca 5BB 123-4 & London OSA 1284)
Puccini: 《TOSCA》
Leontyne Price、Giuseppe Di Stefano、Giuseppe Taddei, Vienna Philharmonic Orchestra & Vienna State Opera Chorus-Herbert von Karajan.

Label : RCA LSB 4090 (=LSC 2990 & SB 6729)
Rachmaninoff: 《Symphony No. 3 in A Minor, Op. 44》《Fantasy for Orchestra, Op. 7 "The
Rock"》, Andre Previn-London Symphony Orchestra, recorded by James Lock, @1967.
Rating: TASEC, (HP's List is UK-RCA LSB 4090)

Label : RCA LSB 4094 (=LSC 2945 & SB 6721 UK)
《Previn conducts Satie》 and Music from France
Satie: 〈Gymnopedies 1 & 2〉; Francaix: 〈The Flower Clock〉;

Ibert: 〈Symphonie Concertante〉
Andre Previn-London Symphony Orchestra, recorded by K. Wilkinson & M. Mailes, @1966.
Rating: TAS-OLD (HP's old list is UK-RCA LSB 4094)

Label : RCA LSC 1806 (=VICS 1265)
Richard Strauss: 《Also sprach Zarathustra, Op. 30》
Chicago Symphony Orchestra-Fritz Reiner. Recorded by Leslie Chase at Orchestra Hall
Chicago (OHC), March 1954, @1958.
Rating: TASEC*, JM10++, Gramophone Top 100

Label : RCA LSC 1817 (=VICS 1012)
Offenbach: Ballet 《Gaite Parisienne》 Boston Pop Symphony Orchestra-Arthur Fiedler.
Recorded by Leslie Chase at Boston Symphony Hall (BSH), @1958.
Rating: TASEC*, JM10++

Label : RCA LSC 1893 (=CHESKY RC 15, VICS 1297)
Ravel: Complete Ballet 《Daphnis & Chloe》, Boston Symphony Orchestra-Charles Munch.
Recorded by Leslie Chase at Boston Symphony Hall (BSH) in 1955, issued in 1959.
Rating: TASEC, JM10++, (HP's list is CHESKY RC 15)

Label : RCA LSC 1900 (=RCA AGL1-5203)
Berlioz: 《Symphony Fantastique》, Boston Symphony Orchestra-Charles Munch.
The first stereo issue is RCA AGL1-5203, LSC 1900 issued only by Classic Records.
Rating: TASEC* (Classic Records 200g only)

Label : RCA LSC 1934 (=VICS 1110)
Bartok: 《Concerto for Orchestra》, Chicago Symphony Orchestra-Fritz Reiner.
Recorded by Lewis Layton-OHC, 1958.
*Also in the list: Top 100-20th Century Classical Music Recordings.
Rating: TASEC*, Gramophone Top 100, JM10++

Label : RCA LSC 2077 (=UK RCA SB 2036, VICS 1004)
Richard Strauss: 《Death and Transfiguration》《Till Eulenspiegel's Merry Pranks》
Vienna Philharmonic Orchestra-Fritz Reiner. Recorded in Vienna Sofiensaal, @1958.
Rating: TAS 40-OLD

Label : RCA LSC 2150 (=VICS 1290)
Prokofiev: 《Lieutenant Kije, Op. 60》; Stravinsky: Symphonic Poem 《Song of the Nightingale》
Chicago Symphony Orchestra-Fritz Reiner, Lewis Layton-Orchestra Hall Chicago, @1958.
Rating: TASEC*44** / JM10++, (**Also in the HP's Old list of Golden Baker's Dozen)

Label : RCA LSC 2183 (=UK RCA SB 2042)
【The Reiner Sound】 Ravel: 《Rapsodie Espagnole》《Pavan for a Dead Princess》
Rachmaninoff: 《Isle of the Dead》, Chicago Symphony Orchestra-Fritz Reiner.
Recorded by Lewis Layton at OHC, @1958.
Rating: TAS 42-OLD**, (**Also in the Old list of Golden Baker's Dozen)

Label : RCA LSC 2201 (=VICS 2042 & UK RCA SB 2001)
Moussorgsky-Ravel : 《Picture at an Exhibition》, Chicago Symphony Orchestra -Fritz Reiner.
Lewis Layton-Orchestra Hall Chicago, @1958.
Rating: TASEC / JM10++*

Label : RCA LSC 2222 (=UK RCA SB 2044; Part of VICS 1025 & 1119)
Debussy: 《Iberia》《Images for Orchestra, No. 2》; Ravel: 《Alborado del Gracioso》《Valses Nobles et Sentimentales》, Chicago Symphony Orchestra-Fritz Reiner.
Lewis Layton-Orchestra Hall Chicago, @1958.
Rating: TASEC*, JM10++* (* Fine Acoustic of OHC)

Label : RCA LSC 2225 (=UK RCA SB 2022, DECCA SPA 175)
《Witches' Brew》
New Symphony Orchestra of London-Alexander Gibson, Kenneth Wilkinson recorded at Kingsway Hall in 1957, @1958.
Rating: TASEC-COLLECTION, JM10++* (* Fine Acoustic of Kingsway hall)

Label : RCA LSC 2230 (=VICS 1294)
【SPAIN】Falla: 〈√ˉÇL˜7>Ç√ˉ Dances from The Three-Cornered Hat〉〈La Vida Breve〉
Goyescas: 〈Intermezzo〉; Ibeniz: 〈Navarra〉〈Fete-Dieu A Seville〉〈Triana〉
Chicago Symphony Orchestra-Fritz Reiner, Lewis Layton-Orchestra Hall Chicago, @1958.
Rating: TAS 44, TAS 50-OLD, JM10++

Label : RCA LSC 2234 (UK=SB 2023)
Saint-Saens: 《Piano Concerto No. 2》; Franck: 《Symphonic Variations》
Piano: Artur Rubinstein, Alfred Wallenstein conducted Symphony of the Air, @1958
Rating: TASEC*, JM10++(10+) (Piano is 10++)

Label : RCA LSC 2241 (=UK RCA SB 2059, Part of VICS 1025)
Tchaikovsky: 《1812 Overture》; Mendelssohn: 《Fingal's Cave Overture》
Liszt: 《Mephisto Waltz》; Brahms: 《Tragic Overture》, Chicago Symphony Orchestra-Fritz Reiner, Leslie Chase & Lewis Layton-Orchestra Hall Chicago, @1958.
Rating: TASEC*, JM10++ * Fine Acoustic of OHC

Label : RCA LSC 2251
Hovhaness: 《Mysterious Mountains, Op. 132》
Stravinsky: 《Divertimento from "The Fairy's Kiss"》
Chicago Symphony Orchestra-Fritz Reiner, Lewis Layton-Orchestra Hall Chicago, @1958.
Rating: TAS-OLD, JM10+, SM59-123++

Label : RCA LSC 2314 (=UK RCA SB 2066)
Mendelssohn: 《Violin Concerto in Em, Op. 64》Prokofiev: 《Concerto No. 2 in Gm, Op. 63》
Violin: Jascha Heifetz, Charles Munch-Boston Symphony Orchestra, @1959.
Rating: TASEC 65 / JM10

Label : RCA LSC 2322 (=VICS 1184) (=UK RCA SB 2051, Decca ECS 580)
Shostakovich: 《Symphony No. 1 in F Minor, Op. 10 (1924-25)》《The Age of Gold-Ballet Suite, Op. 22(1929-30)》, London Symphony Orchestra-Jean Martinon, recorded by Alan Reeve in Kingsway Hall, 1958, @1959.
Rating: TASEC, JM10++, SM64/125++

Label : RCA LSC 2328 (=UK RCA SB 2107, VICS 1460)

Label : RCA LSC 2367 (=Part of VICS 1423)
Gershwin: 《Rhapsody in Blue》《An American in Paris》
Piano: Earl Wild, Boston Pops Orchestra-Fiedler, @1960. Rcorded by Lewis Layton at Boston Symphony Hall in 1959.
Rating: TAS*EC**44, (Also in Old Golden Baker's Dozen & Top 100-20th Century list), JM10+

Tchaikovsky: Excerpts from 《The Nutcracker, Op. 71》, Chicago Symphony Orchestra-Fritz Reiner, recorded by Lewis Layton at Orchestra Hall Chicago in 1959. @1960,
Rating: TAS 44-OLD, JM10+

Label : RCA LSC 2369 (=UK RCA SB 2093)
Tchaikovsky: 《Symphony No. 4 in F Minor, Op. 36》, Boston Symphony Orchestra conducted by Pierre Monteux, recorded by John Crawford-Boston Symphony Hall in 1959, @1960.
Rating: TASEC44 / JM10++* (* Great Perfomance, sound on side 2 is terrific!)

Label : RCA LSC 2374 (=VICS 1620)
Bartok: 《Music for Strings, Percussion & Celesta》《Hungarian Sketches》
Chicago Symphony Orchestra-Fritz Reiner, recorded by Lewis Layton (OHC), @1960.
Rating: TASEC*, JM10++

Label : RCA LSC 2378 (=UK RCA SB 2079)
Schubert: 《Death and the Maiden, Quartet No. 14 in D Minor, Op. Posth.》
《Quartet No. 12 in C Minor, Op. Posth. -Quartettsatz》, Julliard String Quartert,
recorded by Lewis Layton.
Rating: TASEC*42 / JM10+

Label : RCA LSC 2398 (=VICS 1007)
Kabalevsky: 《The Comedians Op. 26》; Khachaturian: 《Masquerade Suite》
RCA Victor Symphony Orchestra-Kiril Kondrashin, (Lewis Layton-1958) @1960
Rating: TASEC44 / JM10++

Label : RCA LSC 2405 (=UK RCA SB 2068, VICS 1016, Decca SPA 122)
Sibelius: 《Symphony No. 5》、《Karelia Suite》
London Symphony Orchestra-Alexander Gibson, @1960, recorded by Kenneth Wilkinson at Kingsway Hall in 1959.
Rating: TASEC, SM++, JM10++

Label : RCA LSC 2423 (=VICS 1068)
【Festival of Russian Music】Kabalevsky: 《Colas Breugnon, Op. 24-Overture》;
Tchaikovsky: 《Marche slave》, 《Marche miniature》;
Borodin: 《Polovski March》;
Moussorgsky: 《A Night on Bare Mountain》; Glinka: 《Russlan & Ludmilla-Overture》
Chicago Symphony Orchestra -Fritz Reiner. (Lewis Layton-OHC, 1959)
Rating: TASEC*65-COLLECTION, JM10++

Label : RCA LSC 2430 (=UK RCA SB 2144)
Rachmaninoff: 《Rhapsody on a theme of Paganini, Op. 43》
Falla: 《Nights in the Garden of Spain》, Chicago Symphony Orcestra-Fritz Reiner.
Piano: Rubinstein, recorded by Lewis Layton at Orchestra Hall Chicago in 1959, @1960
Rating: TASEC44, JM10++

Label : RCA LSC 2435 (=UK RCA SB 2101)
Sibelius: 《Violin Concerto in D minor, Op. 47》, Violin: Jasha Heifetz, Chicago Symphony
Orchestra -Walter Hendl, recorded by Lewis Layton Orchestra Hall Chicago in 1959, @1960.
Rating: TASEC 65, JM10+

Label : RCA LSC 2436 (=VICS 1565, VICS 2040 Germany, UK SB 2103)
Respighi: Symphonic Poems <Fountains Of Rome>, <Pines Of Rome>, Chicago Symphony
Orchestra-Fritz Reiner, recorded by Lewis Layton-Orchestra Hall Chicago in 1959, @1960.
Rating: TAS*EC65**, (**VICS 1565 was in old Golden Backer's Dozen List) / JM10++(10+)

Label : RCA LSC 2446
Rimsky-Korsakov: 《Scheherazade Op. 35》, Chicago Symphony Orchestra-Fritz Reiner.
Producer: Richard Mohr, recording engineer: Lewis Layton recorded at OHC, @1960.
.Rating: TAS*EC44** (HP's WORKSHOP The Golden Dozen LPs in 2007), JM10++

Label : RCA LSC 2449 (=VICS 1108, DECCA SPA 220)
Gounod: 《Ballet Music from "Faust"》 《Funeral March of a Marionette》
Bizet: 《Carmen Suite》, Royal Opera House Orchestra, Convent Garden-Alexander Gibson.
Recorded by Kenneth Wilkinson-Kingsway Hall, @1960.
Rating: TASEC*, JM10++* (Outstanding clarity & stereo stage, Fine Acoustic of Kingsway hall)

Label : RCA LSC 2450
Schumann: 《Carnava》; Meyerbeer: 《Les Patineurs》
Royal Opera House Orchestra, Convent Garden-Rignold Hugo, @1960.
Rating: JM10++, TAS-OLD

Label : RCA LSC 2465
Prokofiev: 《Piano Concerto No. 2 in G, Op. 16》; Haydn: 《Sonata No. 35》,
Piano: Malcolm Frager, Rene Leibowitz conducted Paris Conservatoire Orchestra.
Recorded by Charles Gerhardt & Peter Dellheim, @1960
Rating: TASEC 44, JM10++

Label : RCA LSC 2471 (=UK RCA SB 2130)
【Rhapsodies】Liszt: 《Hungarian Rhapsody No.2》; Enesco: 《Roumanian Rhapsody No.1》
Smetana: 《The Moldau & The Bartered Bride-Overture》, Stokowski Leopold conducted RCA
Victor Symphony Orchestra, recorded by Peter Dellheim & Robert Simpson, @1961.
Rating: TASEC73-COLLECTION, JM10++, R2D4

Label : RCA LSC 2487
Arnold Malcolm 《Guitar Concerto, Op. 67》; Mauro Giuliani: 《Concerto For Guitar & Strings》,
Julian Bream (Guitarist) with Melos Ensemble, @1961, (Decca Studio, London, 1959).
Rating: TASEC*73, JM10++, Penguin 3*

Label : RCA LSC 2500
【Strauss Waltzes】Johann Strauss: 《Vienna Blood》 《Roses from the South》 《Thunder
& Lightning Polka》; Jesef Strauss: 《My Life Is Love & Laughter》, Chicago Symphony

Orchestra-Fritz Reiner, (Lewis Layton-OHC, 1960) @1961.
Rating: TASEC*44, (HP's old list : RCA Fr GL 43706 is part of LSC 2500), JM10++

Label : RCA LSC 2507 (=UK RCA SB 2113)
Prokofeiv: 《Piano Concerto No. 3》; MacDowell: 《Piano Concerto No. 2》
Piano: Van Cliburn, Chicago Symphony Orchestra-Walter Hendl, (Lewis Layton-OHC) @1961.
Rating: TAS 98-OLD, SM100++, JM10++*

Label : RCA LSC 2541 (=VICS 1205)
Rachmaninoff: 《Piano Concerto No. 1, Op. 1》; Liszt: 《Todtentanz》, Piano: Byron Janis,
Chicago Symphony Orchestra-Fritz Reiner, (Lewis Layton-OHC, 1960) @1961,
Rating: TASEC, JM10++

Label : RCA LSC 2566
Grieg: 《Piano Concerto in A Minor, Op. 16》 (and 5 encore piano favories)
Piano: Artur Rubinstein, orchestra conducted by Alfred Wallenstein, (Lewis Layton) @1962.
Rating: TASEC65, JM10+

Label : RCA LSC 2609 (=MFSL 1-522, UK SB 6518)
Richard Strauss: 《Also Sprach Zarathustra, Op. 30》, Chicago Symphony Orchestra-Fritz
Reiner. Recorded by Lewis Layton at Orchestra Hall Chicago, 1962.
Rating: TAS-OLD (HP's old list is: MFSL 1-522), JM10+

Label : RCA LSC 2762 (=UK RCA SB 6634, LSB 4075)
Menotti: 《Amahl and The Night Visitors》, television opera (1951). TV production by NBC
Opera Company in 1963, conducted by Herbert Grossman, @1963.
Rating: TASEC 65-OPERA, (Recorded by Lewis Layton)

Label : RCA LSC 2893
Charles Ives: 《Symphony No. 1 in D Minor》 Premiere Recording, 《The Unanswered Question》
《Variations on America (W. Schuman Orchestration)》, Chicago Symphony Orchestra-Morton
Gould, recorded by Bernard Keville-OHC, 1965, @1966.

Label : RCA LSC 2914
Varese: 《Arcana-music that explodes into space》; Martin: 《Concerto-a wonderful pellucid
score》, Chicago Symphony Orchestra-Jean Martinon. (Recorded by Bernard Keville, 1966)
Rating: TAS 10-OLD, (Also in the list of Top 100-20th Century Classical Music Recordings)

Label : RCA LSC 2990 (=LSB 4090 & SB 6729)
Rachmaninoff: 《Symphony No. 3 in A Minor, Op. 44》 《Fantasy for Orchestra, Op. 7 "The
Rock"》, Andre Previn-London Symphony Orchestra, recorded by James Lock, @1967.
Rating: TASEC, (HP's List is UK-RCA LSB 4090)

Label : LSC 3135 (=RCA SB 6838)
《Previn Conducts Strauss》, Der Rosenkavalier Suite, Don Juan, Muenchen (first recording),
London Symphony Orchestra-Andre Previn. (Recorded by James Lock, 1969)
Rating: TAS 11-OLD

Label : RCA LSC 3280
Vaughan Williams: 《Symphony No. 9》 《3 Portraits from "The England of Elizabeth"》
Andre Previn conducted London Symphony Orchestra, @1972.
Rating: TAS 10-OLD

Label : RCA LSC 6199 (=LDS 6164)
Bizet: 《CARMEN》, Leontyne Price, Franco Corelli, Merrill, Freni, The Vienna Philharmonic
Orchestra & Vienna State Opera Chorus-Herbert von Karajan. (Late issue of LDS 6164)
Rating: TASEC-OPERA

Label : RCA RDC-4
Beethoven: 《Piano Sonata No.23,Op.57, "Appassionata"》
Piano: Ikuyo Kamiya; Producer: Hiroshi Isaka; Recording Engineer: Masaki Ihno,
(D2D, 45 R.P.M.), recorded live from the Iruma Public Hall, Japan, 1977.
Rating: TASEC, (D2D)

Label : RCA RDCE-7
Chopin: 《Scherzo No. 2 in B-Flat Minor, Op. 31》 《Piano Sonata No. 3 in B Minor, Op. 58》
Piano: Edward Auer, recorded live at Iruma City Auditorium, Saitama, Japan, April 18, 1978.
Rating: TAS 31-OLD, (D2D)

Label : RCA RL 1 5129 (=LRL 1 5129)
Tchaikovsky: 《Symphony No. 6 in Bm, Op. 74-Pathetique》
Loris Tjeknavorian-London Symphony Orchestra, @1976.
Rating: TAS 11-OLD

Label : RCA RL 25035 (=CRL2-2263)
Khachaturian: 《The Gayne, Ballet suite No. 1, 2, & 3》
Loris Tjeknavorian-National Philharmonic Orchestra.
(Recorded by Charles Gerhardt & Robert Auger, 1977)
Rating: TAS 11-OLD

Label : RCA RL 25098
Borodin: 《The Complete Orchestral Music》, The Three Symphonies, Prince Igor, Petite Suite,
In the Steppes of Central Asia, Mlada, Noctune for String Orchestra, National Philharmonic
Orchestra & John Alldis Choir-Loris Tjeknavorian, @1977.
Rating: TAS 19-OLD

Label : RCA RVC 2154
Amemiya: 《Summer Prayer (Natsu Nebutsu 1973)》 《Monochrome Sea (1976)》
Morton Feldman: 《King of Denmark》, Percussion-Amemiya, (33 & 45rpm @1977).
Rating: TAS 24-OLD

Label : RCA RVL 1
Kouichi Sugiyama: 《Audio Symphony No. 1》
"Check Up Your Sounds Volume 1". Kazuhiko Komatsu conducted NHK Symphony
Rating: TAS 44-OLD

Label : RCA SB 6729 (=LSB 4090, LSC 2990)
Rachmaninoff: 《Symphony No. 3 in A Minor, Op. 44》 《Fantasy for Orchestra, Op. 7 "The
Rock"》, Andre Previn-London Symphony Orchestra, recorded by James Lock, @1967.
Rating: TASEC, (HP's List is UK-RCA LSB 4090)

Label : RCA SB 6838 (=LSC 3135)
《Previn Conducts Strauss》, Der Rosenkavalier Suite, Don Juan, Muenchen (first recording),
London Symphony Orchestra-Andre Previn. (Recorded by James Lock, 1969)
Rating: TAS 11-OLD

Label : RCA VCS 2659 (=CHESKY RC 30)
《The Power of the Orchestra》
Mussorgsk: <Night on the Bald Mountain> & <Pictures at an Exhibition>
Royal Philharmonic Orchestra-René Leibowitz. Producer: Charles Gerhardt, recorded by
Kenneth Wilkinson, 1962 in the Kingsway Hall, London.
Rating: TASEC-COLLECTION S (=Chesky RC 30)

Label : RCA VICS 1424
《Overtures and Dances》, <The Bartered Bride>, <Carnival, Fingal's Cave>, <Schwanda:
Polka & Fugue>, <Salome: Dance of the Seven Veils>, Chicago Symphony Orchestra-Fritz
Reiner, @1969. *No SXL issue "Salome" is one of the first Reiner's recording, in March 1954.
Rating: TAS-OLD, JM10++

Label : RCA VICS 1565 (=LSC 2436 & VICS 2040 @Germany)
Respighi: Symphonic Poems 《Fountains Of Rome》 《Pines Of Rome》, Chicago Symphony
Orchestra-Fritz Reiner, recorded by Lewis Layton (OHC, 1959), @1960.
Rating: TASEC (=LSC 2436), TAS-OLD** (VICS 1565 was in old Golden Backer's Dozen List)

Label : RCA VICS 2042 (=LSC 2201)
Moussorgsky-Ravel : 《Picture at an Exhibition》, Chicago Symphony Orchestra -Fritz Reiner.
Lewis Layton-Orchestra Hall Chicago, @1958. (1968 reissue)
Rating: TASEC (=LSC 2201), TAS-OLD** (VICS 2042 was in the HP's Old List)

Label : Reader's Digest RDA 29 (Quintessence PMC 7006=Chesky CR 02; Quintessence
PMC 7030=RCA GL 25292; Quintessence PMC 7052 & Quintessence PMC 7053)
《The Romantic Rachmaninoff》 The Complete Piano Concertos、Rhapsody on a Theme of
Paganini、The Isle of the Dead. Piano: Earl Wild, Jascha Horenstein-Royal Philharmonic
Orchestra. Recorded by Kenneth Wilkinson in Walthamstow Town Hall, 1965.
Rating: TASEC, TAS 4, (4LP-Box)

Label : RECUT REC 001, LINN Records (=REC 5001)
Bartok: 《Piano Concerto No. 3》; Ravel: 《Piano Concerto in G Major》
Piano: Julius Katchen, Istvan Kertesz -London Symphony Orchestra.
Rating: TASEC (=London CS 6487, Decca SXL 6209)

Label : Reference Mastercuts RM 1004
Ravel: 《Valse nobles et sentimentales》 《Ma Mere l'Oye》, Skrowaczewski-Minnesota
(Minneapolis) Symphony Orchestra. The original recording made by Vox Records in 1974 at
Orchestra Hall, Minneapolis. The complete box set is VOX QSVBX 5133.
Rating: TASEC, (=Turmabout QTV-S 34603 & Part of VOX QSVBX 5133)

Label : Reference Recordings RR 09
Kronos Quartet: 《IN FORMATION》, Kronos Quartet : David Harrington & John Sherba (Violin)、
Hank Dutt (Viola)、 Joan Jeanrenaud (Cello).
Rating: TASEC-COLLECTION

Label : Reference Recordings RR 10
《The Tempest》, Suites from Act I & Act II. Highlights from the 2 acts ballet by Paul Seiko
Chihara after Henry Purcell. Louis LeRoux conducted The Performing Arts Orchestra of
San Francisco. (45 rpm, @1981)
Rating: TAS 25-OLD

Label : Reference Recordings RR 11
Berlioz: 《Symphony Fantastique》
The Utah Symphony Orchestra-Varujan Kojian, @1982.
Rating: TASEC**, TAS 50, (**also in the Old list of Golden Baker's Dozen)

Label : Reference Recordings RR 13
《Tafelmusik》, Popular Masterworks Of The Baroque (Handel, Purcell, Bach, Vivaldi,
Telemann, Pachelbel), Canada's Original-Instrument Baroque Orchestra, (45 rpm, 1983).
Rating: TAS 65-OLD

Label : Reference Recordings RR 16
Walton: 《FACADE》, R. Strauss: <Till Eulenspiegel>, Einmal Anders! (Once in another way!);
Scriabin: <Waltz In A-Flat>; Nielsen: <Serenata In Vano>, Chicago Pro Musica.
Rating: TAS 44-OLD** (**Also in the old list of Golden Baker's Dozen)

Label : Reference Recordings RR 17
Stravinsky: 《The Soldier's Tale-Suite》; Rimsky-Korsakov: 《Capriccio Espagnol》
arranged by Easley Blackwood, Chicago Pro Musica. (45 rpm & 33 rpm, @1985)
Rating: TAS-OLD

Label : Reference Recordings RR 19
《Marni Nixon Sings Gershwin》, Piano-Lincoln Mayorga, @1985.
Rating: TAS 50-OLD

Label : Reference Recordings RR 29
Weill: 《Threepenny Opera Suite》; Varese: 《Octandre》; Bowles: 《Music for A Farce》;
Martinu: 《La Revue de Cuisine》, Chicago Pro Musica, @1988.
Rating: TAS 73-OLD

Label : Reference Recordings RR 48
Malcolm Arnold: 《Overtures》, <Beckus the Dandipratt>, <A Sussex Overture>, <The Smoke>,
<The Fair Field>, <Commonwealth Christmas Overture>, Malcolm Arnold conducted London
Philharmonic Orchestra, @1992.
Rating: TASEC

Label : Reference Recordings RR 55
Stravinsky: 《Ebony Concerto》; Leonard Berstein: 《Prelude, Fuque & Riffs》; Morton Gould:
《Derivations for Clarinet & Band》; Victor Babin: 《Hillandale Waltzes》; Artie Shaw:
《Concerto for Clarinet》, Clarinet: John Bruce Yeh, DePaul University Wind & Jazz Ensemble.
Rating: TASEC*

Label : Richardson RRS 70001 (=RRS 1)
《Eternal Father, Vol. I》, Chapel Music From The United State Naval Academy, Featuring The
USNA Protestant Chapel Choir, John B. Talley (director), James Dale (organist). @1983.
Rating: TAS 36-OLD, (CD= Richardson 3297-7001-2)

Label : Sarastro SAR 7701
《Verite du Clavecin》, Pieces from Jacques Champion De Chambonnieres; Jacques Duphly &
Scarlatti, Harpsichord: Anne-Francoise Chapelin. (45 rpm- @1977).
Rating: TAS 73-OLD

Label : Sheffield Lab LAB 07
Wagner: 《Die Walkure》《Tristan Und Isolde》《Gotterdammerung》《Siegfried selections》,
Los Angeles Philharmonic Orchestra-Eric Leinsdorf, @1977.
Rating: TAS 65-OLD, Direct to Disc

Label : Sheffield Lab LAB 08
Prokofiev: 《Excerpts from the Ballet Romeo and Juliet》
Los Angeles Philharmonic Orchestra-Eric Leinsdorf, @1978.
Rating: TAS 65-OLD, Direct to Disc

Label : Sheffield Lab LAB 10
【Michael Newman Classical Guitarist】Albeniz: 《Torre Bermeja》; Eduardo Sainz de la Maza:
《Campanas Del Alba》; Bach: 《Chaconne》; Turina: 《Fandanguillo》, @1979.
Rating: TAS 65-OLD, Direct to Disc

Label : Sheffield Lab LAB 16
《Italian Pleasures》, Music from the Golden Age of the Guitar. Giuliani, Carulli, Legnani &
Michael Newman with The Sequoia String Quartet, @1981.
Rating: TAS 65-OLD, Direct to Disc

Label : Sheffield Lab LAB 18
R.Strauss: 《Sonata in E-Flat Major, Op. 18》; Dvorak: 《Romantic Piecess, Op. 75》
Violin: Arnold Steinhard, Piano: Lincoln Mayorga, @1982.
Rating: TAS 65-OLD, Direct to Disc

Label : Sheffield Lab LAB 22
Mozart: 《Serenade No. 11, K.375》; Grieg: 《Four Lyric Pieces》
Chicago Symphony Winds, @1983.
Rating: TAS 98-OLD, Direct to Disc

Label : Sheffield Lab LAB 24
Stravinsky: 《Firebird Suite (1910)》; Debussy: 《Afternoon of a Faun》
Erich Leinsdorf-Los Angeles Philharmonic Orchestra, @1985.
Rating: TAS-OLD Direct To Disc Records

Label : Sheffield Lab TLP 25
《The Moscow Sessions I》, Tchaikovsky: <Symphony No. 5>; Glinka: <Russlan & Ludmilla
Overture>; Mussorgsky: <Khovanshchina Prelude>; Moscow Philharmonic Orchestra,
conducted by Lawrence Leighton Smith.
Rating: TASEC** COLLECTION (**Also in the Old list of Golden Baker's Dozen)

Label : Sheffield Lab TLP 26
《The Moscow Sessions II》, Shostakovich: <Symphony No. 1>; Piston: <Ballet suite-The
Incredible Flutist>; Baber: <First Essay for Orchestra>;
Moscow Philharmonic Orchestra,
conducted by Lawrence Leighton Smith & Dmitri Kitayenko.
**Also in the Old list of Golden Baker's Dozen.
Rating: TASEC** COLLECTION (**Also in the Old list of Golden Baker's Dozen)

Label : Sheffield Lab TLP 27
《The Moscow Sessions III》, Shostakovich: <Festive Overture>; Gershwin: <Lullaby>;
Copland: <Appalachian Spring>; Glazunov: <Valse de Concert in D>; Griffes: <The White
Peacock>; Ives: <The Unanswered Question>, Moscow Philharmonic Orchestra conducted by
Lawrence Leighton Smith & Dmitri Kitayenko.
Rating: TASEC** COLLECTION (**Also in the Old list of Golden Baker's Dozen)

Label : Sheffield Lab TLP 1000 (=TLP 25; 26 & 27)
《The Moscow Sessions I, II, III》, The Moscow Philharmonic Orchestra, conducted by
Lawrence Leighton Smith & Dmitri Kitayenko.
Rating: TASEC** COLLECTION (**Also in the Old list of Golden Baker's Dozen)

Label : SYRINX 002
Schubert: 《String Quintet in C Major, D-956》 《Sonata In G Minor, Op. 137, D-408》
《Impromptus In A Flat, Op. 90》, The Members Of The Scottish Baroque Ensemble.
Rating: TAS 73-OLD

Label : TELARC DG 10038 (=DG 5038)
Holst: 《Suite No. 1 & No. 2》; Handel: 《Fireworks》; Bach: 《Fantasia in G》
Cleveland Symphonic Winds-Fennell Frederick. Recorded by Jack Renner, in 1978.
Rating: TAS-OLD

Label : TELARC DG 10039
Stravinsky: 《The Firebird Suite -1919》; Borodin: 《Price Igor-Overture & Polovetsian Dances》
Atalanta Symphony Orchestra-Robert Shaw. Sound Engineer: Jack Renner, recorded in 1978.
Rating: TAS 36-OLD

Label : TELARC DG 10040
《Malcolm Frager Play Chopin》, Piano: Boesendorfer Imperial Concert Grand.
Sound Engineer: Jack Renner, recorded in 1978.
Rating: TAS-OLD

Label : TELARC DG 10042
Moussorgsky: 《Picture at an Exhibition》 & 《Night on Bald Mountain》
Lorin Maazel-Cleveland Orchestra. Sound Engineer: Jack Renner, recorded in 1978.
Rating: TAS 27-OLD

Label : TELARC DG 10047
Tchaikovsky: 《Symphony No. 4 in F Minor, Op. 36》
Lorin Maazel-Cleveland Orchestra. Sound Engineer: Jack Renner, recorded in 1979.
Rating: TAS 31-OLD

Label : TELARC DG 10048
Bizet: 《Carmen Suite, No. 1 & No. 2》; Grieg: 《Suite from Peer Gynt, Op. 55, 46》
Leonard Slatkin conducted The Saint Louis Symphony, Jack Renner, recorded in 1979.
Rating: TAS 20-OLD

Label : TELARC DG 10050
Leo Arnaud: 《Three Fanfares》; Vaughan Williams: 《Toccata Marziale & Folk Song Suite》
Percy Graiger: 《Lincolnshire Posy & Shepherd's Hey》
Cleveland Symphonic Winds-Fennell Frederick. Jack Renner, recorded in 1979.
Rating: TAS 36-OLD

Label : TELARC DG 10051
Saint-Saens: 《Symphony No. 3-Organ, Op.78》 (Organ: Michael Murray)
Eugene Ormandy-Philadelphia Orchestra. Sound Engineer: Jack Renner, recorded in 1980.
Rating: TAS-OLD

Label : TELARC DG 10055
【IBERIA】 Rimsky-Korsakov: 《Capriccio Espagnol》; Debussy: 《Iberia》; J.Turina: 《Orgia》
Dallas Symphony Orchestra-Eduardo Mata. Sound Engineer: Jack Renner, recorded in 1979.
Rating: TAS 65-OLD CD List

Label : TELARC DG 10056/57
Carl Orff: 《Carmina Burana》; Paul Hindemith: 《Symphonic Metamorphosis》
Atalanta Symphony Orchestra & Chorus-Robert Shaw, Jack Renner, recorded in 1981.
Rating: TAS-OLD

Label : TELARC DG 10059
V.Willaims: 《Fantasia on a Theme by Thomas Tallis》; Satie: 《Gymnopedies Nos. 1 & 3》;
Grainger: 《Irish Tune from County Derry》; Baber: 《Adagio for Strings》; Faure: 《Pavane》,
Leonard Slatkin conducted The Saint Louis Symphony, Jack Renner, recorded in 1981.
Rating: TAS-OLD (CD List)

Label : TELARC DG 10066
Mahler: 《Symphony No. 1 in D Major, "Titan"》
Leonard Slatkin conducted The Saint Louis Symphony, Jack Renner, recorded in 1981.
Rating: TASEC

Label : TELEFUNKEN 6.41724 (=LONDON CS 6840 ; DECCA SXL 6624)
Grieg & Schumann: 《Piano Concertos in A minor》 Piano: Radu Lupu, Andre Previn-London
Symphony Orchestra. Recorded by Kenneth Wilkinson at Kingsway Hall, 1973.
Rating: TAS-Old & TASEC (TAS list is London 6840)

Label : TURNABOUT QTV S 34595 (Part of VOX QSVBX 5133)
Ravel: 《Bolero》 《La Valse》 《Rapsodie Espagnol》 《Pavane Pour Une Infante Defunte》
Skrowaczewski-Minnesota Symphony Orchestra.
Rating: TASEC, (TAS list is VOX QSVBX 5133)

Label : TURNABOUT TV 34145 S (=ATHENA ALSW 10001)

Rachmaninoff: 《Symphonic Dances No. 45》 《Vocalise No. 14》
Donald Johanos-Dallas Symphony Orchestra.
Rating: TASEC** (**Also in the Old list of Golden Baker's Dozen)

Label : UNICORN RHS 302/3 (=UN2-75004X, NONESUCH HB 73023)

Mahler: 《Symphony No. 3》, Jascha Horenstein-London Symphony Orchestra.
Producer: Harold Lawrence, recorded by Bob Auger in July 1970.
Old HP's list is UN2-75004X, RHS 302-3 is the original recording.
Rating: TAS 10-OLD (Old HP's list is UN2-75004X), R2D4 (1991)

Label : VANGUARD SRV 275 SD (=Analogue Productions AP 003)

Gould: 《Latin-American Symphonette, No. 4, (1940)》
Gottschalk: 《A Night In The Tropics (1859)》 《Grande Tarentelle for Piano & Orchestra》,
Piano: Reid Nibley, Utah Symphony Orchestra-Maurice Abravanel, @1962.
Rating: TASEC (TAS list is VANGUARD SRV 275 SD)

Label : VANGUARD VSD 2090 (=Analogue Productions AP 002)

《Songs of the Auvergne》, Volume I, arranged by Canteloube. Soprano: Netania Davrath.
Sung in the Auvergne dialect, Orchestra conducted by Pierre de la Roche.
Rating: TAS 65-Old, Penguin 3*+

Label : VANGUARD VSD 2095 (=Analogue Productions AP 001)

Virgil Thomson: 《Suite from The River》 《The Plow that Broke the Plains》
Leopold Stokowski conducted the Symphony of the Air.
Original recording: VANGUARD VSD 2095
Rating: TASEC

Label : VOX QSVBX 5132 (Partially reissued =Reference Recordings RM 1003 & 1005)

Gershwin: 《All the Works for Orchestra & for Piano & Orchestra》, Pianist: Jeffrey Siegel.
Leonard Slatkin conducted The Saint Louis Symphony.
Engineering & supervision: Joanna Nickrenz & Marc Aubort (Elite Recordings), recorded at Orchestra Hall, Minneapolis in 1974.
Rating: TASEC, TAS 3

Label : VOX QSVBX 5133 (Partially reissued =Reference Recordings RM 1001 & 1004)

Ravel: 《All the Works for Orchestra》, Skrowaczewski-Minnesota (Minneapolis) Symphony
Orchestra. Recorded by the Joanna Nickrenz & Marc Aubort recording team at Orchestra Hall,
Minneapolis in 1974.
Rating: TASEC, TAS 4

Label : Wilson Audiophile W 8111

《Magnum Opus》 Volume one. Organist: James Welch;
Organ: Built by D.A.
Flentrop in 1965, St. Mark's Episcopal Cathedral, Seattle, Washington.
Engineering & Mastering Engineer: David Wilson & Bruce Leek, recorded in 1981.
Rating: TASEC-COLLECTION

Label : Wilson Audiophile W 8313

Beethoven: 《Sonata in C, Op.53 "Waldstein"》
Stravinsky: 《Three Movements from Petrushka (1921)》
Pianist: Hyperion Knight, Recorded & Mastering by David Wilson & Bruce Leek in 1983.
Rating: TASEC*

Label : Wilson Audiophile W 8315

Beethoven: 《Violin Sonata G Major Op. 96》, Violin : David Abel
Enescu: 《Sonata No. 3 Op. 25 in Rumanian Folkstyle》,
Piano: Julie Steinberg
Recorded & Mastering by David Wilson & Bruce Leek in 1983.
Rating: TAS 50-OLD

Label: Wilson Audiophile W 8722

【Sonatas For Violin And Piano】 Debussy: 《Sonata for Violin & Piano》;
Bartok: 《Rumanian Folk Dances》; Brahms: 《Sonata No. 1 in G major Op. 78》
Violin : David Abel, Piano : Julie Steinberg. Recorded in 1987 by David Wilson.
Rating: TASEC

Label : Wilson Audiophile W 8824

《Center Stage》, Lowell Graham-National Symphonic Winds.
Recording Team: David Wilson, Bruce Leek, Joseph Magee, 1988.
Rating: TAS**-OLD (**also in the Old list of Golden Baker's Dozen)

Label : Wilson Audiophile WEMI 01 (=EMI SAN 324, 180g HQ remastered)

Walton: 《Belshazzar's Feast》 《Improvisations on an Impromptu of Benjamin Britten》
London Symphony Orchestra & Chor-Andre Previn, ℗1972 ©1993.
Rating: TAS 98-OLD

Label : World Record Club SCM 50 (=EMI HQS 1260 & EVEREST SDBR 6136)

Gustav Holst: 《A Choral Fantasia》 《Psalm 86》; Gerald Finzi: 《Dies Natalis》
English Chamber Orchestra conducted by Imogen Holst & Christopher Finzi. @1964
Rating: TASEC* (TAS list is World Record Club SCM 50), Stereophile R2D4

Chapter 1.2 (List only, without Photos & Comments) [Super LP List]
includes: Best of the Bunch Popular,Special Merit of the Informal, Popular, Rock, Jazz & Film Soundtrack.

黑膠發燒天碟流行、爵士及電影原聲帶

Label : 20th Century SXG 5008
Alex North: 《Cleopatra》- Original Soundtrack Album.
Rating: TASEC 44-OLD Soundtrack

Label : 20th Century T 508 (=T 539, MFSL 1-204)
Woolfsongs, Parsons & Powell: 《Alan Parsons Project》
Tales of Mystery and Imagination (Edgar Allan Poe),
Orchestra & Choir Arranged by Andrew
Powell. Produced & Engineered by Alan Parsons, Keith.
O.Johnson & Gordon Parry.
Rating: TAS 98-OLD POP

Label : A&M AMLS 68258 Br. (=SP 3647, MFSL 1-005,
 Jap AMP 7045 SP 3647)
Supertramp: 《Crime of the Century》
Rating: TAS 44-OLD POP(UK)

Label : A&M SD 4555 (UK= ISLAND ILPSP 9370)
Cat Stevens: 《Numbers》- A Pythagorean Theory Tale-with
Alun Davies, Gerry Conway, Jean
Roussel, Bruce Lynch, @1975.
Rating: TASEC 10-OLD POP

Label : A&M SP 3233 (=SP 4527, MFSL 1-238)
Joan Baez: 《Diamonds & Rust》
Arranged by Joan Baez and Larry Carlton.
Rating: TASEC-POP (TAS List is MFSL 1-238)

Label : A&M SP 4260 (=ISLAND 88165 XAT)
Cat Stevens: 《Mona Bone Jakon》- Additional arrangements
by Del Newman.
Rating: TAS 11-OLD POP

Label : A&M SP 4280 (=ISLAND ILPS 9135, MFSL
 1-035)
Cat Stevens: 《Tea for the Tillerman》, @1970
**also in the HP's WORKSHOP The Golden Dozen LPs, List
2007.
Rating: TASEC**-POP (HP's list is ISLAND ILPS 9135)

Label : A&M SP 4313 (=ISLAND ILPS 9154, MFSL
 1-244)
Cat Stevens: 《Teaser and the Firecat》, @1971
Rating: TASEC-POP, (HP's list is MFSL 1-244)

Label : A&M SP 4365 (=ISLAND ILPS 9206 & 86372
 XOT)
Cat Stevens: 《Catch Bull at Four》, @1972.
Rating: TAS 14-OLD POP

Label : ABC ABCS-OC 13
Jimmie Haskell: 《Zachariah》- Original Motion Picture
Soundtrack, @1970.
Country Joe and the Fish, The James Gang, Doug Kershaw,
The New York Rock Ensemble,

White Lightnin', Elvis Jones.
Rating: TAS-OLD Soundtrack

Label : American Gramaphone AG 359
Mannheim Steamroller: 《Fresh Aire II》- Written and
Arranged by Chip Davis, @1977 US.
Rating: TASEC-POP

Label : American Gramaphone AG 365
Mannheim Steamroller: 《Fresh Aire III》
Written and Arranged by Chip Davis, @1979 US.
Rating: TASEC-POP

Label : Analogue Productions APJ 020 (=India
 Navigation IN 1045)
Chico Freeman: 《Spirit Sensitive》- Freeman (tenor), Cecil
McBee (bass), Billy Hart (drums),
John Hicks (piano) and Don Moye (drums).
Rating: TAS-POP Jazz, (Original : India Navigation IN 1045,
@1979 US)

Label : ASYLUM 7E 1001 (= NAUT NR 11 HSM)
Joni Mitchell 《Court and Spark》, @1974.
Rating: TASEC-POP

Label : ASYLUM K 53051 (=P 10221Y , Japanese)
Eagles: 《Hotel California》
Rating: TAS-POP

Label : ASYLUM SYL 9011 (USA=SD 5068)
Eagles: 《Desperado》- Original UK, @1973.
Rating: TASEC-POP

Label : ATLANTIC 81842-1
《ENYA》, self-titled debut. @1986.
Rating: TASEC-POP

Label : ATLANTIC SD 7203
David Crosby: 《If I Could Only Remember My Name》,
@1971 US.
Rating: TASEC-POP

Label : Audiophile AP 80 (=Athena ALSS-10005)
《Salt City Six plays The Classics in dixeland》
Rating: TASEC-POP Jazz

Label : Audioquest Records AQ 1012
Bruce Katz Band: 《Crescent Crawl》- Crescent Crawl, Just
An Expression, Contrition,
One way Ticket, etc., @1992.
Rating: TASEC-POP Jazz

Label : Backstreet BSR 6107
Georgio Moroder: 《CAT PEOPLE》- Original
Soundtrack-@1982
Rating: TASEC-Soundtrack

Label : Barclay BA 253
Vangelis: 《La Fete Sauvage》 - Original Soundtrack (France), @1976.
Bande sonore originale du film de Frederic Rossie.
Rating: TASEC65-OLD

Label : Beserkley 0-67932
Greg Kihn: 《Jeopardy》 - The Greg Kihn Band, @1983.
Rating: TASEC-POP Single

Label : BBC REB 440
《The Flight of the Condor》 - Original Soundtrack Music from The BBC TV Series, @1982.
Rating: TASEC-Soundtrack

Label : CBS-COLUMBIA CS 8163 (=CBS 32109)
Miles Davis: 《Kind of Blue》
-So What, Freddie Freeloader, Blue In Green, All Blues, Flamenco Sketches, @1962.
Rating: TASEC-POP Jazz

Label : CBS-COLUMBIA CS 8171
Charles Mingus: 《Mingus Ah Um》 - Better Git It In Your Soul, Bird Calls, Fables of Faubus,
Goodbye Pork Pie Hat, Boogie Stop Shuffl, Self-Portrait In Three Colors, Open Letter to Duke,
Pussy Cat Dues, Jelly Roll.
Rating: TASEC-POP Jazz, (1st issue 6 Eye)

Label : CBS-COLUMBIA CS 8192
The Dave Brubeck Quartet: 《TIME OUT》 – Take Five, Blue Rondo A La Turk, Strange
Meadow Lark, Three To Get Ready, Kathy's Waltz, Everybody's Jumpin', Pick Up Sticks.
Rating: TASEC-POP Jazz

Label : CBS- COLUMBIA CS 8271
Miles Davis: 《Sketches of Spain》 , arranged and conducted by Gil Evans.
Rating: TASEC-POP Jazz, (1st issue 6 Eye)

Label : CBS-COLUMBIA CS 8333
Saul Goodman: 《MALLETS, MELODY & MAYHEM》
The Exciting Percussion World Of Saul Goodman.
Rating: TASEC-POP

Label : CBS-COLUMBIA CS 9196
Don Shirley Trio: 《Water Boy》 - Don Shirley (Piano), Bass-Ken Fricker (Juillard School)
& Juri That (Manhattan School).
Rating: TASEC☆☆-POP Jazz, (Best of the Bunch)

Label : CBS- COLUMBIA FM 37827
Andreas Vollenweider: 《Caverna Magica》 @1983.
Rating: TAS-POP

Label : CBS- COLUMBIA JC 35305
Willie Nelson: 《Stardust》 , arranged by Booker T. Jones, @1978.
Rating: TAS 73-OLD POP

Label : CBS-Sony 25AP 1373 (= UK-CBS 32 574, CBS Columbia PC 33700)
Art Garfunkel: 《BREAKAWAY》 , @ 1975.
Rating: TASEC-POP, (TAS List is CBS/Sony Japan: 25 AP 1373)

Label : CBS-Sony 40AP 1750-1 (=CBS Columbia PC2 36183, EMI SVHW 411)
Pink Floyd: 《The Wall》, @1979 Japan
Rating: TASEC**- POP, (**Also in the old list of Golden Baker's Dozen)

Label : Charisma PG-4 (=Geffen GHS 2011 & Fr. Virgin 70328)
《Peter Gabriel 4》 , is known also in the U.S.A., as "Security" . Recorded between 1981 and
1982 at Ashcombe House, Bath, England. Rhythm of the heat, San Jacinto, etc.
Rating: TAS 36 -OLD POP

Label : Classic Records / Discovery JP0779-12
Bill Henderson: 《Send in the Clowns》
Rating: TASEC-POP Single

Label : COLGEMS COSO 5001
Maurice Jarre: 《THE PROFESSIONALS》 – Directed by Richard Brooks, Music & conducted
by Maurice Jarre. Recording engineer: John Norman, 1966.
Rating: TASEC**-Soundtrack, (**Also In the Old list of Golden Baker's Dozen)

Label : COLGEMS COSO 5005
Burt Bacharach: 《Casino Royale》 - Directed by John Huston, music & conducted by
Burt Bacharach, producer: Charles K. Feldman. Recorded by Jack Clegg, 1967 in London.
Rating: TASEC☆☆-POP (Best of the Bunch List & The Golden Dozen LPs, 2007)

Label : CYPRESS 661 111-1
Jennifer Warnes: 《Famous Blue Raincoat》 - The Songs of Leonard Cohen, @1986 US.
Rating: TAS-OLD POP

Label : DECCA PFS 4213 (=LONDON SPC 44144)
Bernard Herrmann: 《Music from Great Film Classics》
Bernanrd Herrmann with the London Philharmonic Orchestra.
Rating: TAS-OLD –Soundtrack, (HP's List is PFS 4213)

Label : DECCA PFS 4309 (=LONDON SPC 44207)
Bernard Herrmann: 《The Fantasy Film World of Bernard Herrmann》 – Journey To The
Center Of Earth, The Seventh Voyage Of Sinbad, Fahrenheit 451, Bernard Herrmann &
National Philharmonic Orchestra, @1974.
Rating: TASEC, Soundtrack (HP's List is PFS 4309), AS List

Label : DECCA PFS 4337 (=LONDON SPC 21137)
Bernard Herrmann: 《The Three Worlds of Gulliver from The Mysterious Film World of Bernard
Herrmann》 , National Philharmonic Orchestra- Bernard Herrmann, @1975.
**In the Old Golden Baker's Dozen List, also in the HP's The Golden Dozen LPs, 2007.
Rating: TASEC**, Soundtrack (HP's List is PFS 4337), AS List

Label : DECCA PFS 4394 (=LONDON SPC 21166)
Miklos Rozsa: 《Ben Hur》
Miklos Rozsa conducting The National Philharmonic Orchestra and Chorus, @1977.
Rating: TASEC-Soundtrack (HP's List is DECCA PFS 4394)

Label : DECCA PFS 4430 (=LONDON SPC 21180)
Miklos Rozsa: 《Quo Vadis》
Miklos Rozsa conducting The Royal Philharmonic Orchestra,
@1978.
Rating: TASEC-Soundtrack (HP's List is DECCA PFS 4430)

Label : ELEKTRA 6E 111
Judy Collins: 《Judith》 , @1975 US.
Rating: TASEC-POP

Label : ELEKTRA 9669790 (Reissued = Vertigo
 8146111)
Yello: 《Lost Again, Bostich》
Rating: TASEC-POP (Single)

Label : EMI (Electrola) 1C 064 46 311
Kraftwerk: 《Computerwelt》
Rating: TAS 73-OLD POP

Label : EMI ASD 3416
Bliss: 《Thngs to Come-Music from the film》 《A Colour
Symphony, Op. 24, F. 106》
Charles Groves-Royal Philharmonic Orchestra. Recorded by
Stuart Eltham, @1977.
Rating: TASEC-Soundtrack

Label : EMI EST 11542 (=CAPITOL ST 11542)
Klaatu: 《Klaatu》
Rating: TASEC-POP

Label : EMI SHVL 804 (=SMAS 11163)
Pink Floyd: 《Dark Side of the Moon》 , @1973.
Rating: TASEC✳✳-POP (Best of the Bunch List)

Label : EMI SLS 5110 (= ANGEL SB 3851)
Prokofiev: 《Ivan The Terrible, Film music, Op. 116》
《Sinfonietta in A Major, Op. 48》
The Ambrosian Chorus and Philharmonic Orchestra
conducted by Riccardo Muti. (Arranged in
the form of an oratoria by Abram Stasevich)
Rating: TASEC-Soundtrack, (HP's list: Special Merit-Film &
Broadway Score)

Label : Filmmusic Collection FMC 3
Waxman: 《The Silver Chalice》 , conducted by Elmer
Bernstein, @1975 UK.
Rating: TAS 36-OLD Soundtrack

Label : Filmmusic Collection FMC 4 (=Varese
 Sarabamde 704340)
Bernard Herrmann: 《The ghost and Mrs.Muir》
Original Motion Picture Score, conducted by Elmer Bernstein
@1985,
Rating: TASEC-Soundtrack

Label : Geffen Records GHS 2019
Joni Mitchell: 《Wild Things Run Fast》 , @1982.
Rating: TASEC-POP

Label : INSIGHT A 201
Pigs Eye Jass: 《Fidelity First, Volume 2》
Rating: TASEC-POP

Label : ISLAND ILPS 9281
Bob Marley & The Wailers: 《Natty Dread》 , @1974
Rating: TASEC-POP

Label : Kamasutra KSBS 2035
Jim Dawson: 《Songman》
Rating: TASEC-POP

Label : KAPP KRS 5513
Gil Melle: 《Andromeda Strain》 - KAPP Hexagon @1971.
Rating: TAS 10-OLD Soundtrack

Label : LABYRINTH LBR 1001
《FM-Headroom, Border Crossing》 - Martin Deller (drums,
percussion), Cameron Hawkins
(bass, synthesizers), Ben Mink (electric violin, electric
mandolin), D2D Album, @1978.
Rating: TAS 18-OLD POP-Direct to Disc

Label : LIMELIGHT LS 86072
The Electronic Concept Orchestra: 《Electric Love》
An Album of Musical Love-Dreams for Moog Synthesizer and
Strings. @1973
Rating: TASEC-POP

Label : LONDON SP 44207 (=DECCA PFS 4309)
Bernard Herrmann: 《The Fantasy Film World of Bernard
Herrmann》 – Journey To The
Center Of Earth, The Seventh Voyage Of Sinbad, Fahrenheit
451, Bernard Herrmann &
National Philharmonic Orchestra, @1974.
Rating: TASEC, Soundtrack (HP's List is PFS 4309), AS List

Label : LONDON SPC 21137 (=DECCA PFS 4337)
Bernard Herrmann: 《The Three Worlds of Gulliver from The
Mysterious Film World of Bernard
Herrmann》 , National Philharmonic Orchestra- Bernard
Herrmann, @1975.
**In the Old Golden Baker's Dozen List, also in the HP's The
Golden Dozen LPs, 2007.
Rating: TASEC**, Soundtrack (HP's List is PFS 4337), AS List

Label : LONDON SPC 21166 (=DECCA PFS 4394)
Miklos Rozsa: 《Ben Hur》
Miklos Rozsa conducting The National Philharmonic
Orchestra and Chorus, @1977.
Rating: TASEC-Soundtrack (HP's List is DECCA PFS 4394)

Label : LONDON SPC 21180 (=DECCA PFS 4430)
Miklos Rozsa: 《Quo Vadis》
Miklos Rozsa conducting The Royal Philharmonic Orchestra,
@1978.
Rating: TASEC-Soundtrack (HP's List is DECCA PFS 4430)

Label : LONDON SPC 44144 (=DECCA PFS 4213)
Bernard Herrmann: 《Music from Great Film Classics》
Bernanrd Herrmann with the London Philharmonic
Orchestra.
Rating: TAS-OLD –Soundtrack, (HP's List is PFS 4213)

Label : M & K Realtime RT 101
《For Duke》 Bill Berry & His Ellington All-Stars, M & K
Realtime Direct To Disc Studio, @1978.
Rating: TASEC✳✳, (In the HP's Best of the Bunch List), AS
List

Label : M&K Realtime RT 105
Earl "Fatha" Hines: 《Fatha》
Plays Hits He Missed, Direct to Disc Collectors Edition,
@1978 Gerrmany
Rating: TASEC-POP

Label : M&K Realtime RT 106
Ed Graham: 《Hot Stix》 Earl "Fatha" Hines Presents, Direct to Disc 45 rpm Collectors Edition, @1978 Germany.
Rating: TASEC-POP, AS List

Label : M&K Realtime RT 110
Roger Wagner Chorale: 《Encore》 - Roger Wagner Chorale Live in Concert, Porgy and Bess Medley; Summertime; Oh! Dear!; etc., Exciting Encores Front Row-Center.
Rating: TAS 33-OLD, (Direct to Disc Collector's Edition)

Label : M&K Realtime Sample
M & K Realtime Records: 《Super Sampler》 - One Exciting Cut From Each of 11 Realtime.
Rating: TAS-OLD POP, (Direct-to-Disc Albums)

Label : Mercury 888-746-1
Yello & Shirley Bassey: 《The Rhythm Divine》 - 12″, Maxi-Single, 45 RPM, @1987.
Rating: TASEC-POP (Single)

Label : MERCURY SR 90310 (=SRI 75106)
《Balalaika Favorites》 - Osipov State Russian Folk Orchestra,1962 in Moscow.
Rating: TASEC☆☆(In the HP's Best of the Bunch List), Penguin 3*+

Label : MERCURY SRI 75117
《VERTIGO》 - Bernard Herrmann's Music from Alfred Hitchcock (Original Soundtrack).
Rating: TAS-OLD Soundtrack

Label : Mobile Fidelity BC 1
《Beatles Collection》, 14 LPs box set of half-speed mastered, @ September 1982.
MFSL 1-100; 1-101; 1-102; 1-103; 1-104; 1-105; 1-106; 1-107; 1-108; 1-109; 1-023; 1-047; &
MFSL 2-072 (2 LPs)
Rating: TAS 31-OLD POP

Label : Mobile Fidelity MFSL 1-004
《The Power And The Majesty》
The Thunderstrom & The Coast Daylights, produced & recorded by Brad Miller, 1978.
Rating: TAS 25-OLD** (In the Old list of Golden Baker's Dozen)

Label : Mobile Fidelity MFSL 1-005 (=A&M Br AMLS 68258, Jap AMP 7045, SP 3647)
Supertramp: 《Crime of the Century》
A&M SP 3674 @1974, Mobile Fidelity speed reissued @1978
Rating: TAS 44-OLD POP

Label : Mobile Fidelity MFSL 1-006 (=ABC Records ABCD 922)
John Klemmer: 《Touch》 - Touch, Glass Dolphing, Sleeping Eyes, etc., @1975.
Rating: TAS 25-OLD POP

Label : Mobile Fidelity MFSL 1-030 (=R.S.O.Deluxe 2479 201-UK)
Eric Clapton: 《Slowhand》 - Cocaine, Wondelful Tonight, The Core, etc., 1977.
Rating: TAS 22-OLD POP

Label : Mobile Fidelity MFSL 1-058 (=United Artists 5C 062.60395, UA-LA 840)
Gerry Rafferty: 《City To City》, @ 1978.
Rating: TAS 25-OLD POP

Label : Mobile Fidelity MFSL 1-238 (=A&M SP 4527)
Joan Baez: 《Diamonds & Rust》, arranged by Joan Baez and Larry Carlton.
Rating: TASEC-POP

Label : Mobile Fidelity MFSL1-244 (=ISLAND ILPS 9135, A&M SP 4313)
Cat Stevens: 《Teaser and the Firecat》
Rating: TASEC-POP

Label : MONUMENT SLP 18045
Roy Orbinson: 《The Very Best of Roy Orbinson》 – Only the Lonely, Crying, It's Over, Running Scared, Candy Man, Oh Pretty Woman, Blue Angel, In Dreams, Dream Baby, Mean Woman Blues.
Rating: TAS 98-OLD POP

Label : MOTOWN 6059 ML
Lionel Richie: 《Can't Slow Down》
Rating: TASEC-POP (Single)

Label : Mute Records YAZ-001
Yazoo: 《Don't Go》, @1982.
Rating:TASEC-POP (Single)

Label : PARLOPHONE EJ24 701(=VERTIGO 6360620, PHILIPS 630 5231)
Kraftwerk: 《Autobahn》
**Also in the Old list of Golden Baker's Dozen (Popular)
Rating: TASEC**-POP, (HP's list is PARLOPHONE EJ24 701)

Label : POLYDOR 28MM 0290
Vangelis: 《ANTARCTICA》 - Music from Koreyoshi Kurahara's Film.
Rating: TASEC-Soundtrack

Label : Polydor 887-529-1
Gerry Woo: 《Help Yourself》 - (12″) @1987.
Rating: TASEC -POP (Single)

Label : POLYDOR PD 1 6112 (=MFSL 1-212)
Jean Michel Jarre: 《Oxygene》, @1976
Rating: TASEC-POP

Label : POLYDOR VAN 04 (= 2473 105)
Vangelis: 《Opera Sauvage》 - Original music from the TV series by Frederic Rossif, @1979.
Rating: TAS 98-OLD Soundtrack

Label : RCA ARL 1-0452 (=GL 43440)
Steiner: 《Gone With The Wind》 - Charles Gerhardt-National Philharmonic Orchestra.
Rating: TAS-OLD Soundtrack

Label : RCA ARL 1-0707 (=GL 43441)
Bernard Herrmann: 《Citizen Kane》 – Charles Gerhardt-National Philharmonic Orchestra.
Rating: TASEC-Soundtrack

Label : RCA ARL1-0708
Franz Waxman: 《Sunset Boulevard》 - The Classic Film Scores of Franz Waxman.
Charles Gerhadt conducted National Philharmonic Orchestra.
Rating: TAS 36-OLD Soundtrack

Label : RCA ARL 1-1367 (=ARL 1-4407)
Sondheim: 《Pacific Overtures》
Original Broadway Cast Recording, directed by Harold Prince, @1976.
Rating: TASEC-Soundtrack

Label : RCA ARL 1-1669 (=GL 43445)
Dimitri Tiomkin: 《Lost Horizon》 , Charles Gerhardt-National Philharmonic Orchestra, @ 1976.
Rating: TASEC-Soundtrack

Label : RCA CBL2 3379
Sondheim: 《Sweeney Todd》 The Demon Barber of Fleet Street, A Musical Thriller.
Rating: TASEC-Soundtrack

Label : RCA GL 43440 (=ARL1-0452)
Steiner: 《Gone With The Wind》 - Charles Gerhardt-National Philharmonic Orchestra.
Rating: TAS-OLD Soundtrack

Label : RCA GL 43441 (=ARL1-0707)
Bernard Herrmann: 《Citizen Kane》
Charles Gerhardt-National Philharmonic Orchestra.
Rating: TASEC-Soundtrack

Label : RCA GL 43445 (=ARL1-1669)
Dimitri Tiomkin: 《Lost Horizon》 - The Classic Film Scores of Dimitri Tiomkin.
Charles Gerhardt-National Philharmonic Orchestra, @ 1976.
Rating: TASEC-Soundtrack

Label : RCA LSO 6006
Harry Belafonte: 《Belafonte At Carnegie Hall》 – The complete Concert.
Rating: TASEC☆☆-POP, (Best of the Bunch & The Golden Dozen LPs, List 2007)

Label : RCA LSP 1773
《Bob and Ray throw a stereo spectacular》 , with Julie Andrews, The Belafonte Singers, Skitch Henderson, Lena Horne, Guckenheime Sour Kraut Band, Abbe Lane, The Melachrino Strings, Radio City Music Hall Organ, Sauter-Finegan Orchestra.
Rating: TASEC-POP

Label : RCA LSP 1866
《Music For Bang, Baarroom & Harp》 Biggest Battery of Percussion West of Cape Canaveral,
Dick Schory's New Percussion Ensemble. Produced by Bob Bollard, recorded in Orchestra Hall, Chicago, 1958.
Rating: TASEC☆☆-POP, (Best of the Bunch List)

Label : RCA LSP 1968
《The Wild Wild West》 - The Ralph Hunter Choir, arranged & conducted by Ralph Hunter.
Recorded in Webster Hall, New York, 1958 by Bob Simpson.
Rating: TASEC☆☆-POP, (Best of the Bunch List)

Label : RCA LSP 1972
《BELAFONTE SINGS THE BLUES》 - A fool for you, Losing Hand, One for My Baby, In the Evenin' Mama, Hallelujah I love Her So, The Way That I Feel, Cotton Fields, Mary Ann, God Bless' the Child, Sinner's Prayer, Fare Thee Well. Recorded in 1958, produced by Ed Welker.
Rating: TASEC-POP

Label : RCA LSP 1993
Chet Atkins: 《Chet Atkins in Hollywood》 – Armen's Theme, Let It Be Me, Greensleeves, Theme from Picnic, Santa Lucia, Them from a Dream, The Three Bells, Meet Mr.Callaghan.
Recorded in Hollywood 1958, orchestra conducted by Dennis Farnon, @1959.
Rating: TASEC-POP

Label : RCA LSP 2175
Chet Atkins: 《The Other Chet Atkins》 - Begin the Beguine, Sabrosa, Yours, Siboney, The Streets of Laredo, Delicado, Peanut Venddo, El Rilicario, Maria Elena, Marcheta, Poinciana, Tzena Tzena Tzena. Recorded in Nashville, @1960.
Rating: TASEC-POP

Label : RCA LSP 2549
Chet Atkins: 《Caribbean Guitar》 - Mayan Dance, Yellow Bird, Wild Orchids, The Bandit, Jungle Dream, The Banana Boat Song, Montego Bay, Theme from Come September, Moon Over Miami, Come to the Mardi Gras, The Enchanted Sea, Temptation. Recorded in Nashville, @ 1962.
Rating: TASEC-POP

Label : RCA LSP 2559
Henry Mancini: 《Howard Hawks' Hatari !》
Music from the Paramount Motion Picture Score, @1962.
Rating: TASEC-Soundtrack

Label : RCA LSP 4140
Henry Mancini: 《A Warm Shade of Ivory》 The Piano Orchestra and Chorus of Henry Mancini.
Featuring Love Theme from Romeo & Juliet, A Day in the life of a Fool, Moment to Moment, The Windmills of your Mind, Cycles, etc., @1969.
Rating: TAS-OLD POP

Label : RCA NL 70032 (=RCA Ital OLS3)
Ennio Morricone: 《Once Upon A Time In The West》 - The Original Soundtrack Recording.
Music, composed and conducted by Ennio Morricone.
Rating: TAS 18-OLD Soundtrack

Label : RCA RL 14748
John Williams: 《Star Wars-Return Of The Jedi》 – Charles Gerhardt-National Philharmonic Orchestra, @1983, Digital. (Last recording from Kenneth Wilkinson)
Rating: TAS-OLD (HP's CD List)

Label : RCA RL 42005
Tiomkin: 《The Spectacular World Of Classic Film Scores》
Charles Gerhardt-National Philharmonic Orchestra, @1976.
Rating: TASEC-Soundtrack

Label : Reference Recordings RR 07
Professor Johnson's Astounding 《SOUND SHOW !!》
Rating: TASEC-POP, (Direct to Tape recording, 45rpm)

Label : Reference Recordings RR 08
Red Norvo Quintet: 《The Forward Look》
A live performance recorder on New Year's Eve, 1957. "The sound is spectacular"
Rating: TAS 50-OLD POP, (45 rpm & 33 rpm)

Label : Reference Recordings RR 12
《DAFOS, (DAEFOS)》
Mickey Hart, Airto Moreira & Purium Flora etc., (45 rpm, 1983)
Rating: TASEC**-POP, (Old Golden Dozen LPs),

Label : Reference Recordings RR 14
《Your Friendly Neighborhood Big Band》 - Featuring: Matt Catingub & Mavis Rivers.
Rating: TAS 65-OLD POP, (45 rpm & 33 rpm,1984)

Label : Reference Recordings RR 18
《Reflections》
Jim Walker, Flute & Mike Garson, Piano, all Songs by Mike Garson. (1985)
Rating: TASEC-POP

Label : Reference Recordings RR 20
《SERENDIPITY》 - Mike Garson-Piano; Jim Walker-Flute; Gary Herbig-Alto Saxophone; Peter Sprague-Guitar & im Lacefield-Bass. (1986)
Rating: TAS 98-OLD POP

Label : Reference Recordings RR 21
《Star Of Wonder》
Music for the Season, Ralph Hooper-San Francisco Choral Artists. (1986)
Rating: TASEC-POP INFORMA

Label : Reference Recordings RR 24
《Three Way Mirror》
Joe Farrell, Airto Moreira & Purium Flora etc., (1985).
Rating: TAS 73-OLD POP

Label : Reference Recordings RR 26
《Blazing Redheads》
Reference Recordings: "it's jazz, it's Latin, it's R & B, but mostly it's FUN ! ".
Rating: TAS 26-OLD POP, D2D limited recording.
Reference price: $40.00

Label : Reference Recordings RR 30
《Eileen Farrell Sings Harold Arlen》, arrangements by Loonis McGlohon, Trumpet: Joe Wilder,
Vocal: Eileen Farrell, special guest artist, 1988.
Rating: TAS 73-OLD** POP, (Old Golden Dozen LPs)

Label : Reference Recordings RR 31
《Tropic Affair》
Jim Brock-Percussion, Produced byGrammy Award winner Don Dixon. (1989).
Rating: TAS 73-OLD** POP, (Old Golden Dozen LPs)

Label : Reference Recordings RR 32
《Eileen Farrell Sings Rodgers and Hart Songs》
Trumpet: Joe Wilder, special guest artist. Vocal: Eileen Farrell.
Rating: TAS 73-OLD** POP, (Old Golden Dozen LPs)

Label : Reference Recordings RR 33
Dick Hyman: 《Plays Fats Waller》, @1998.
Rating: TAS-POP

Label : Reference Recordings RR 34
《Eillen Farrell sings Torch Songs》, arrangements by Loonis McGlohon, Trumpet: Joe Wilder,
special guest artist, Vocal: Eileen Farrell, @1989.
Rating: TASEC**-POP, (Old Golden Backer's Dozen)

Label : Reference Recordings RR 37
Michael Garson: 《Oxnard Sessions》, Volume I
Rating: TAS 73-OLD POP

Label : Reprise Records MS 2037
Gordon Lightfoot: 《Summer Side of Life》, @1971.
Rating: TASEC-POP

Label : Reprise Records MS 2038
Joni Mitchell: 《BLUE》
Rating: TASEC-POP

Label : Reprise Records MS 2260
John Barry: 《King Kong》 - Original Soundtrack.
Rating: TAS 11-OLD Soundtrack

Label : Reprise Records RS 6453
The Beach Boys: 《Surf's Up》
Rating: TAS 13-OLD POP

Label : Scepter SPS 573
Dionne Warwick: 《Soulful》 - I've Been Loving You Too Long, People Got To Be Free,
You've Lost That Lovin' Feelin', People Get Ready, Do Right Woman, I'm Your Puppet, You're
All I Need to Get By, We Can Work It Out, Hard Day's Night, Hey Jude.
Rating: TASEC-POP (Soul)

Label : Sheffield S 10
【The Missing Linc】 《Lincoln Mayorga & Distinguished Colleagues Vol.II》
Rating: TAS 7-OLD POP (Direct to Disc)

Label : Sheffield Lab LAB 01
《Lincoln Mayorga & Distinguished Colleagues Vol.III》
Grammy Nomination for Best Engineered Album, @1973.
Rating: TAS 7-OLD POP (Direct To Disc)

Label : Sheffield Lab LAB 03
《The King James Version》 - Harry James and His Big Band, Recorded in 1976.
Grammy Nomination for Best Engineered Album.
Rating: TAS 27-OLD POP (Direct to Disc)

Label : Sheffield Lab LAB 05 (Sheffield Lab ST 500, reissue)
Dave Crusin: 《Discovered Again》 – Recorded in 1976.
Rating: TAS 73-OLD POP (Direct to Disc)

Label : Sheffield Lab LAB 11
《Still Harry After All These Years》 - Harry James and His Big Band celebrating Harry's 40th
Anniversary as a big band trumpeter and leader. Recorded in 1979.
Rating: TAS 73-OLD POP, Audio Technica Award (Direct to Disc)

Label : Sheffield Lab LAB 12
Don Randi and Quest : 《New Baby》 - A Jazz sextet with a collection of contemporary and
upbeat instrumental, recorded in 1980. Grammy Nomination for Best Engineered Album.
Rating: TAS 73-OLD POP (Direct to Disc)

Label : Sheffield Lab LAB 13
《Growing up in Hollywood》 - Vocals by Amanda McBroom, arranged & conducted by Lincoln
Mayorga, recorded in 1980. Grammy Nomination for Best Engineered Album.
Rating: TASEC-POP (Direct to Disc)

Label : Sheffield Lab LAB 14
《The Sheffield Drum Record》 - For Audio Component Test & Evalution. Improvisations by Jim
Keltner & Ron Tutt. Produced by Doug Sax & Bill Schnee, engineered by Bill Schne, in 1980.
Rating: TASEC-POP (Direct to Disc)

Label : Sheffield Lab LAB 20
《The Sheffield Track Record》 - This special record is designed for component testing &
features rock and roll Instrumental tracks. Produced & engineered by Bill Schnee, 1982.
Rating: TASEC☆☆-POP (Best of the Bunch List)

Label : Sheffield Lab LAB 21
《The Name Is Makowicz》
Adam Makowitcz on piano and Phil Woods on saxophone. Recorded in 1983.
Rating: TAS 65-OLD POP (Direct to Disc)

Label : Sheffield Lab LAB 23
《James Newton Howard & Friends》 - This is a Sheffield landmark recording of keyboardist,
composer James Newton Howard and his friends from the group "Toto", produced and
engineered by Bill Schnee.
Rating: TAS 73-OLD POP (Direct to Disc)

Label : SIRE Records SA 7526 (=Br WB K 56422)
《Renaissance Novella》 , @1977, Originl recording: Br WB K 56422.
Rating: TASEC-POP INFORMAL

Label : SOLAR 60239-1
Shalamar: 《The Look》, @1983
Rating: TAS 65-OLD POP

Label : Song of the Wood 7811
Jerry Read Smith: 《The Strayaway Child》, @1981
Rating: TASEC-POP

Label : Streetwise SWRL 2210
Freez: 《I.O.U.》, (12″) @1982.
Rating: TASEC-POP (Single)

Label : True North TN 43
Rough Trade: 《Avoid Freud》, @1980.
Rating: TASEC-POP

Label : True North TN 48 (=PG 33435)
Rough Trade: 《for those who think young》
All Touch、 Blood Lust、 Bodies in Collision、 Fakin' It, @1981.
Rating: TASEC-POP, (UK =True North TN 48)

Label : True North TN 50 (=Br CBS 25412)
Rough Trade: 《Shacking the Foundations》 , @1982
Rating: TASEC-POP

Label : True North TN 55 (=BIG TIME BT 7024)
Rough Trade: 《Weapons》 , @1983
Rating: TAS 65-OLD POP

Label : UMBRELLA UMB DD4
《Big Band Jazz》 - Rob McConnell and the Boss Brass, @1971, Canada.
Rating: TAS 50-OLD POP-D2D

Label : UNICORN DKP 9000
Bernard Herrmann: 《North by Northwest》 – London Studio Symphony Orchestra conducted
by Laurie Johnson, @1980. Producer: Alfred Hitchcock.
Rating: TAS 20-OLD Soundtrack

Label : UNICORN RHS 336
Bernard Herrmann: 《Psycho》 - Bernard Herrmann's complete music for Alfred Hitchcock's
classic suspense thriller. National Philharmonic Orchestra conducted by composer, @1975.
Rating: TAS 18-OLD Soundtrack

Label : VANGUARD VSD 2122
Joan Baez: 《Joan Baez in Concert》 , @1963
Rating: TASEC-POP

Label : VANGUARD VSD 2150
The Weavers: 《Reunion at Carnegie Hall 1963》
15th Anniversary of the Weavers, recorded at Carnegie Hall, 02 & 03 May, 1963.
Rating:TASEC☆☆-POP, (Best of the Bunch & The Golden Dozen LPs, List 2007)

Label : VANGUARD VSD 79200
Joan Baez: 《Farewell Angelina》, @1965
Rating: TASEC-POP

Label : Varese Sarabamde 704340 (=Filmmusic Collection FMC 4)
Bernard Herrmann: 《The ghost and Mrs. Muir》
Original Motion Picture Score, conducted by Elmer Bernstein @1985.
Rating: TASEC-Soundtrack

Label : Varese Sarabamde STV 81244
Junior Homrich & Brian Gascoigne: 《The Emerald Forest》
Original Motion Picture Sound by John Boorman, @ 1985.
Rating: TASEC-Soundtrack

Label : Varese Sarabande VC 81105
《PHANTASM》 - Original Motion Picture Soundtrack-Don Coscarelli, music by Fred Myrow
and Malcolm Seagrave. @1979
Rating: TASEC-Soundtrack

Label : VERTIGO 814 6111 (=Elektra 966790)
Yello: 《Lost Again, I love you Bostich》 - One single "Lost agin" in the Hp's list.
Rating: TASEC-POP (Single)

Label : VERTIGO 824499-1 (=VERH 25)
Dire Straits: 《Brother in Arms》
Rating: TAS-POP

Label : VERVE V6 4053
Ella Fitzgerald: 《Clap Hands, Here Comes Charlie》
Rating: TAS-POP

Label : VIRGIN 1-91329 (=VL 3087)
James Horner: 《GLORY》
Original Motion Picture Soundtrack, @1989.
Rating: TASEC-Soundtrack

Label : VIRGIN 466-12B
Human League: 《Don't You Want Me》, UK @1981.
Rating: TASEC-POP (Single)

Label : VIRGIN V 2185
Phil Collins: 《Face Value》
Rating: TAS 50-OLD POP

Label : VIRGIN VS 76512
China Crisis: 《In a Catholic Style》, UK @1985.
Rating: TASEC-POP (Single)

Label : VIRGIN ZTT 1ZZTAS1
Frankie Goes To Hollywood: 《Relax》, UK @1983.
Rating: TASEC-POP (Single)

Label : VIRGIN ZTT 12Z TAS12
Propaganda: 《Machinery》, UK @1985.
Rating: TASEC-POP (Single)

Label : Warner Bros 23728-1 (=Vertigo 6359 109)
Dire Straits: 《Love Over Gold》, @1982.
Rating: TAS 73-OLD POP

Label : Warner Bros BS 2886
Seals & Crofts: 《Greatest Hits》, @1975
Rating: TASEC-POP

Label : Warner Bros PRO 496
《Supercord. Contemporary》 - Lovecraft: The Dawn; Mason Williams: Jose's Place;
Joni Mitchell: For Free; Gordon Lightfoot: If You Could Read My Mind, etc., @1971.
Rating: TAS 25-OLD POP

Label : Warner Bros W 9006
a-ha: 《Take Me On》, UK @1985.
Rating: TASEC-POP (Single)

Label : Warner Bros WS 1449
Peter, Paul & Mary: 《Peter, Paul & Mary》, @1962
Rating: TASEC-POP

Label : Warner Bros WS 1727
Van Dyke Parks: 《Song Cycle》
Rating: TASEC-POP

Label : Wilson Audiophile W 808
Mark P.Wetch: 《Ragtime Razzmatazz Vol.1》
12 Nostalgic Piano Performances, (1980).
Rating: TAS 98-OLD POP

Label : Wilson Audiophile W 8823
《Winds of War and Peace》 - Lowell Graham-National Symphonic Winds.
Recording Team: David Wilson, Bruce Leek, Joseph Magee, on 17 September 1988.
Rating: TASEC**-POP, (Old Golden Dozen LPs)

Label : Wilson Audiophile W 8824
《Center Stage》 - Lowell Graham-National Symphonic Winds.
Recording Team: David Wilson, Bruce Leek, Joseph Magee, 17 September 1988.
Rating: TASEC**-POP, (Old Golden Dozen LPs)_

BIBLIOGRAPHY　參考書目

Audiophile Record Collector's Handbook (7th ED), Phil Rees

Collector's Illustrated Vinyl Bible,　Alfred H.C. Wu

Collector's Illustrated Vinyl Bible II, Alfred H.C. Wu

Collector's Illustrated Vinyl Bible III, Alfred H.C. Wu

Full Frequency Stereophonic Sound, © 1990, Robert Moon & Michael Gray

Primyl Vinyl: PVX Newsletter–TAS Super Disc List, Vol.1 #6 & Vol.2 #1 (Updated) ,

Writer: Larry Toy, Editor: Bruce C. Kinch

The Penquin Stereo Record Guide (2nd Edition, 1978), E. Greenfield, R. Layton & I. March

The New Penquin Stereo Record & Cassette Guide (1982), E. Greenfield, R. Layton & I. March

The Complete Penquin Stereo Record & Cassette Guide (1984), E. Greenfield, R. Layton & I. March

The Penquin Guide To Compact Discs, Cassettes & LPs (1986), E. Greenfield, R. Layton & I. March

The Stereo Record Guide (Vol. I to Vol. IX, 1960 to1974), E. Greenfield, I. March, D.Steven

The Vinyl Bible, Max Lin

唱片收藏面面觀，郭思蔚 著　有鹿文化

唱片聖經 - 30 年來最值得購買的 900 張軟體 (臺灣音響論壇創刊周年附冊)

黑膠唱片聖經 (The Vinyl Bible), 林耀民 著

黑膠唱片聖經收藏圖鑑　 (Collector's Illustrated Vinyl Bible), 吳輝舟 著

黑膠唱片聖經收藏圖鑑 II (Collector's Illustrated Vinyl Bible II), 吳輝舟 著

黑膠唱片聖經收藏圖鑑 III (Collector's Illustrated Vinyl Bible III), 吳輝舟 著

安塞美黑膠收藏指南 , 侯宏易 著 , 世界文物出版社

黑膠版位攻略 , 侯宏易 著 , 世界文物出版社

黑膠唱片收藏圖鑑 , 侯宏易 著 , 世界文物出版社

黑膠專書 劉漢盛 書世豪 陶忠豪 等人著 (臺灣音響論壇特刊)

COLLECTOR'S VINYL RECORDS BIBLE (Ⅰ)

黑膠唱片聖經收藏索引(Ⅰ)

作　　　者	吳輝舟（ Alfred H.C. Wu ）	總 代 理	三友圖書有限公司	
編　　　輯	楊志雄	地　　　址	106台北市安和路2段213號4樓	
美 術 設 計	劉錦堂、黃珮瑜	電　　　話	(02) 2377-4155	
		傳　　　真	(02) 2377-4355	
發 行 人	程顯灝	E - m a i l	service@sanyau.com.tw	
總 編 輯	呂增娣	郵 政 劃 撥	05844889 三友圖書有限公司	
主　　　編	徐詩淵			
編　　　輯	林憶欣、黃莛勻、林宜靜	總 經 銷	大和書報圖書股份有限公司	
美 術 主 編	劉錦堂	地　　　址	新北市新莊區五工五路2號	
美 術 編 輯	曹文甄、黃珮瑜	電　　　話	(02) 8990-2588	
行 銷 總 監	呂增慧	傳　　　真	(02) 2299-7900	
資 深 行 銷	謝儀方、吳孟蓉			
		製 版 印 刷	卡樂彩色製版印刷有限公司	
發 行 部	侯莉莉			
財 務 部	許麗娟、陳美齡	初　　　版	2018年12月	
印　　　務	許丁財	定　　　價	新臺幣390元	
出 版 者	四塊玉文創有限公司	I S B N	978-957-8587-53-3（平裝）	

國家圖書館出版品預行編目(CIP)資料

黑膠唱片聖經收藏索引 / 吳輝舟作. -- 初版. --
臺北市：四塊玉文創, 2018.12
　　面；　公分
ISBN 978-957-8587-53-3(平裝)

1.唱片 2.索引
910.21　　　　　　　　　　107020762

SANYAU
http://www.ju-zi.com.tw
三友圖書
友直 友諒 友多聞